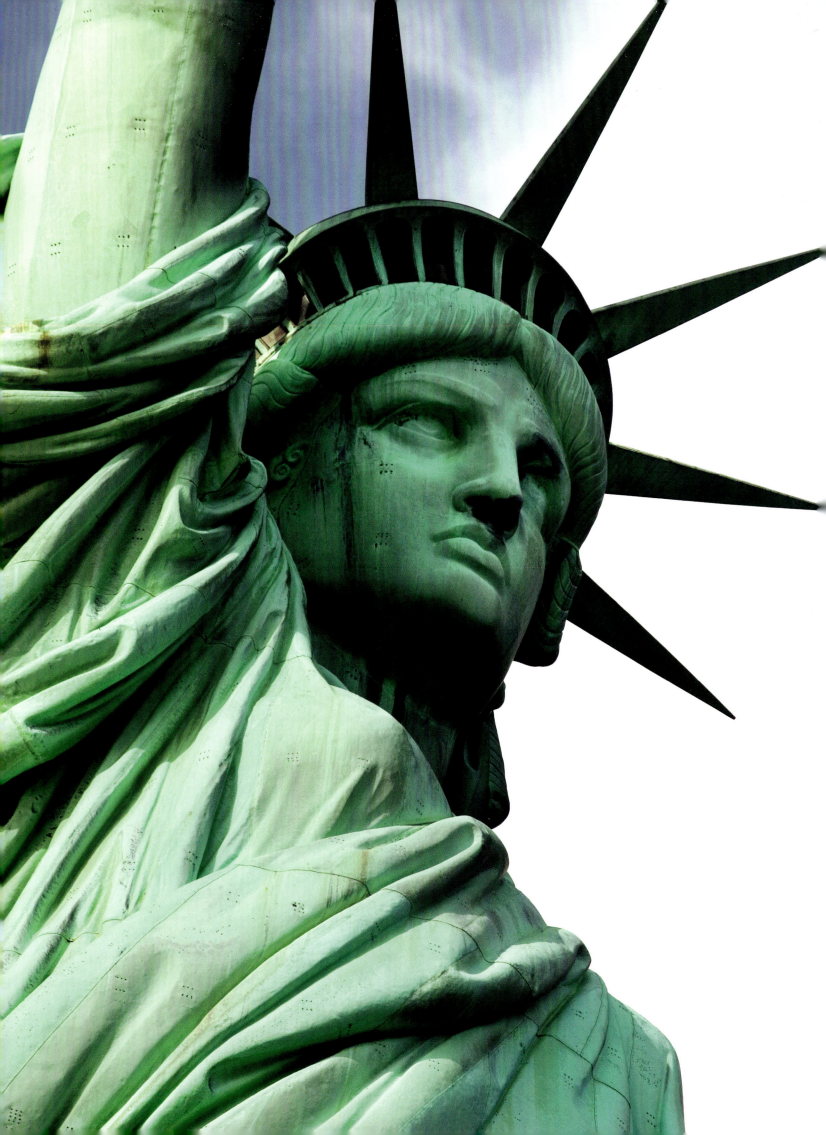

Pierre Toromanoff

NEW YORK

IN FASHION

ACC ART BOOKS

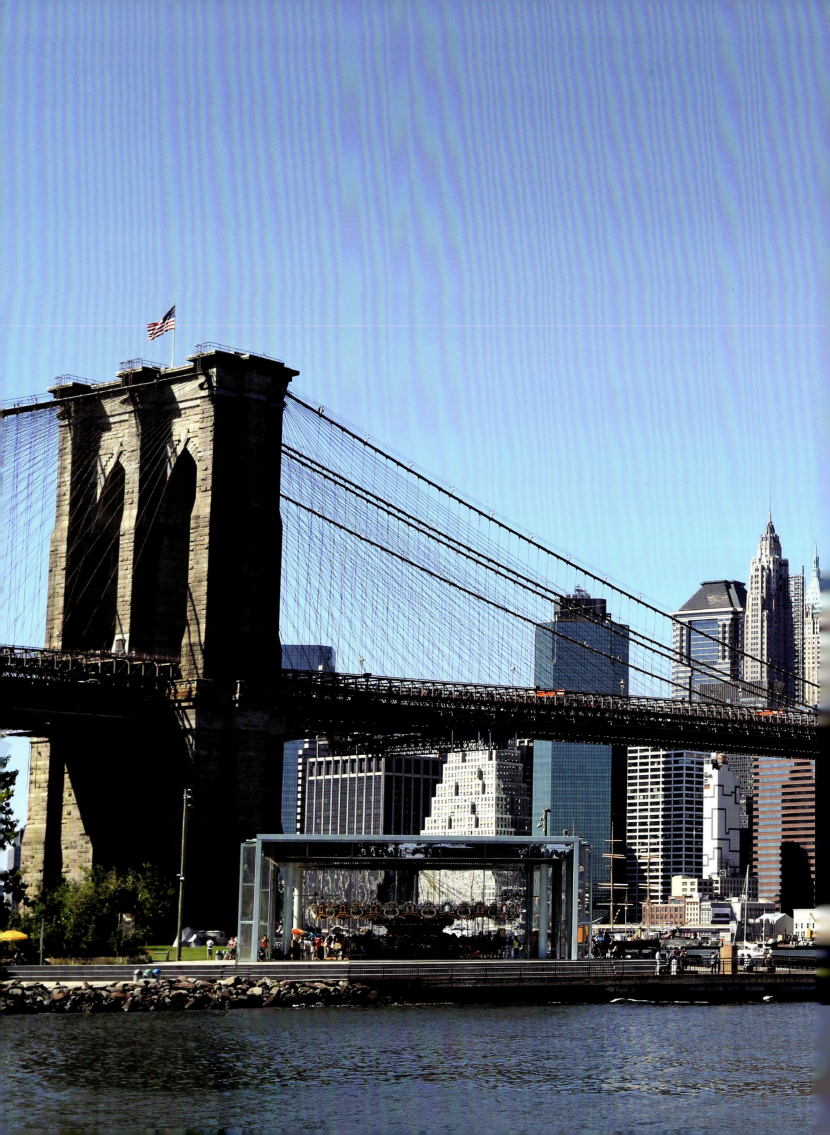

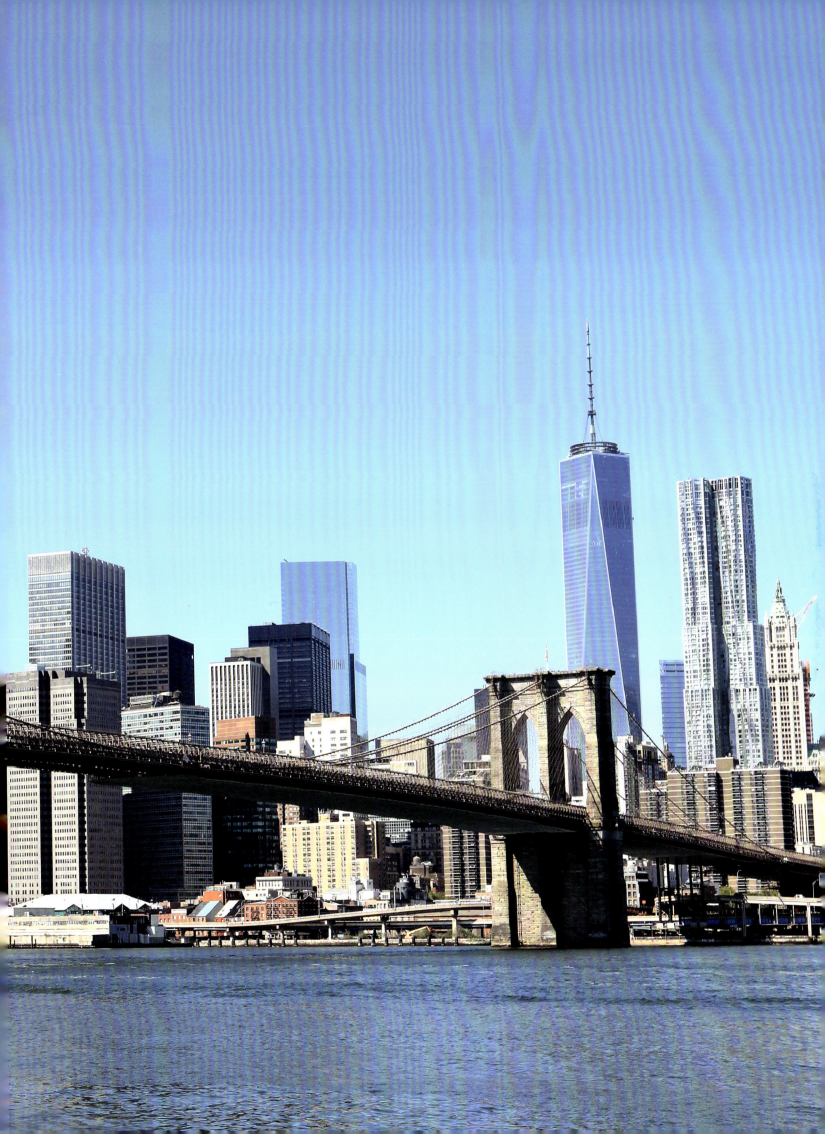

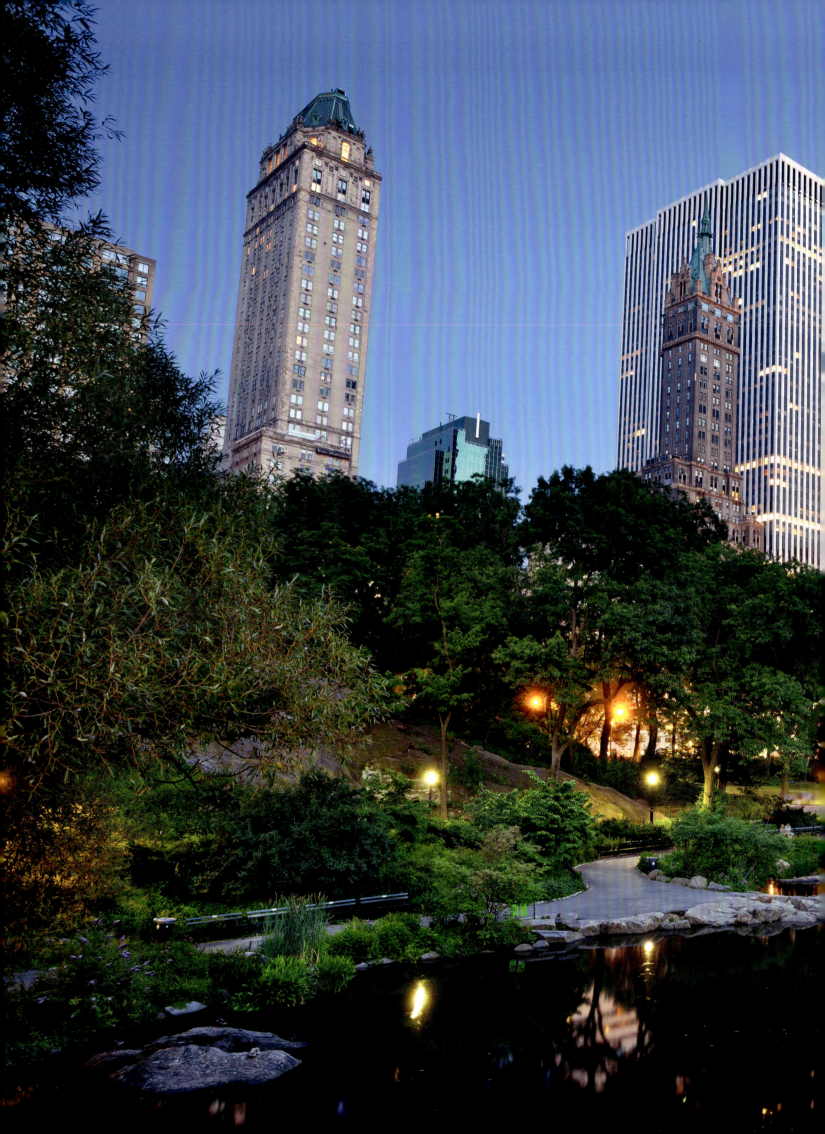

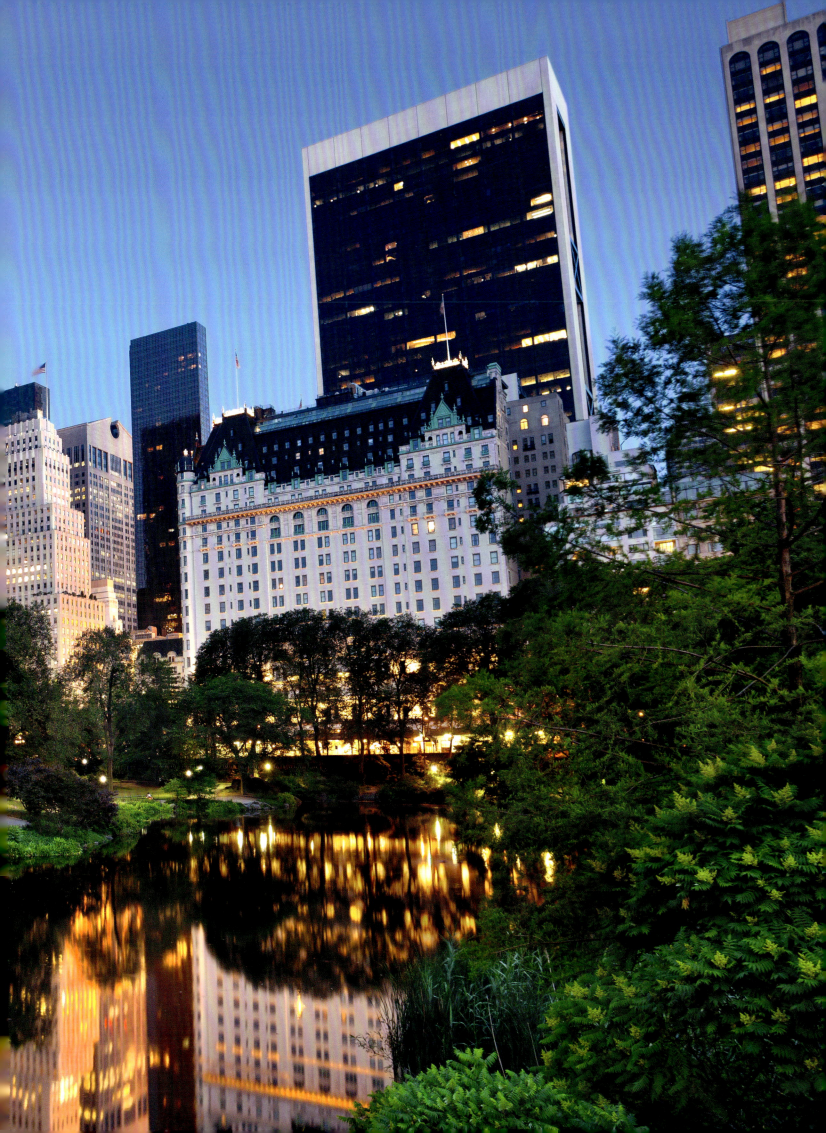

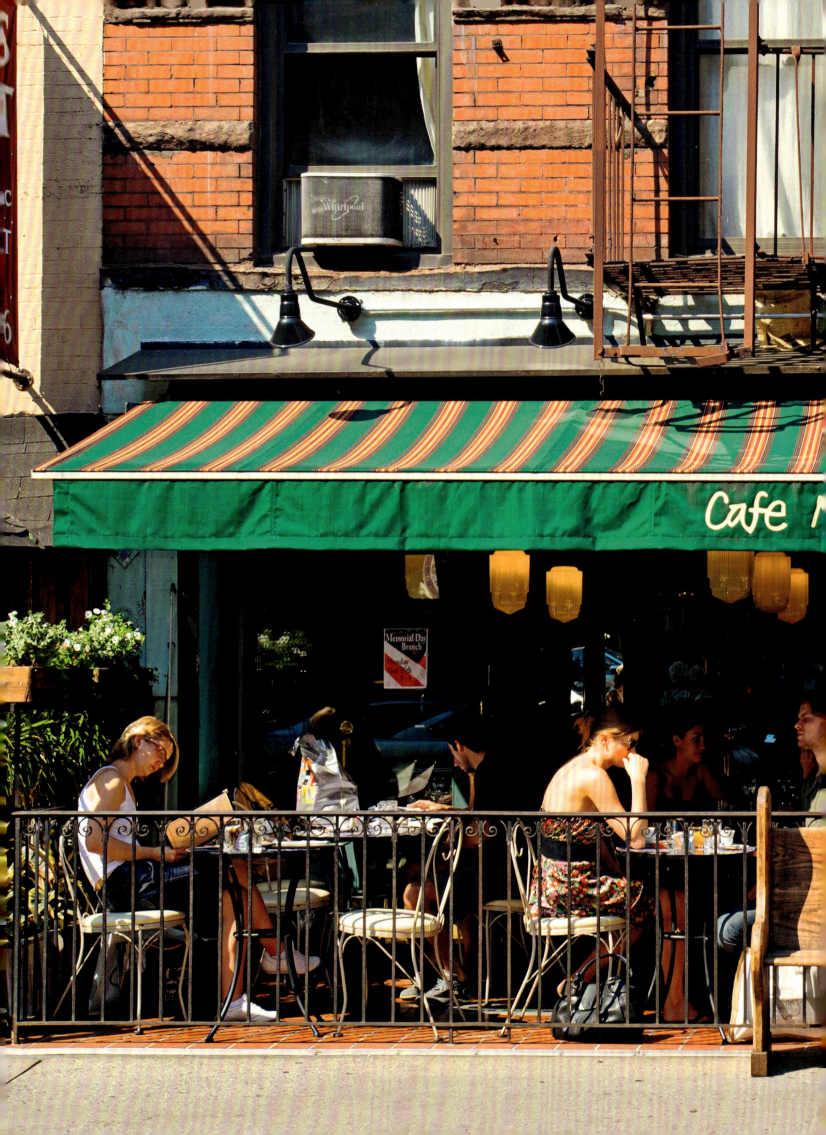

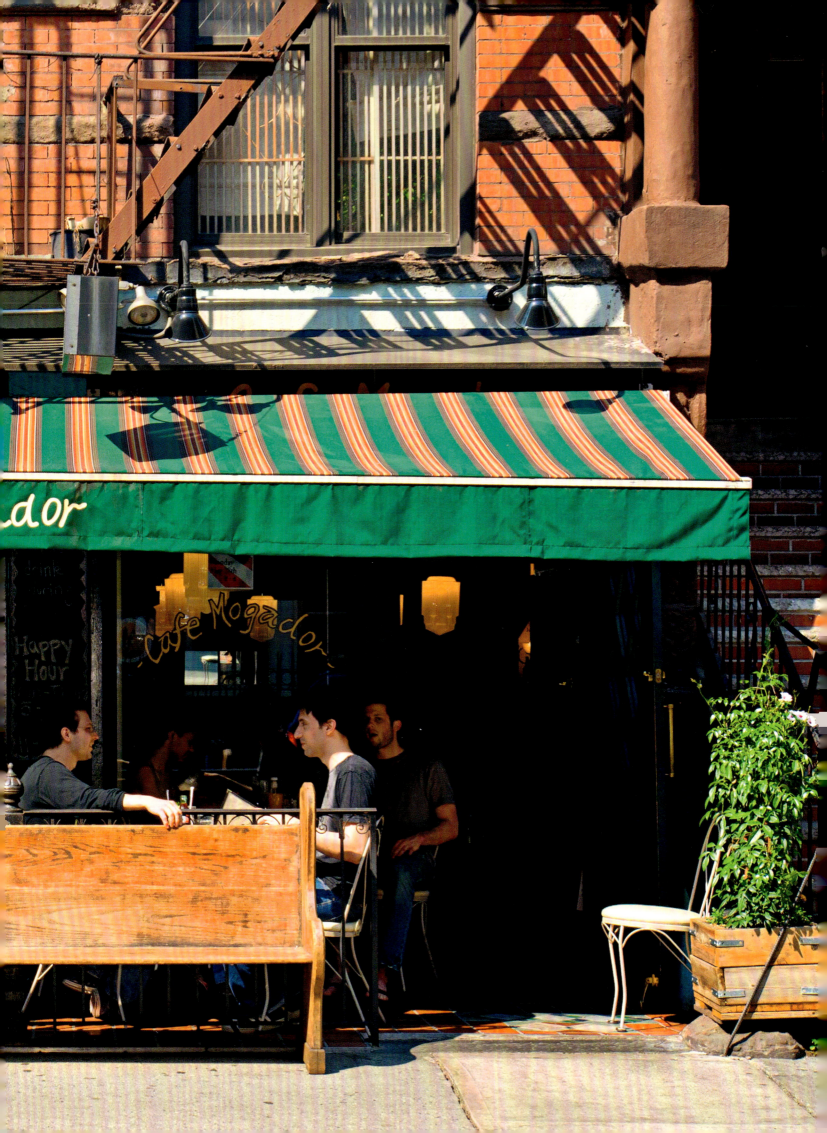

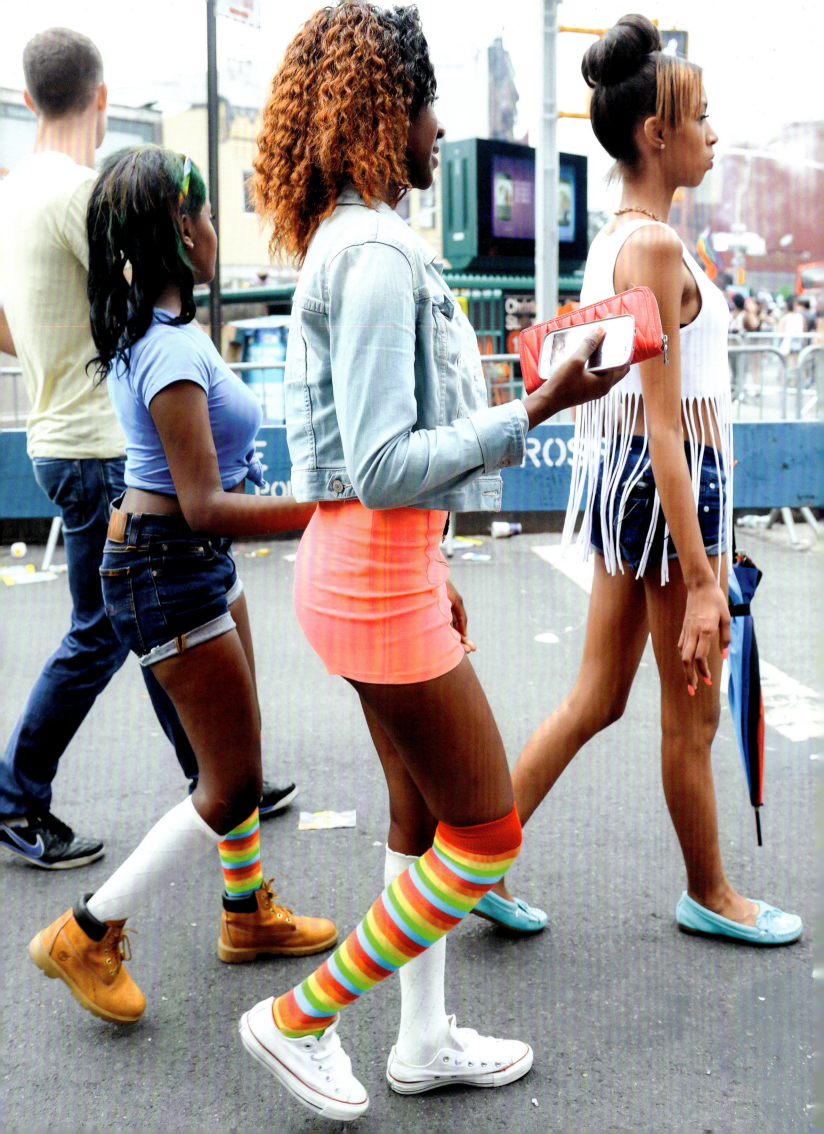

"New York City is truly the fashion capital of the world. There is a new look around every corner, down every block."

MICHAEL KORS

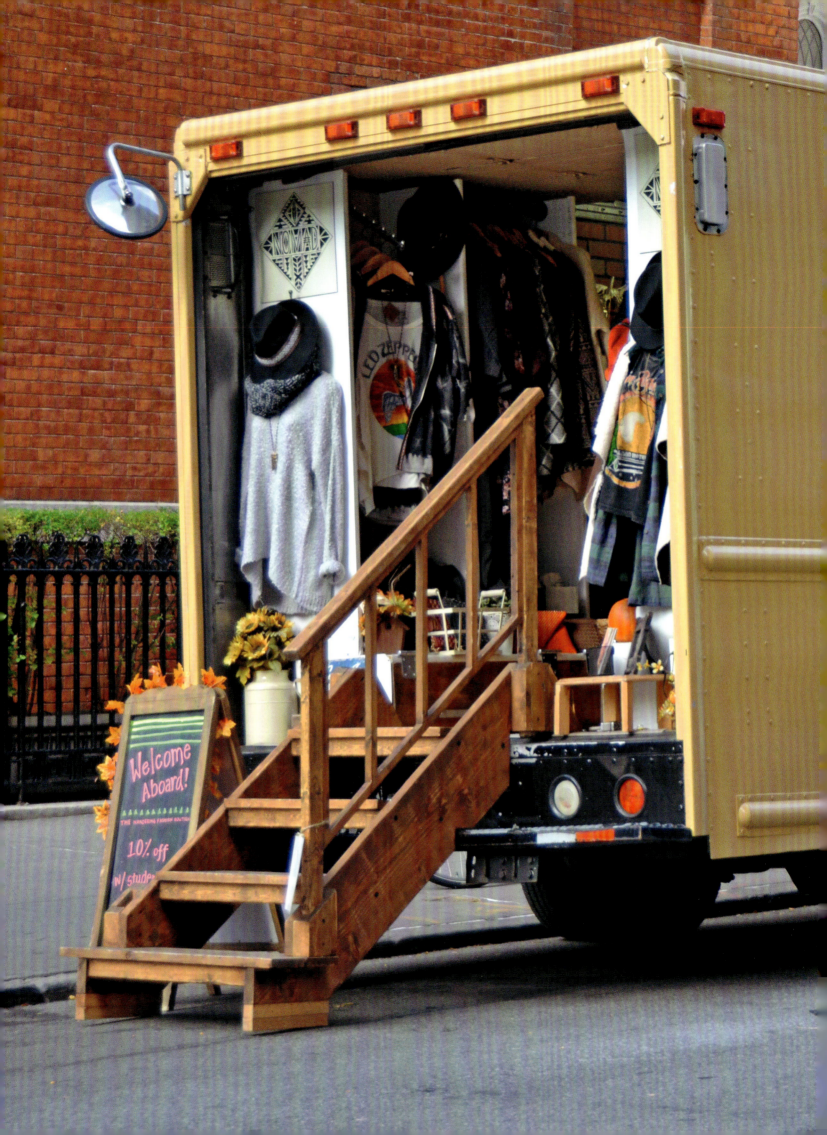

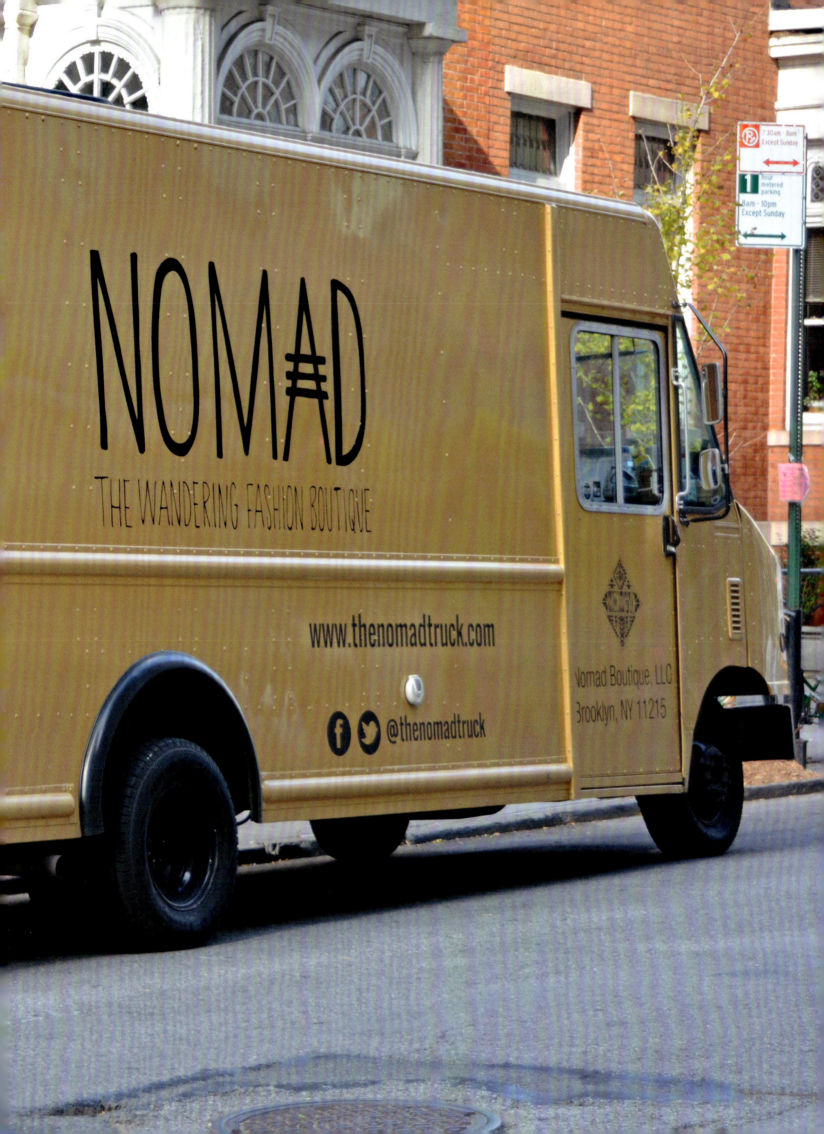

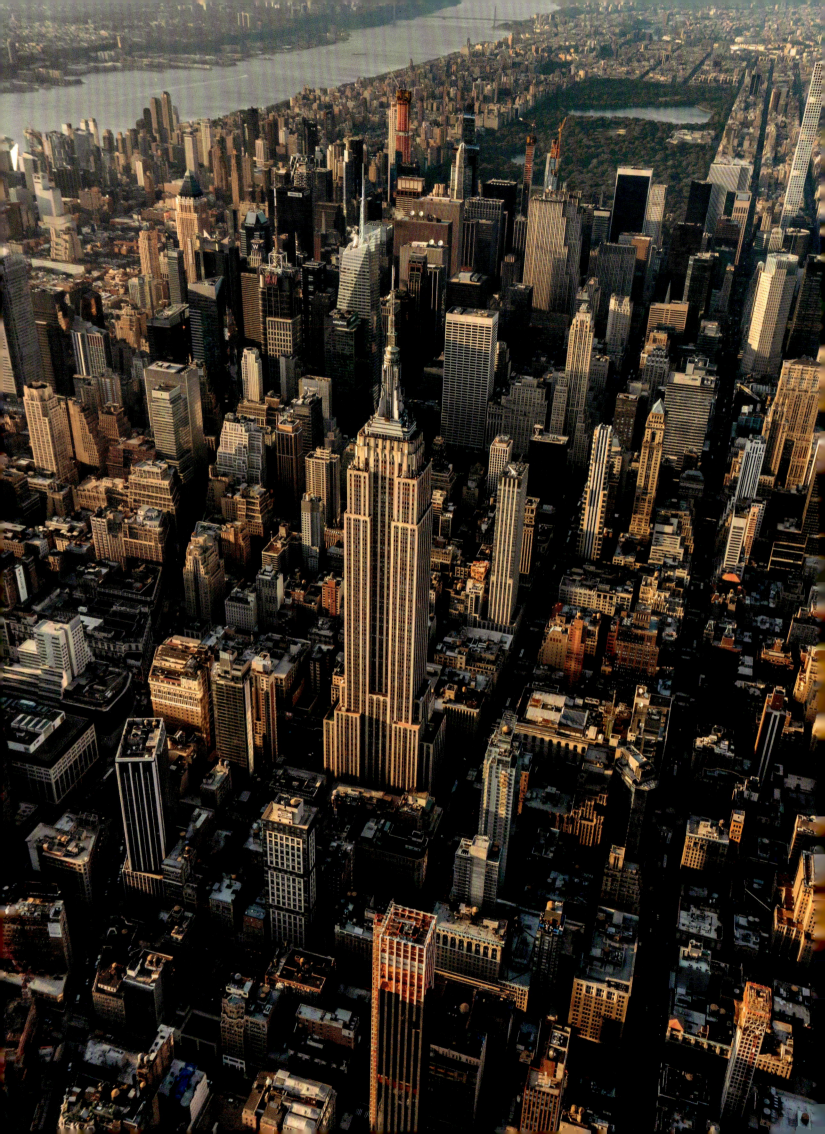

Introduction
16

Fashion in New York:
Past and Present
18

New York City on the Catwalk
38

New York Street Style
122

Shopping
210

Only in New York
254

Photo Credits
302

Acknowledgements
303

> "No amount of money can buy you style.
> It's just instinctive."
>
> IRIS APFEL

INTRODUCTION

New York is often nicknamed "the city that never sleeps", a testament to the extraordinary energy emanating from its buildings, streets, and inhabitants. You might just as easily think of it as the city of unceasing wonders – a concrete capital for the cyberspace concept of "global village". We should refer to New York fashion as New York *fashions*, plural, as diversity and variety are essential components of the Big Apple's fashion DNA. Nowhere else is fashion so teeming with a thousand intertwining and echoing trends: from flawlessly preppy to extremely transgressive, and from purist minimalism to ecstatic maximalism, every style here blends into an exceptional artistic composition – even anti-fashion is part of the picture!

New York's streets are like blood vessels that nourish the body of high fashion: many designers draw their inspiration from the daily spectacle, sniffing out the spirit of the times. If not for the streets and the new trends that are constantly emerging there, New York's contribution to fashion history would have been far more modest. Would we ever have seen sportswear and hip-hop take over the catwalks? New York's genius was to create fashion for everyone – instead of rivalling Paris in haute couture, the city conquered the world with ready-to-wear. And yet, New York is also a hotspot for luxury and refinement. The extravagant sartorial splendour of the guests at the Met Gala is proof of this every year. The same celebrities may be spotted the next morning in athleisure or with ripped jeans, and nobody will wonder at this, for New York is the capital of sartorial freedom, where everyone follows their own style and taste.

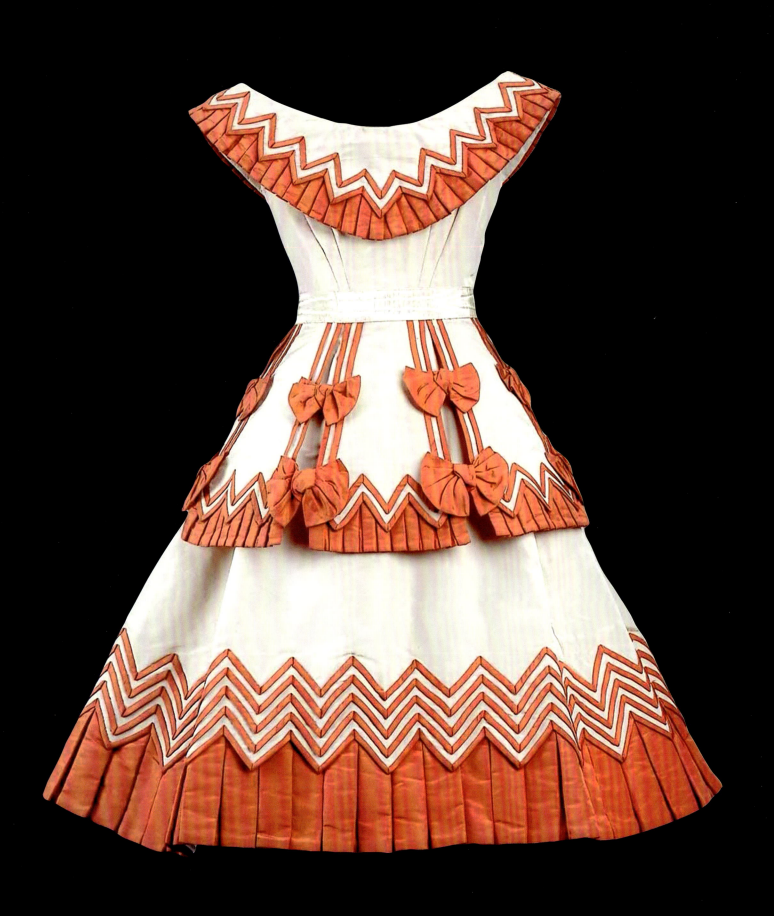

FASHION IN NEW YORK: PAST AND PRESENT

In a bit more than a century and a half, New York has become one of the world's fashion capitals, rivalling cities as prestigious and steeped in history as London, Milan, and Paris. New York nowadays is the trendsetting city par excellence, with its own distinctive style, combining elegance and modernity with practicality and comfort.

If American fashion had to be given a birth year, 1850 would be a reasonable choice, when Isaac Merritt Singer (1811–1875) developed the first straight-stitch sewing machine, called Standard 1. While Singer's company was founded in Boston, he promptly relocated his operations to New York in 1853, whence Singer's sewing machines would conquer households around the globe in two decades. They would also transform the fate of many Central and Eastern European Jews, who fled poverty and discrimination in their home countries and set up in America throughout the 19th century. Among these fresh immigrants, skilled workers with knowledge of clothing manufacture constituted a sizable group. In fact, it is estimated that by 1890, more than 70% of New York's clothing factories were owned by German Jews. By the turn of the century, around 75% of the city's garment-industry workforce was Jewish.

Since New York was the nation's largest site for textile storage, it was no surprise that so many Jewish clothiers decided to settle in the city. The use of sewing machines cut working time enormously – the first Singer machines made it possible to sew 10 times faster than an experienced seamster, thus enabling the transition from craft to mass production. This transition proved very timely at the outbreak of the American Civil War, when the Union army urgently needed a considerable number of uniforms and commissioned the New York manufacturers with this task. Although sewing workshops were still modest in size, the clothing industry was finding its feet and would soon find new outlets thanks to department stores, such as A. T. Stewart, Bloomingdale's, Lord & Taylor, Macy's, and Saks (at that time located at the corner of Broadway and 34th Street, in an area known as the Ladies' Mile). The high-end fashion departments offered collections replicating the latest Parisian trends, which could be adjusted to the clients' wishes by an army of seamstresses usually working in the stores' attics. For more affordable, ready-to-wear clothing, the department stores hired fashion designers who created clothing for the brand while staying anonymous, as was the custom of the time. Young Elizabeth Hawes (1903–1971), for example, who would become a star of American couture in the late 1920s, started her career as an apprentice in the workrooms of Bergdorf Goodman. She moved to Paris in 1925 and her job there consisted of counterfeiting dresses by famous couturiers on behalf of American clients (despite this, a couple of years later, in 1931, she would be the first American fashion designer to ever be invited to show her collections in Paris).

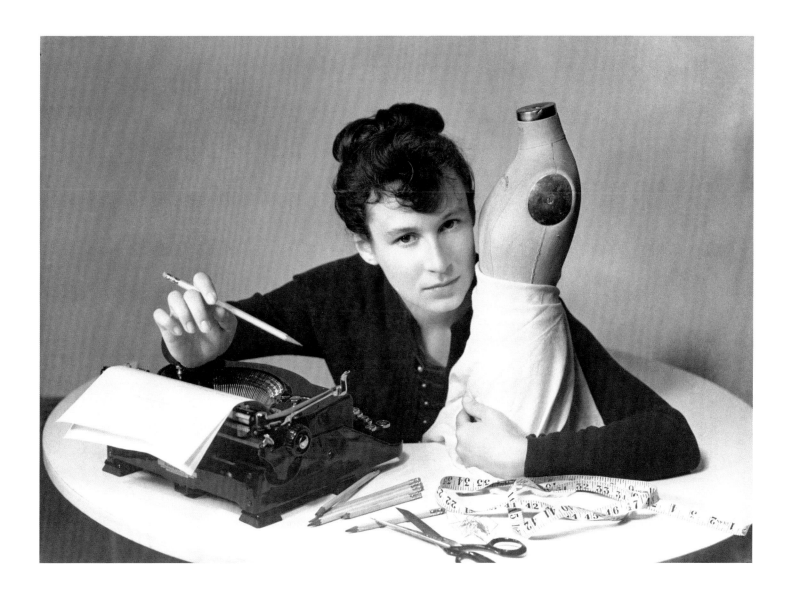

"Men's clothes will really be revolutionized when the male asserts his right to be considered as alluring and decorative and beautiful as women."

ELIZABETH HAWES

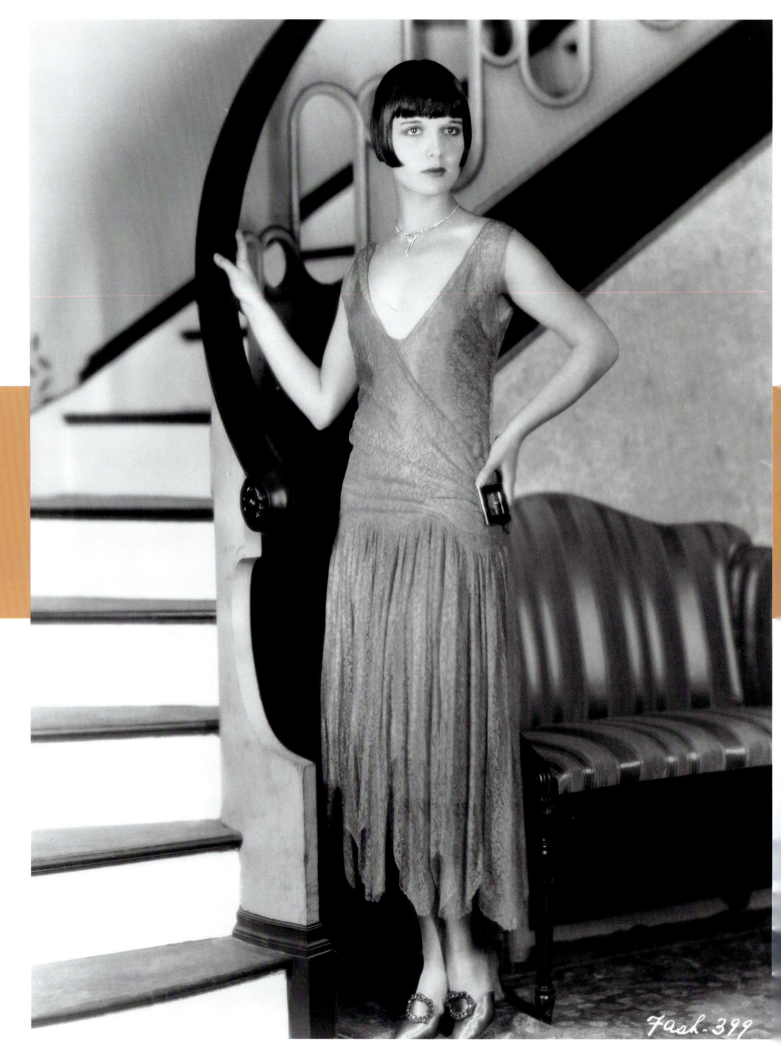

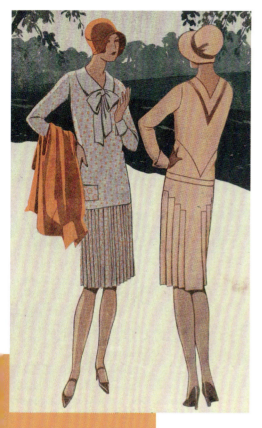

By restricting trade and mobility between Europe and the United States, the First World War encouraged American fashion retailers to offer their own designs, although French couturiers promptly held a memorable fashion show in New York in November 1915, just one year after the outbreak of the war, to show their collections and keep their North American clientele aware of the latest Parisian trends.

Above all, the rise of the cinema in the 1910s would have a lasting impact on the history of fashion, creating iconic archetypes that would inspire a wide audience. Hollywood stars Louise Brooks, Colleen Moore, and Clara Bow directly contributed to the popularity of the first truly American style, the flapper girl, characterised by short, sleek hair (covered by a cloche hat when outside), a calf-length shift dress, sophisticated make-up, and the habit of smoking in public. The flapper girl was modern and emancipated, and loved dancing to jazz music, to the point of personifying the atmosphere of the Roaring Twenties. Underlying its provocative and slightly decadent appearance, the flapper girl trend hastened the liberation of the female body from the shackles of classic fashion and heralded an evolution towards more casual outfits. By shaking up codes, the flapper girl style challenged the quasi-monopolistic status of Parisian fashion in terms of innovation and trendsetting, and young fashion designers stepped into the breach.

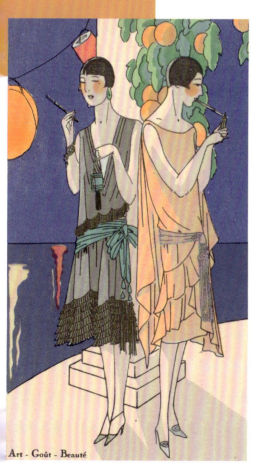

Unsurprisingly, some of them started out as costume designers for Hollywood divas and would use their relationships with celebrities to promote their work. A good example is that of Valentina Schlee (1899–1989), known mononymously as Valentina, a Ukrainian-born Russian émigré and close friend (not to mention close lookalike) of Greta Garbo (although Valentina's husband, George, became one of the actress's most devoted lovers), Katharine Hepburn, and Marlene Dietrich. Initially designing for theatre and dance Valentina created theatrical-looking dresses, inspired by Madeleine Vionnet (1876–1975) and Alix Grès (1903–1993), which attracted a glittering celebrity clientele, making her "America's most glamorous dressmaker". Her boutique on Madison Avenue, Valentina, opened in 1928 and was known for her luxurious collections – it was said that even well-off people would save up to shop there, and the number of her clients did not exceed 200 at any given time. Though she spoke with a strong Russian accent, Valentina is remembered for her legendary aphorisms on fashion and style, such as "I do not believe in fashion, only in individually dressed women", "simplicity survives the changes of fashion", and "fit the century, forget the year". Meanwhile, the Chicago-born Main Rousseau Bocher (1890–1976) started a career in the fashion world as the Paris fashion editor of *Vogue*, and then as chief editor of the French edition, before launching his own Paris-based brand, Mainbocher, in November 1929, a couple of weeks after the Wall Street crash. However, the timing did not particularly affect the successful launch of the new house, and soon his elegant collections were all the rage among the Parisian aristocracy. The wedding dress he designed for Wallis Simpson, the future Duchess of Windsor, in 1937 is one of his masterpieces of the period.

The protectionist policy implemented by President Herbert Hoover (1874–1964) in the wake of the Great Depression arguably had a beneficial effect on the expansion of American fashion in the 1930s. Prohibitive tariffs on imported textiles and clothing gave local products a clear advantage. Furthermore, the zeitgeist had now shifted towards sobriety and simple comfort, as if rejecting the flamboyant eccentricities of the previous decade, and this new direction in fashion paved the way for a generation of American designers trained both at department stores and in Paris, such as Claire McCardell (1905–1958), whose garments, according to fashion historian Julie Eilber, "were equipped with large pockets and made from practical, easy-care fabrics such as quilting cottons, denim, men's suiting wools, jersey, and synthetics." But, as Eilber suggests, McCardell's "innate style and draping prowess turned these humble fabrics into alluring, body-conscious, and feminine fashions". A model and Metropolitan Opera ballet dancer turned fashion designer, Vera Maxwell (1901–1995) started sketching comfortable, chic, and timelessly elegant day wear for various ready-to-wear brands such as Adler & Adler and Max Millstein, developing collections of separates and suits, which were hailed as the quintessence of practicality and chic simplicity. Along with Bonnie Cashin (1908–2000), Tina Leser (1910–1986), Carolyn Schnurer (1908–1998), and Clare Potter (1903–1999), McCardell and Maxwell are also credited for boosting a fashion segment that was still in its early years, but was in line with the new ideal of the sporty woman: sportswear.

Hattie Carnegie (1886–1956) was another key figure of the 1930s. Born Henrietta Kanengeiser to an impoverished Austrian-Jewish family, Carnegie emigrated to New York with her parents and siblings at the turn of the century and began her professional life at the age of 13, as an apprentice at Macy's. Her successful experience as a milliner led her to open a custom fashion shop with a friend, Rose Roth, in 1909, where she promoted avant-garde fashion by Coco Chanel, Madeleine Vionnet, and other pioneers.

Her close business relationships with department stores led her to develop her first ready-to-wear collection in 1928, which transformed her company into a fashion empire – by 1940, Carnegie had a staff of 1,000 employees, and her designs were sold nationwide.

Princess silhouette

Among the fashions seen last fall in Paris, the princess silhouette seems to have grown more and more beloved. This spring we see it again in many versions, always with the soft fullness and slimly molded line that is so appealing to most women. It comes in wool or bengaline coats, silk or wool dresses, tie-pattern prints, in a jumper for morning, an ankle-length faille for afternoon. It is one of the few fashions that are almost universally becoming. ★ BY WILHELA CUSHMAN
Fashion Editor of the Journal

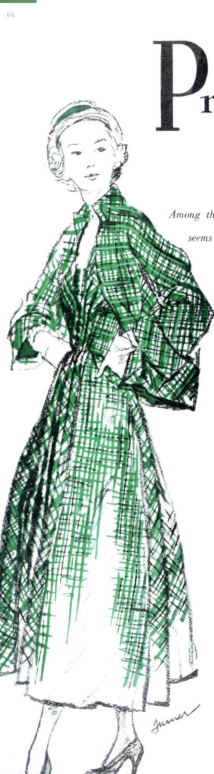

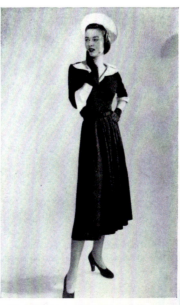

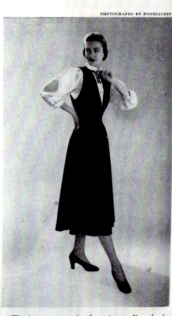

The princess dress in lightweight navy wool, touched with white, worn with a little flat sailor.

The little dolman, perfect jacket for a princess dress in plaid taffeta, extra full.

The belted princess line with its fullness in the front. Sheer navy wool with white piqué.

The jumper, new in the princess line, basic in navy rayon with a white crepe blouse.

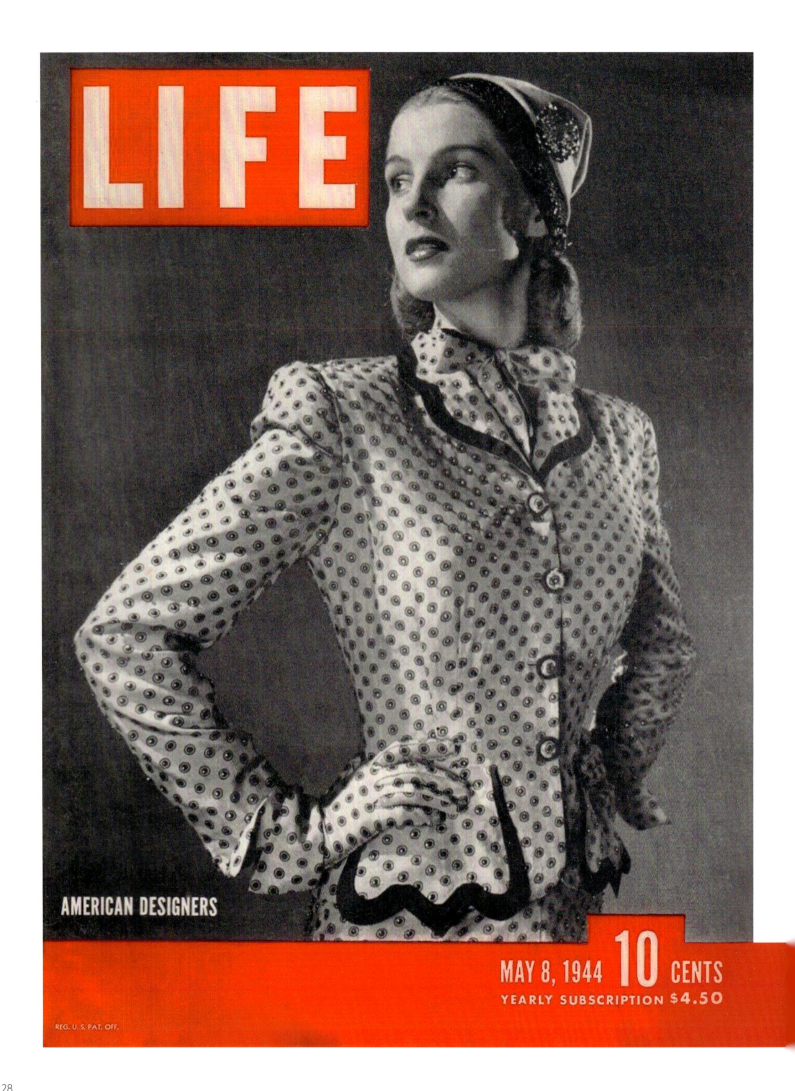

The launch of the first New York Fashion Week (NYFW) on 19 July 1943, under the initiative of publicist Eleanor Lambert, press director of the New York Dress Institute, confirmed the maturity of a distinctly New York fashion world and offered a pragmatic response to the disruptions caused by the Second World War: while some fashion designers, including Main Bocher and Elsa Schiaparelli, managed to flee Nazi-occupied France and settle in New York, most Parisian couturiers were trapped in Paris, and American buyers could not attend their shows. The "Press Week", as NYFW was initially called, proved a convenient alternative and an opportunity to assess the state of the New York fashion scene. A year earlier, in 1942, the internationally renowned cosmetics and perfume company Coty had wisely created a prize for the best American couturier of the year, the Coty American Fashion Critics' Awards. Its first winner in the Winnies (women's underwear) category was Norman Norell (1900–1972), a former student of Parsons School of Design and Pratt Institute, who started his career as a costume designer for both Hollywood and Broadway before joining Hattie Carnegie's company to create successful ready-to-wear collections. The list of subsequent laureates includes Claire McCardell, Clare Potter, Tina Leser, Hattie Carnegie, Mark Mooring (head of fashion at Bergdorf Goodman, 1901–1971), and French-born Pauline Trigère (1908–2002), demonstrating the dynamism and creativity of the New York scene in the 1940s.

Starting in the 1950s, the influence and significance of New York fashion would undergo constant expansion around the globe. While always open to other sources of innovation, such as Christian Dior's "New Look", American couturiers were able to capitalise on the local trends and subcultures of the post-war decades, from the preppy style of the 1950s to the hippie fashion of the late 1960s, and further. One of the hallmarks of New York fashion in the post-Second World War years was the impressive number of leading women designers. In addition to the designers already mentioned, several names came to the fore in the 1950s, including Anne Klein (1923–1974), with her resolutely modern style characterised by interchangeability and versatility. Klein would be the only woman to take part in the "Battle of Versailles", a creative duel that pitted five New York designers against their French counterparts in 1973, and she was the first employer of Donna Karan (b. 1948), who succeeded her as head of the fashion house in 1974, before setting up her own company in 1984. In a more classical style, Ann Lowe (1898–1981), the first African-American designer to have a shop on Madison Avenue (a famous shopping strip), created collections that were popular with high society – one of her most famous achievements was designing Jacqueline Bouvier's silk taffeta wedding dress for her marriage to future US president, Senator John F. Kennedy, in 1953.

Dressing the First Ladies has long been a badge of professional recognition in the USA, as shown by the examples of Oleg Cassini (1913–2006), who was appointed by Jacqueline Kennedy as her exclusive couturier in 1961 and dubbed "The Secretary of Style" by White House staff, and Venezuela-born socialite and designer Carolina Herrera (b. 1939), whose gowns have been worn by Laura Bush, Michelle Obama, and Melania Trump. Oscar de la Renta (1932–2014) had a long history of dressing First Ladies, from Jackie Kennedy's iconic peach dress for an official visit to India to several evening gowns for Nancy Reagan, as well as re-styling Hillary Clinton.

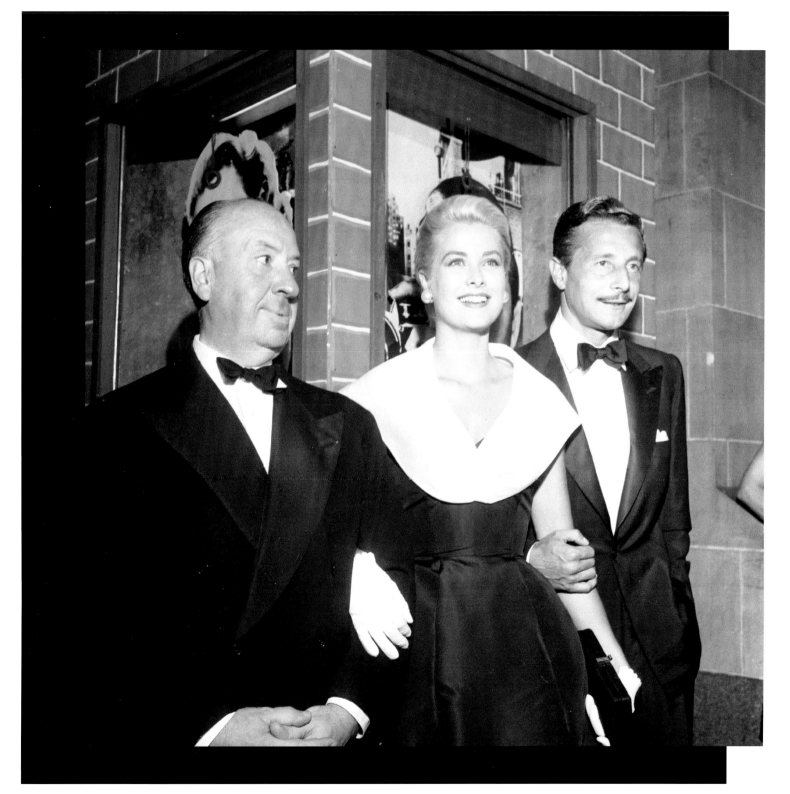

In the 1950s, a significant shift in fashion and customs occurred: the hat, once an indispensable accessory, disappeared from the streets – John F. Kennedy is often mentioned as the first president who showed up hatless on the day of his inauguration. This sudden disaffection, among both women and men, prompted some milliners to venture into fashion as an alternative to the fading hat industry. This is particularly true of Roy Halston Frowick (1932–1990), known as Halston, who, ironically enough, had designed the blue pillbox hat worn by Jackie Kennedy to her husband's inauguration. The boutique he opened on Madison Avenue in 1968 offered designs that were minimalist, modern, urban, and chic all at once, thus drawing the attention of the New York socialites such as Bianca Jagger and Liza Minnelli. Halston was also among the first American fashion designers, along with Californian Rudi Gernreich (1922–1985), to launch unisex collections. He would also contribute to the fashion of the disco era, together with Stephen Burrows (b. 1943), whose rainbow jersey dresses and lettuce-edge hems shaped the look of the decade. In an even more exuberant, maximalist signature style, former milliner Adolfo Faustino Sardiña (1923–2021) won over the country's wealthy clientele of the 1960s and 1970s, including Betsy Bloomingdale, Nancy Reagan, Gloria Vanderbilt, and Nan Kempner.

No sooner had the disco balls stopped shining as the '70s faded into memory than a completely different fashion trend resurfaced: a comeback of the preppy style was suddenly sweeping the globe in the wake of *The Official Preppy Handbook* (1980), a publication that was meant to poke fun at preppy styles, but which readers took literally instead. The trend found iconic representatives in two leading personalities of the decade, newlywed Princess Diana, and actress Brooke Shields, and was fuelled by particularly talented designers, who were smart enough to breathe new, modern life into a strictly classic, elitist style: Ralph Lauren (b. 1939), who even played himself in a cameo appearance in *Friends*, Tommy Hilfiger (b. 1951), and Perry Ellis (1940–1986) in the sportswear market.

The preppy style of the 1980s also echoed a new wave of optimism in American society, which was expressed in President Ronald Reagan's famous slogan for his second term: "America is back!"

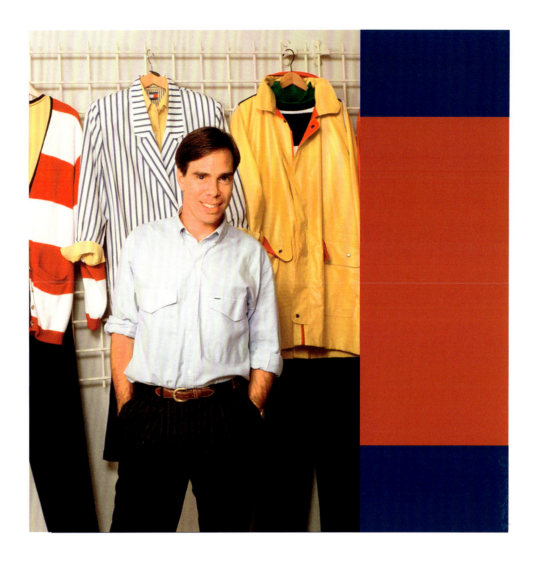

Was it to counterbalance the overly smooth and "correct" image of the preppy that the leading designers of the 1990s wielded provocation with brio? Calvin Klein (b. 1942) set the trend with his ads showing stars and models posing with sexually provocative attitudes. Marc Jacobs (b. 1963) threw a spanner in the works when he launched a collection inspired by the grunge subculture for the Perry Ellis label in 1992, which led to his immediate sacking. The collection and the designer behind it were reviled by some of the most authoritative fashion magazines – however, the scandal earned Jacobs a reputation as one of fashion's *enfants terribles* and prodigies. His example was emulated by Anna Sui (b. 1955), one of Madonna's favourite designers, who also drew inspiration from the French new wave of the time, epitomised by Jean Paul Gaultier and Thierry Mugler.

The excellence of the training provided by New York fashion and design schools such as Parsons, Pratt Institute, and FIT has meant that young designers who graduated from these schools are ideal candidates for the major international brands. A former student of Parsons, Tom Ford took over as artistic director of Gucci in 1990, transforming the Milanese brand, which had teetered on the brink of financial collapse, into a fashion powerhouse. One of Ford's alumni, Marc Jacobs, was appointed by Louis Vuitton in 1997 as creative director in charge of launching the label's first ready-to-wear collection. In 2019, FIT alumnus Daniel Roseberry (b. 1985) was appointed artistic director of Schiaparelli. These examples demonstrate the leading role played by New York in the world of fashion and the city's exceptional creative dynamism.

The fashion industry is now an integral part of the Big Apple's landscape, and is reflected in many cult series, such as *The Bold Type* and *Sex and the City*, and blockbusters, such as *The Devil Wears Prada*, where half-fictional characters mention prominent fashion designers of the day such as Michael Kors.

Just like the late Iris Apfel (1921–2024), New York fashion is set to continually amaze us with unwavering elegance, eccentricity, and vitality.

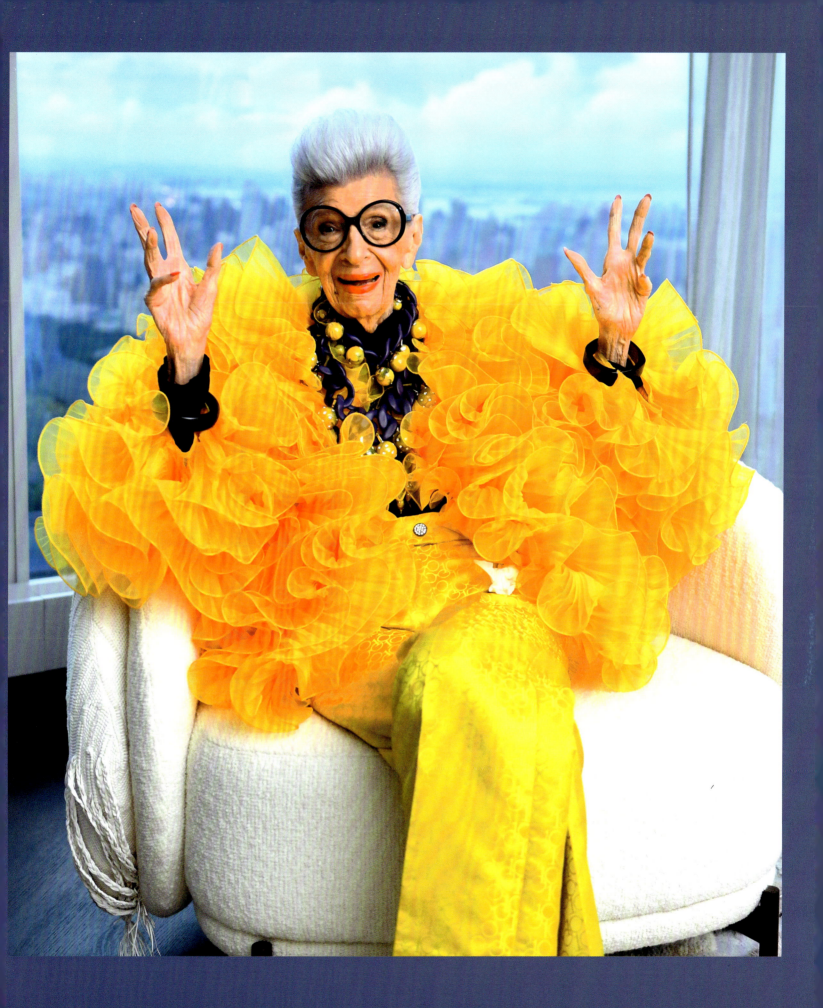

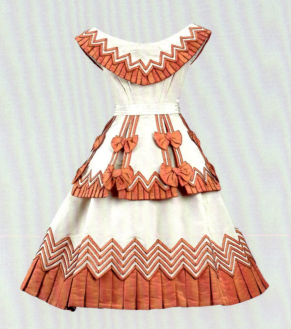

Girl's dress, c.1865.

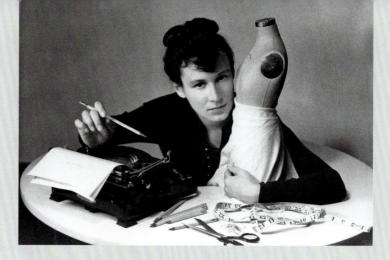

Fashion revolutionary Elizabeth Hawes in 1942.

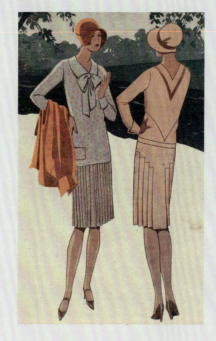

Flapper girls in the 1920s.

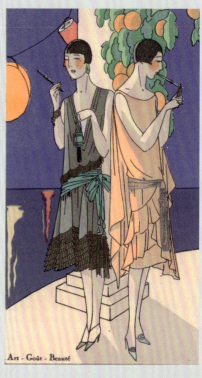

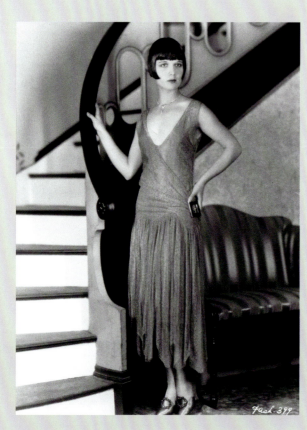

Actress Louise Brooks in a classic flapper dress, 1925.

Portrait of Valentina Schlee for *Vogue*, 1948.

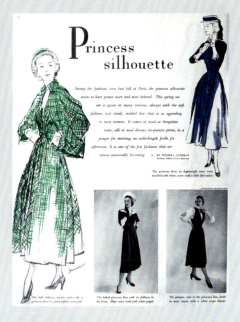

A plate from *Ladies' Home Journal*, 1948.

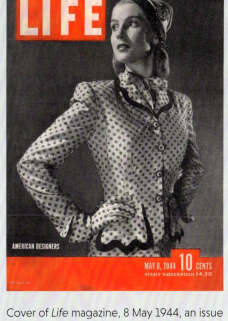

Cover of *Life* magazine, 8 May 1944, an issue focusing on American fashion designers.

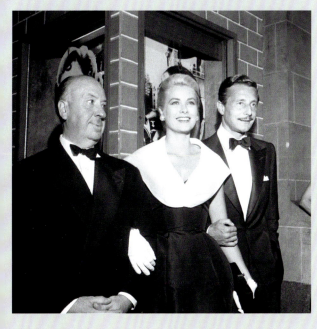

Film director Alfred Hitchcock, star actress Grace Kelly and fashion designer Oleg Cassini at the premiere of *Rear Window*, Los Angeles, August 1954.

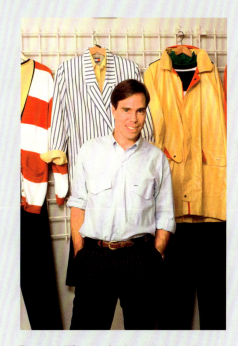

Tommy Hilfiger in his New York studio with some of his designs, 1987.

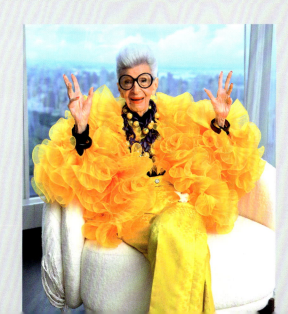

Iris Apfel during her 100th birthday party at Central Park Tower, September 2021.

NEW YORK CITY ON THE CATWALK

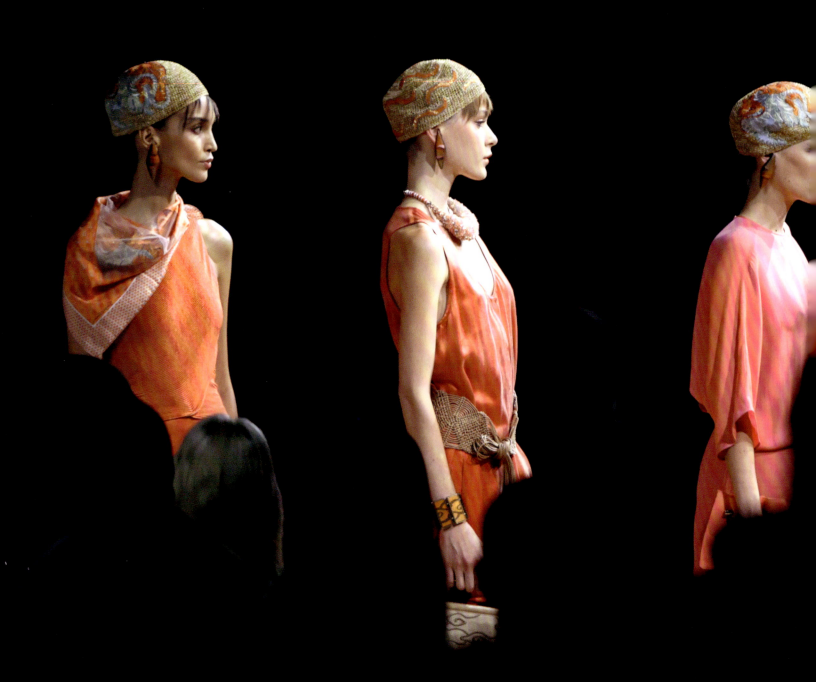

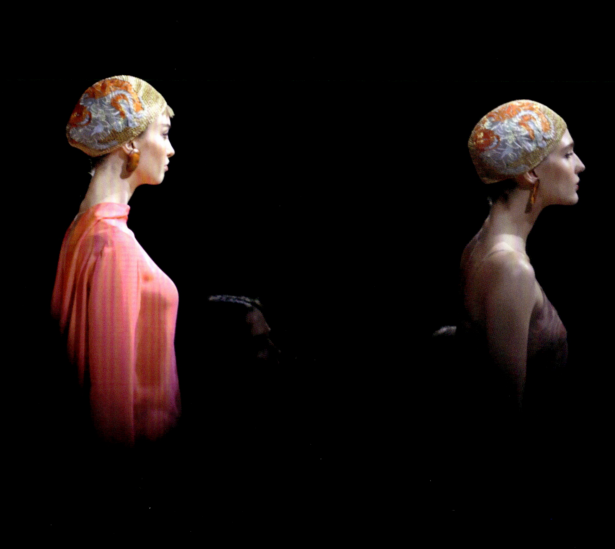

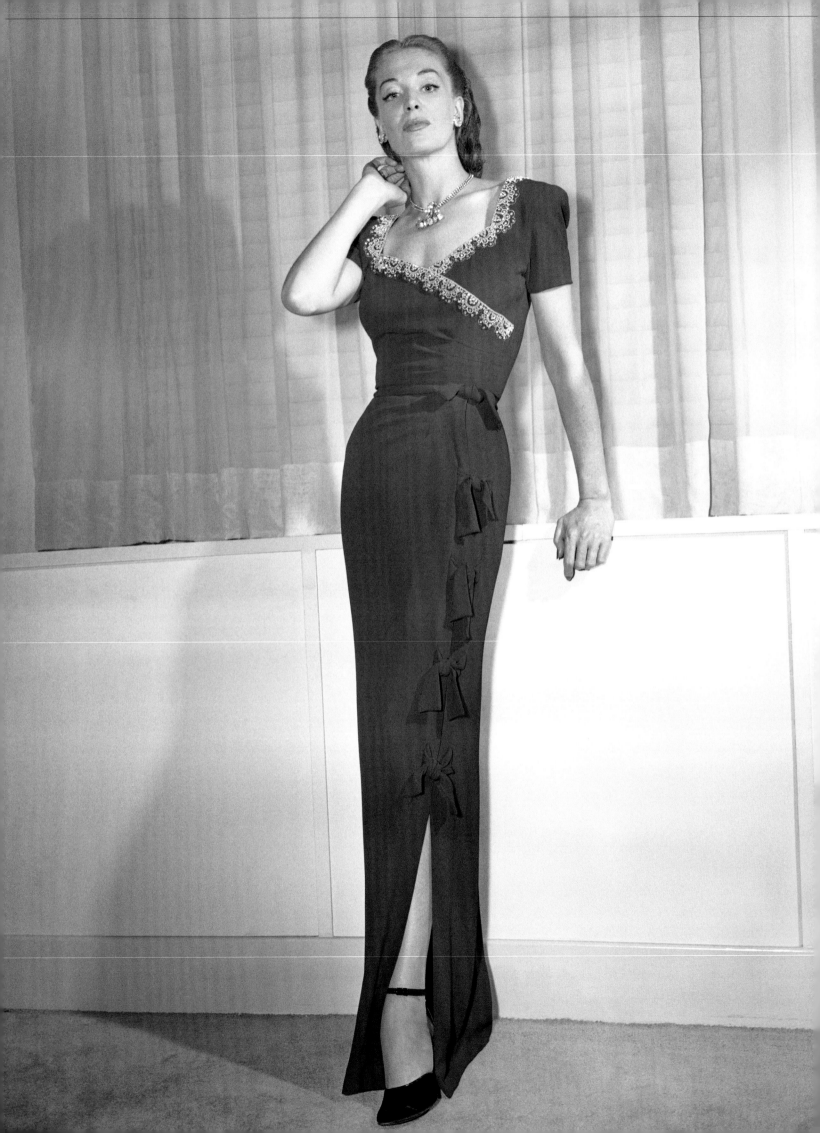

The origins of New York fashion shows are often associated with the first New York Fashion Week, held on 19 July 1943, which established the Big Apple as one of the world's fashion hubs. However, since the beginning of the 20th century, most of the city's high-end department stores, such as Saks and Bergdorf Goodman, had already been in the habit of inviting their privileged clientele to discover new gowns "inspired" by European collections or created by local designers who worked for the department stores. Ready-to-wear pieces were then altered by in-house seamstresses to ensure a perfect fit.

The success of these "mannequin parades" encouraged department store managers to turn them into theatrical performances designed to entertain customers and encourage them to shop. This was probably due to the influence of Broadway musicals, which were quite popular in the 1900s and 1910s (until they became partly overshadowed by "talkies" – films with audible dialogue – in the 1920s). One of the most significant dates in these early fashion shows was the *Fête Parisienne*, staged on 23 November 1915 at the prestigious Ritz-Carlton Hotel in praise of French fashion, as the war ravaging the European continent prevented American buyers from visiting Paris. Nearly 100 couture ensembles by the most famous French couturiers of the time, including Jeanne Lanvin, Jeanne Paquin, Paul Poiret, Jean Patou, and Jean-Charles Worth were met with great enthusiasm by the American public, and the numerous purchase orders that followed saved the French haute couture industry from the financially disastrous consequences of the war.

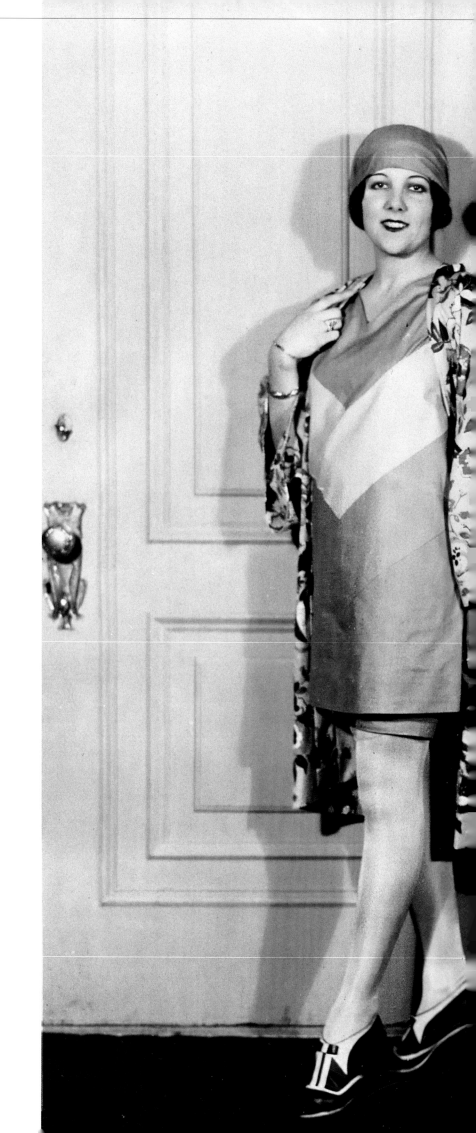

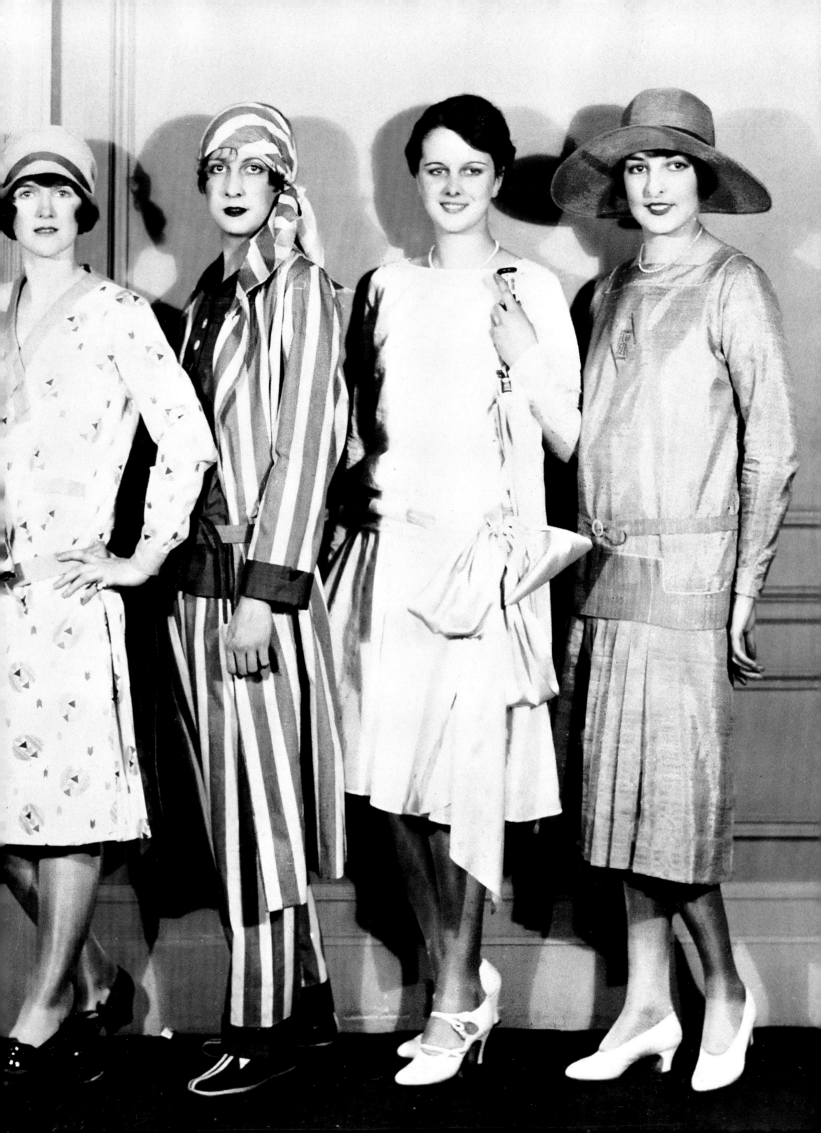

The Roaring Twenties was a period of change, including women's emancipation, with the granting of voting rights to white women in 1919, and the strengthening of the United States' role as a leading political and economic power on the international stage. Prohibition, introduced in 1920, had an important side effect – a vibrant nightlife and clubbing – which, like the first Hollywood movies, also had a beneficial effect on the dynamics of fashion and new trends. Meanwhile, students of the Pratt Institute and Parsons also participated in the Budget Fashion Show, an annual competition for young talent that was focused on practical designs and economical production costs. The competition was sponsored by Wanamaker's Department Stores and gave the students a great opportunity to try their hands at creating ready-to-wear clothing. It is quite easy to imagine the popularity of these shows in the context of the Great Depression during the 1930s.

The launch of New York Fashion Week (NYFW) in 1943 was the culmination of a well-established tradition of fashion shows at department stores and exclusive boutiques. It was also the manifestation of a fashion-conscious scene: buyers, journalists, and photographers were invited to these celebrations of New York creativity, along with celebrities and VIP clients. The name initially given to NYFW by its founder, Eleanor Lambert, "Press Week", hinted at the important role the press would play in the fashion world in the decades to come. In the 1950s and 1960s, fashion magazines, radio, and then television gradually transformed these local-scale events into national and then global shows.

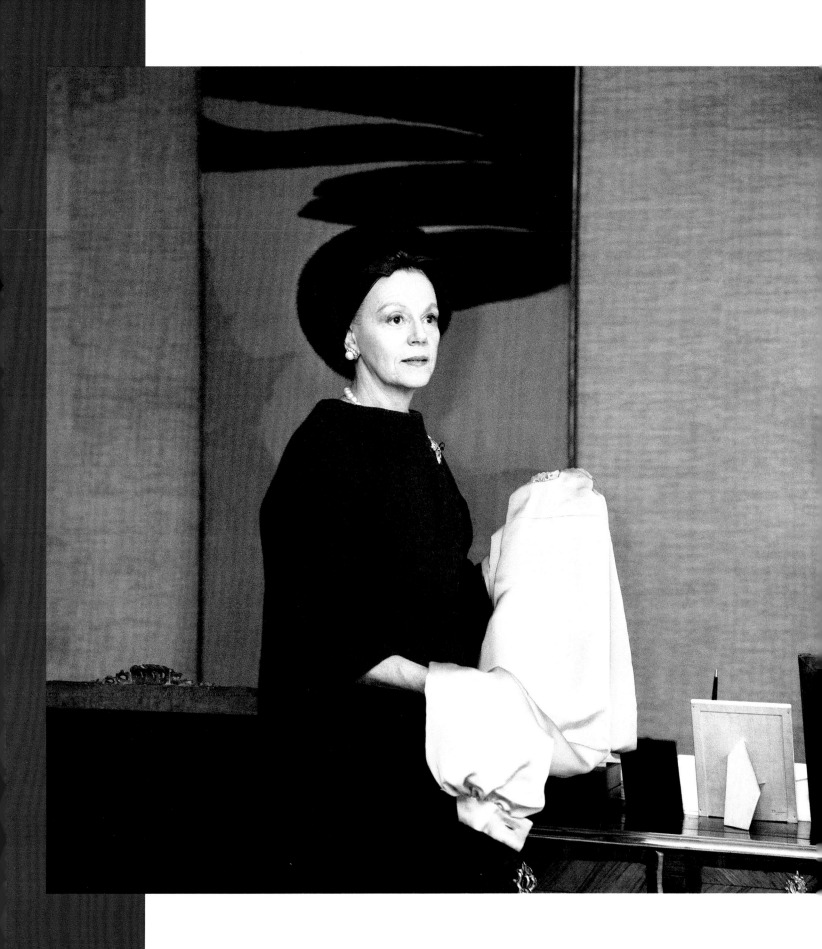

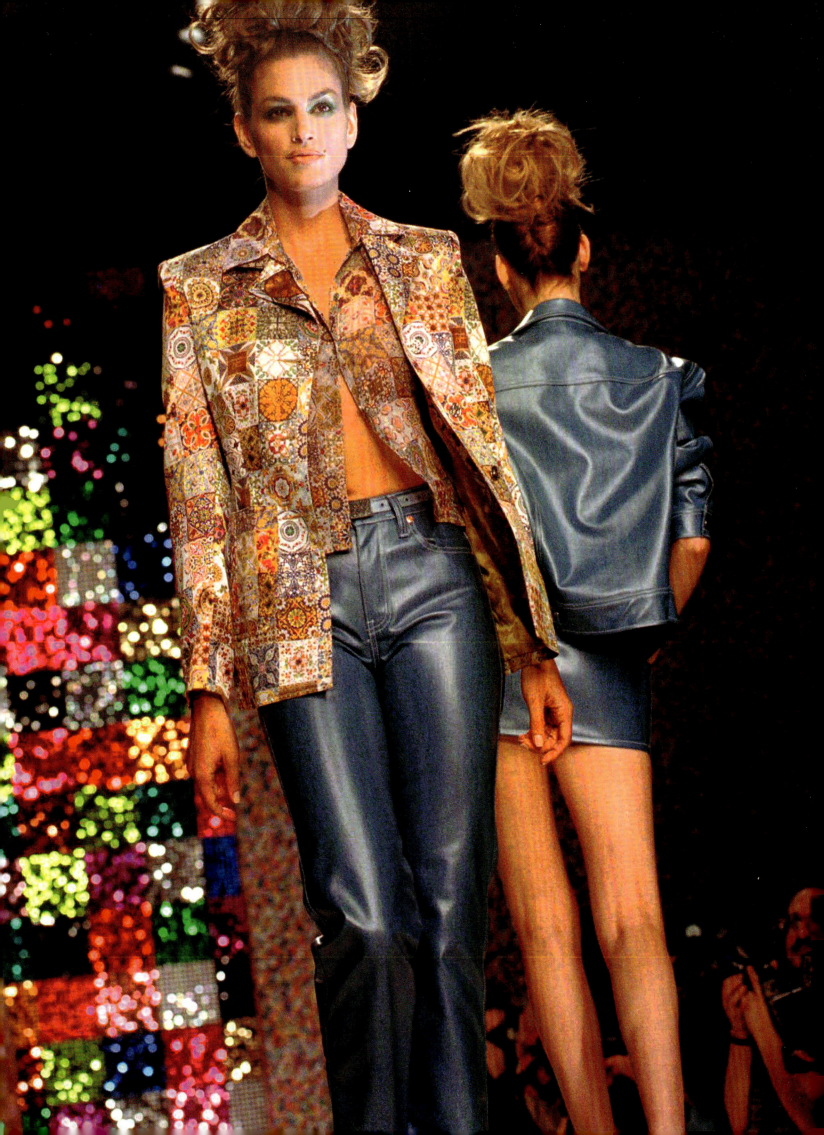

The universal appeal of the American way of life encouraged people's interest in the collections of American designers, some of whom, such as Ralph Lauren and Oscar de la Renta, had already become stars of the ready-to-wear scene. With the advent of supermodels in the 1980s and 1990s, fashion shows became a staple of the celebrity press, which devoted more pages to the celebrities attending them and the models than to fashion itself. Cindy Crawford, Linda Evangelista, Iman, Isabella Rossellini, Elle Macpherson, and Paulina Porizkova contributed to turning professional events into mainstream shows, thus promoting elegance and sartorial refinement, thanks to press coverage and to the support of influential TV programmes such as *Style with Elsa Klensch*, which was aired for the first time on CNN in 1980.

The New York fashion shows are now global phenomena followed and commented on by fashion bloggers from all over the world with the perfect ingredients for a maximum audience: surprising collections, star designers, thoughtful scenographies, glamorous celebrities from the film and music industries, socialites, and models.

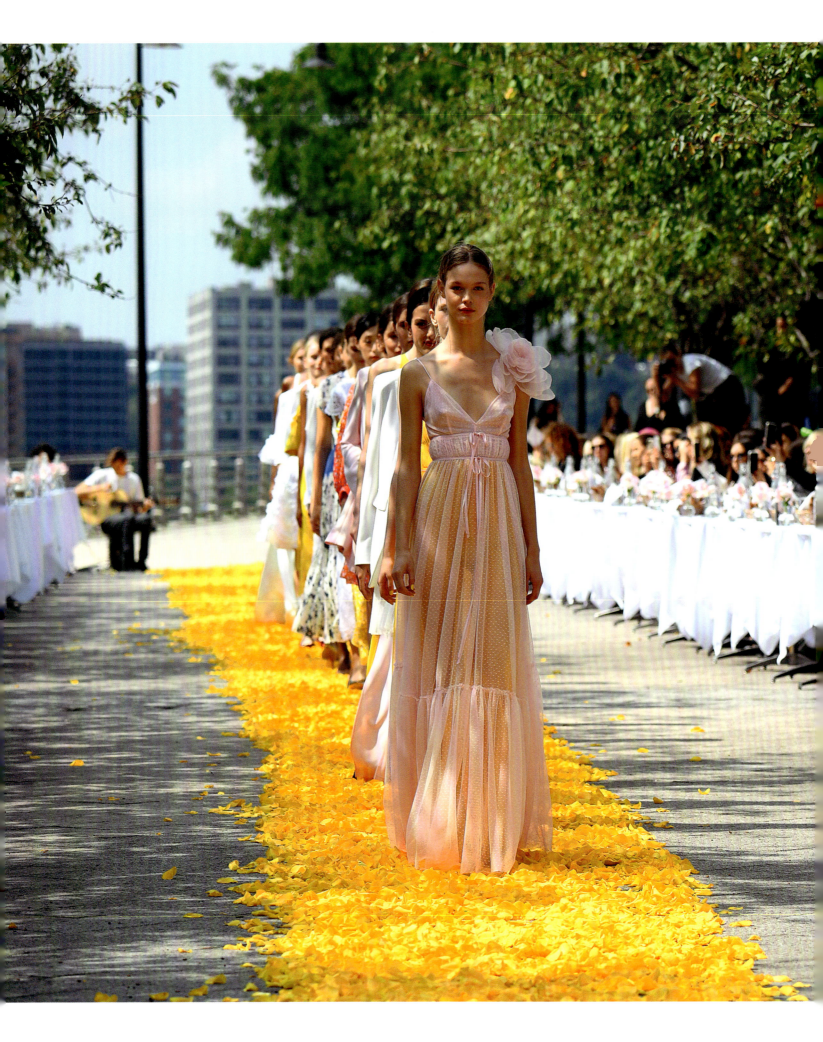

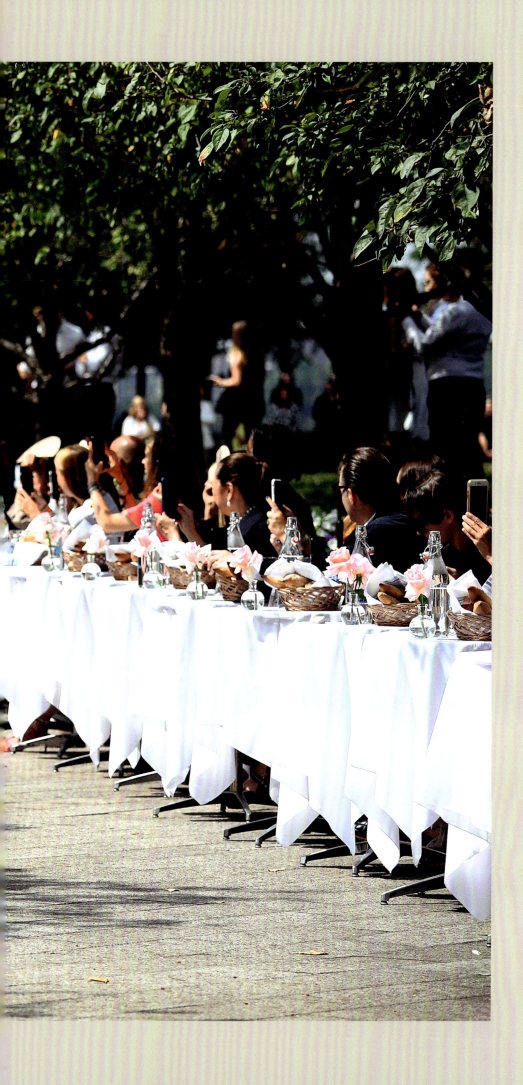

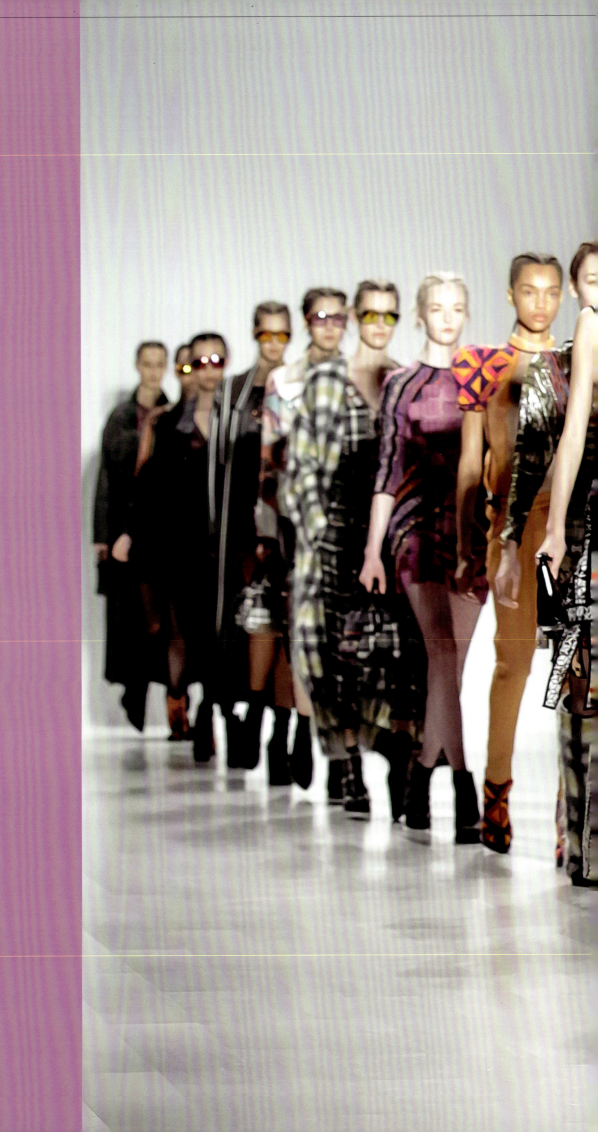

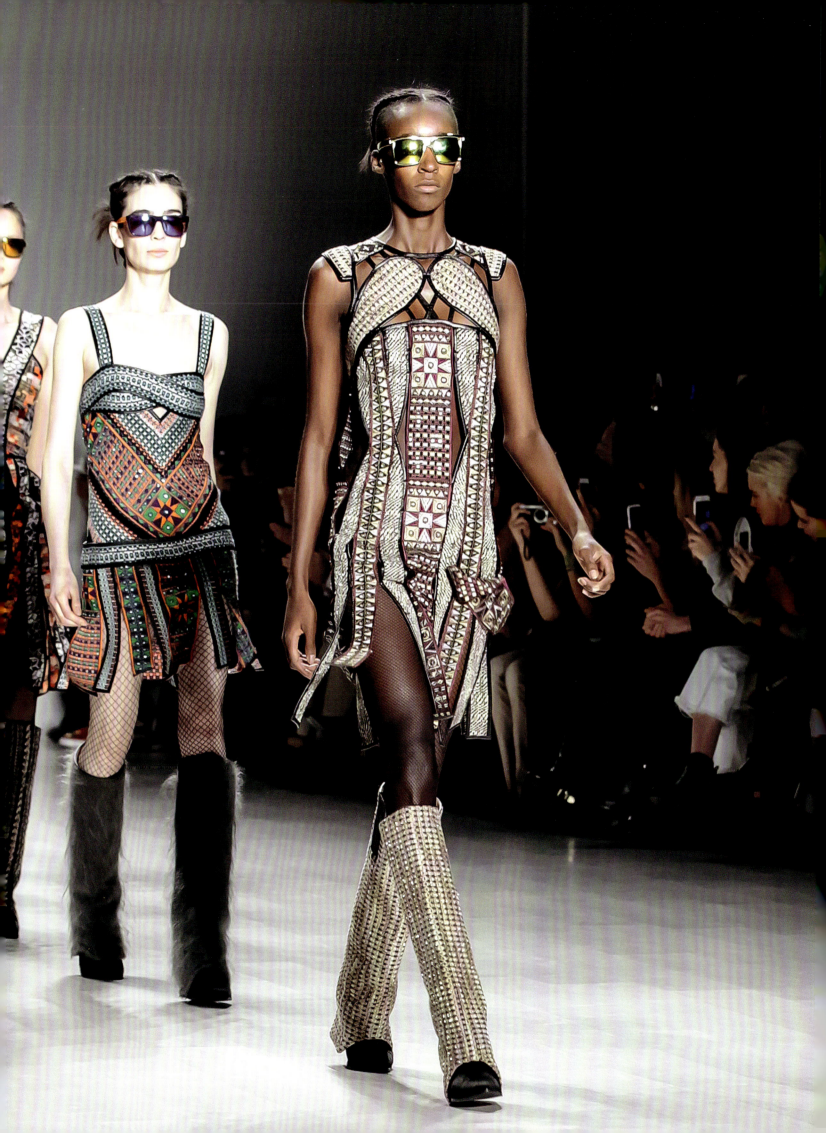

> "Fashion is a reflection of our times.
> Fashion can tell you everything that's going on
> in the world with a strong fashion image."
>
> ANNA WINTOUR

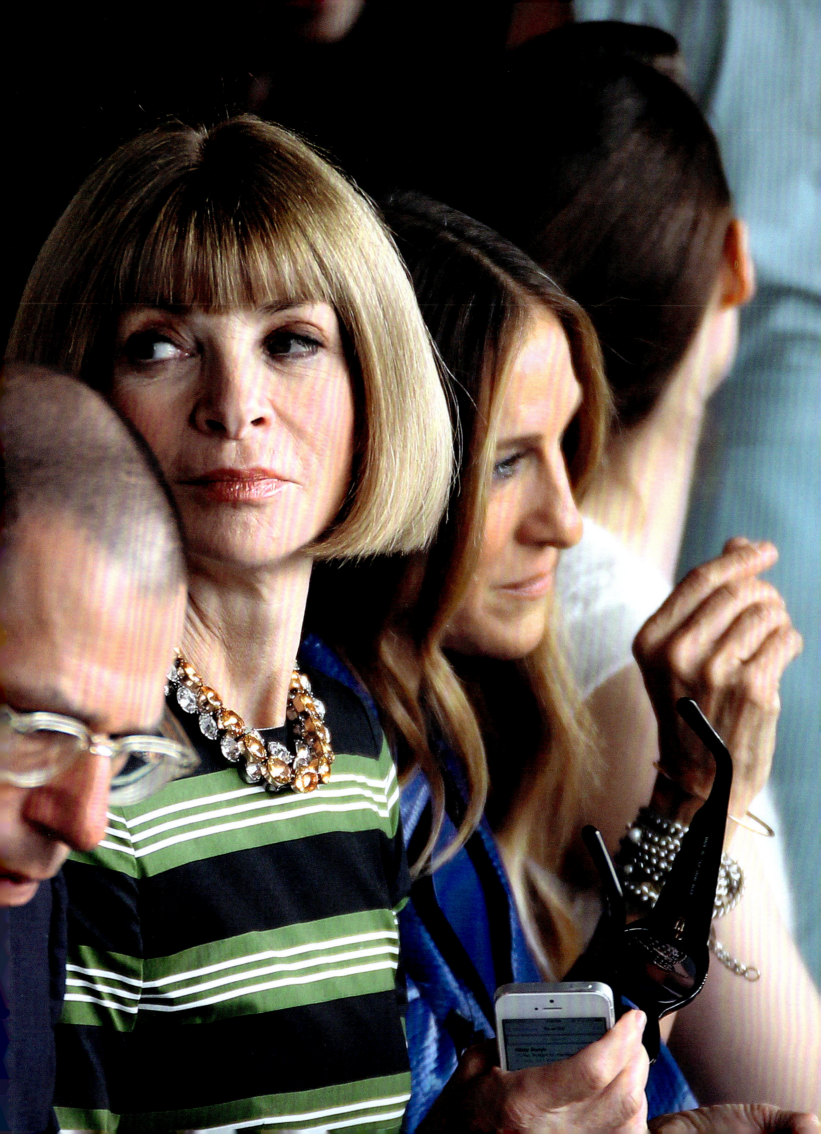

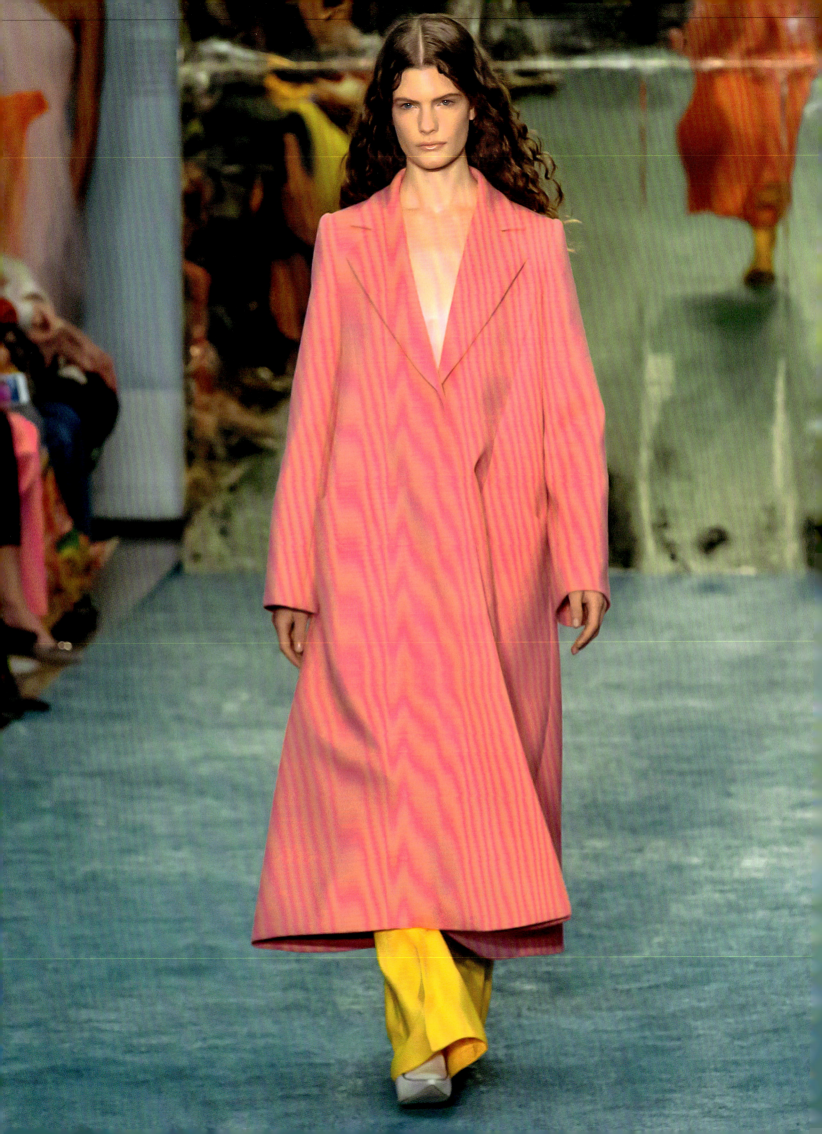

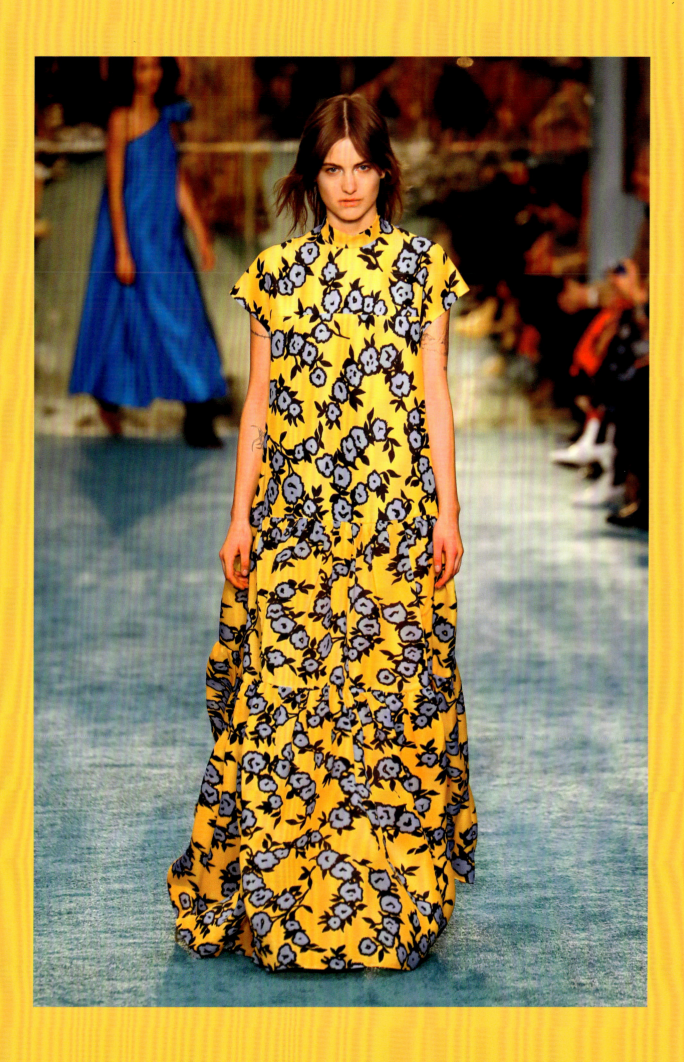

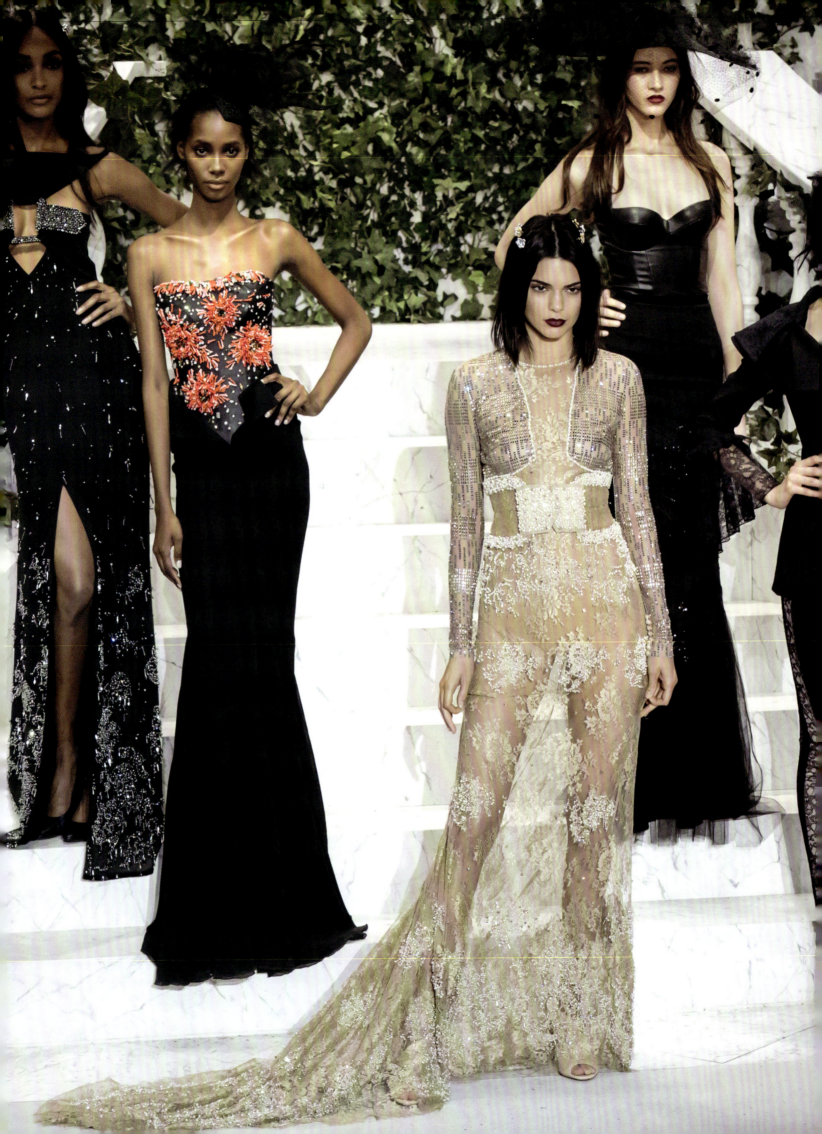

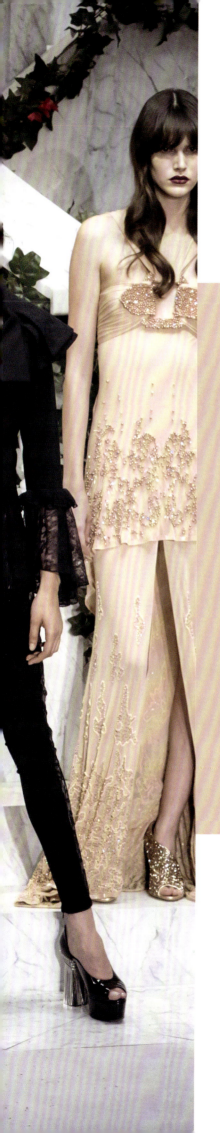

"The New York fashion scene is crazy, madness, but I love the energy."

KENDALL JENNER

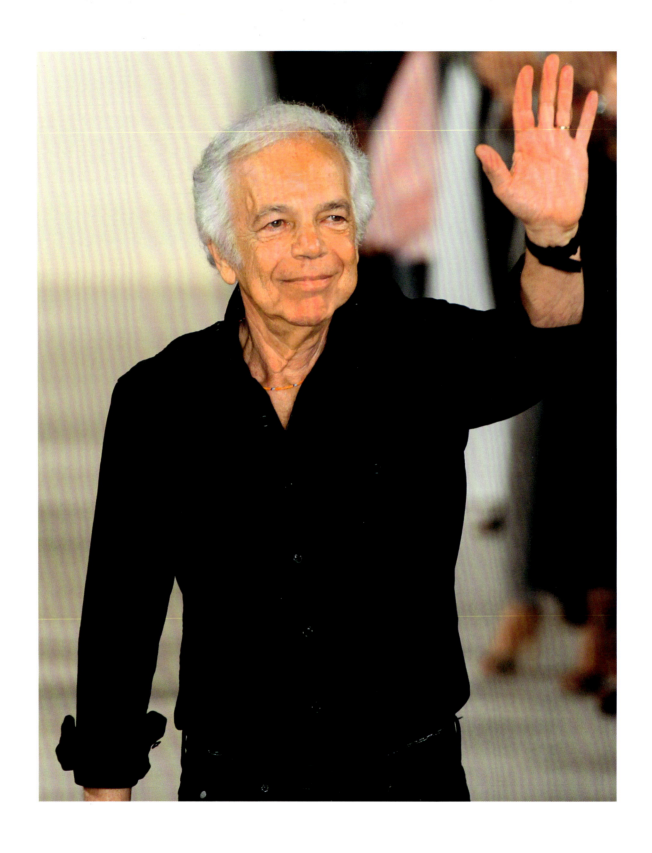

"I don't design clothes, I design dreams."

RALPH LAUREN

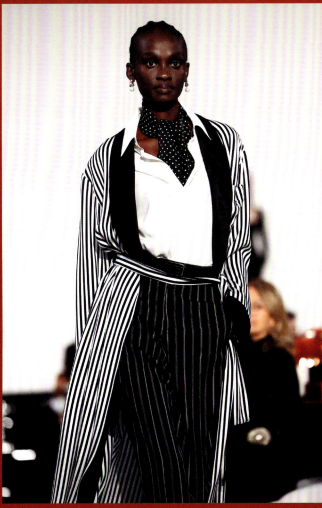
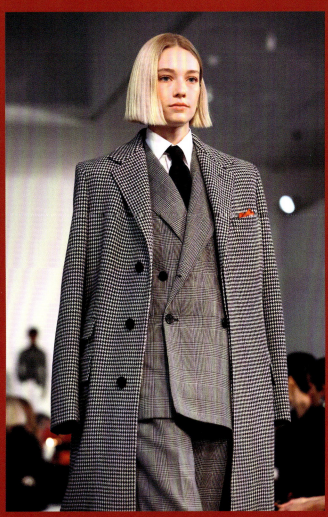

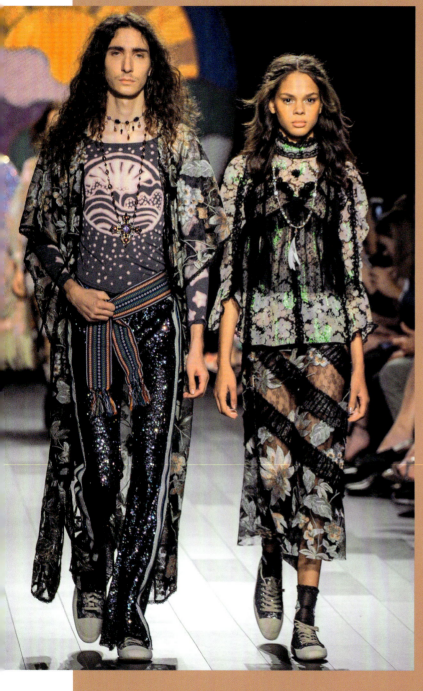
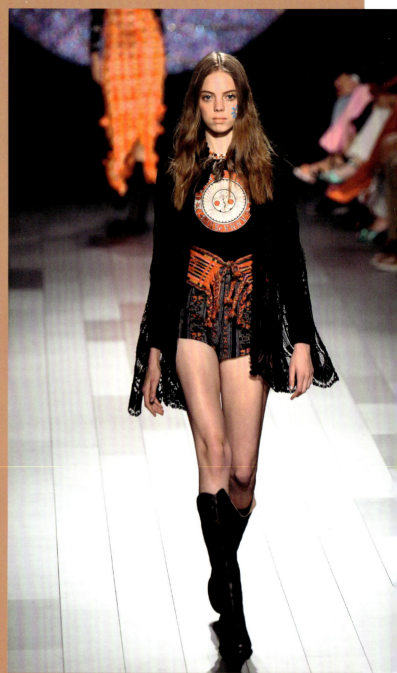

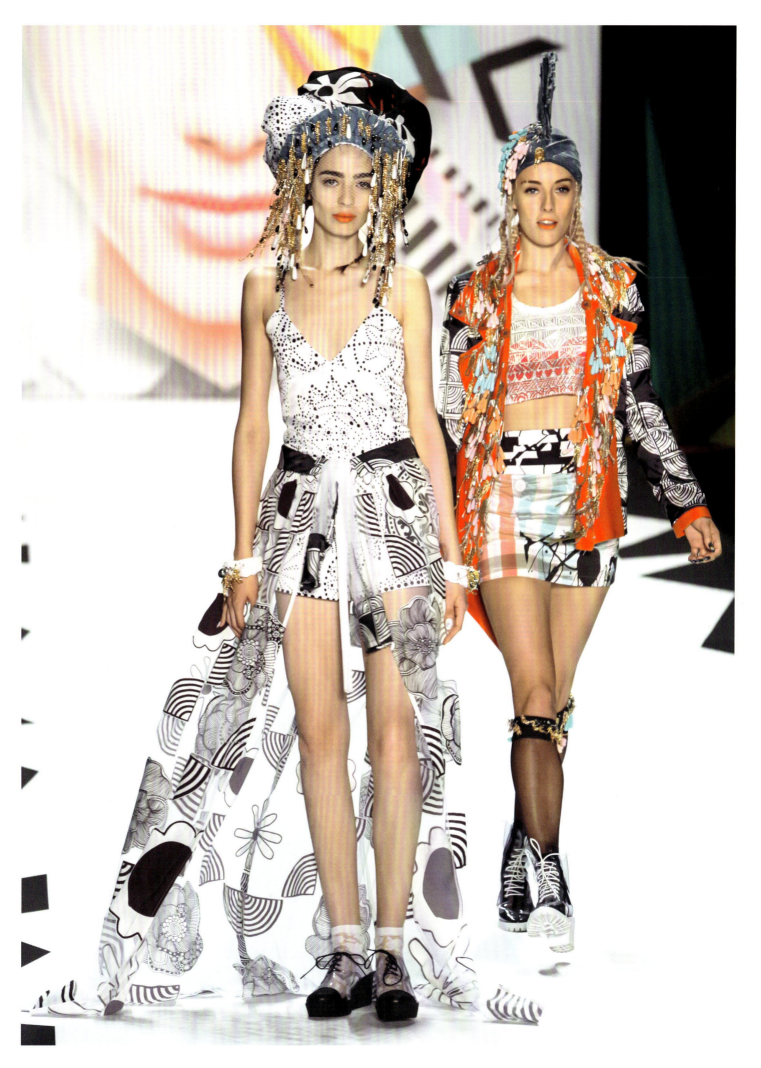

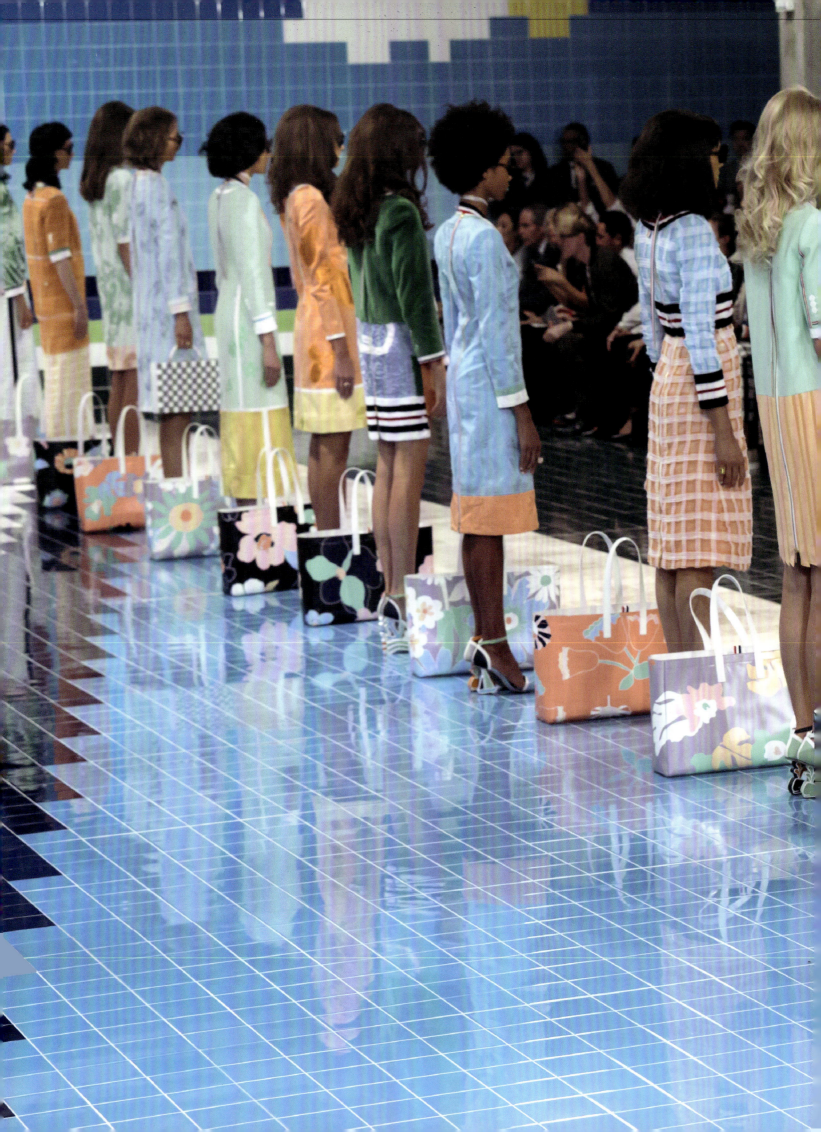

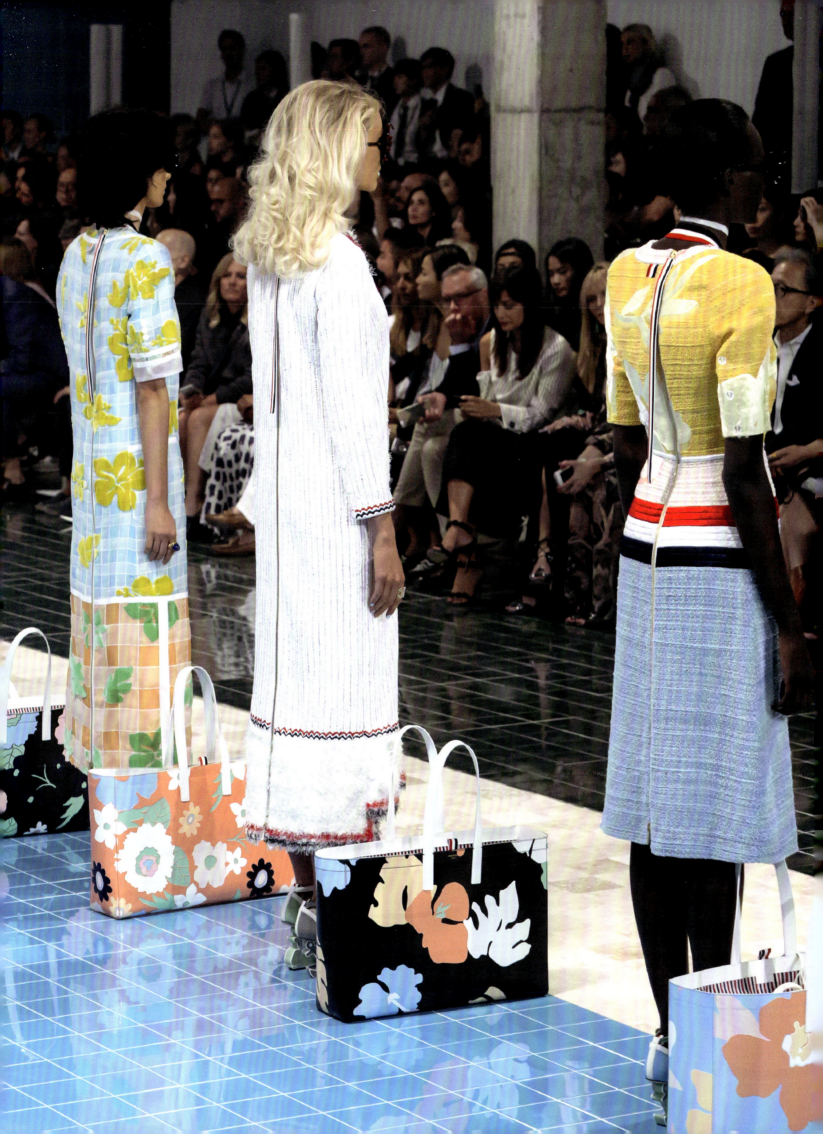

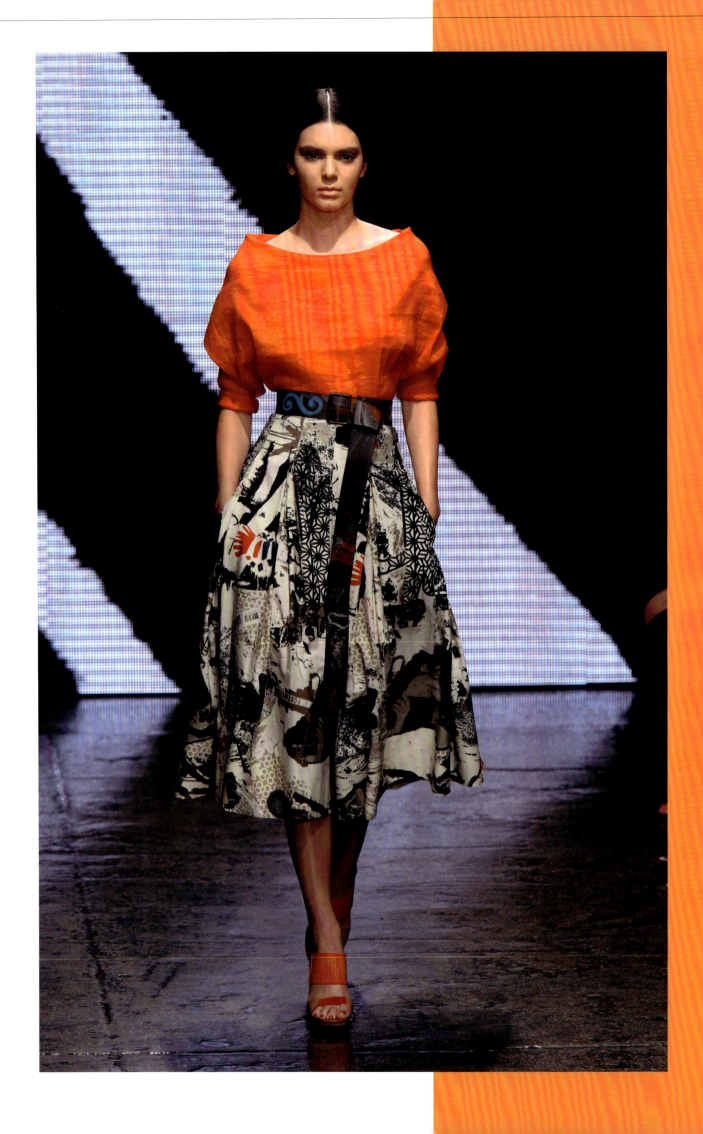

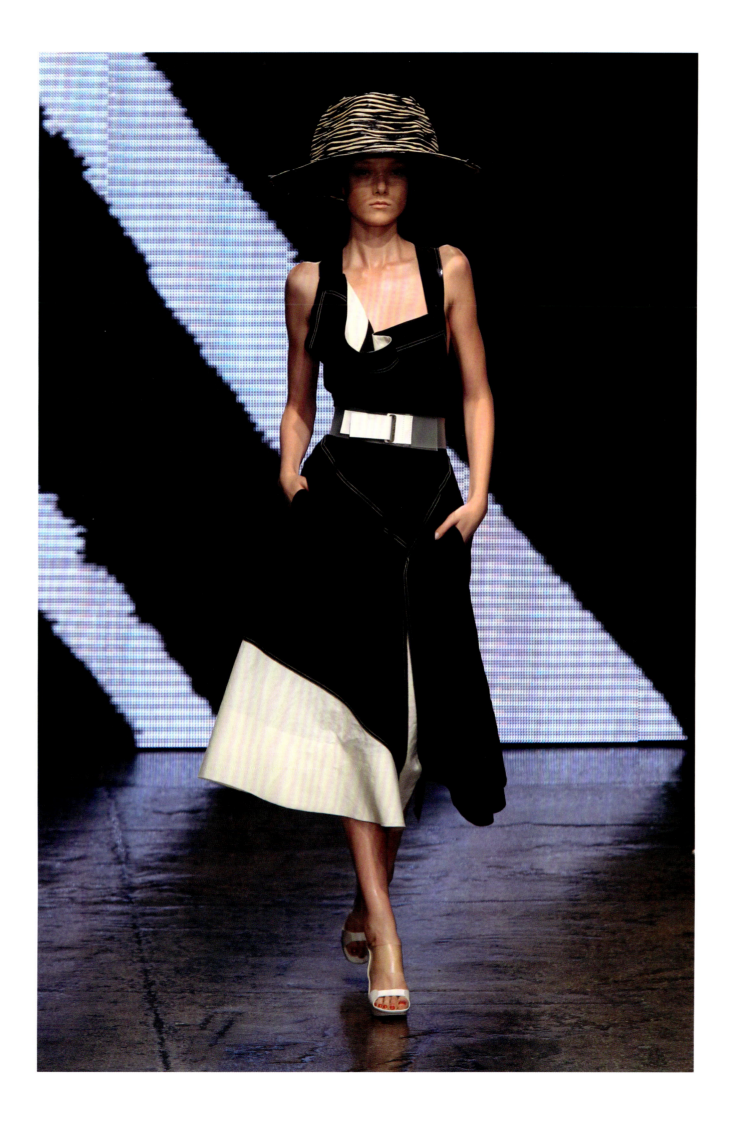

"DKNY and New York are one, that's why DKNY."

DONNA KARAN

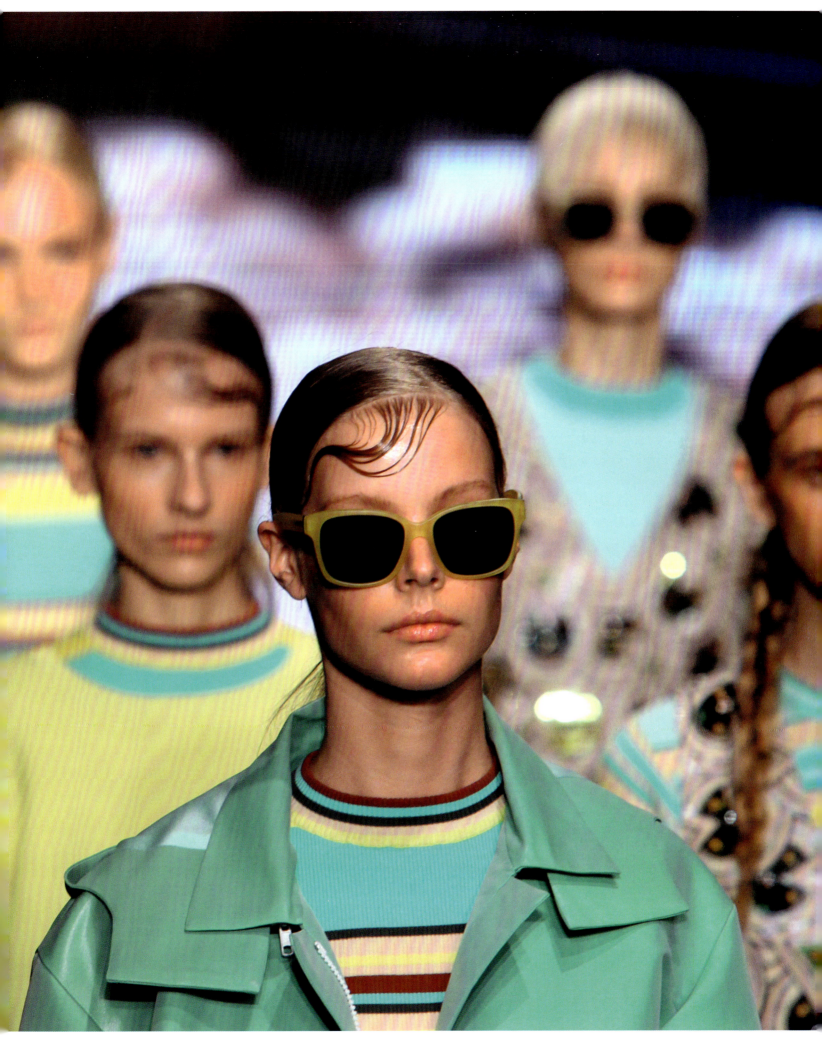

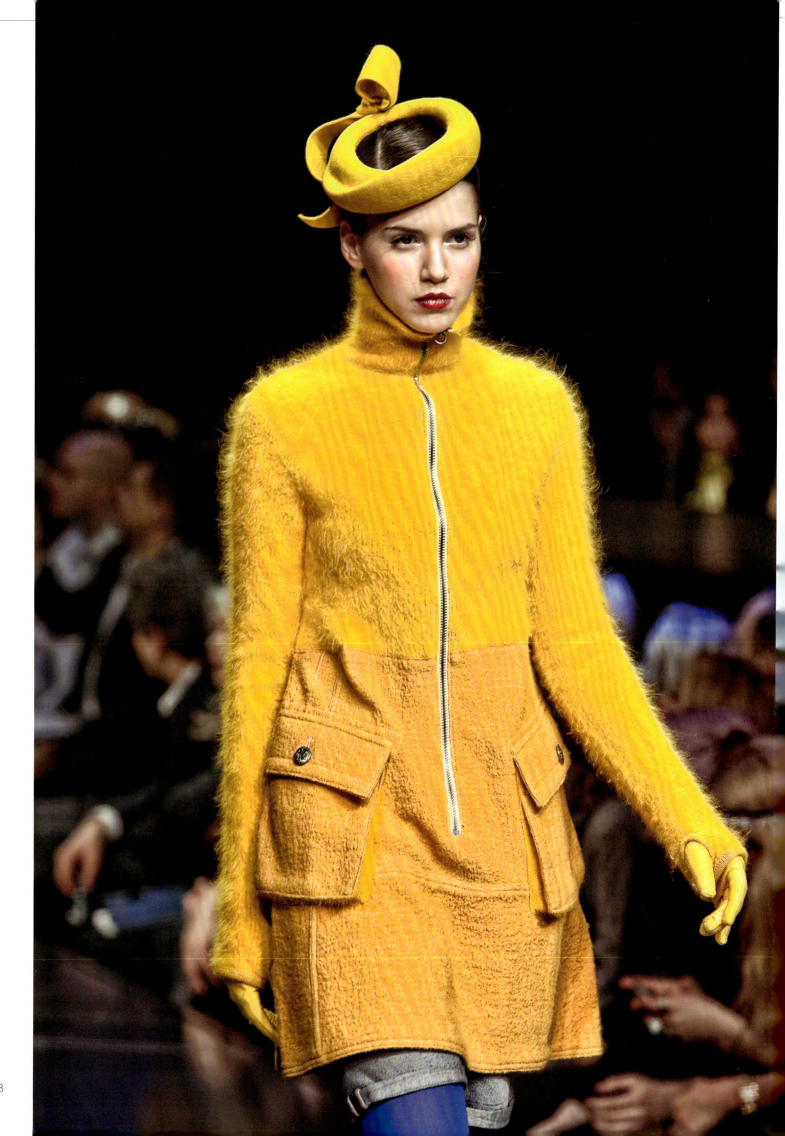

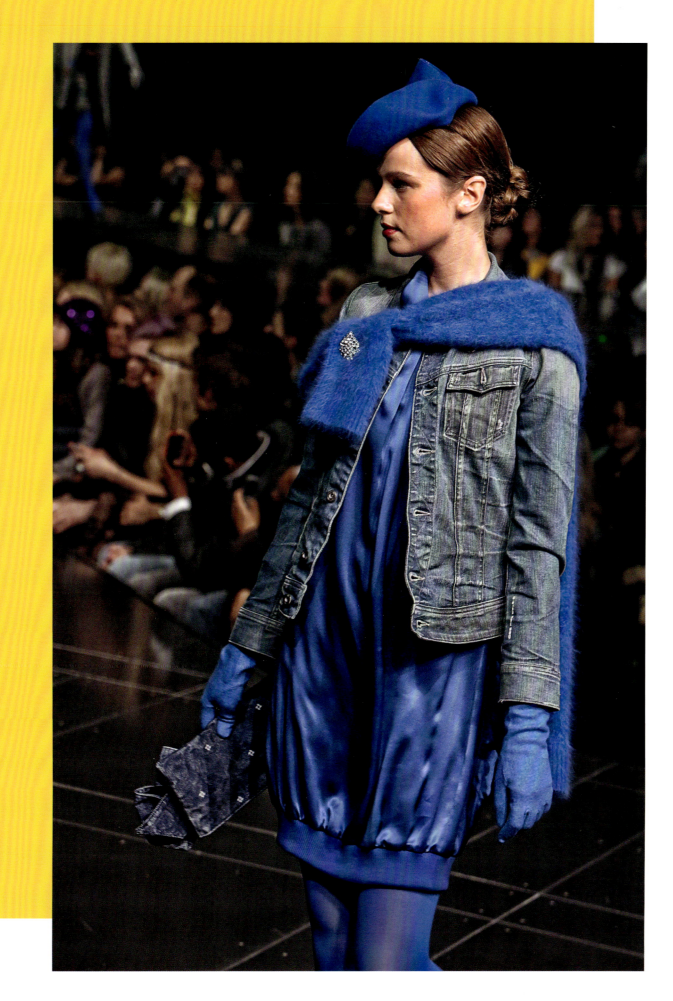

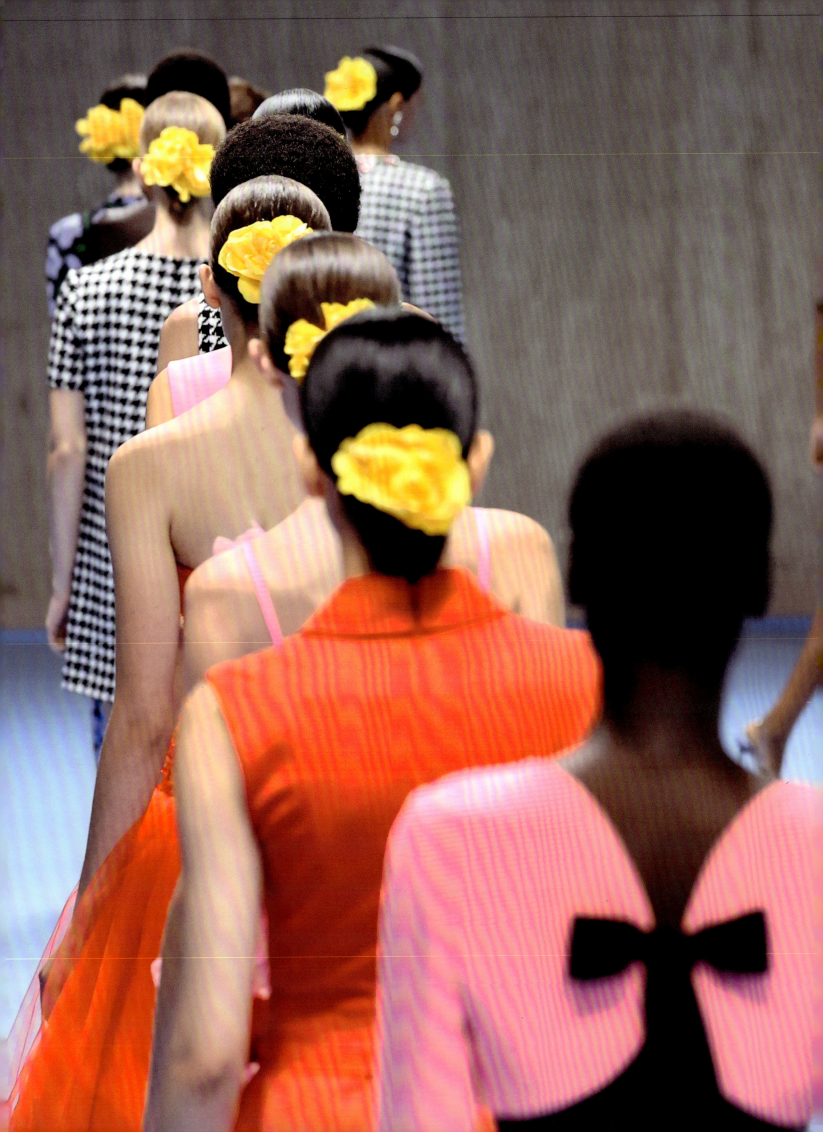

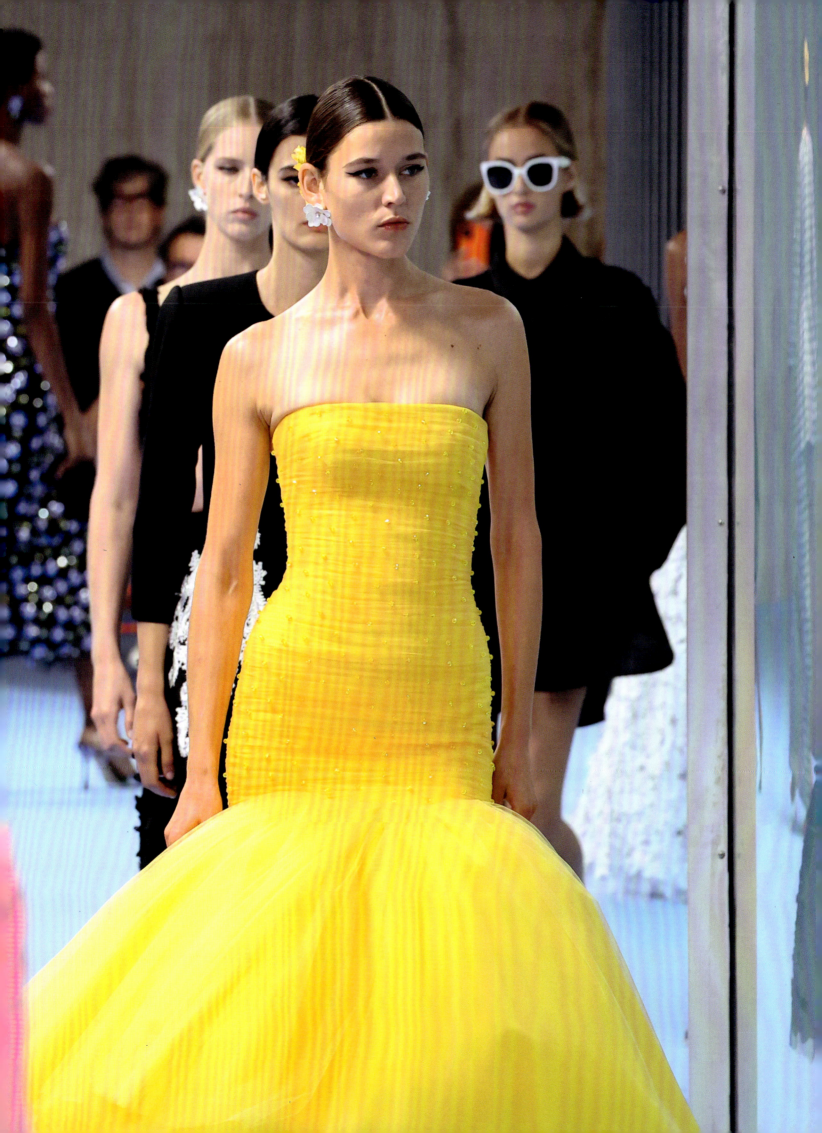

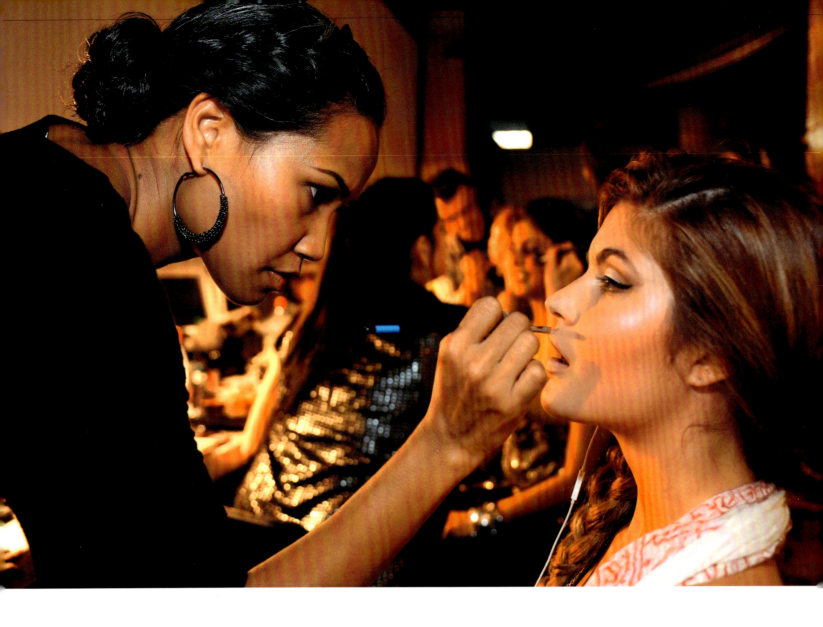

"Every year the women of New York leave the past behind and look forward to the future. This is known as Fashion Week."

CARRIE BRADSHAW

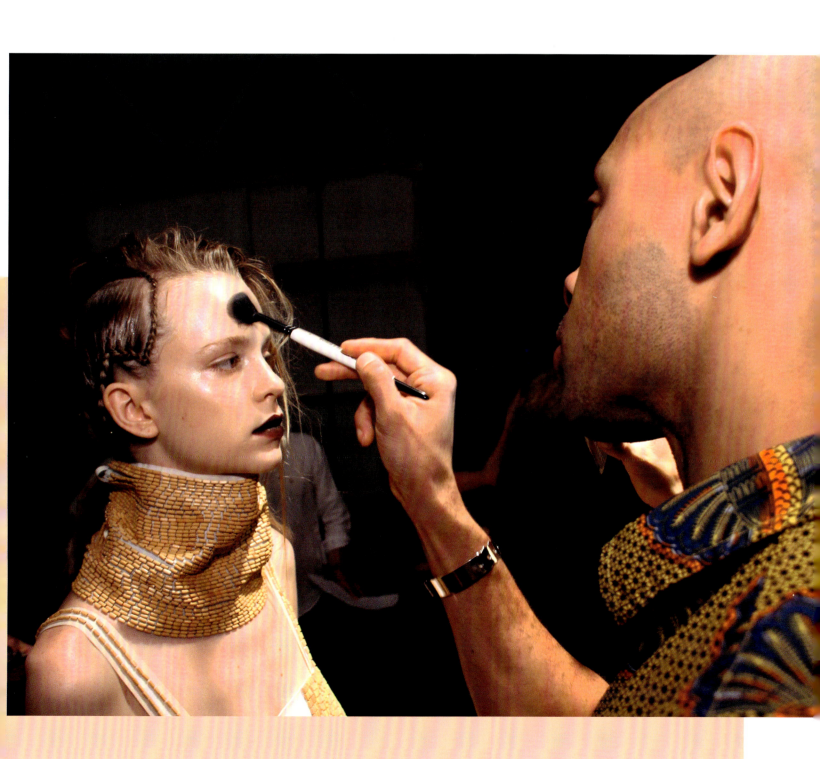

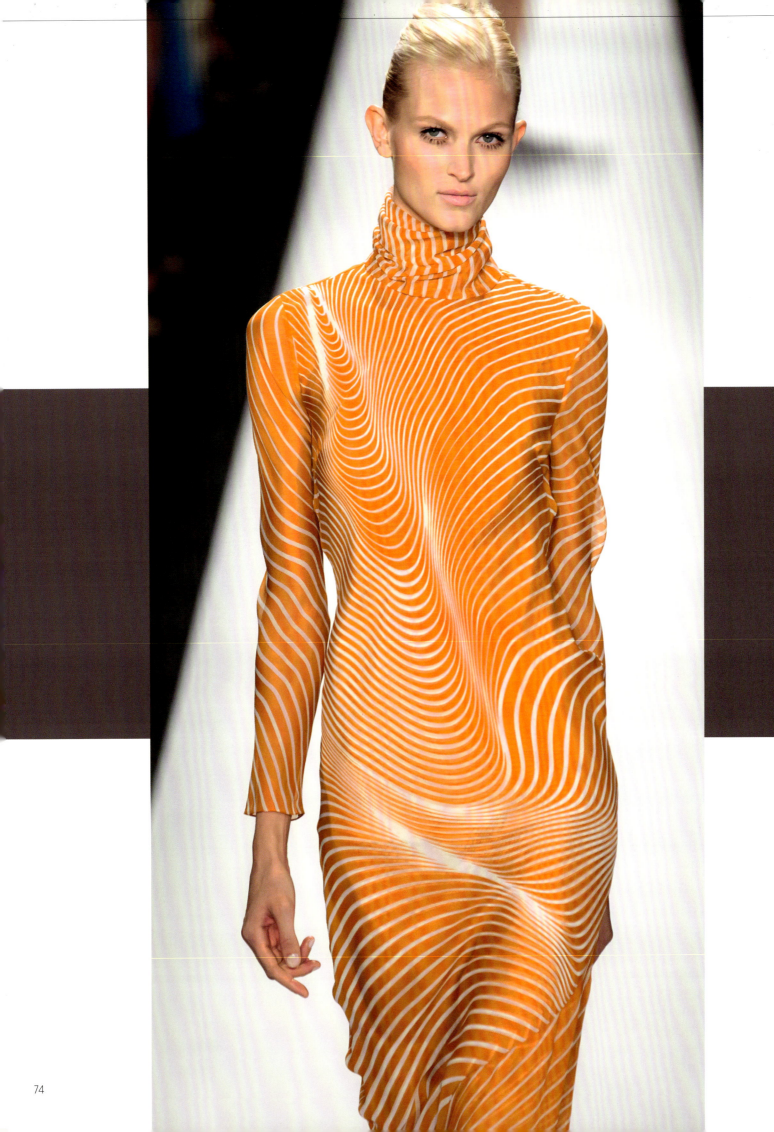

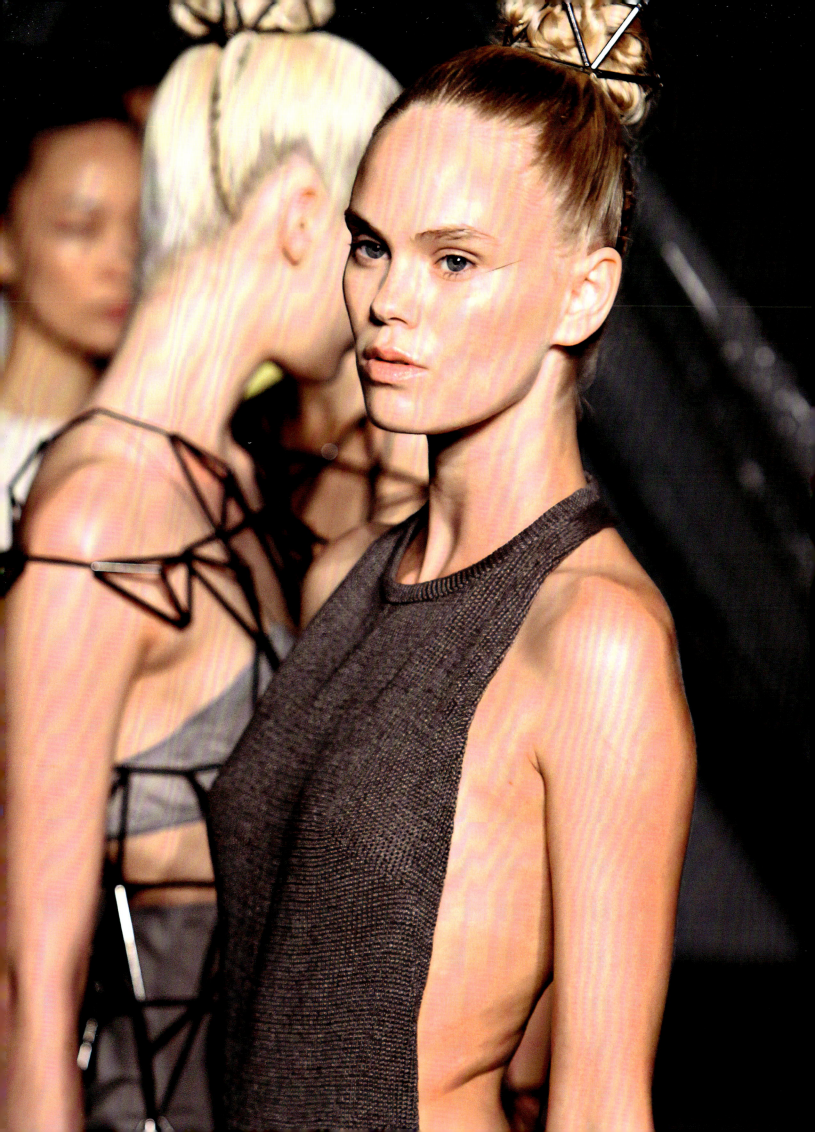

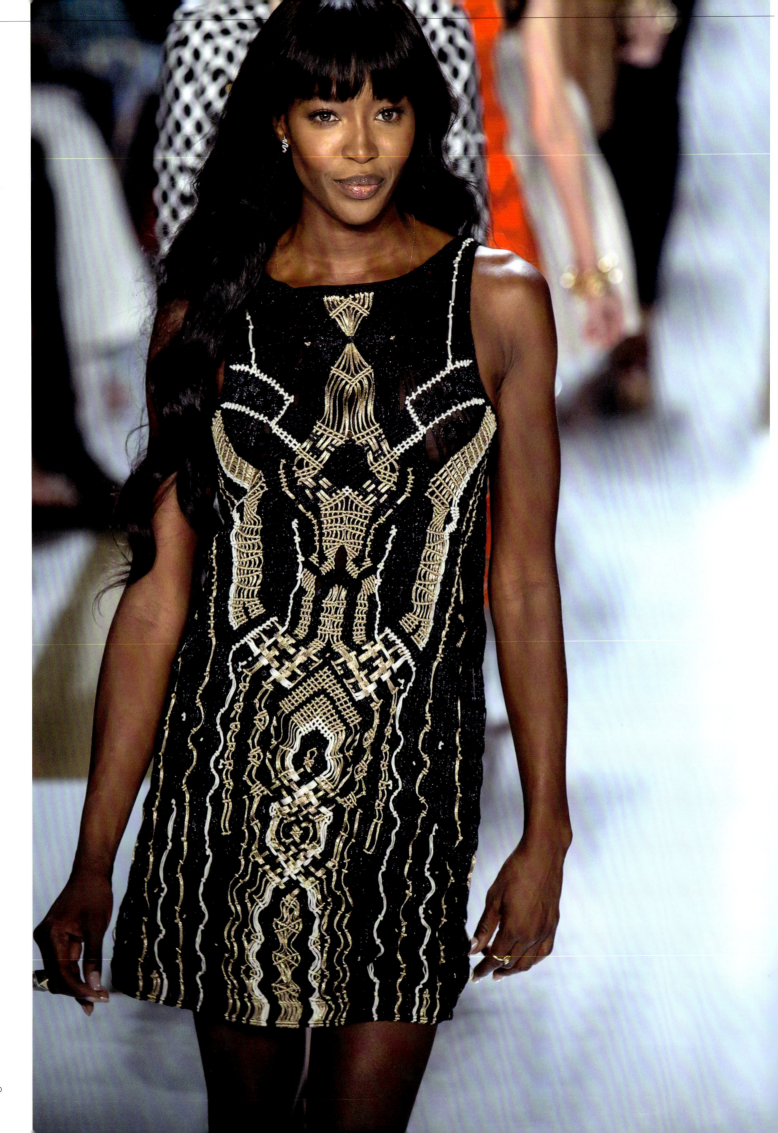

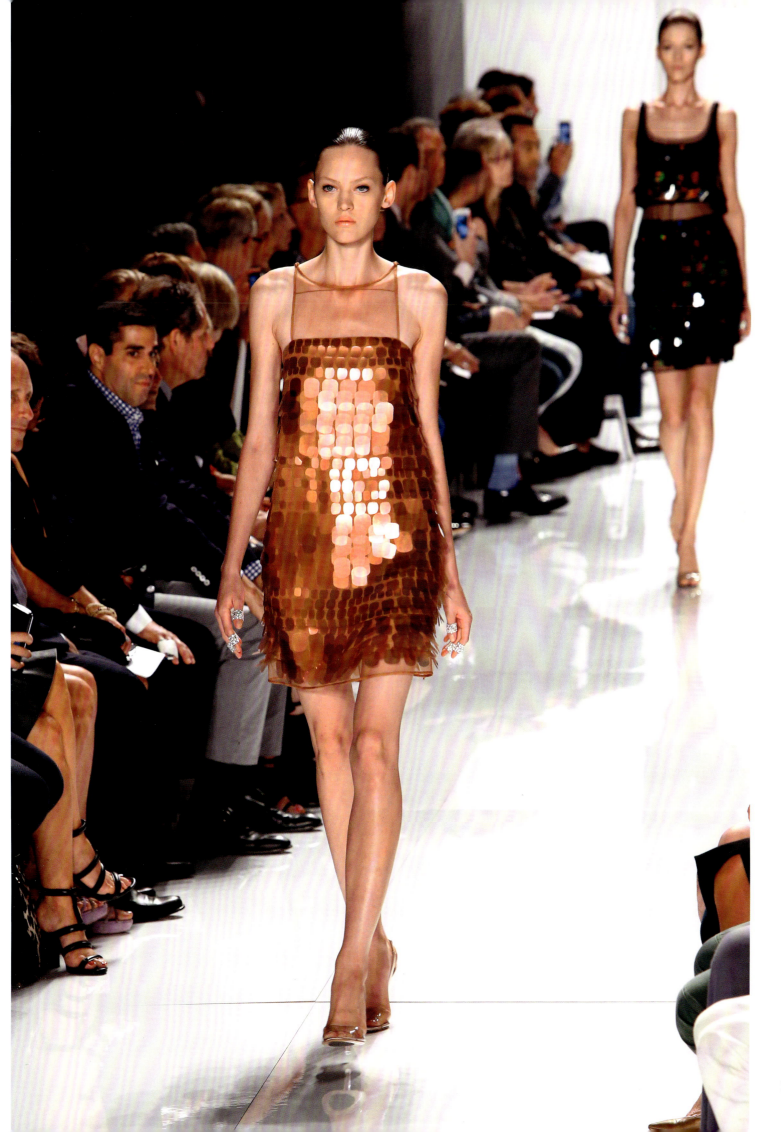

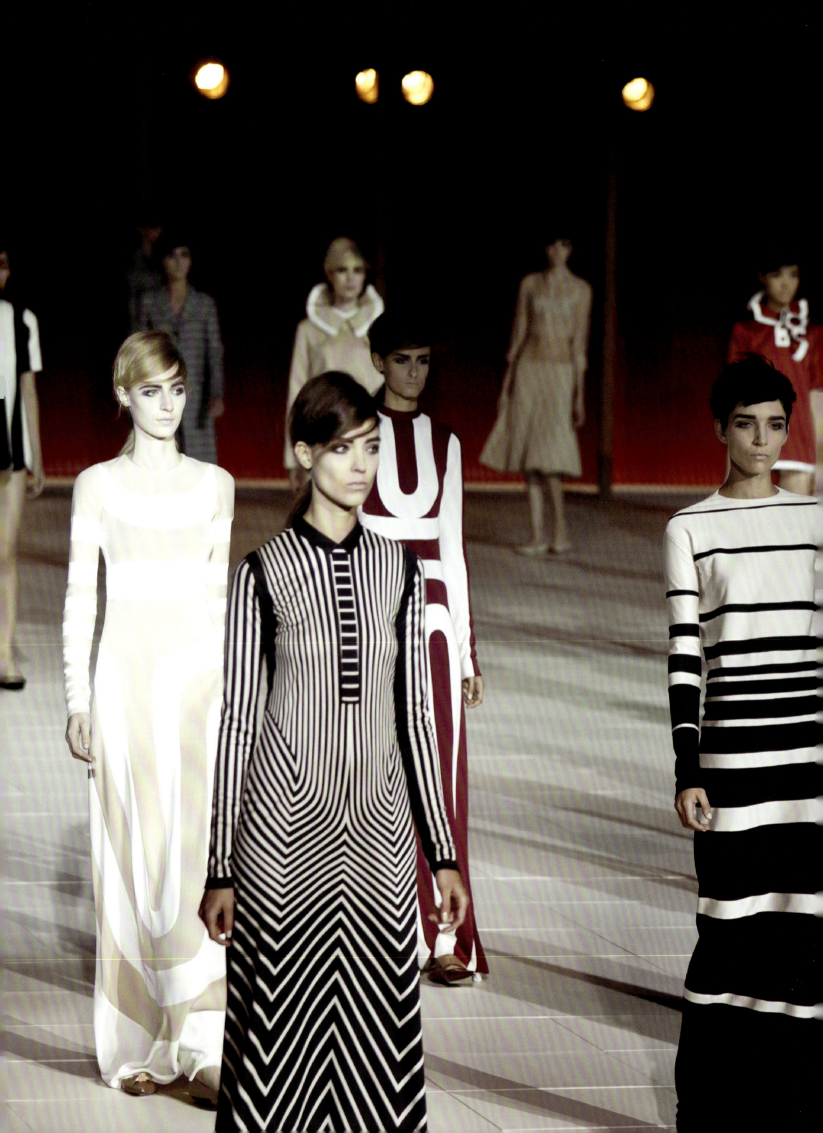

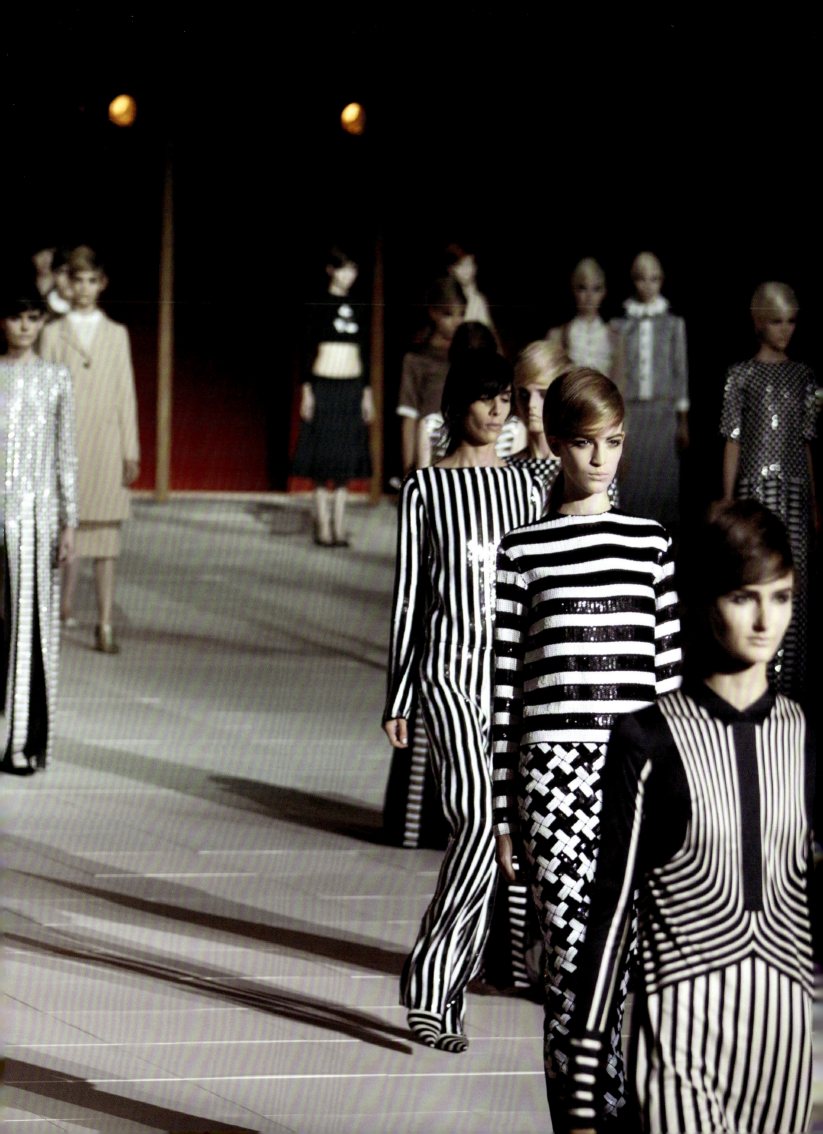

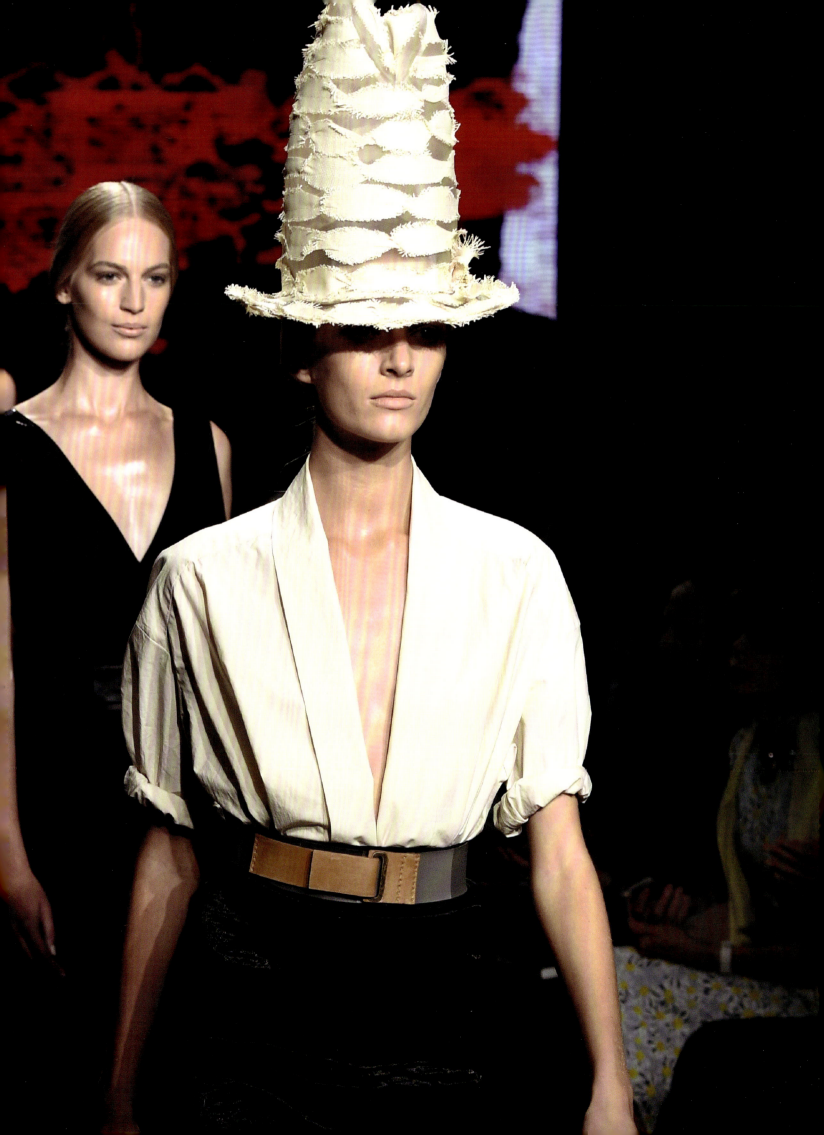

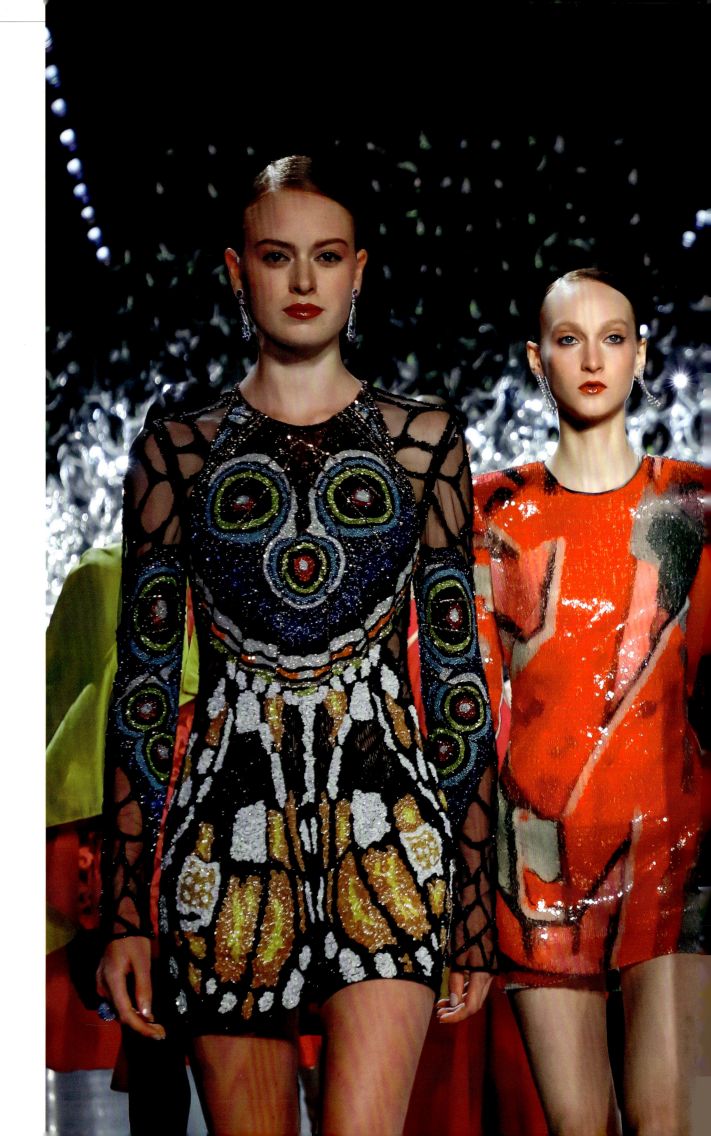

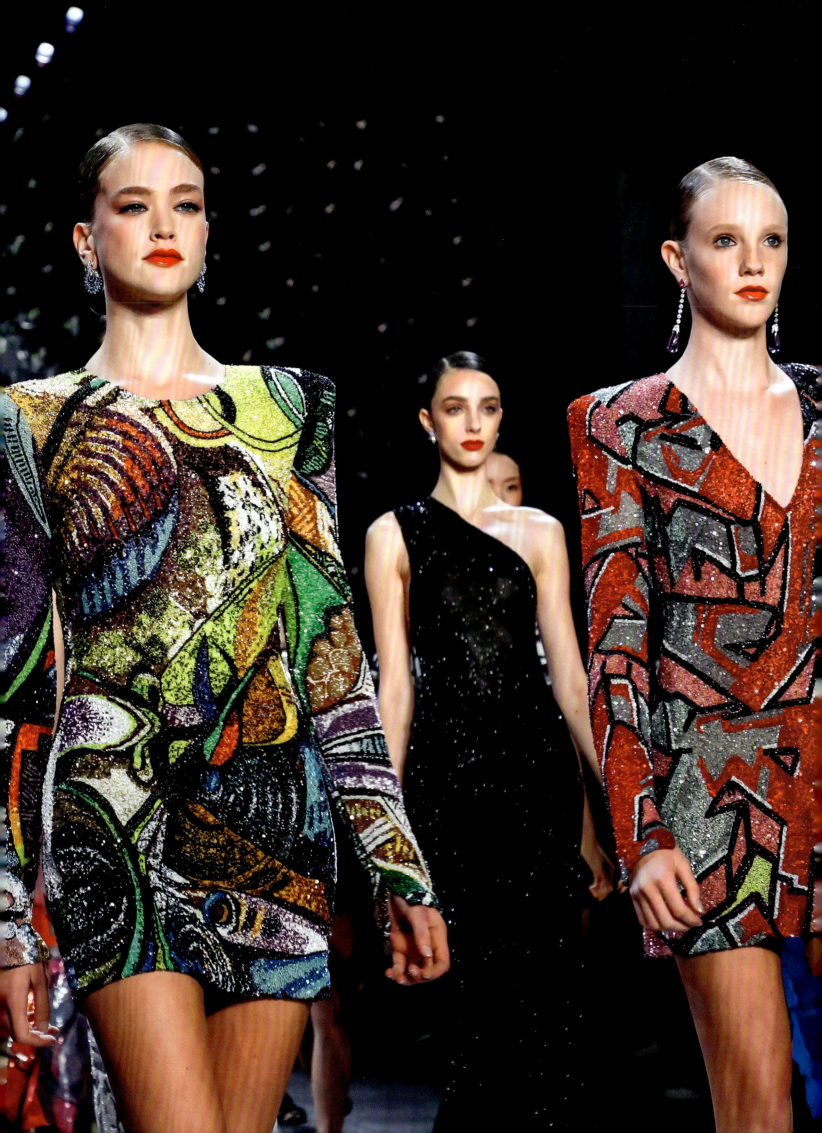

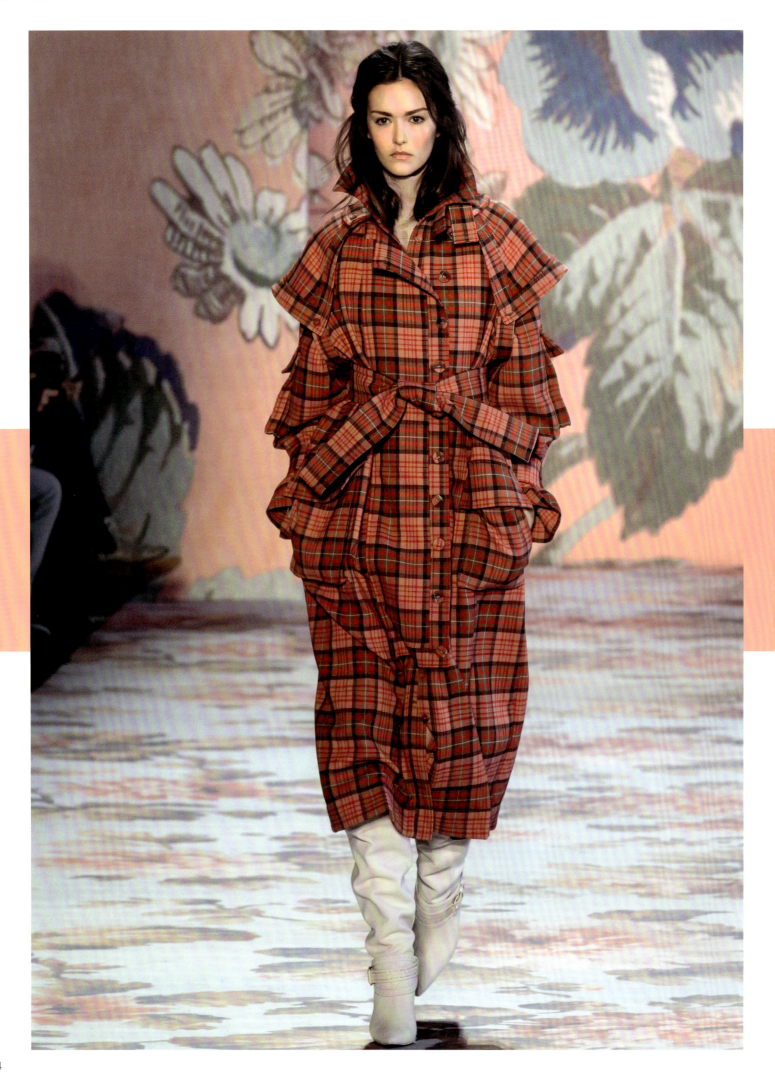

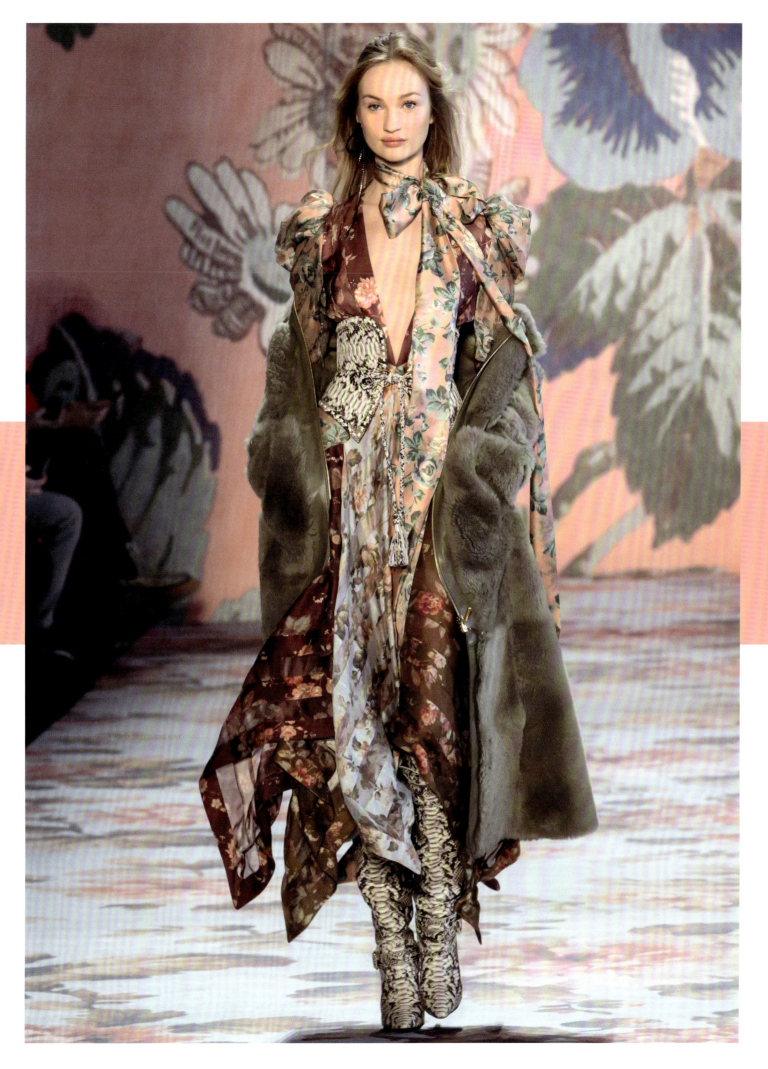

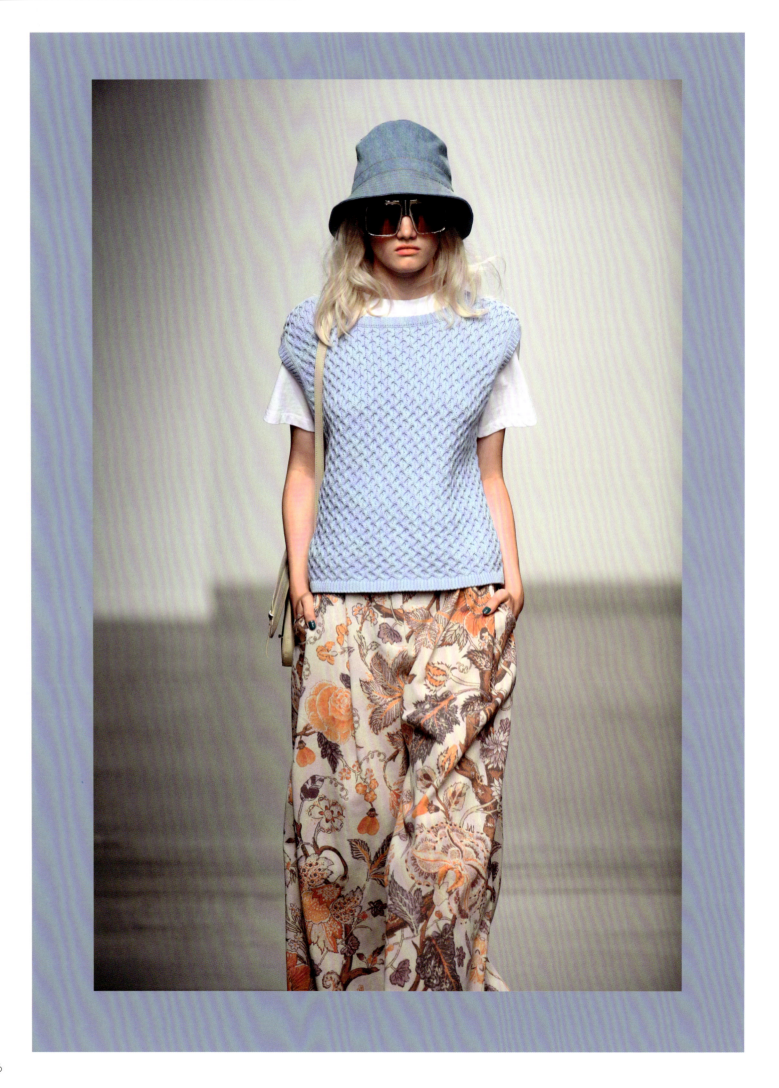

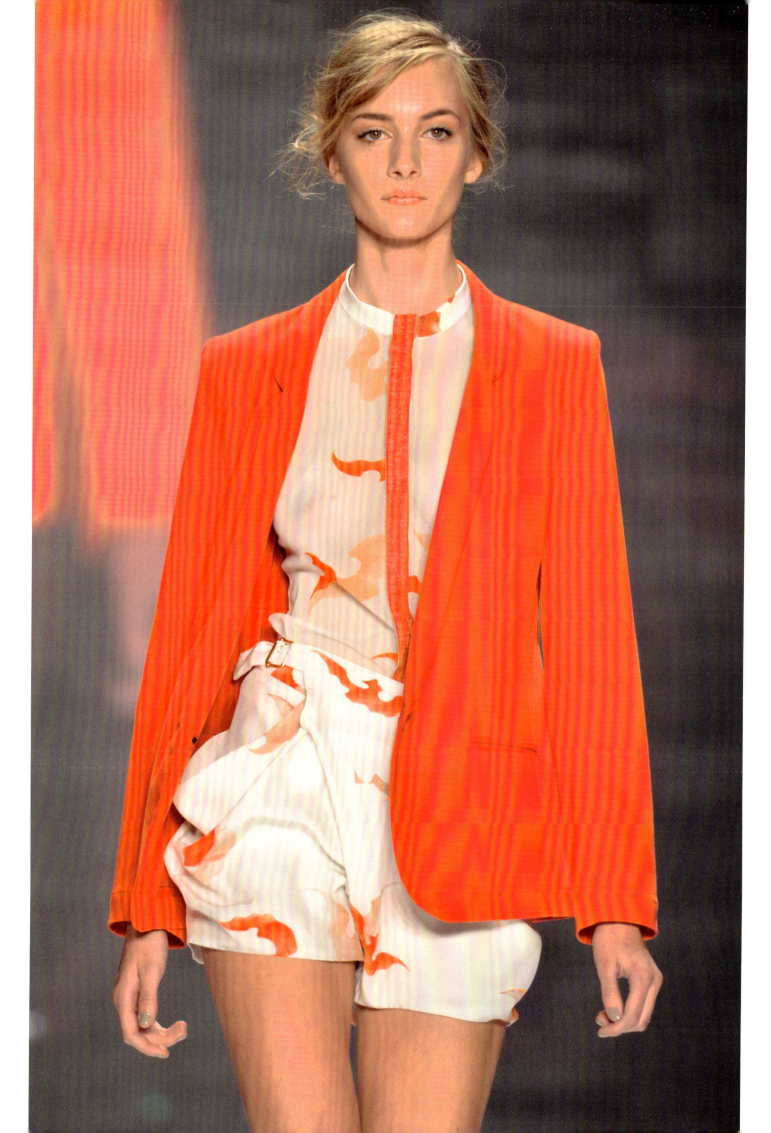

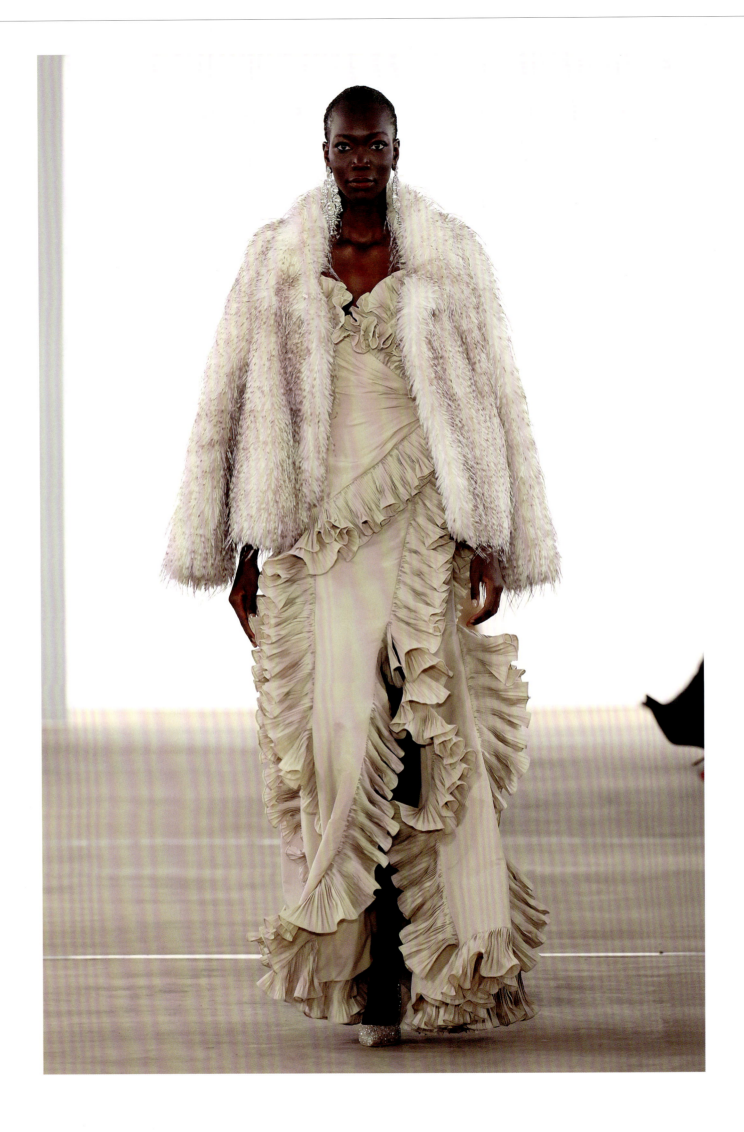

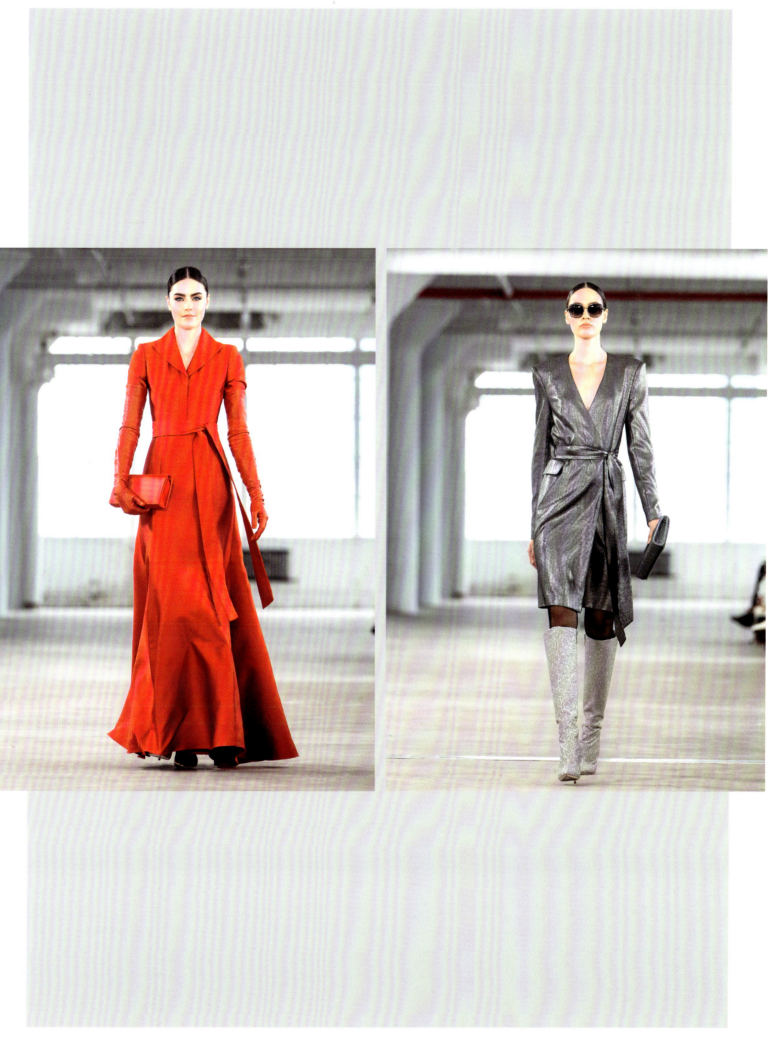

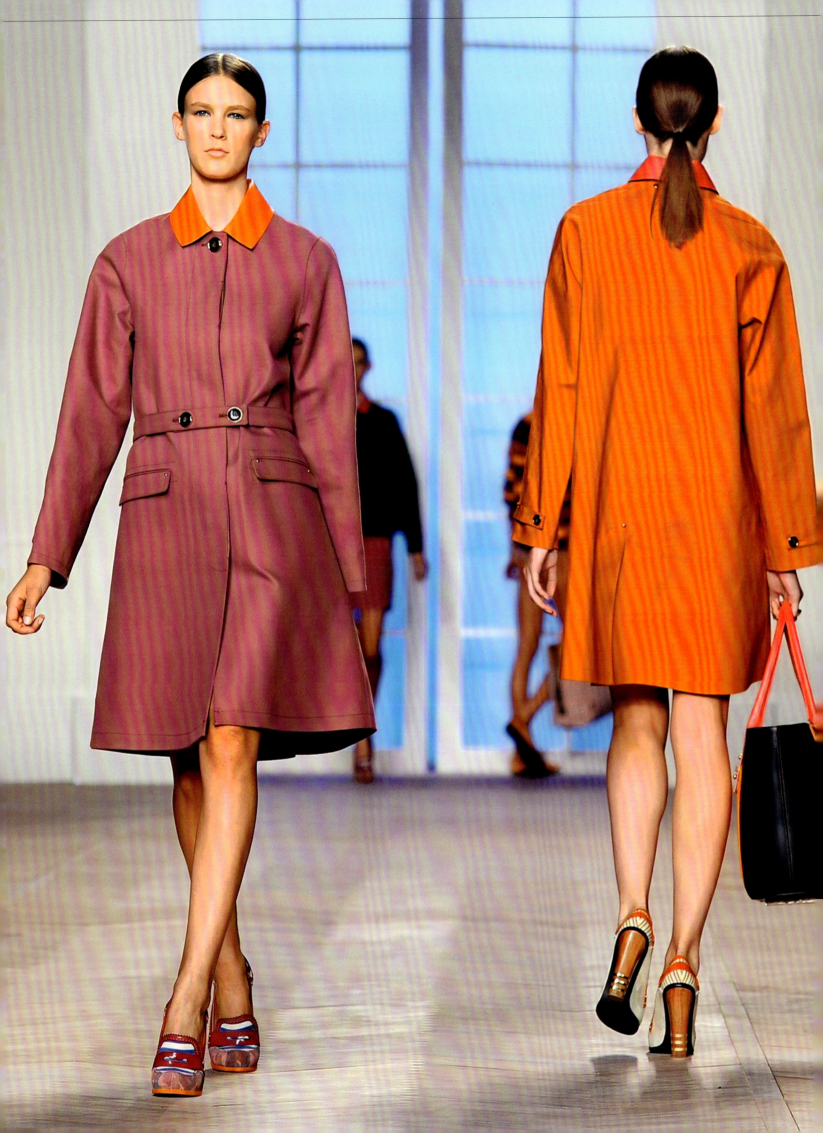

"I feel that we've shaped fashion in New York for almost 40 years. And though we've had a lot of influence in other parts of the world, this, really, is where it all started."

TOMMY HILFIGER

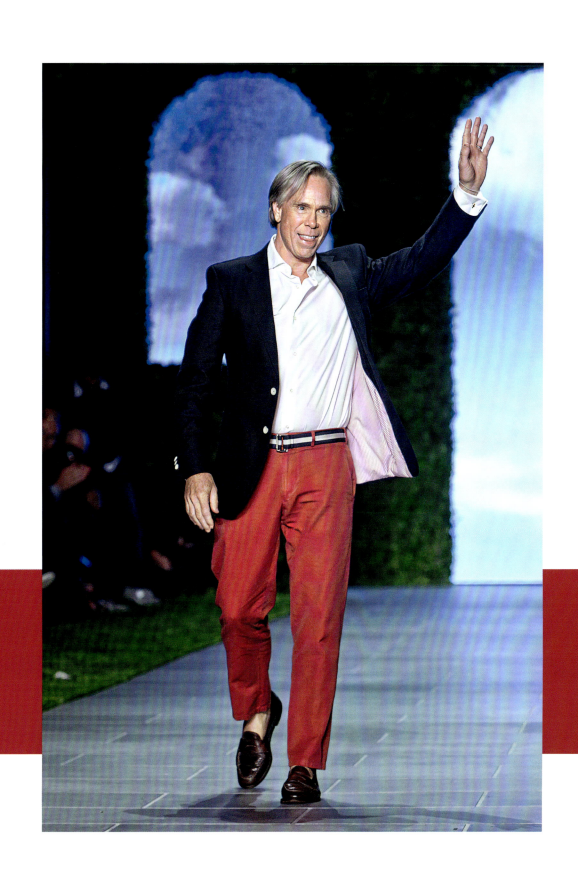

> "I love clothes. They're a very wonderful outlet for creativity, to challenge yourself to create an image and change how things work. Women are real works of art..."

VERA WANG

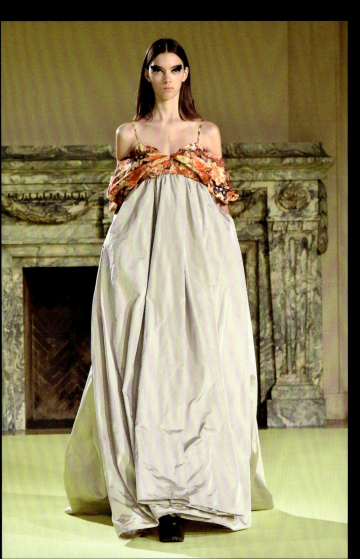
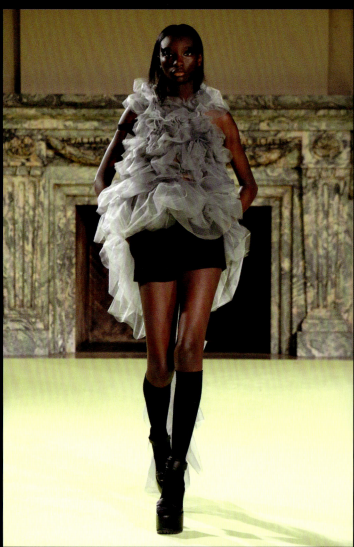

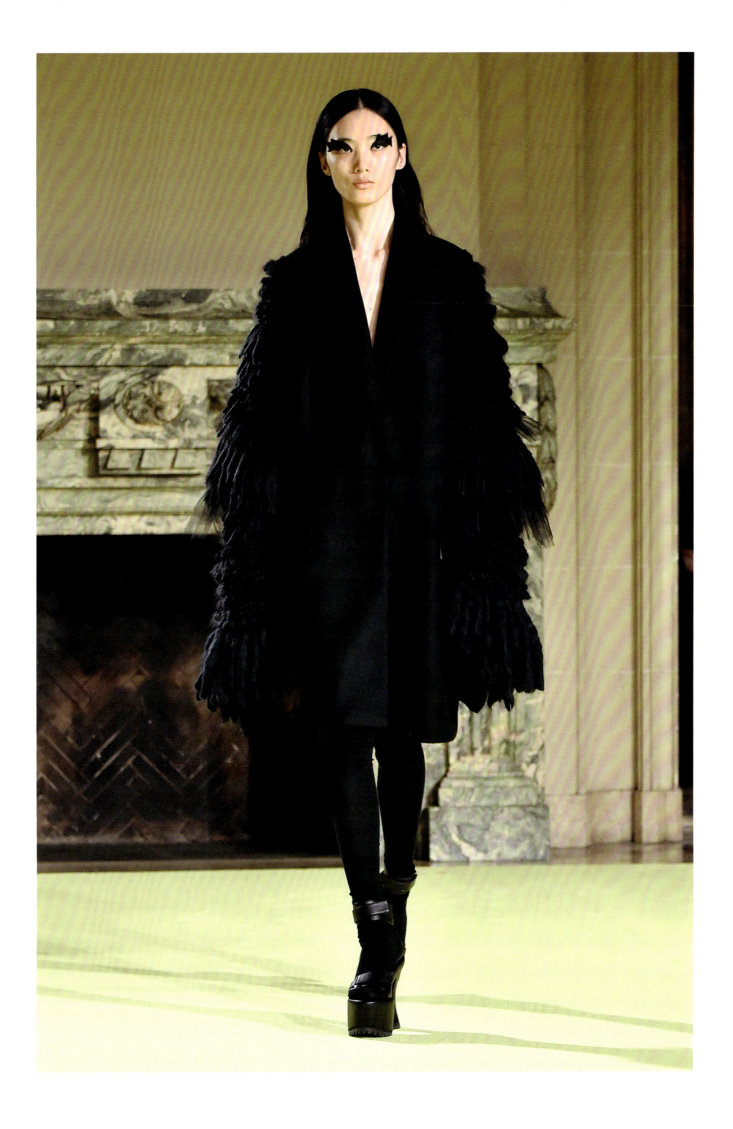

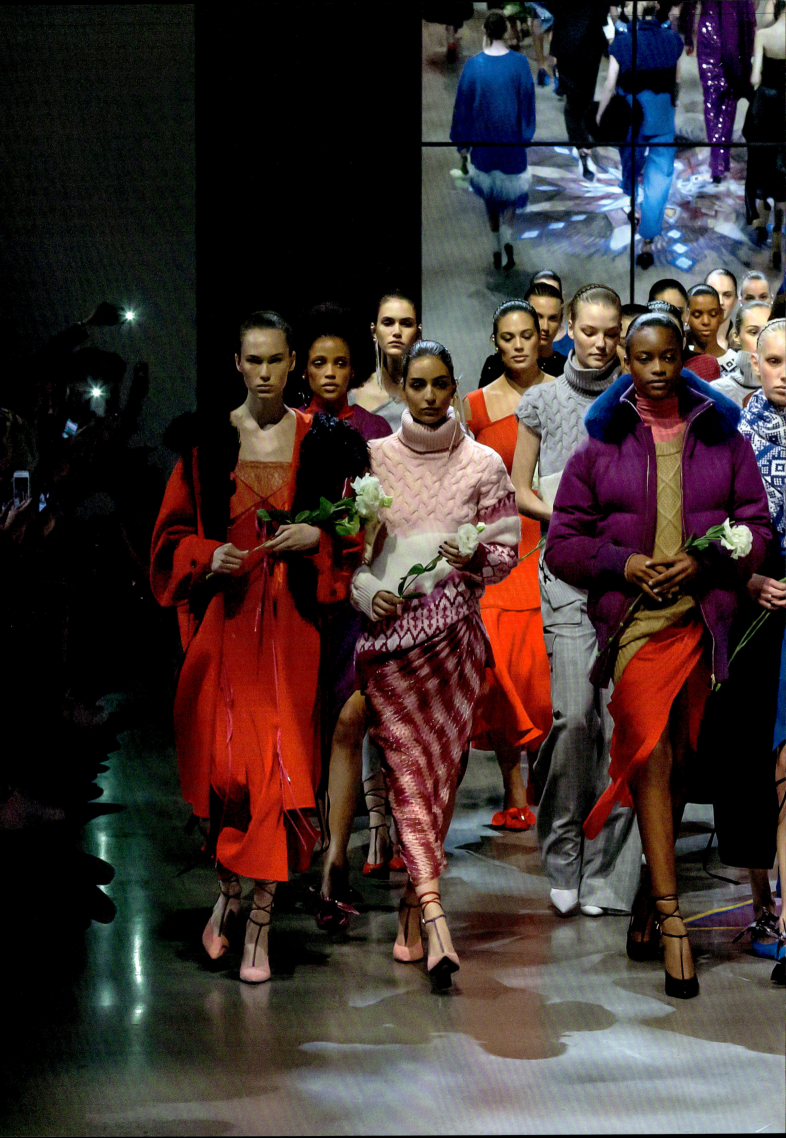

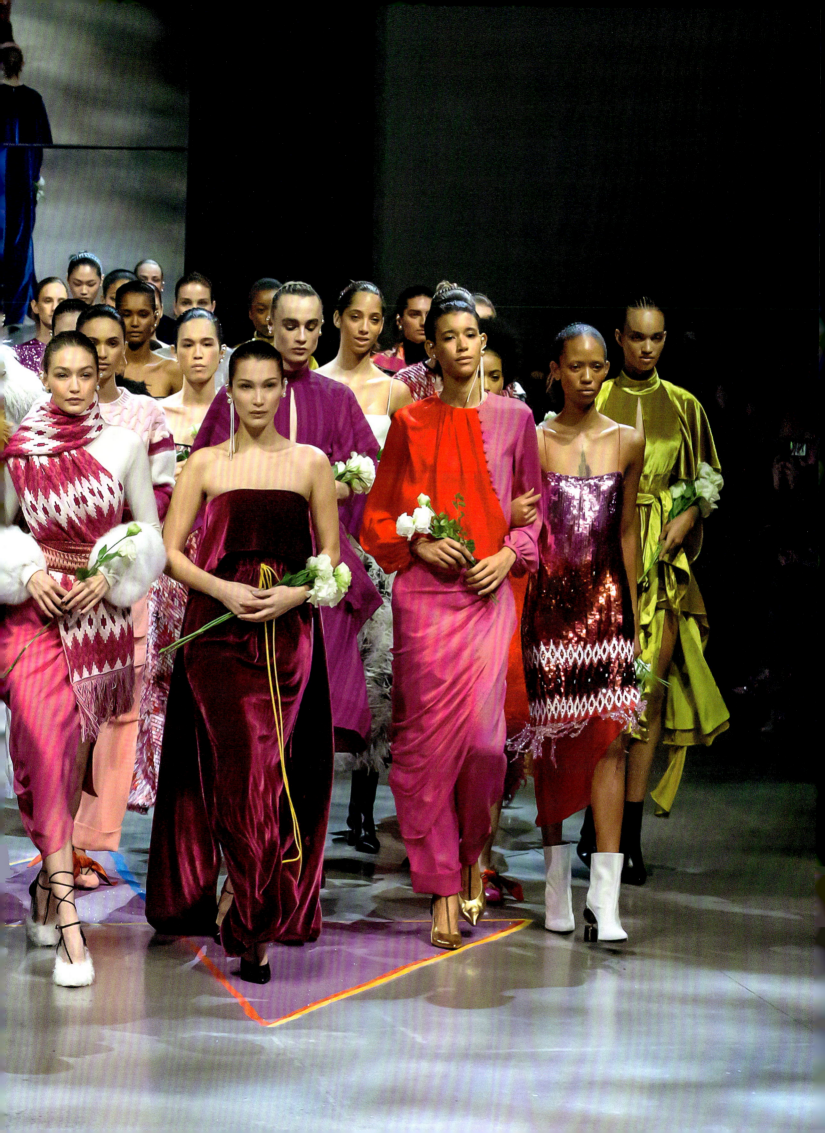

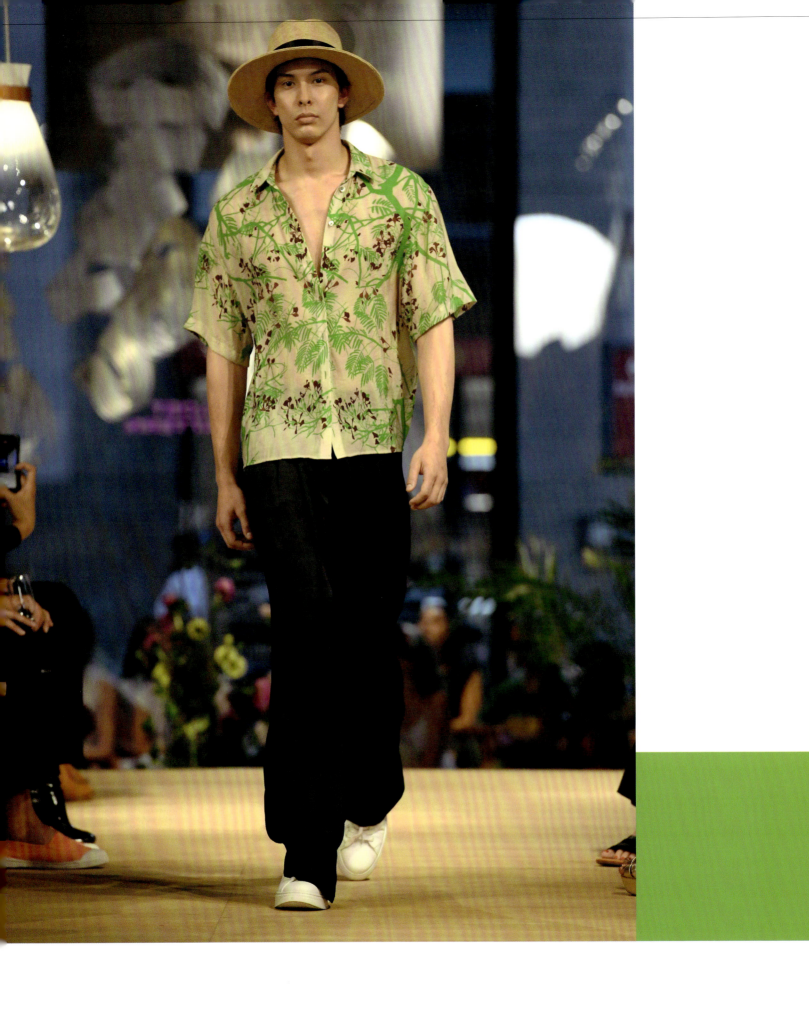

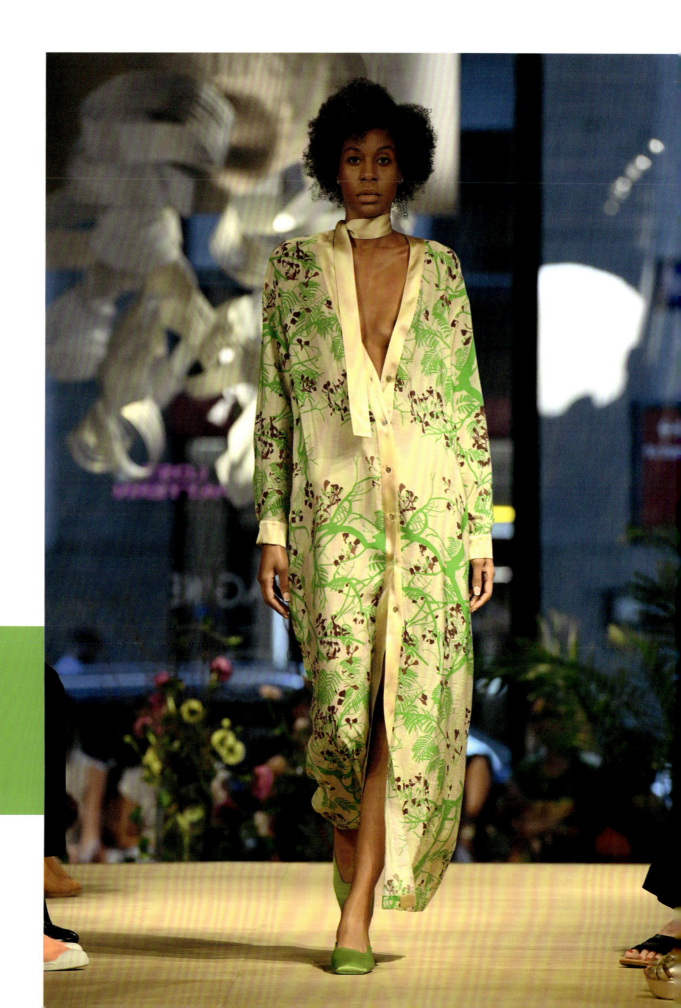

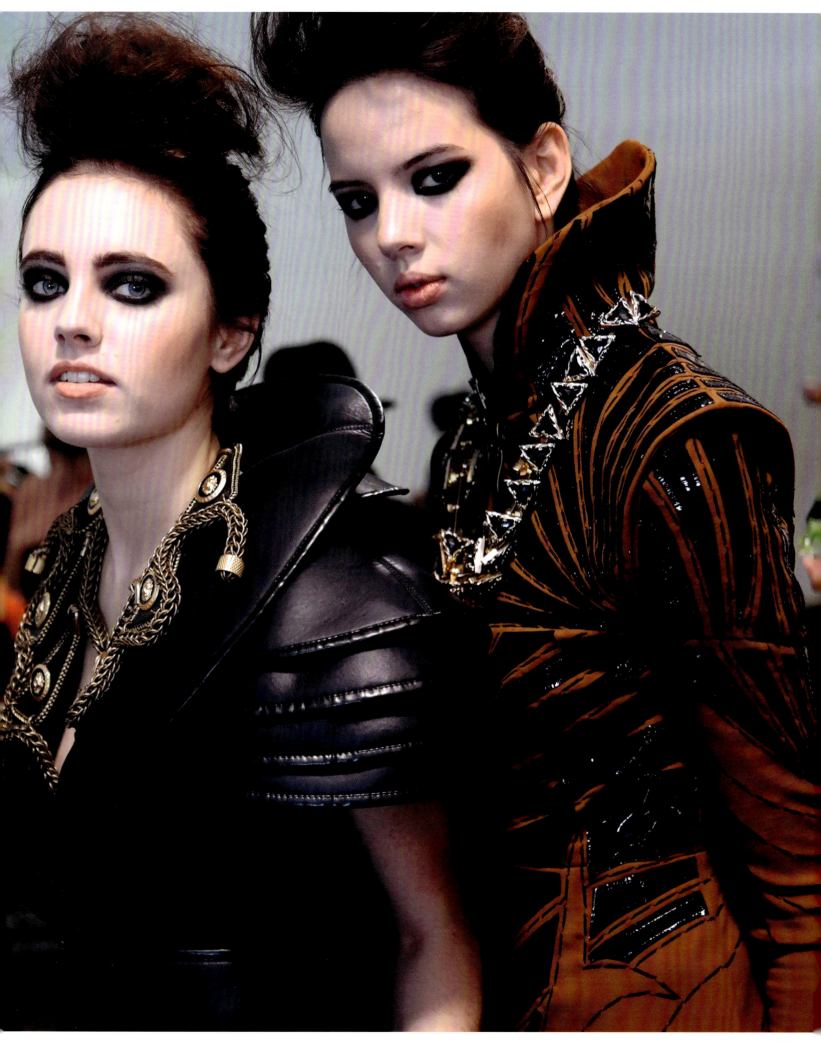

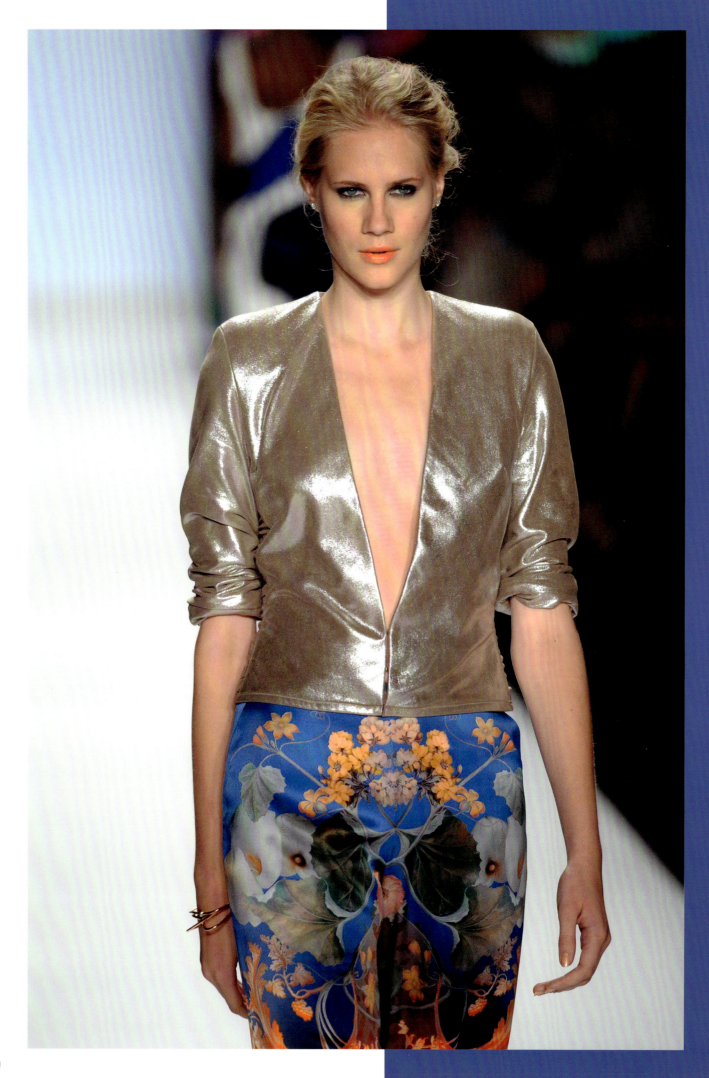

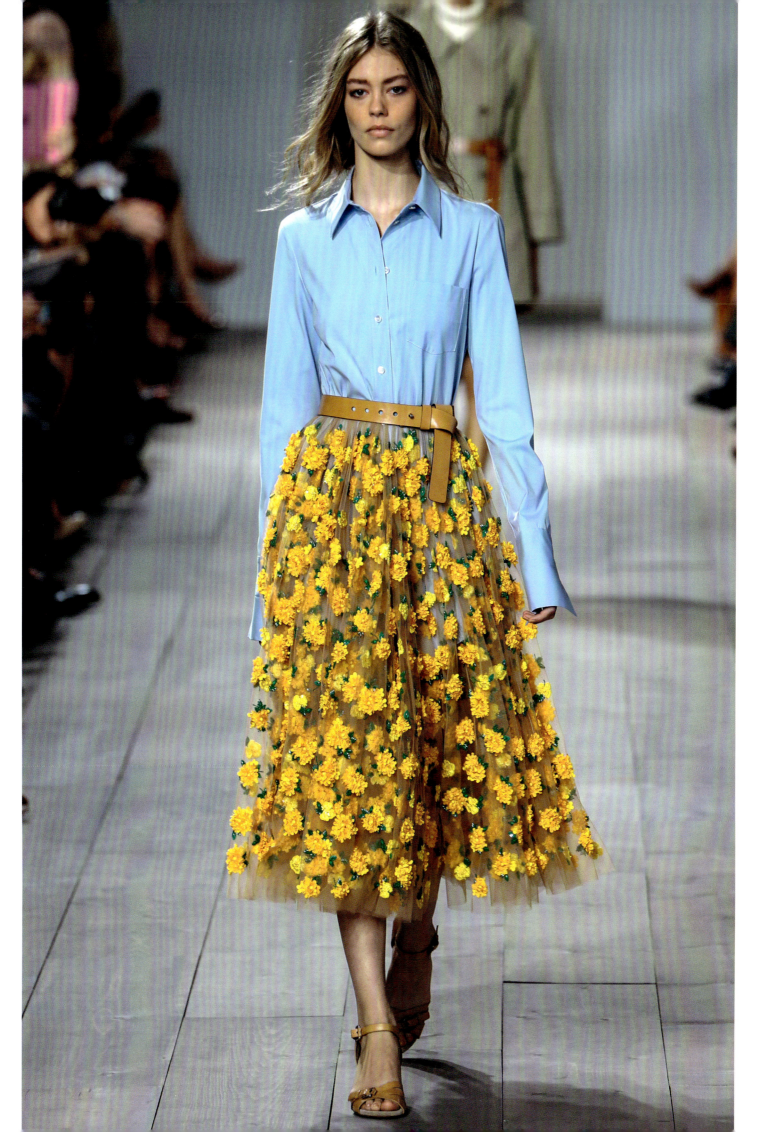

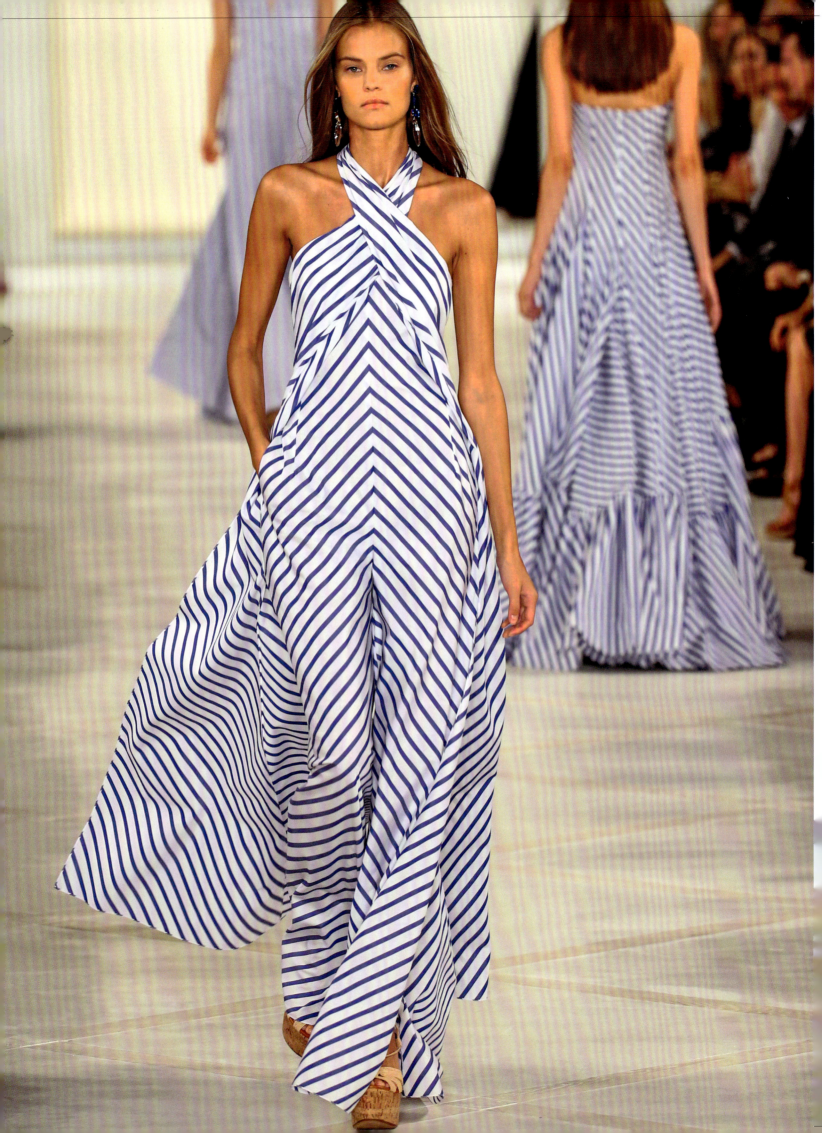

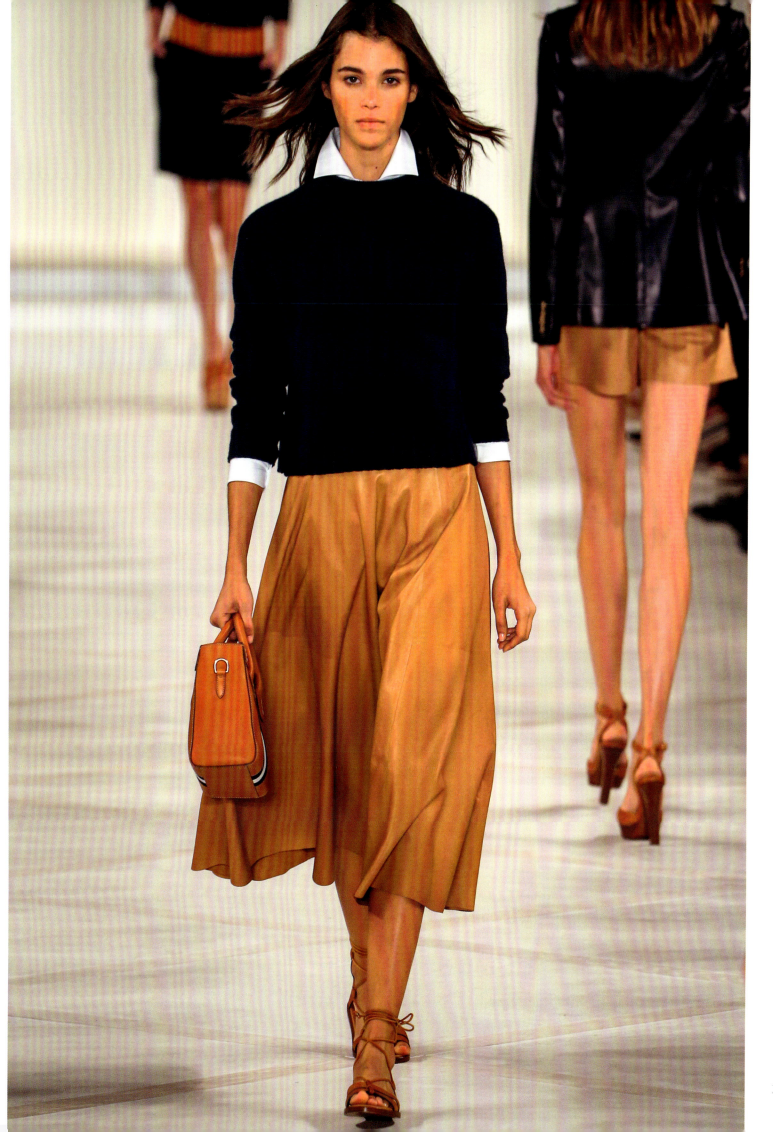

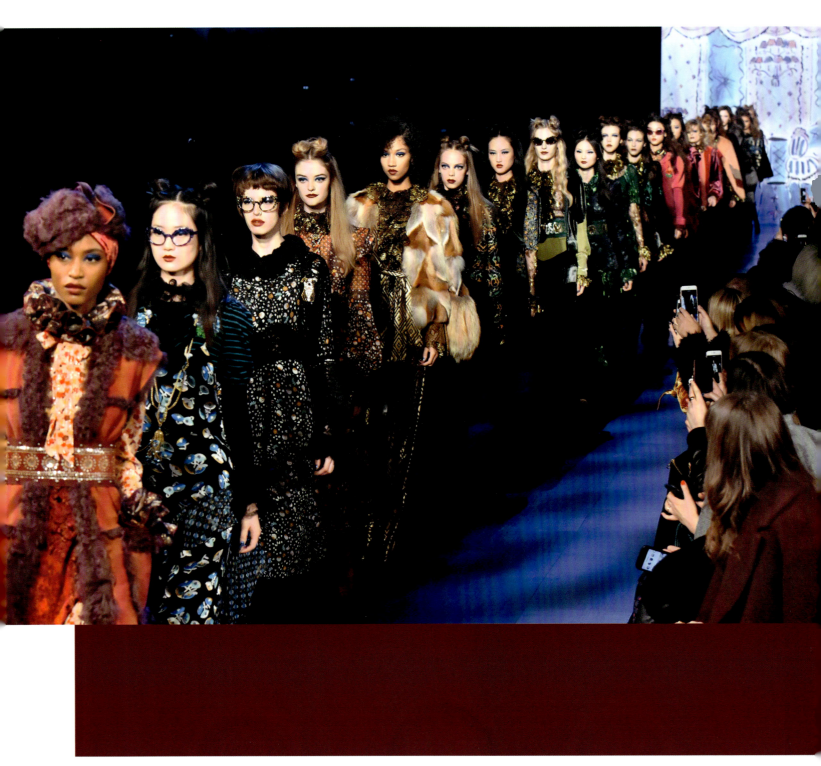

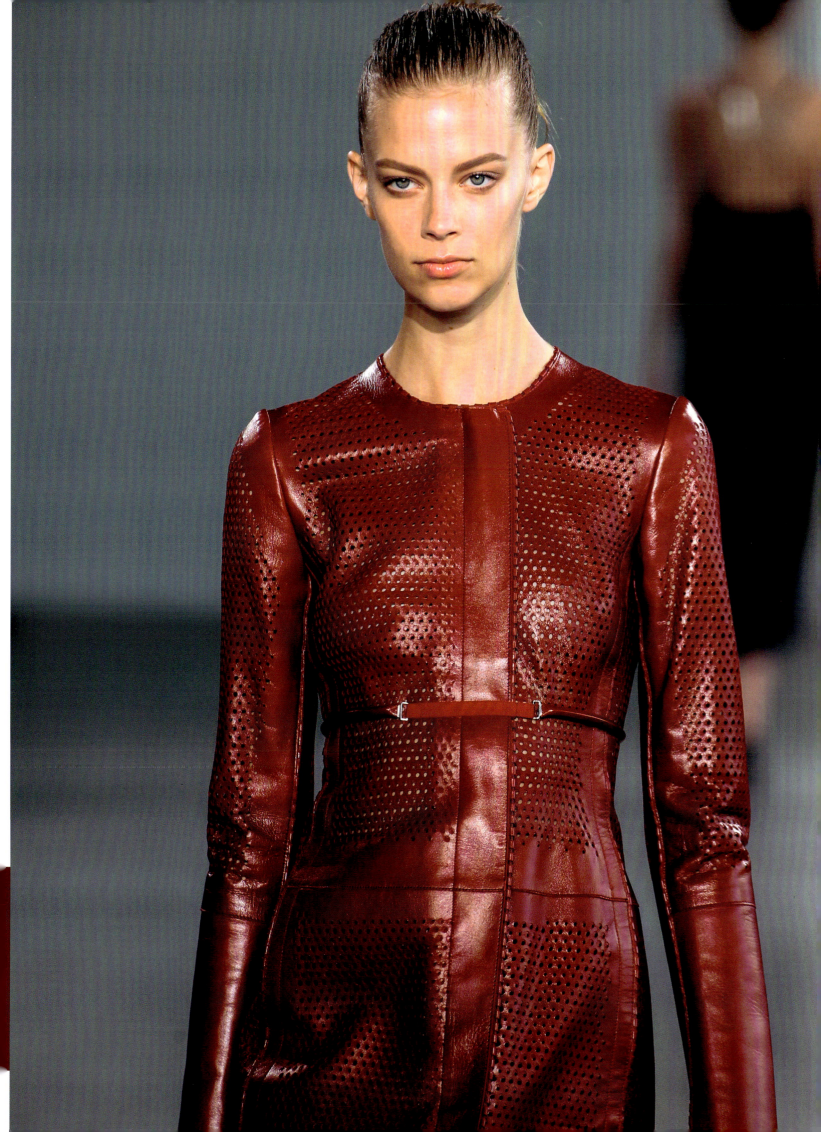

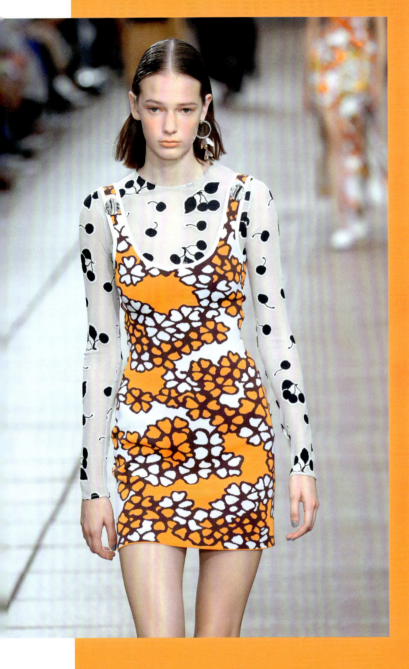
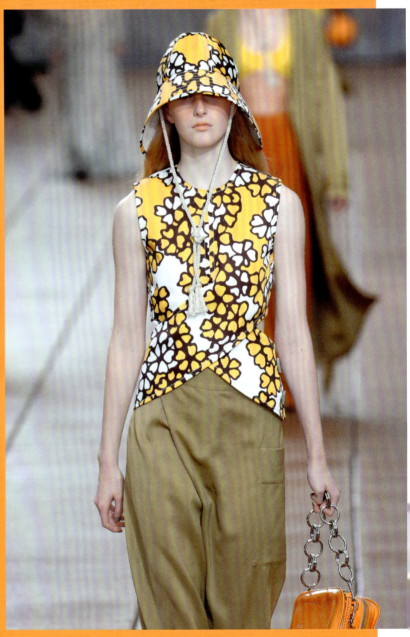

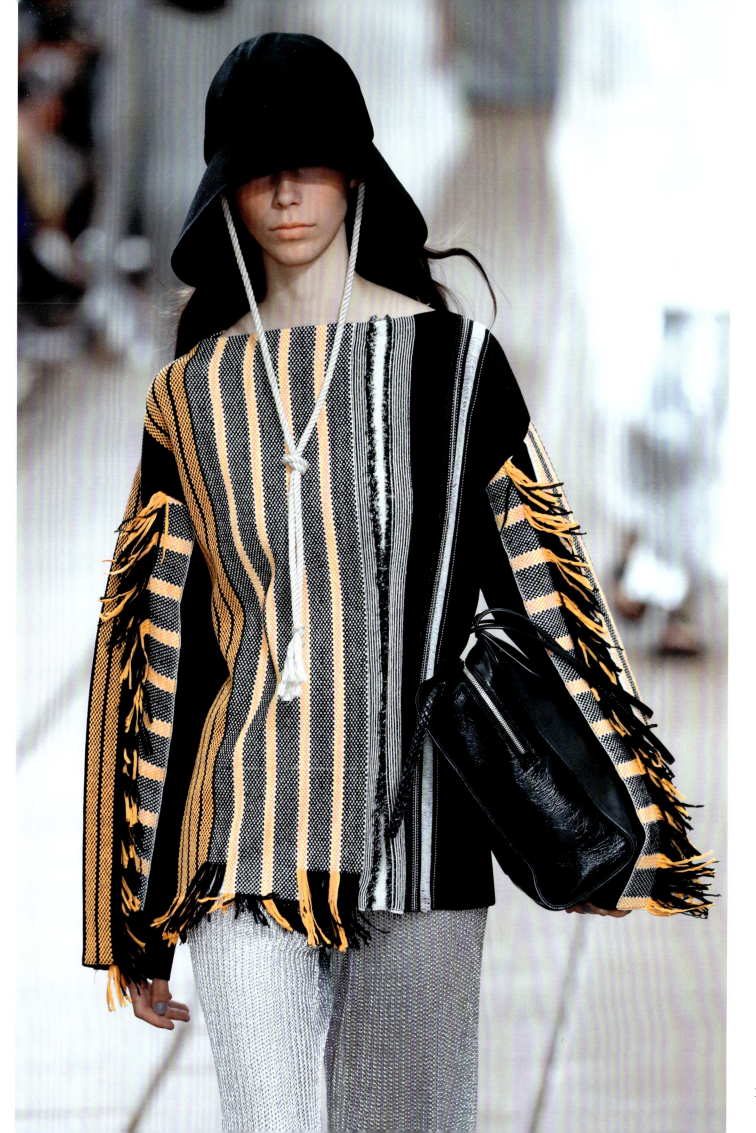

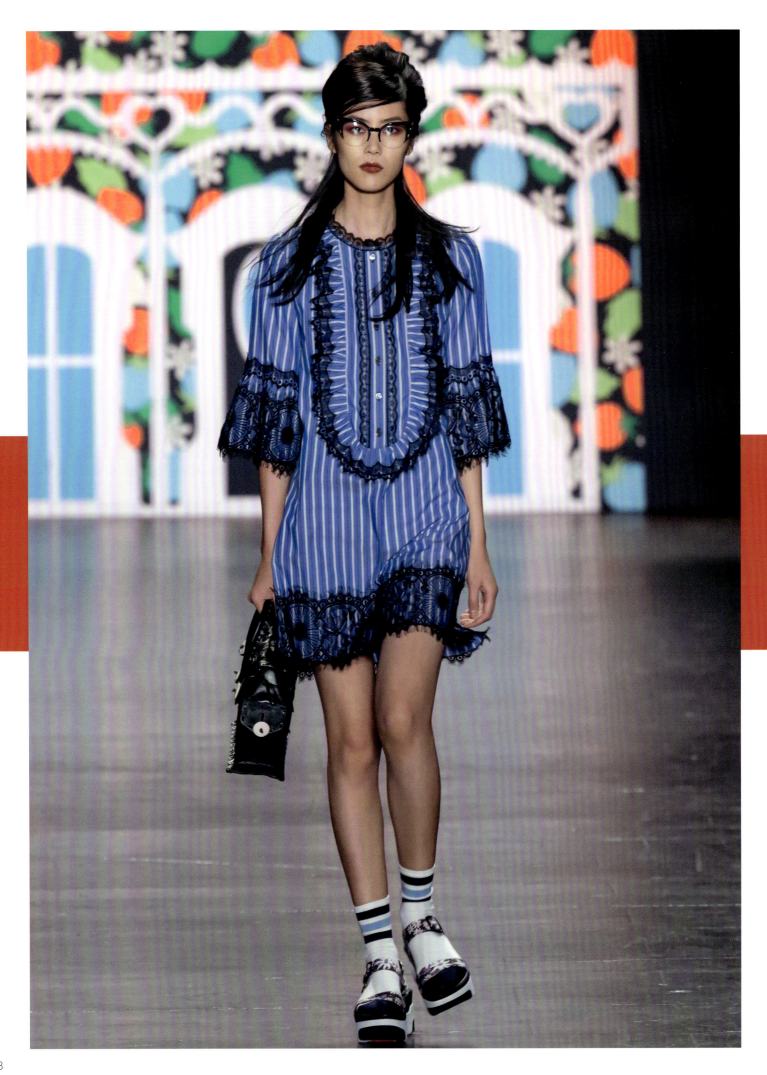

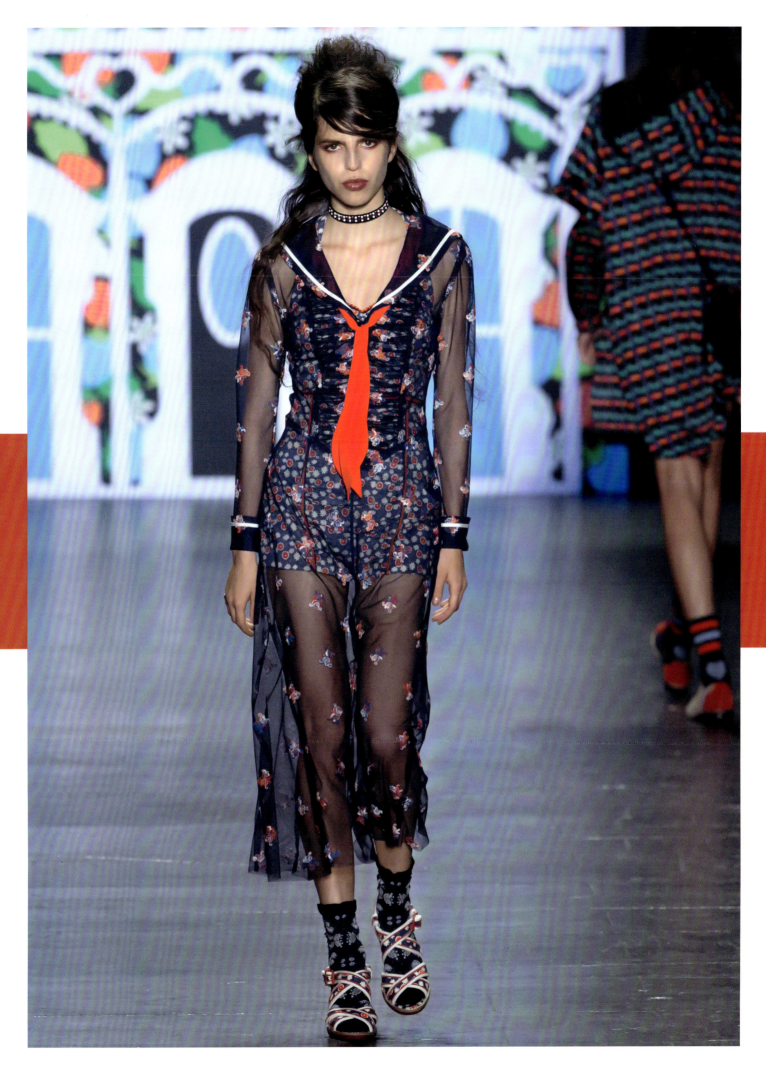

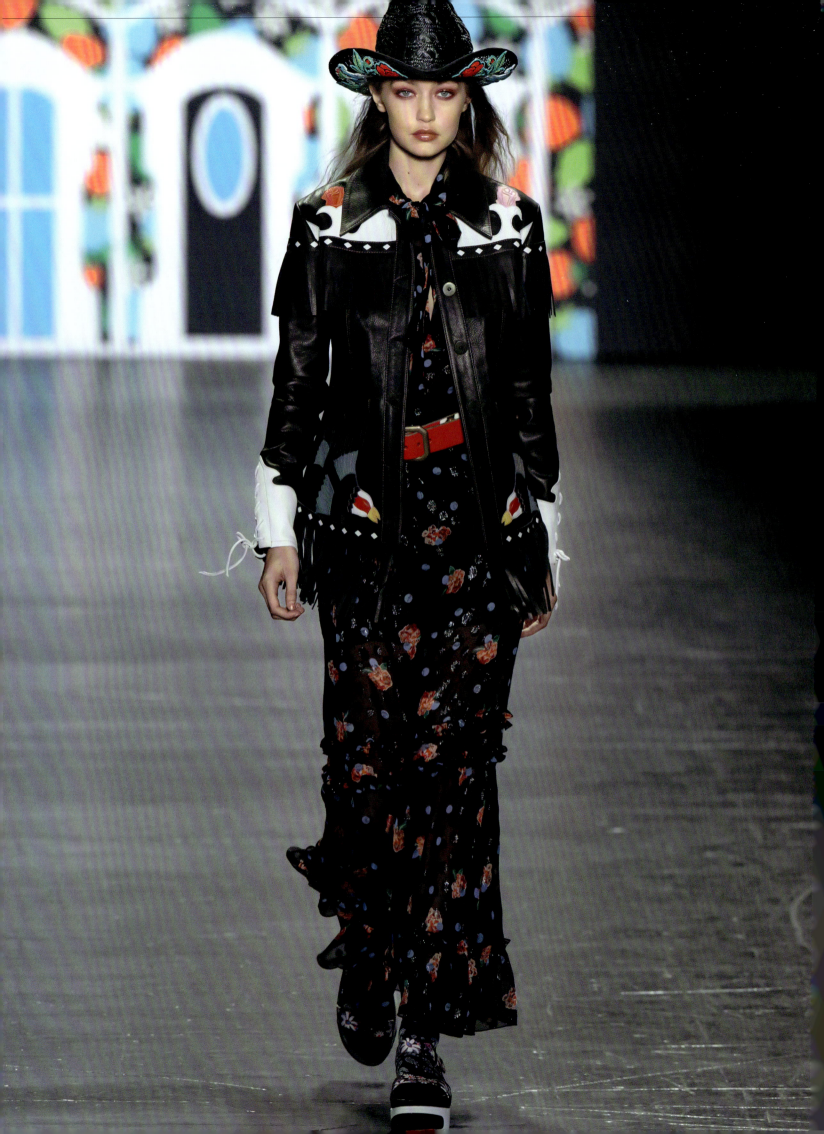

"To me, fashion is like a mirror… It's a reflection of the times. And if it doesn't reflect the times, it's not fashion. Because people aren't gonna be wearing it."

ANNA SUI

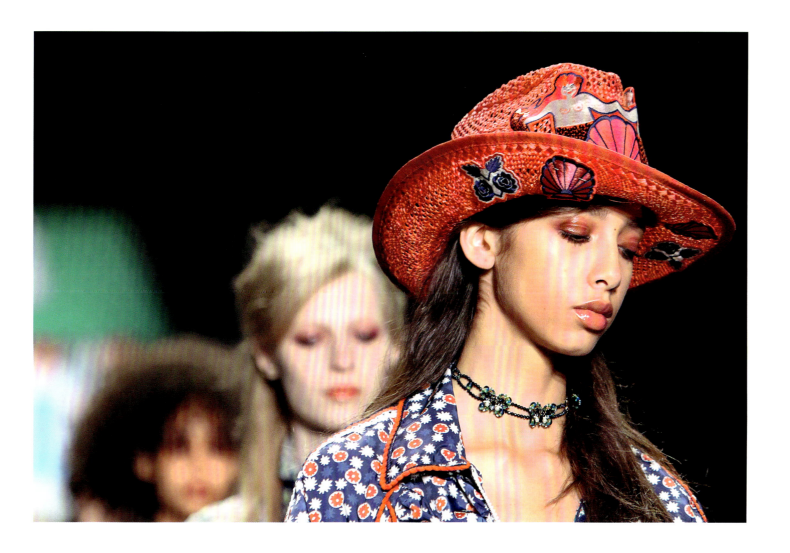

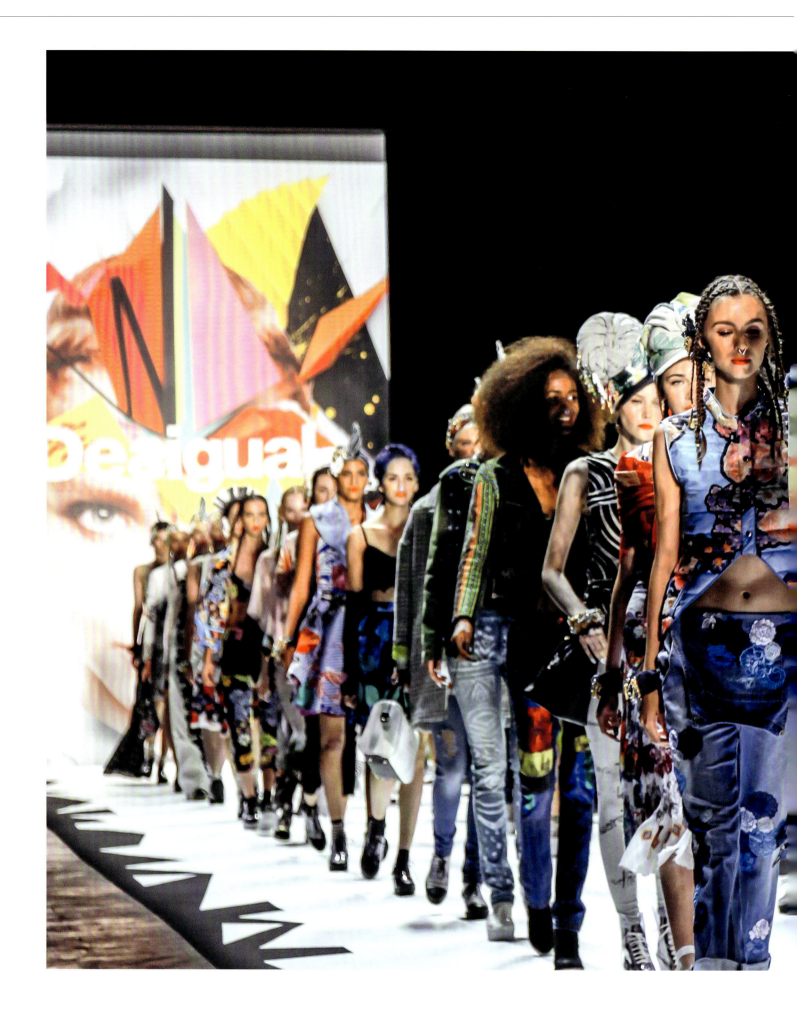

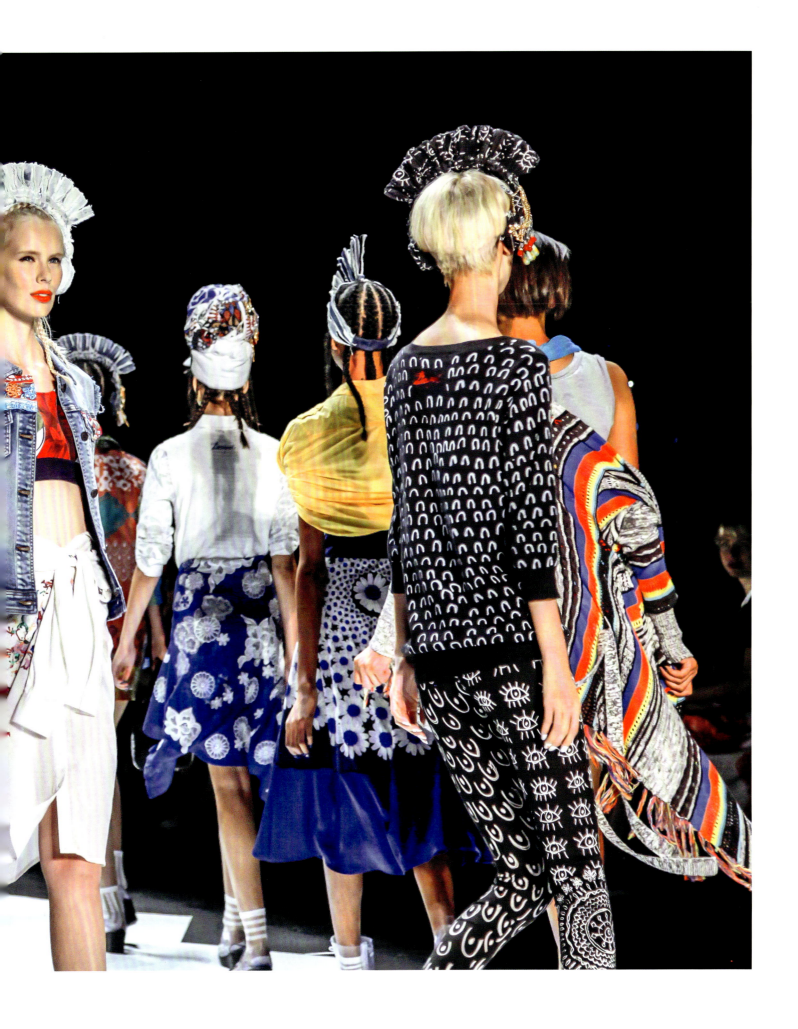

Runway models at a Giorgio Armani show at the Park Avenue Armory in October 2024.

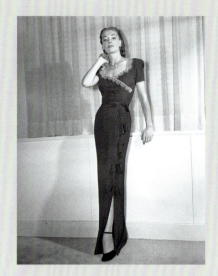

Model showing a dinner gown at the first New York Fashion Week in 1943. The gown was reportedly the colour of Bordeaux wine.

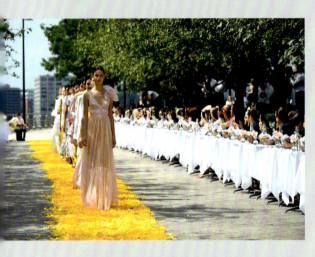

Models walk the runway at the Lela Rose Spring 2020 collection show, September 2019.

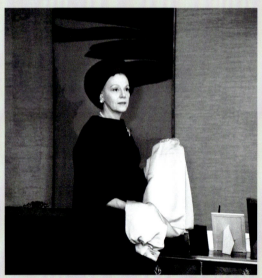

A travelling fashion show, demonstrating various cotton garments at the Waldorf Astoria, 1927.

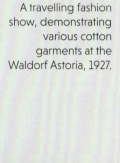

Eleanor Lambert, December 1963.

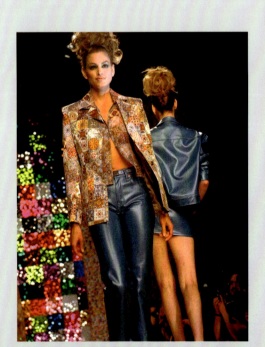

Cindy Crawford (left) and Carla Bruni (right) model for designer Todd Oldham, 1995.

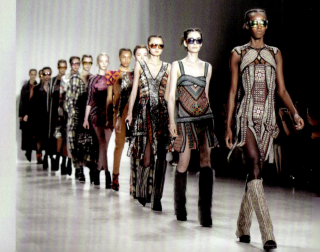

Models walk the runway at the Custo Barcelona Autumn/Winter 2015/2016 collection show, February 2015.

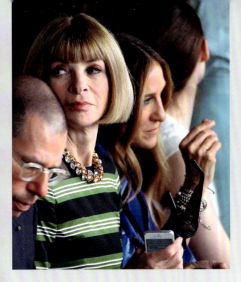

Vogue's editor-in-chief, Anna Wintour, and actress Sarah Jessica Parker at the Calvin Klein Spring/Summer 2015 collection show, September 2014.

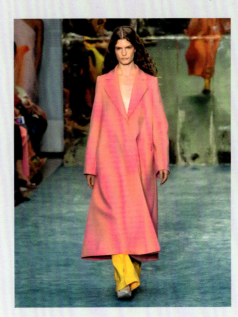 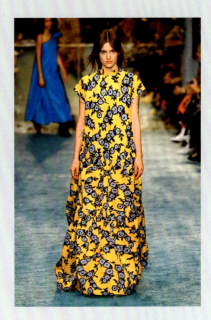

Runway models at the Carolina Herrera Autumn/Winter 2019/2020 collection show, February 2019.

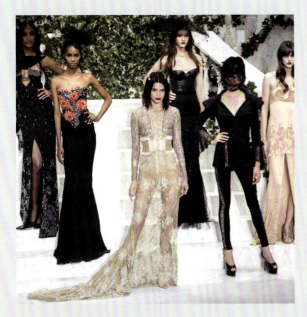

Top model, socialite and reality show star Kendall Jenner with other models at the La Perla Autumn/Winter 2017/2018 collection show, February 2017.

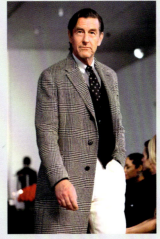 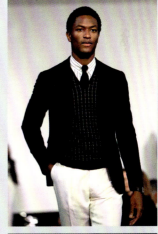

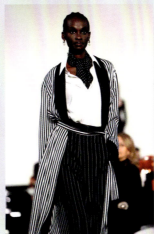 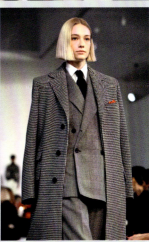

Ralph Lauren greets the audience at the end of his Spring/Summer 2015 collection show, September 2014.

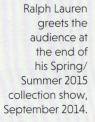

Some of the designs by Ralph Lauren at his Autumn/Winter 2022/2023 collection show held at MoMA, March 2022.

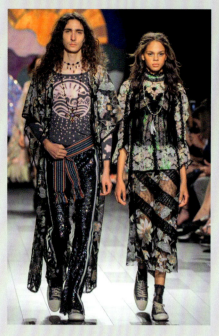
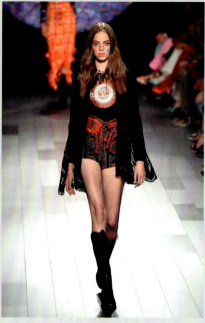
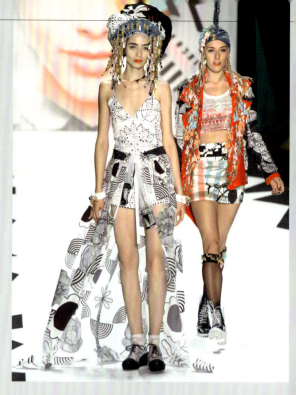

Models at the Anna Sui Spring/Summer 2018 collection show, September 2017.

Models at the Desigual Spring/Summer 2016 collection show, September 2015.

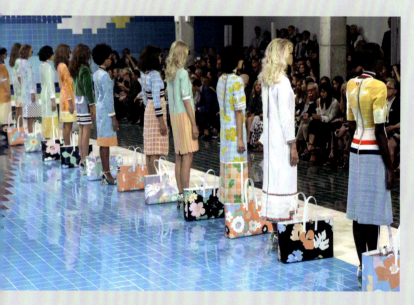

Models pose at the Thom Browne Spring/Summer 2017 collection show, September 2016.

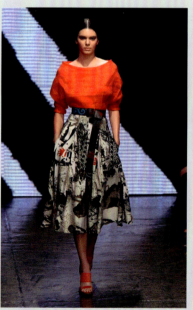

Models at the DKNY Spring/Summer 2014 collection show, September 2013.

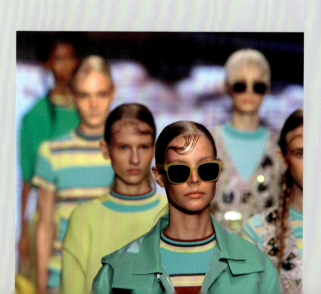

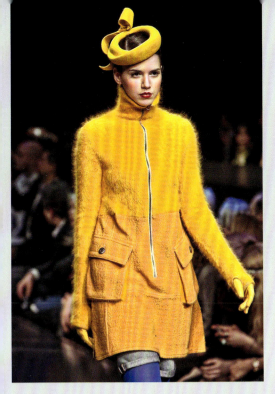
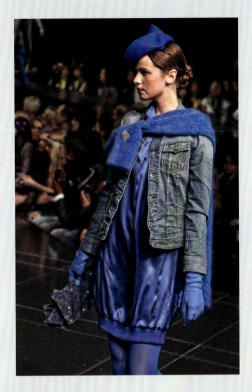

Models at the G-Star Autumn/Winter 2010/2011 collection show, February 2010.

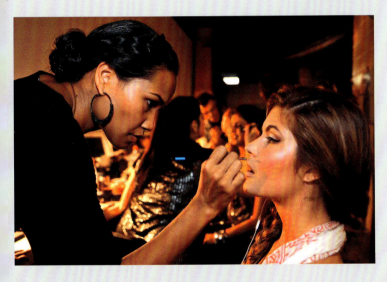

A stylist working backstage at the DL1961 Premium Denim Spring/Summer 2013 collection show, September 2012.

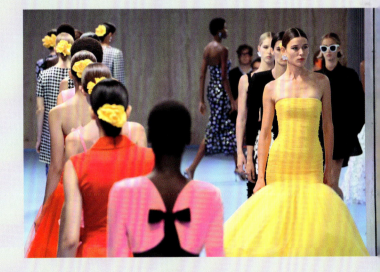

Models on-stage for Carolina Herrera during New York Fashion Week, September 2024.

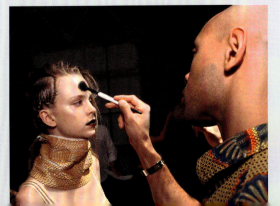

Backstage at the Ivana Helsinki Spring/Summer 2014 collection show, September 2013.

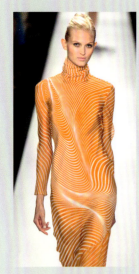
A model at the Carolina Herrera Spring/Summer 2014 collection show.

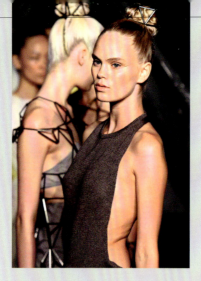
A model at the Titania Inglis Spring/Summer 2014 collection show.

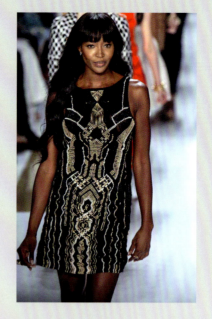
Naomi Campbell walks the runaway at the Diane von Furstenberg Spring/Summer 2014 collection show, 2013.

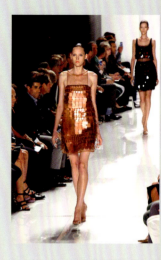
Models at the Ralph Rucci Spring/Summer 2014 collection show, September 2013.

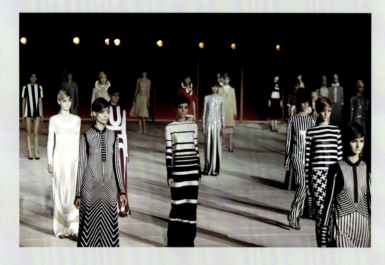
Models at the finale of the Marc Jacobs Spring/Summer 2013 collection show, September 2012.

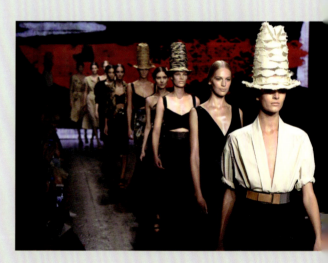
Models at the finale of the DKNY Spring/Summer 2015 collection show, September 2014.

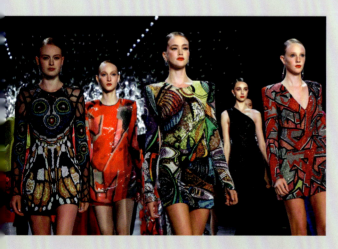
Models at the finale of the Naeem Khan Spring/Summer 2019 collection show, September 2018.

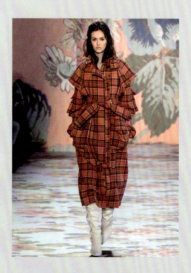
Model Vika Karelaya at the Zimmermann Autumn/Winter 2018/2019 collection show, February 2018.

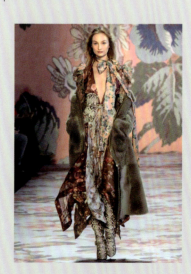
Model Clara McSweeney at the Zimmermann Autumn/Winter 2018/2019 collection show, February 2018.

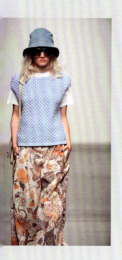
A model at the Karen Walker Spring/Summer 2015 collection show, September 2014.

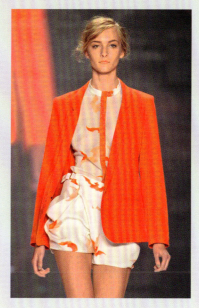
A model at the Vivienne Tam Spring/Summer 2012 collection show, September 2011.

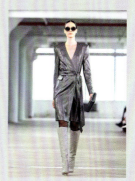
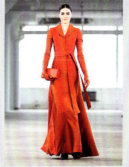

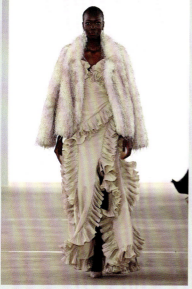
Models at the Badgley Mischka (Mark Badgley & James Mischka) Autumn 2024 collection show, February 2024.

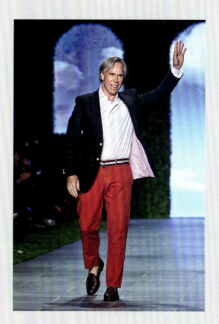
Tommy Hilfiger greeting the audience at the end of the Tommy Hilfiger Spring/Summer 2011 collection show, September 2010.

Tommy Hilfiger runway models during New York Fashion Week, September 2011.

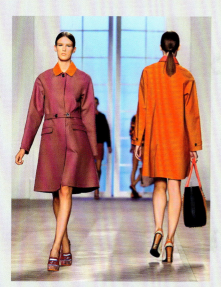

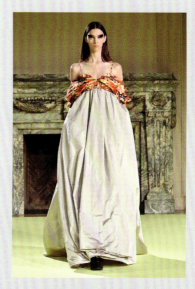
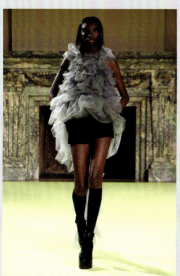
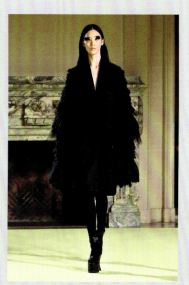
Models on the Vera Wang runway, February 2020.

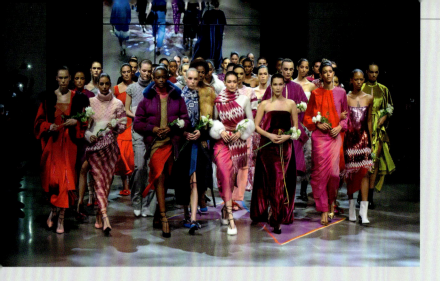

Models at the finale of the Prabal Gurung Autumn/Winter 2018/2019 collection show, February 2018.

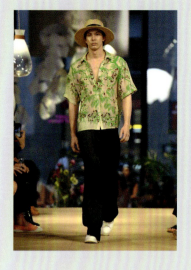

Models on the Lost Pattern runway, New York Fashion Week, September 2024.

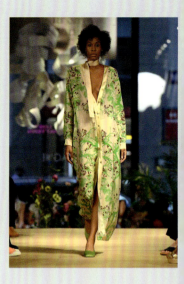

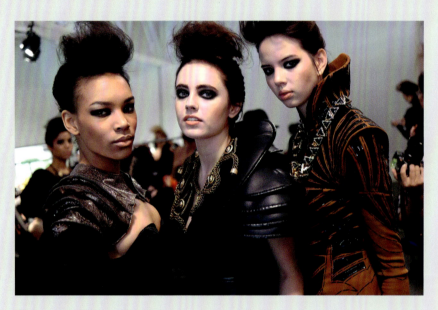

Backstage at a Léka show, 2014.

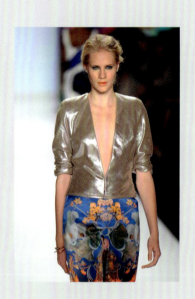

A model at the *Project Runway* show held during the Spring/Summer 2014 Mercedes-Benz Fashion Week, September 2013.

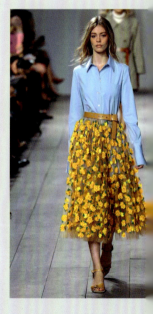

A model at the Michael Kors Spring/Summer 2015 collection show.

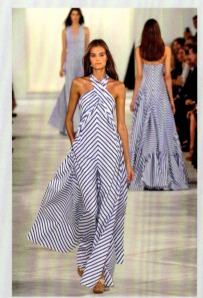

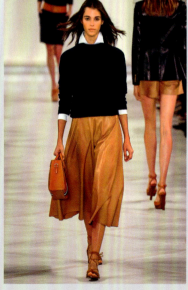

Models at the Ralph Lauren Spring/Summer 2016 collection show, September 2015.

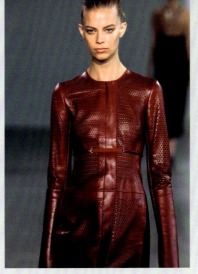

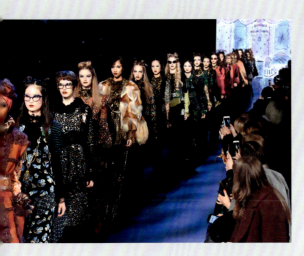

A model at the Calvin Klein Spring/Summer 2015 collection show, September 2014.

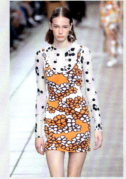 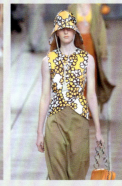

The Anna Sui runway, Fashion Week, February 2017.

Models at the 3.1 Phillip Lim Spring/Summer 2019 collection show, September 2018.

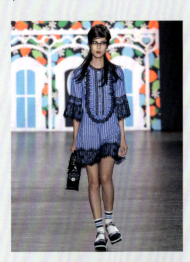

Models at the Anna Sui Spring/Summer 2017 collection show, September 2016.

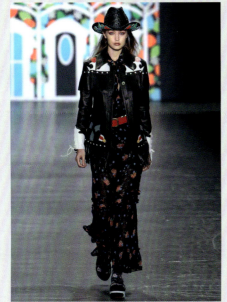

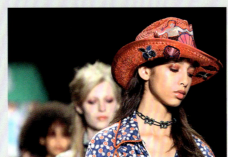

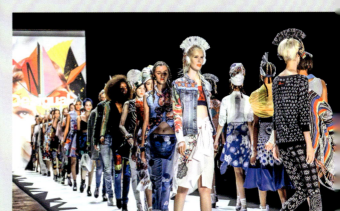

Models at the finale of the Desigual Spring/Summer 2016 collection show, September 2015.

NEW YORK
STREET STYLE

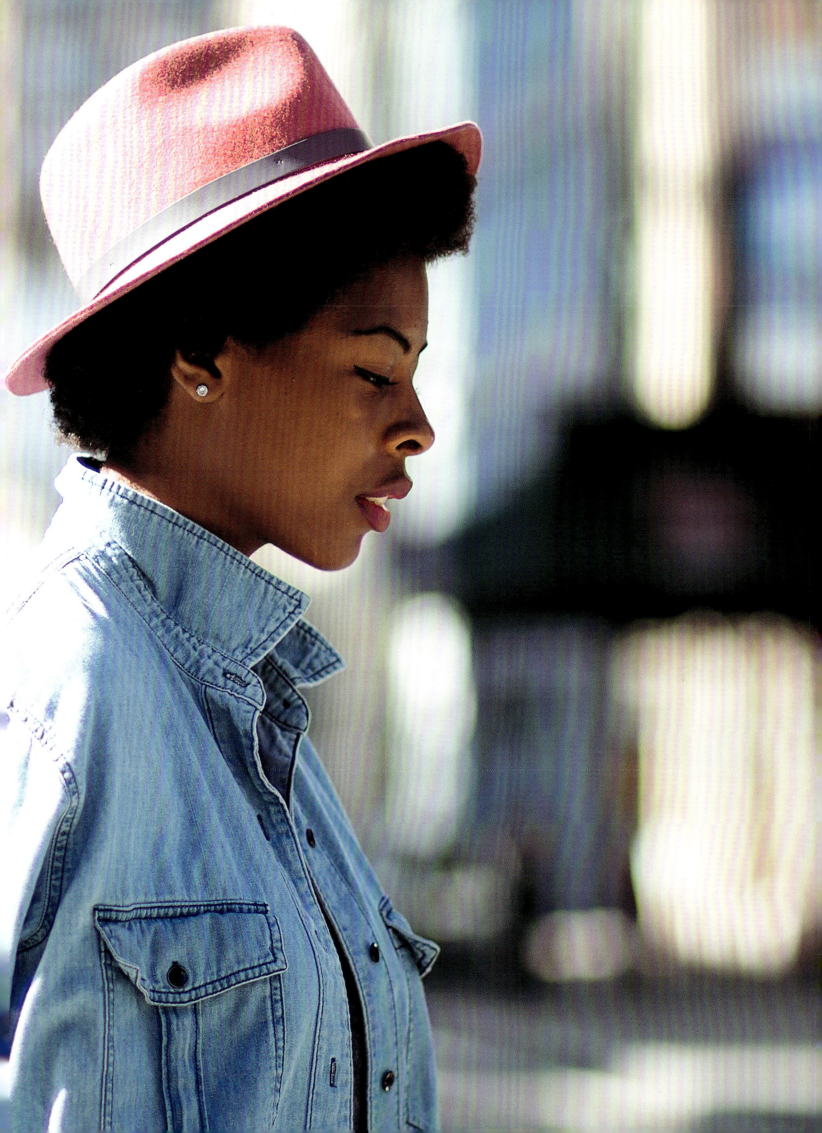

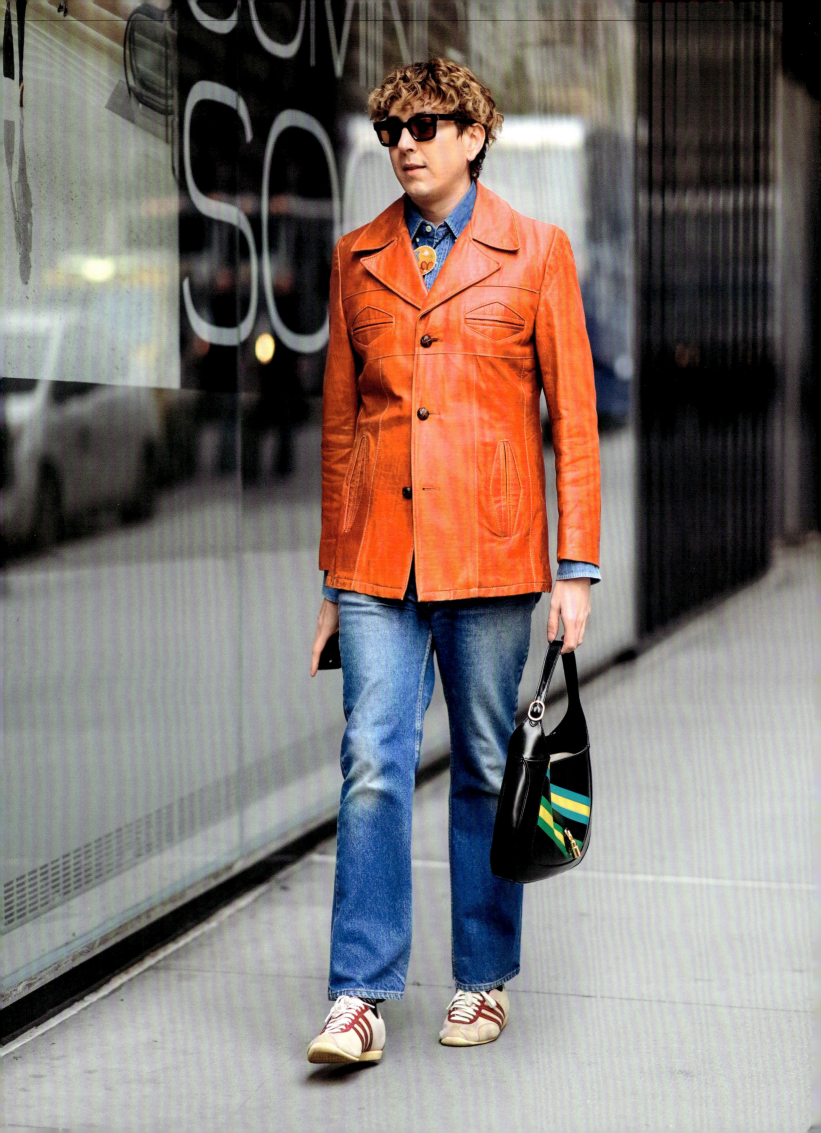

The diversity of sartorial styles seen on the streets of New York is, arguably, unmatched by any other fashion capital, even London. It seems that the full spectrum of elegance and silhouettes can be spotted in this whirlwind, resonating in tune with the hustle and bustle of the city. New York fashionistas are never afraid to reveal their personality and express themselves through clothing. They often inspire designers, who seek new trends and ideas from individuals they have seen on the streets.

What is the key to New York style? A unique blend of eclecticism, versatility, practicality, and elaborate simplicity. It starts with minimalism: a pair of jeans, a plain t-shirt and sneakers, with other elements that complement them according to one's mood and personality, especially as layering is a well-established New York tradition. Mixing and matching textures and colours is another style twist beloved by the inhabitants of the Big Apple. There is always a touch of comfort and warmth, as clothing is like a protective cocoon, and some carefully selected accessories create the sense of fantasy and individuality so dear to New Yorkers. Hairstyles are also an integral component of the look, whether in the form of a particular haircut or dye, or complemented by a beanie, cap, or hat.

Self-confidence is part of New York City's DNA, which is reflected in the mix of low and high fashion, the lack of restraint when it comes to experimentation, and the celebration of diversity and creativity.

Statement coats are among the latest trends in New York street style, as stylist Tina Broccole puts it, a coat is "the first and last thing people see when you're coming or going... A statement coat is an essential that can either make or break a look." The right coat easily combines coolness and power, two key elements of New York style. Dressing in all black is another beloved mainstay, as it allows you to stay elegant, neutral, and tasteful throughout the day, whatever your agenda: work or a business lunch, an evening party or a drink with friends. It does not necessarily have to be the LBD (Little Black Dress), but that is always a safe choice, and very New York, influenced in part by the one Audrey Hepburn wore in *Breakfast at Tiffany's*. That memorable dress was designed by a French couturier (Hubert de Givenchy) and worn by a British actress in a big-screen adaptation of an American play – just the kind of cultural exchange that makes New York what it is.

The huge variety of sneakers gracing the city's streets, from vintage to sporty, is more than enough to satisfy even the most demanding of New Yorkers. Ballet flats and loafers have also enjoyed a lasting boom, due to their comfort and timeless elegance. Clogs, kitten mules, and knee-high leather boots play the roles of the never-fading underdogs.

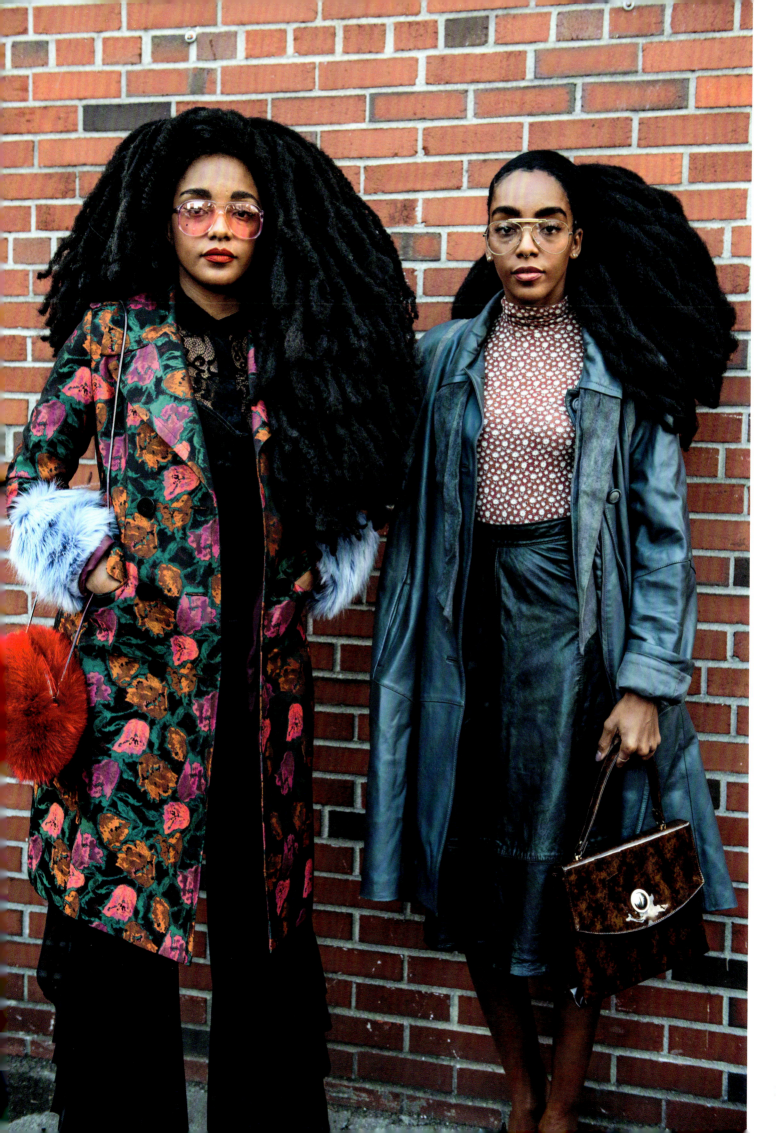

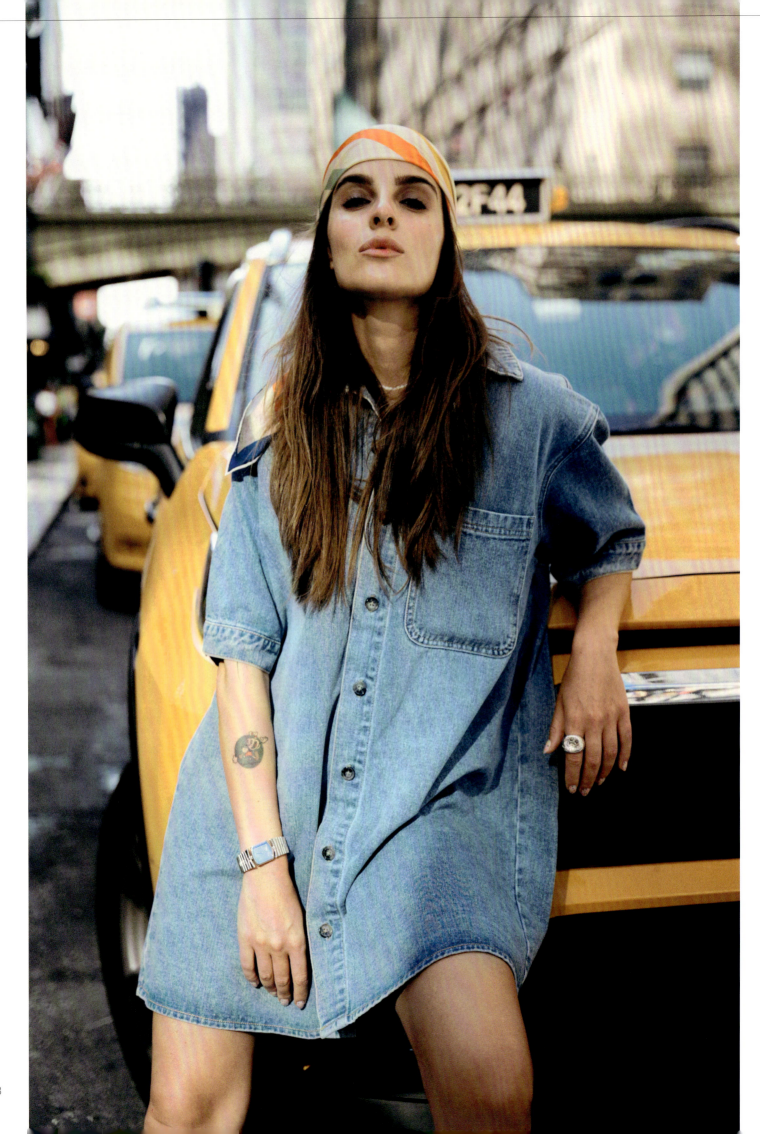

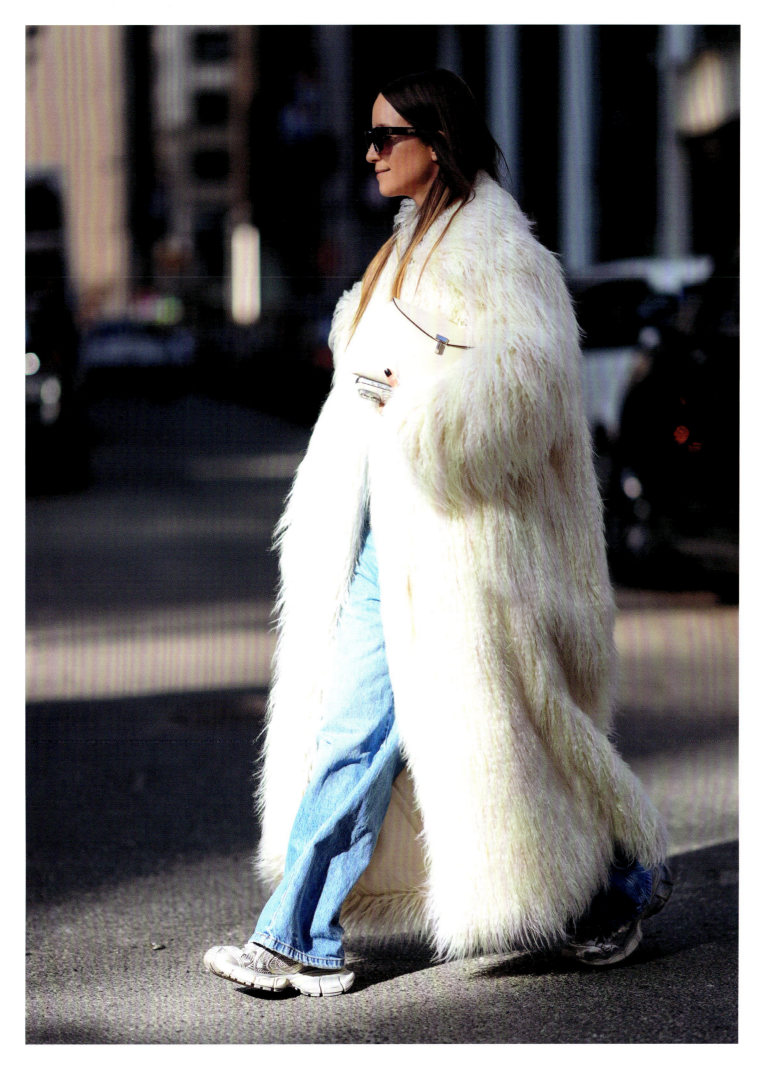

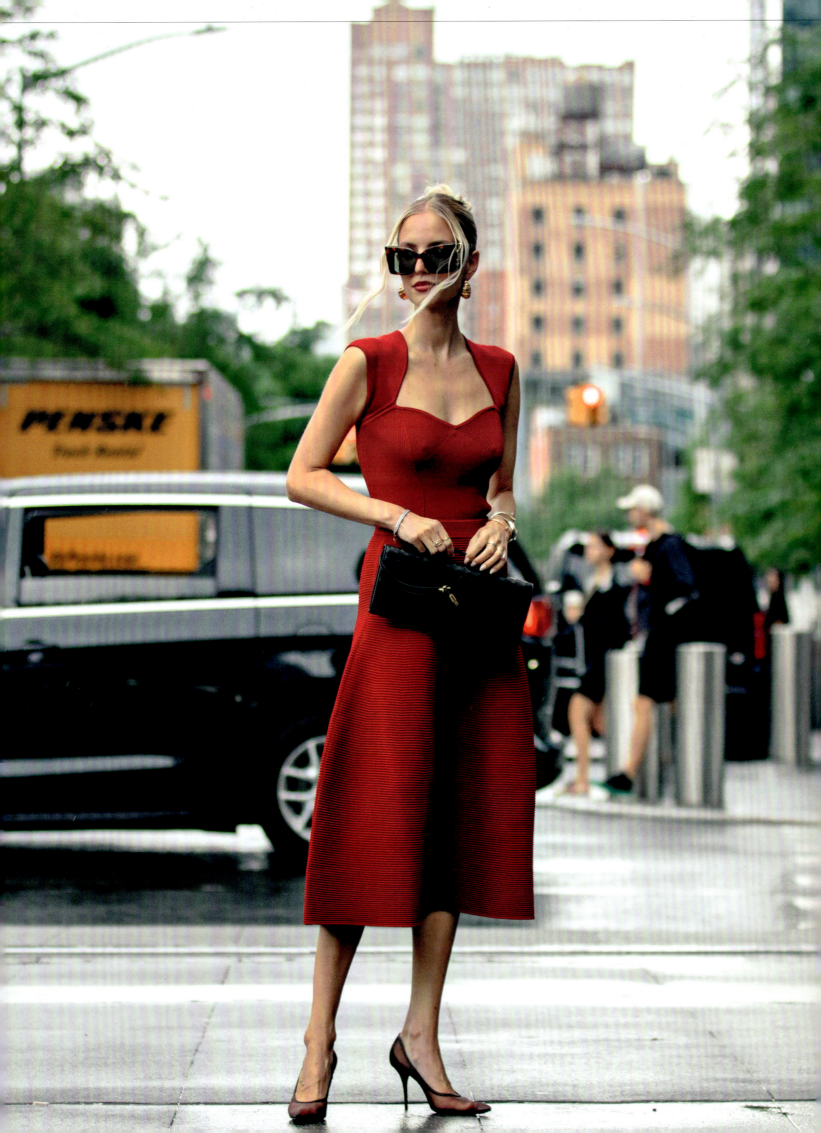

"New York City is home to some of the most stylish women in America."

ALIA AHMED-YAHIA
FASHION JOURNALIST AND CELEBRITY STYLIST

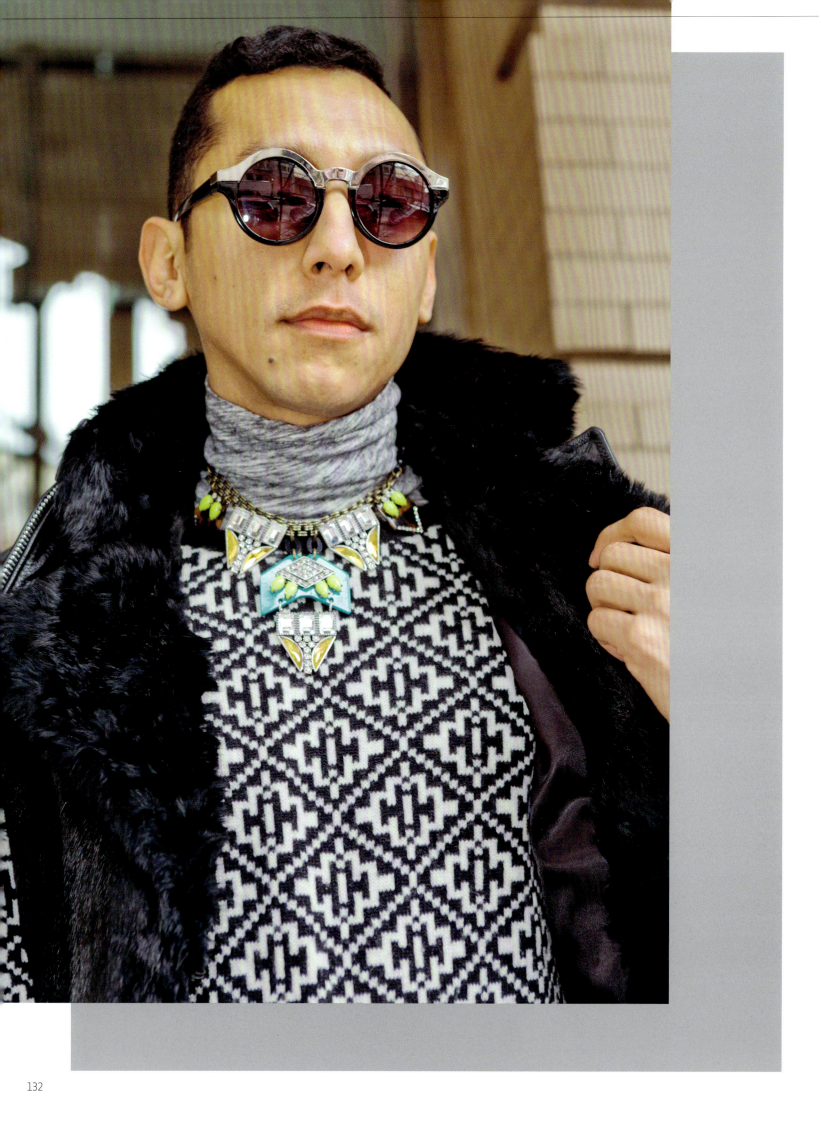

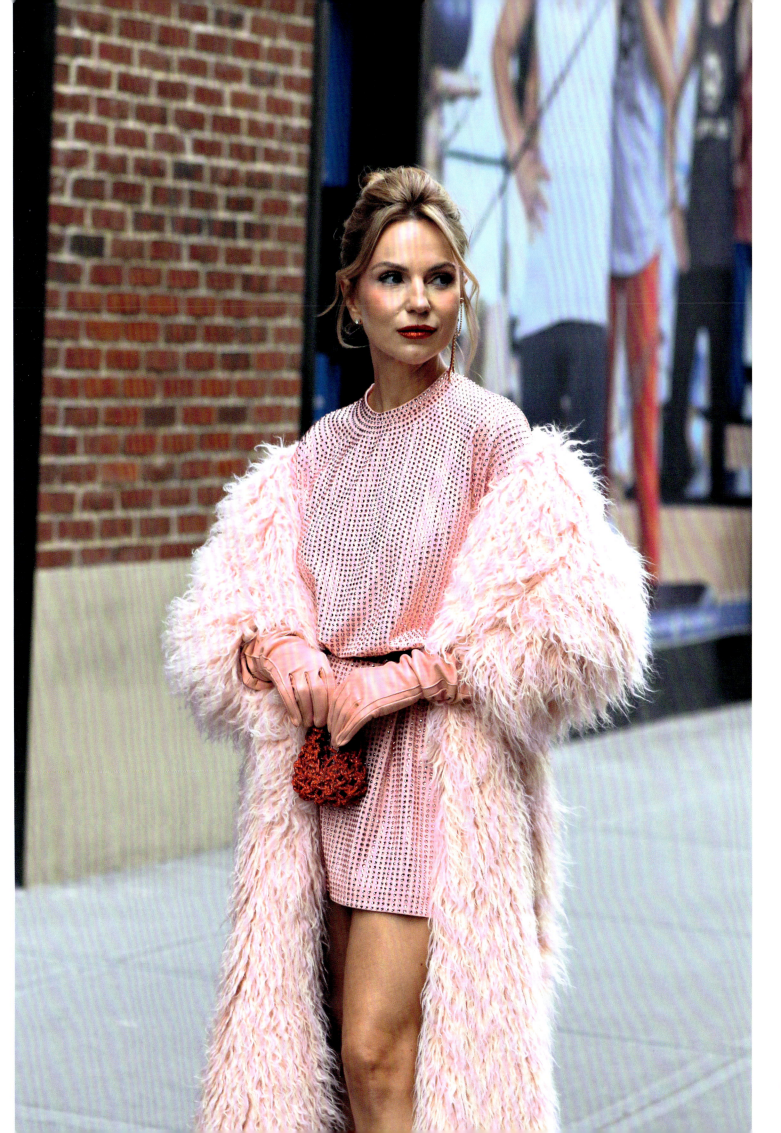

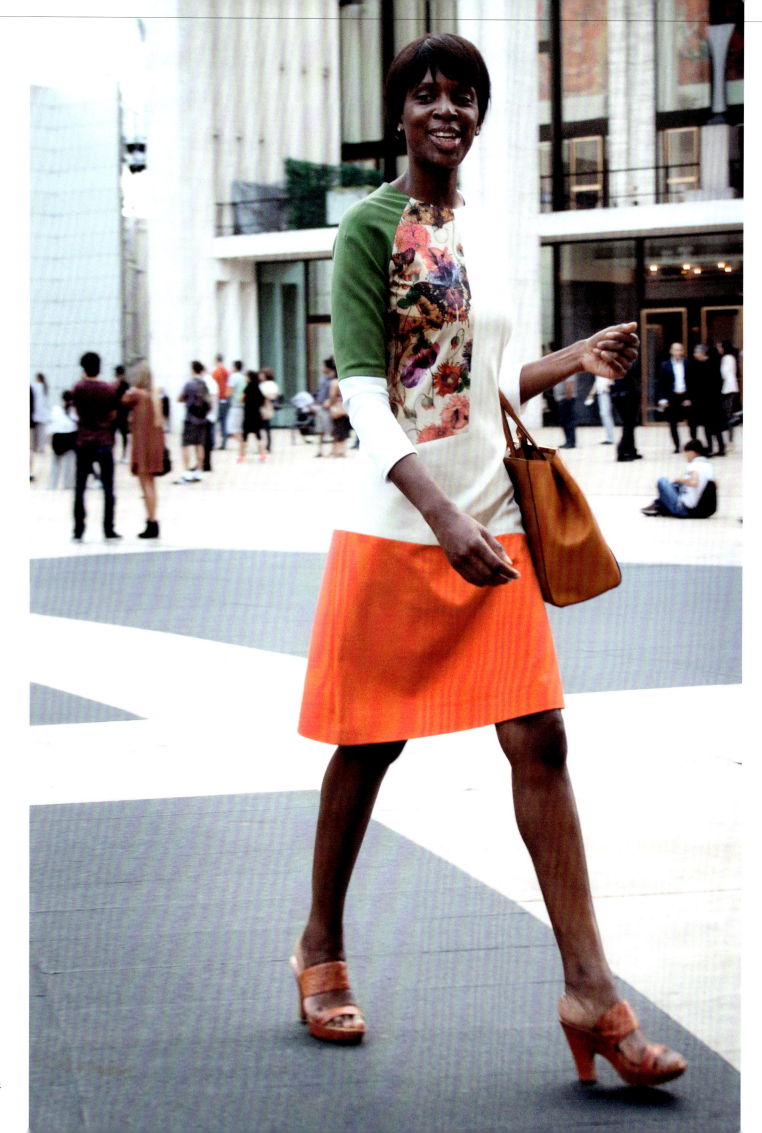

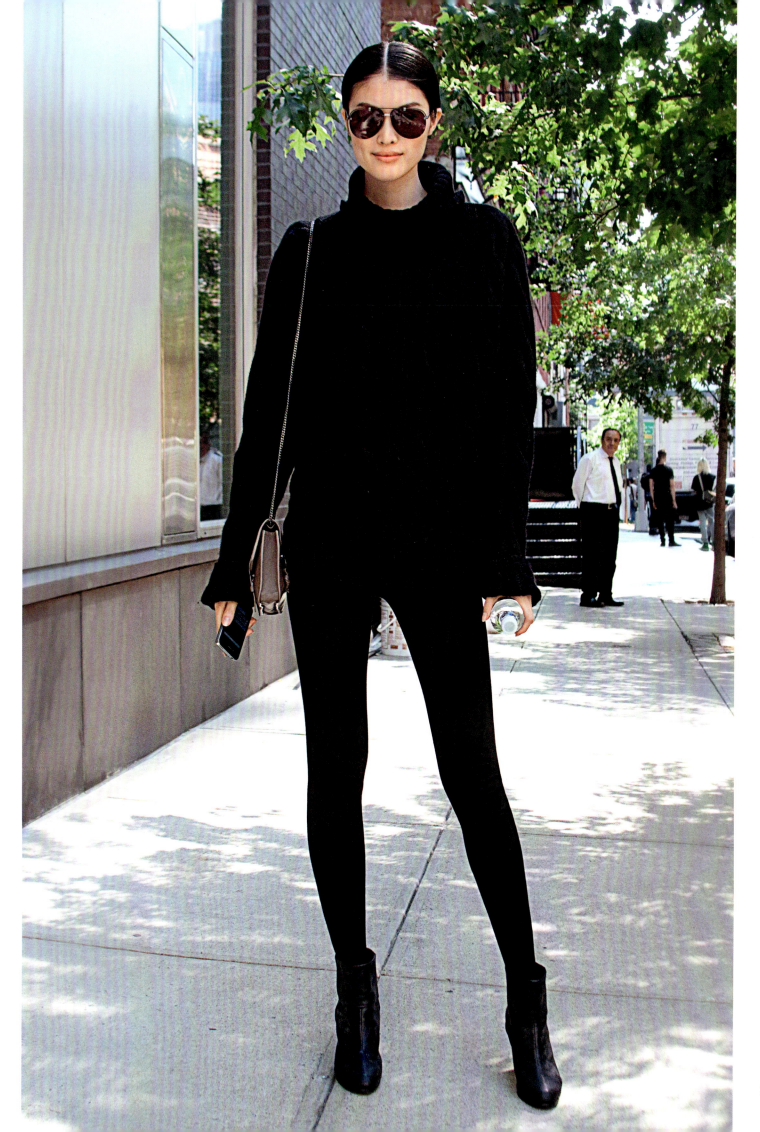

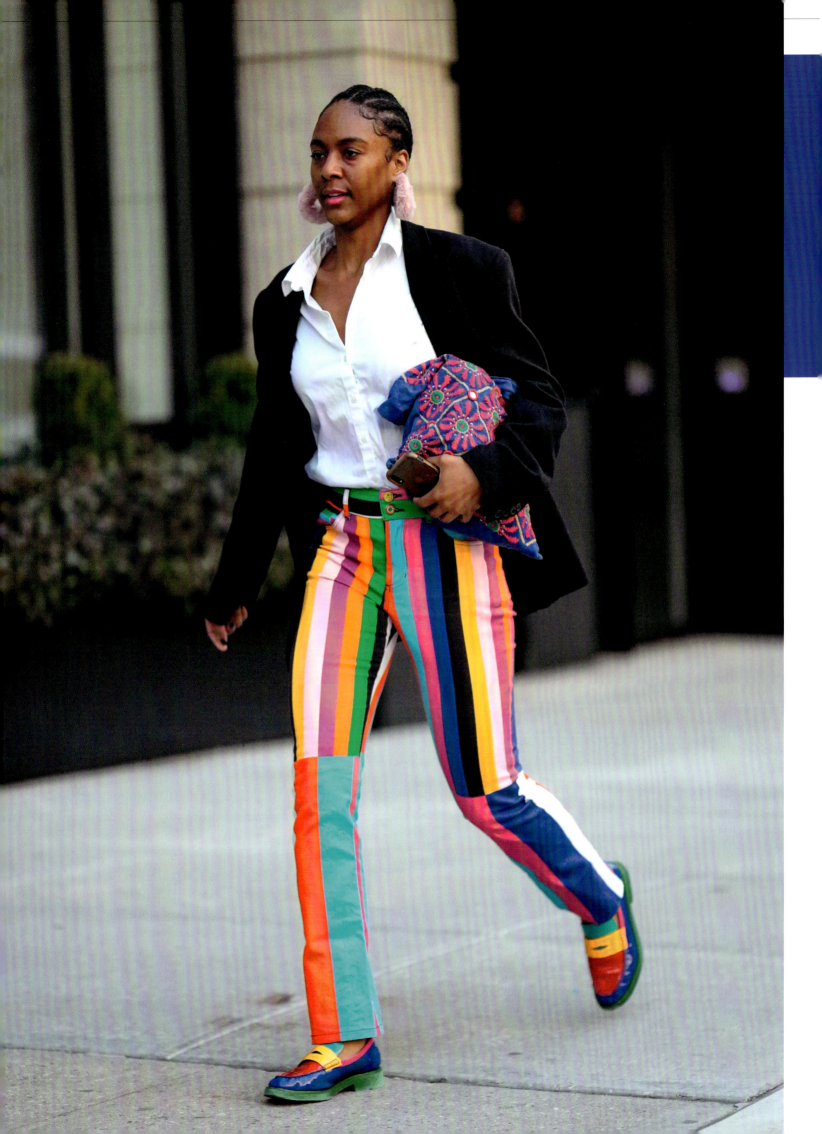

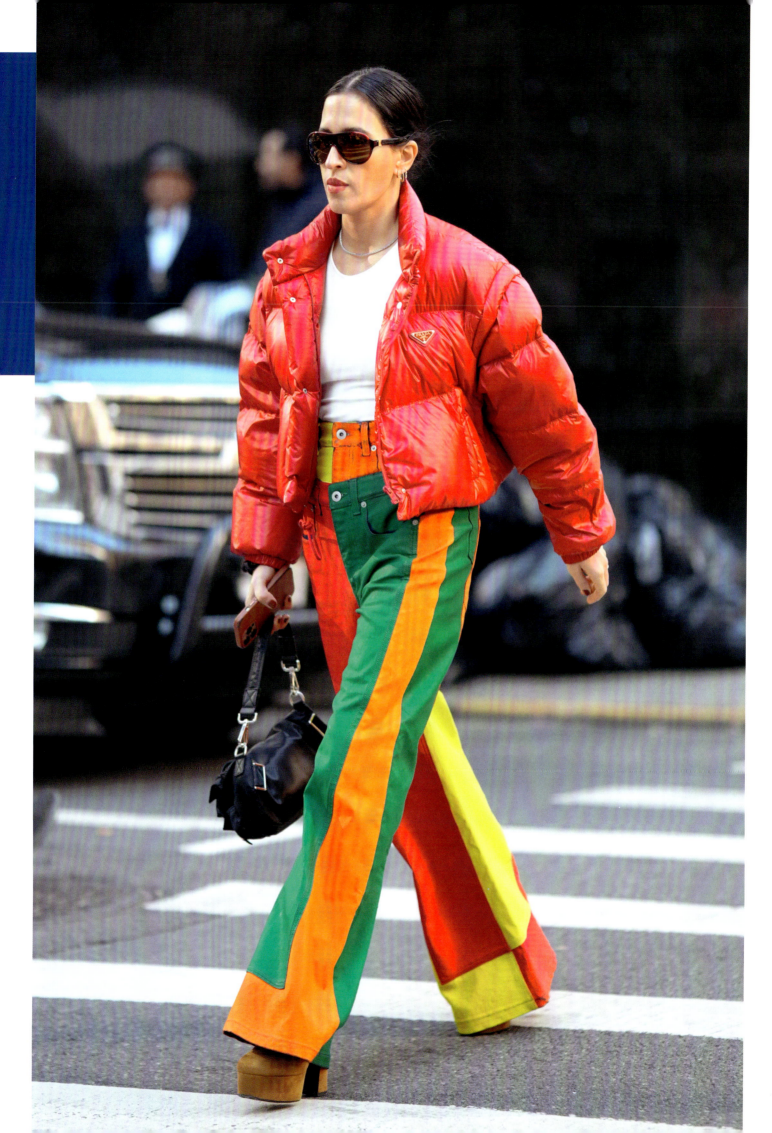

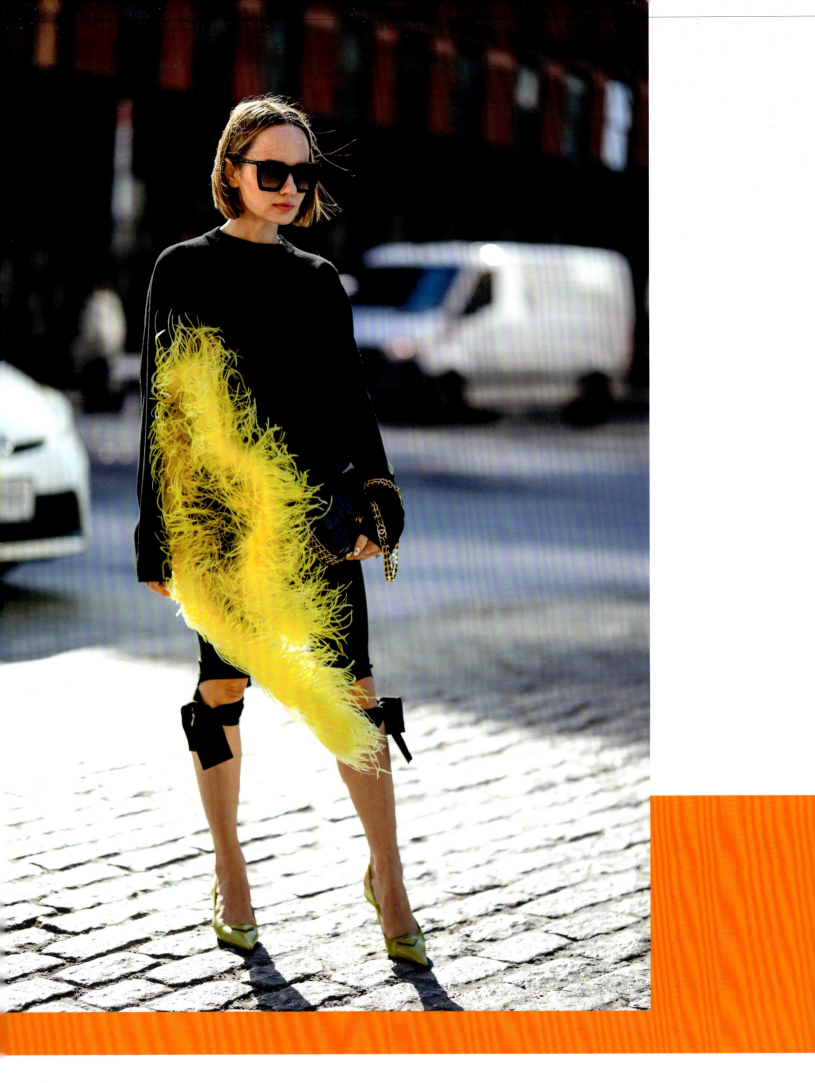

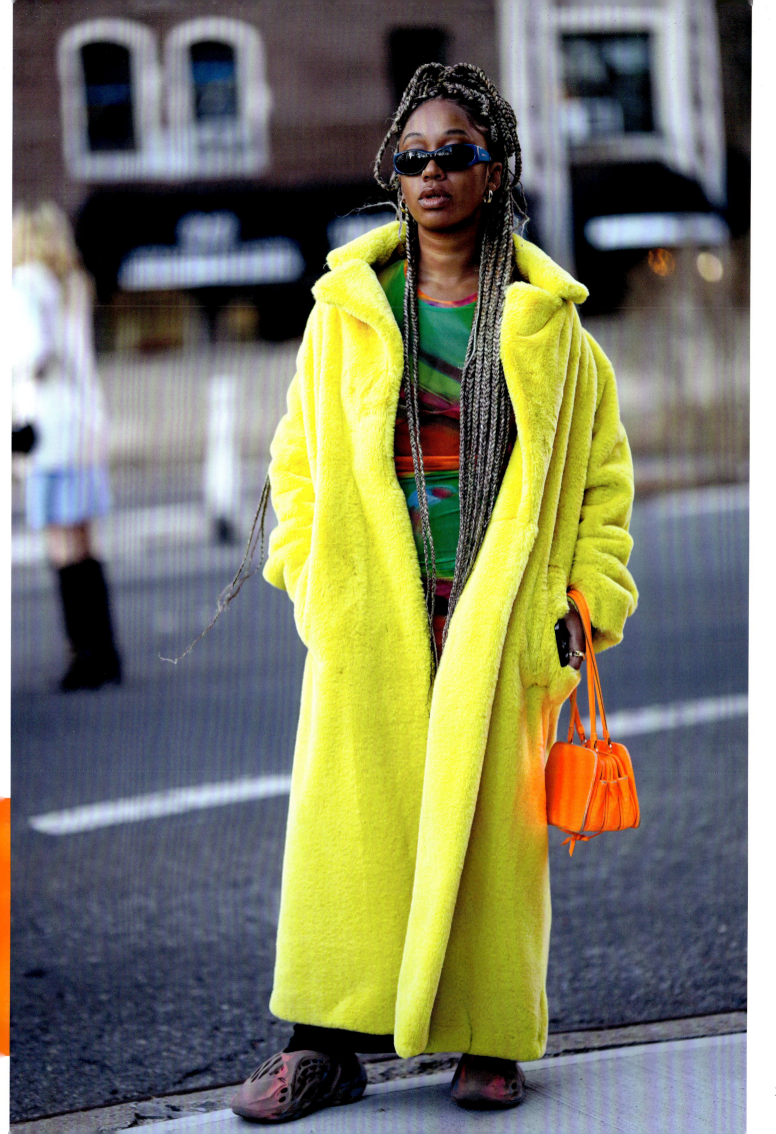

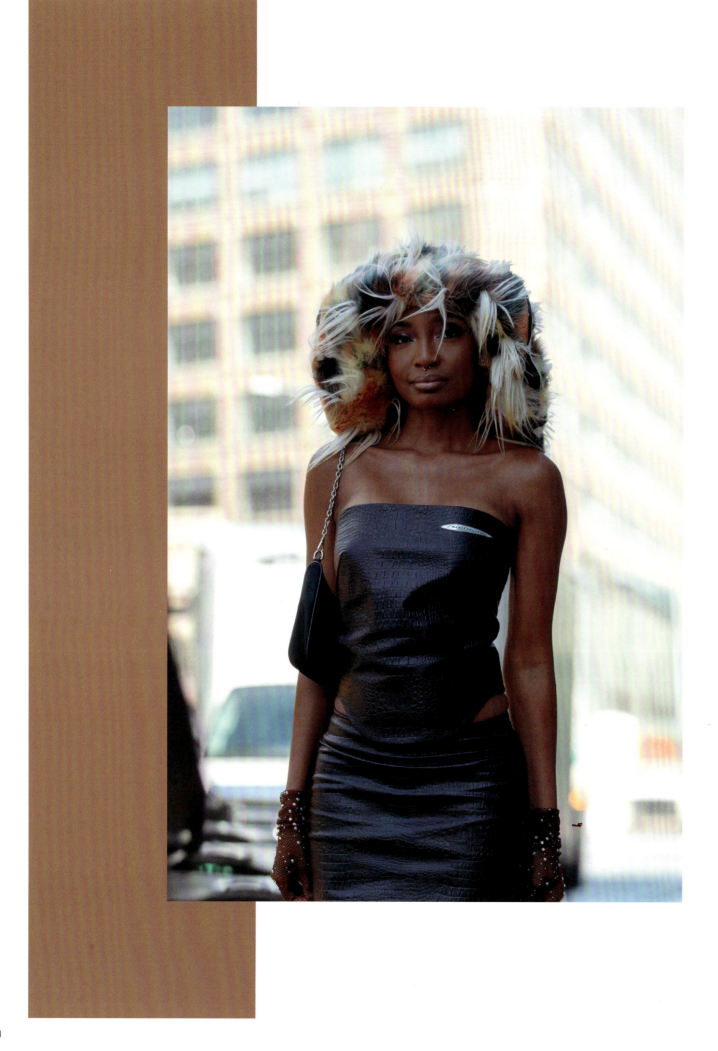

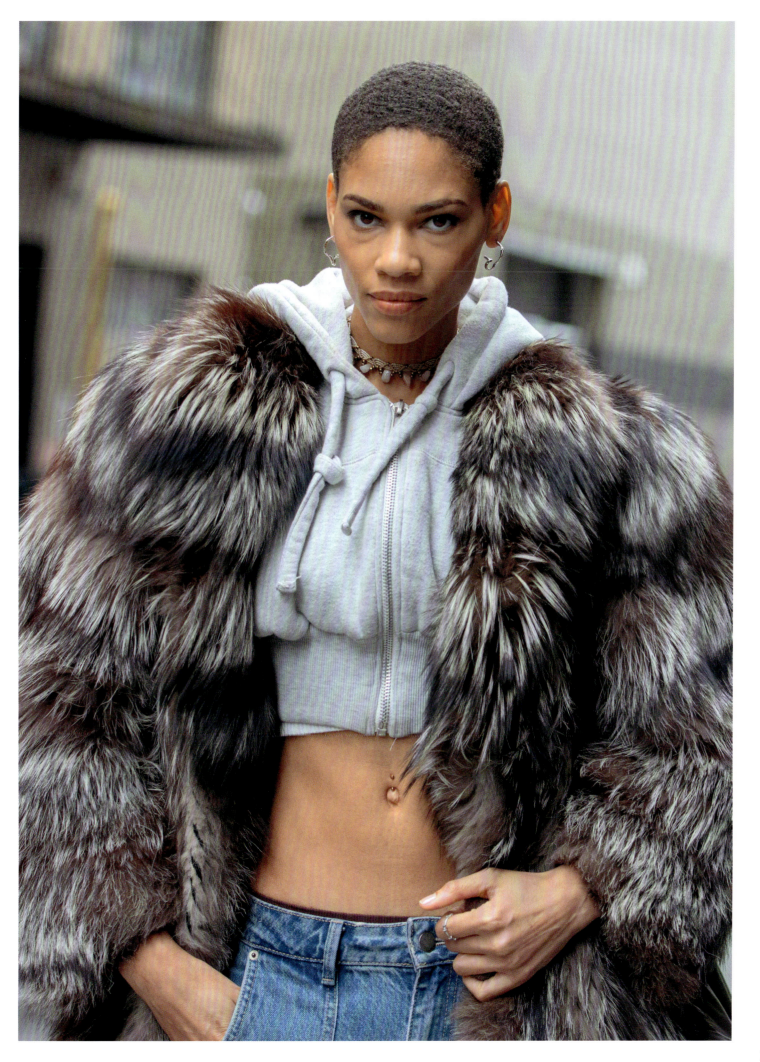

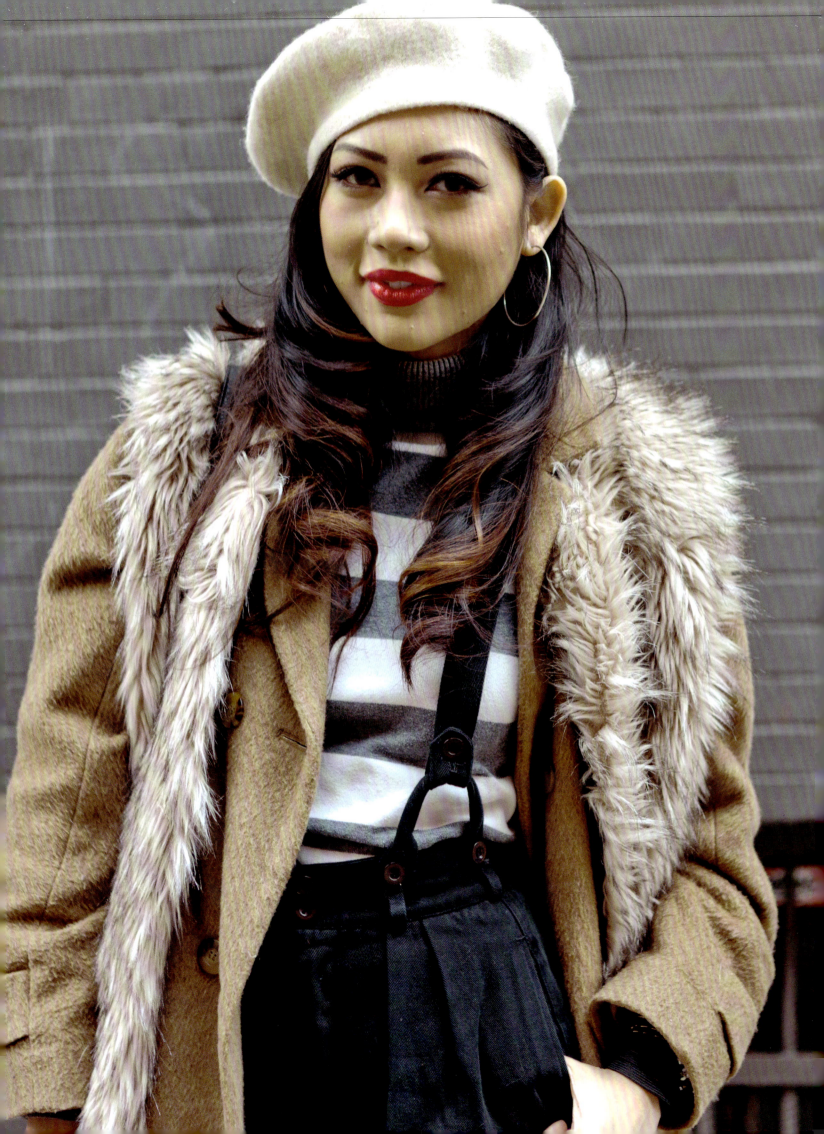

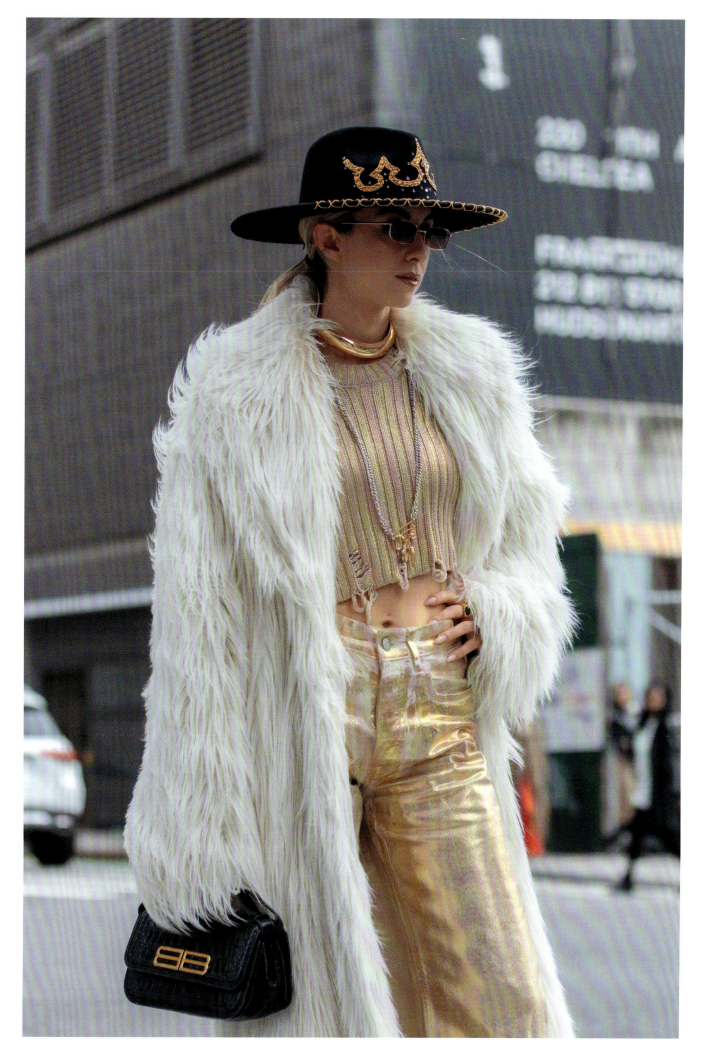

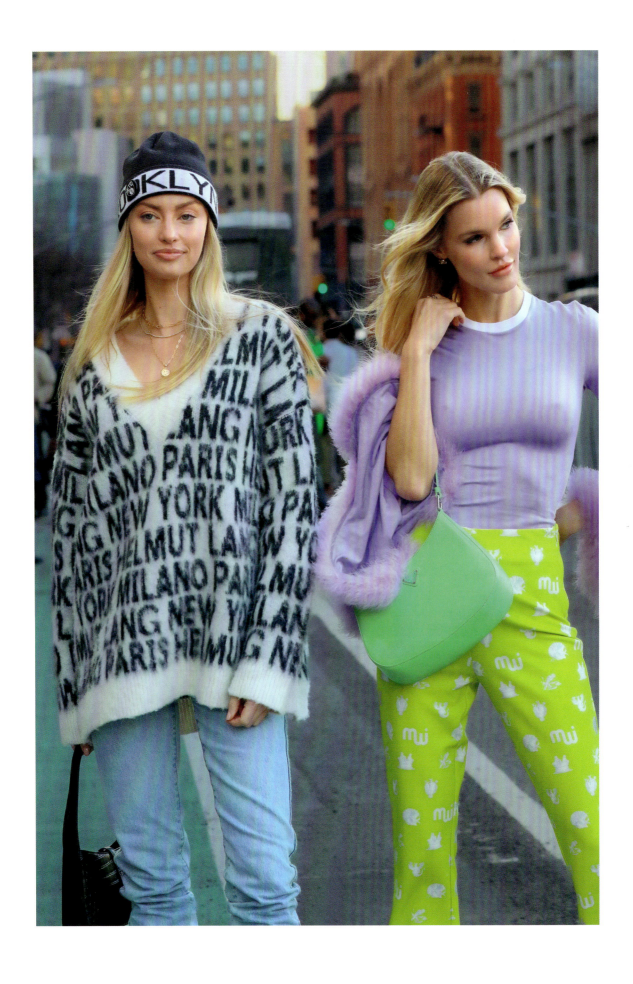

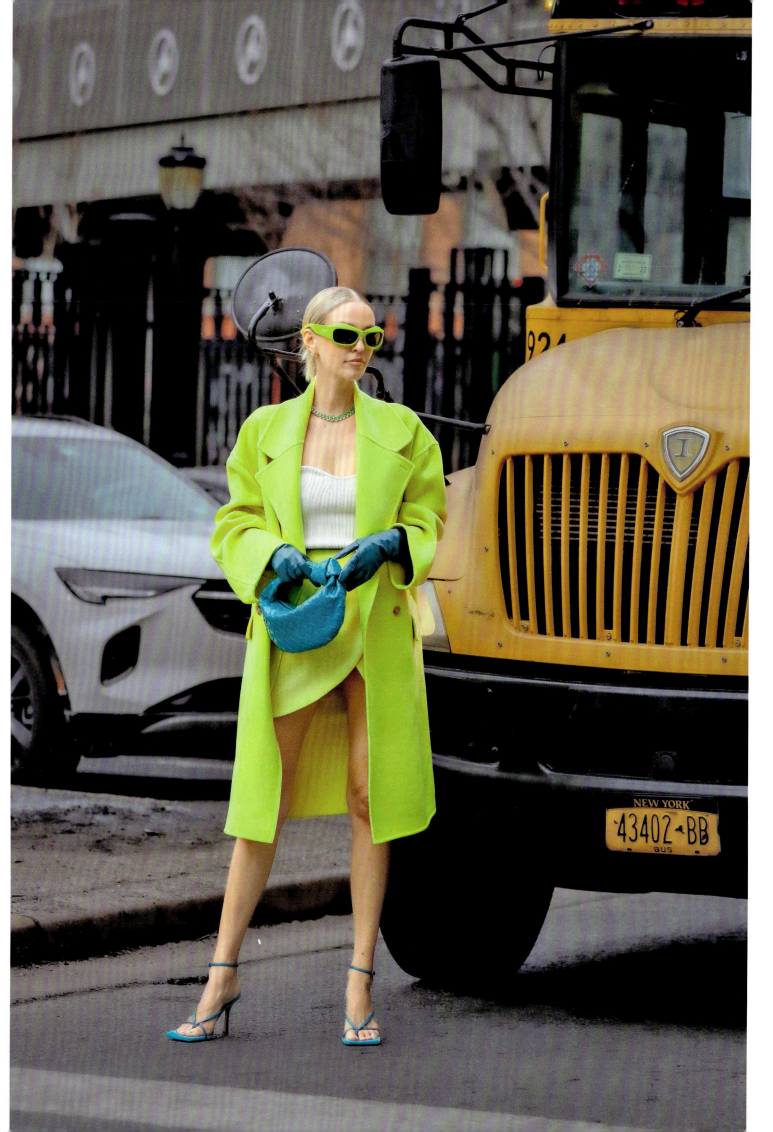

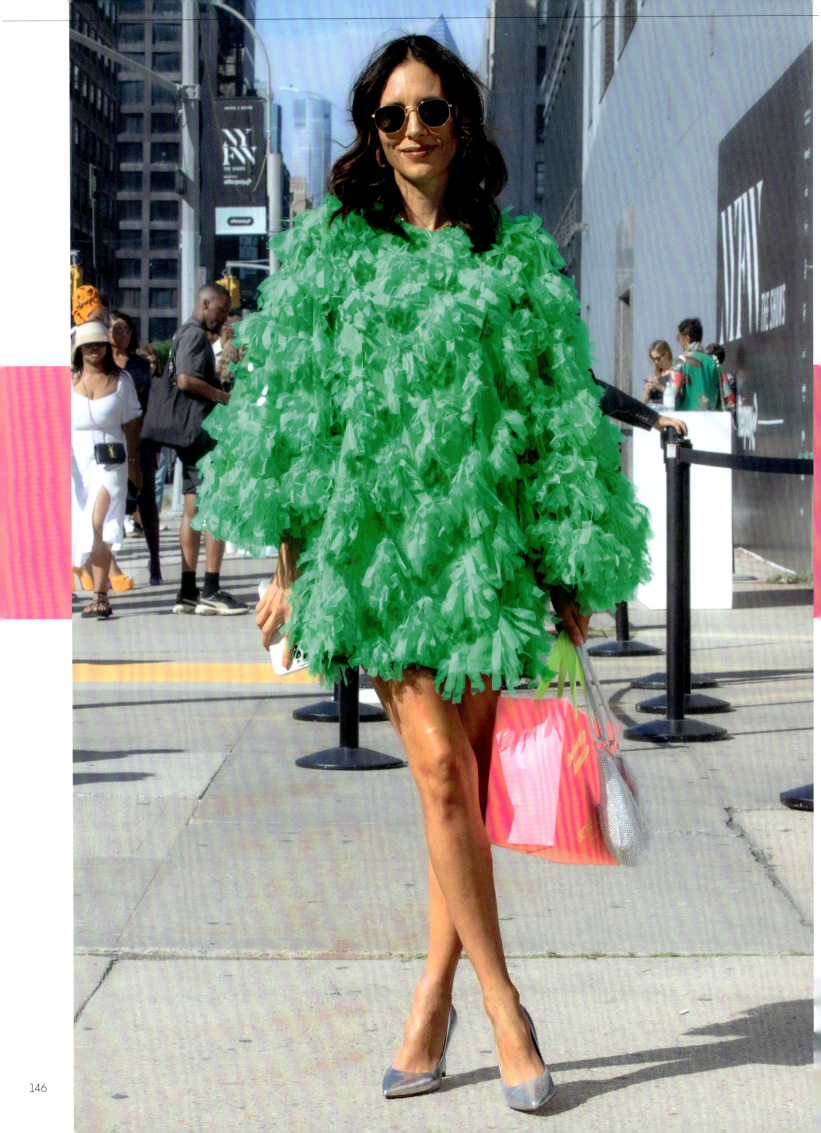

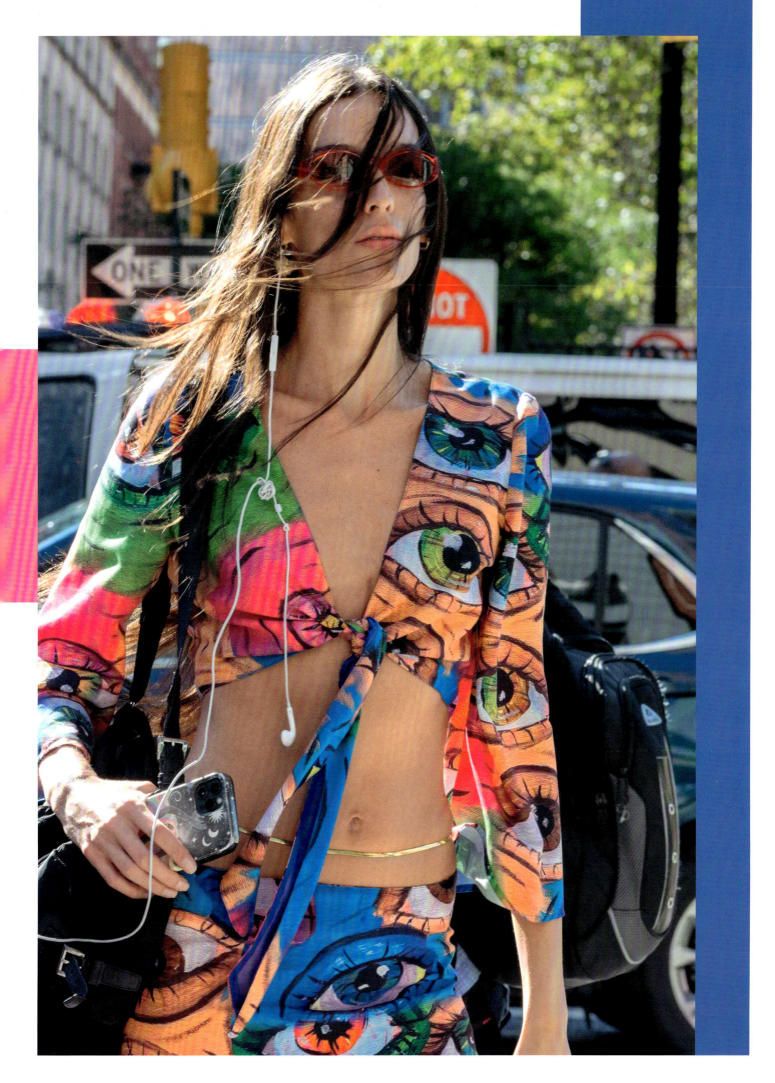

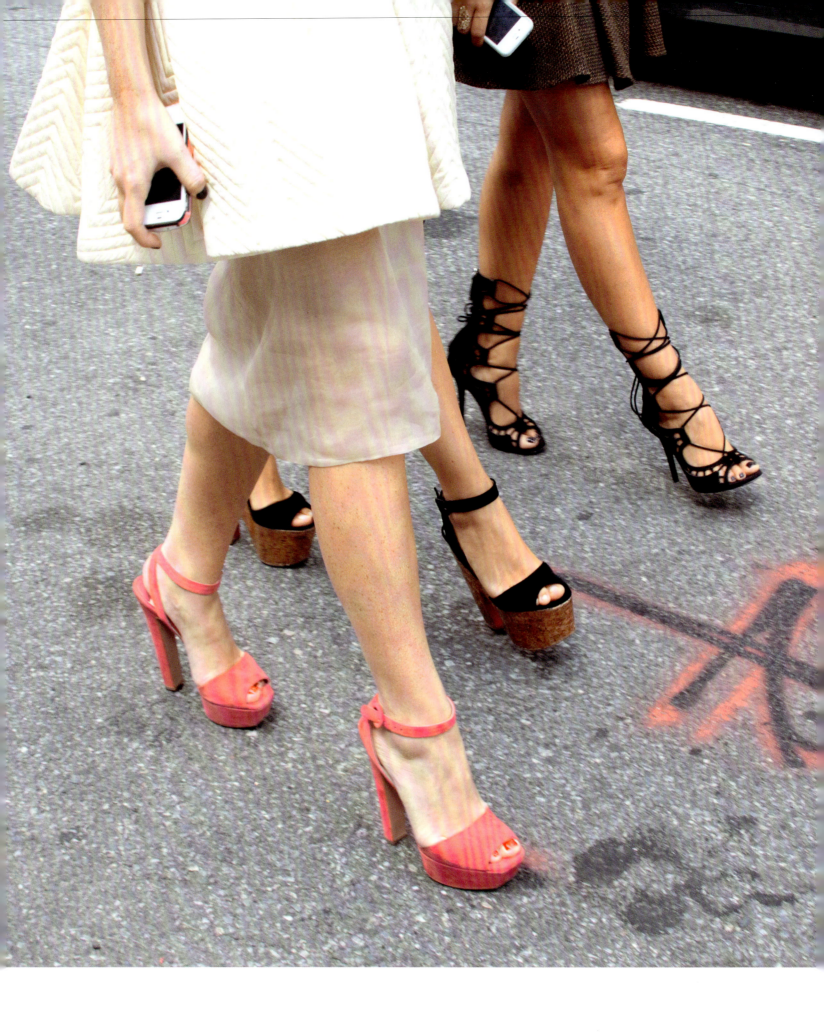

"How can you live the high life
if you do not wear the high heels?"

SONIA RYKIEL

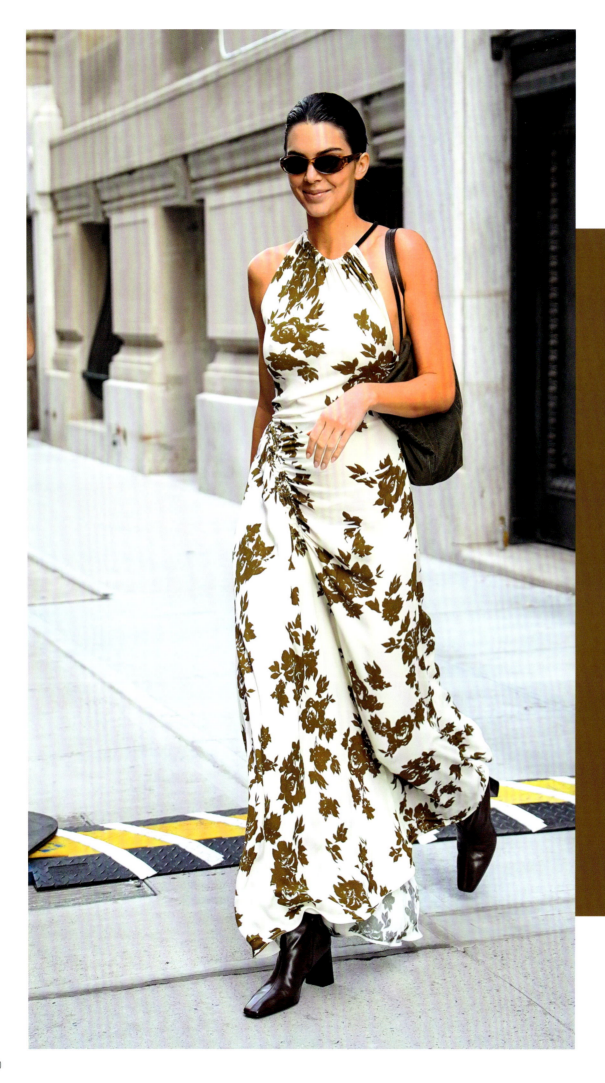

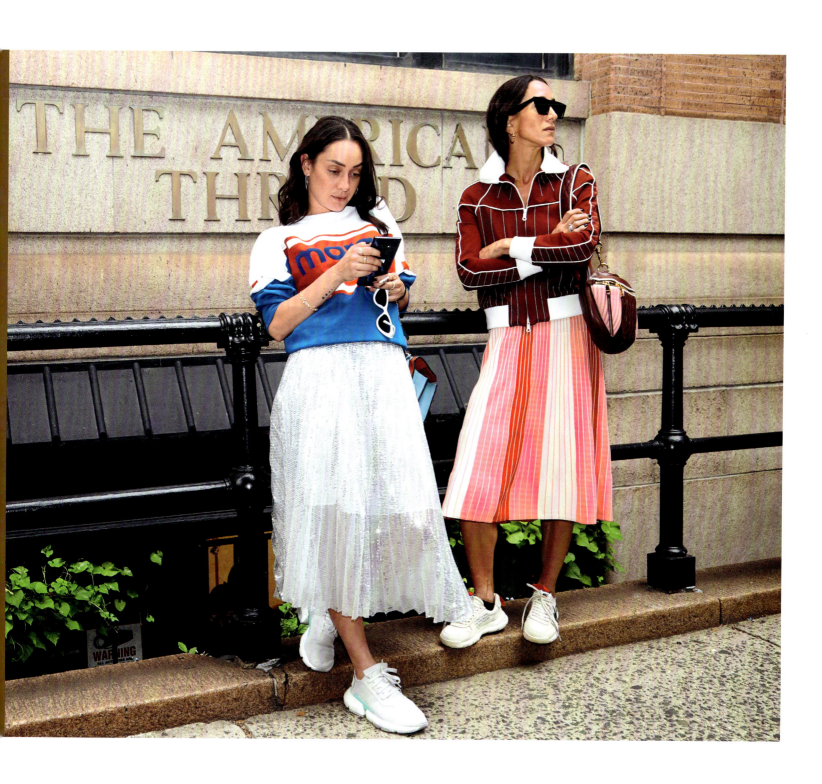

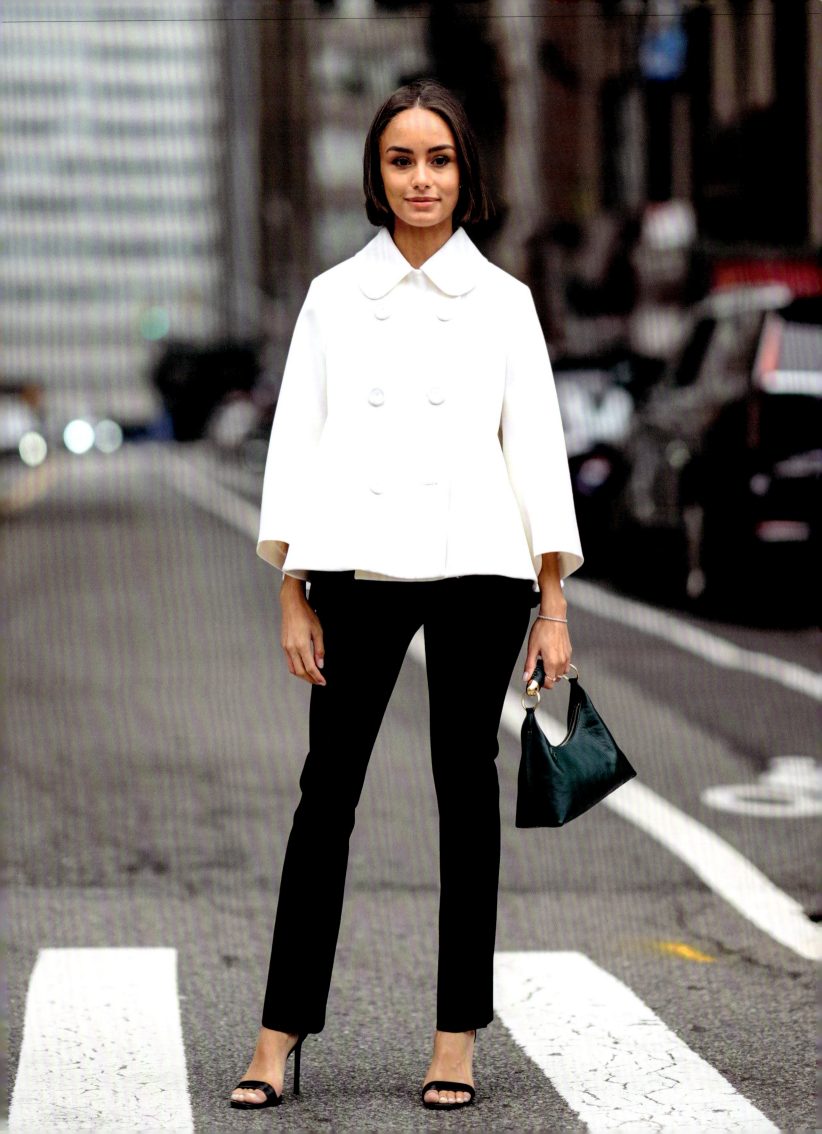

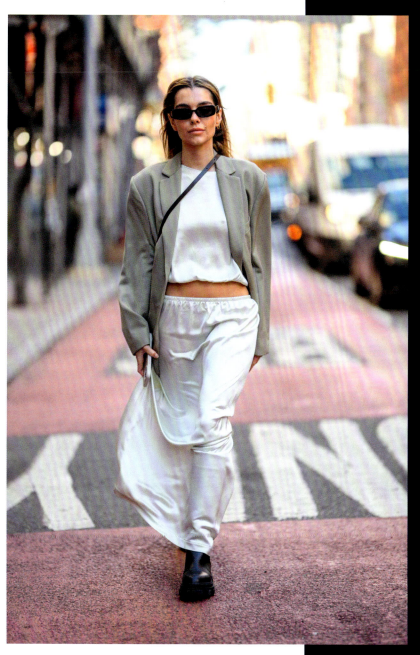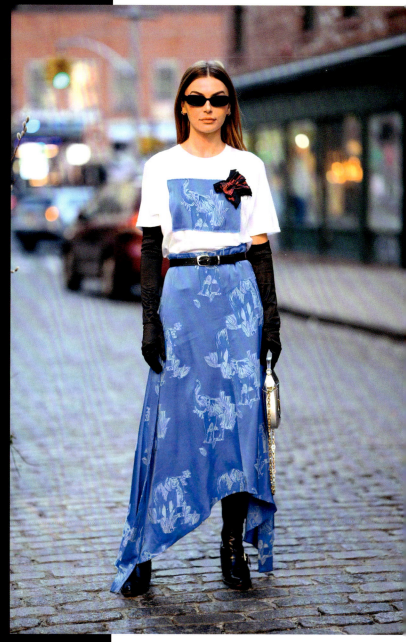

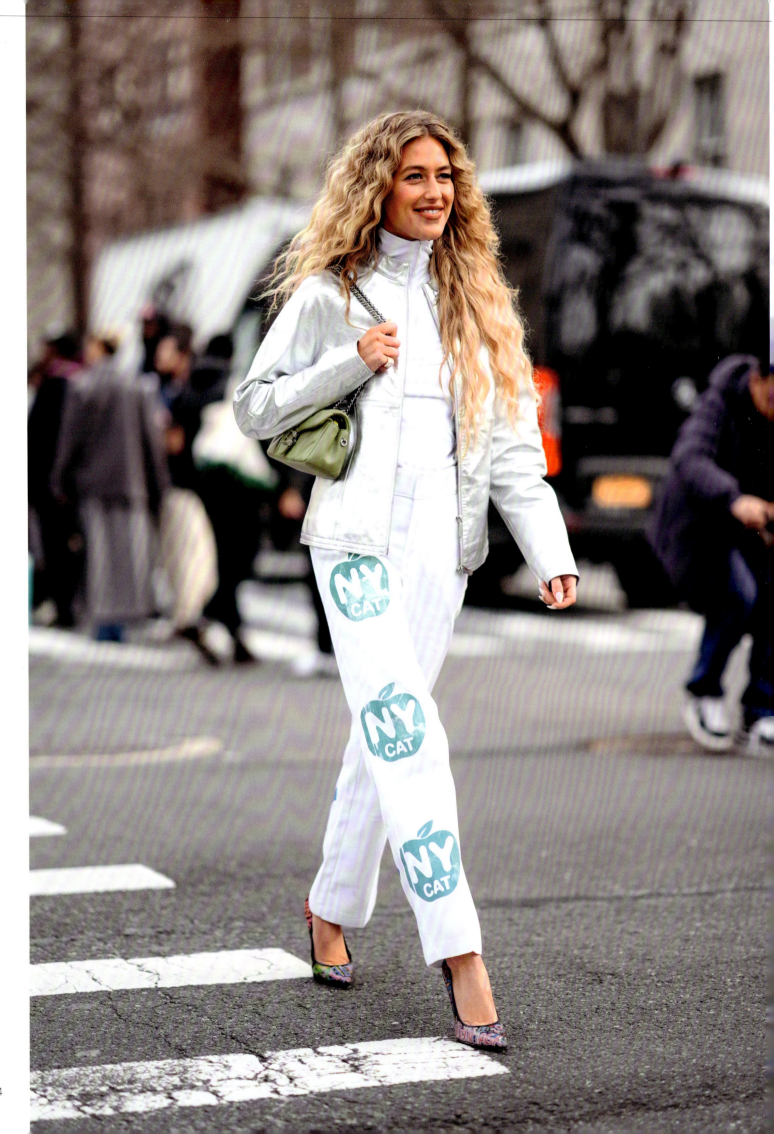

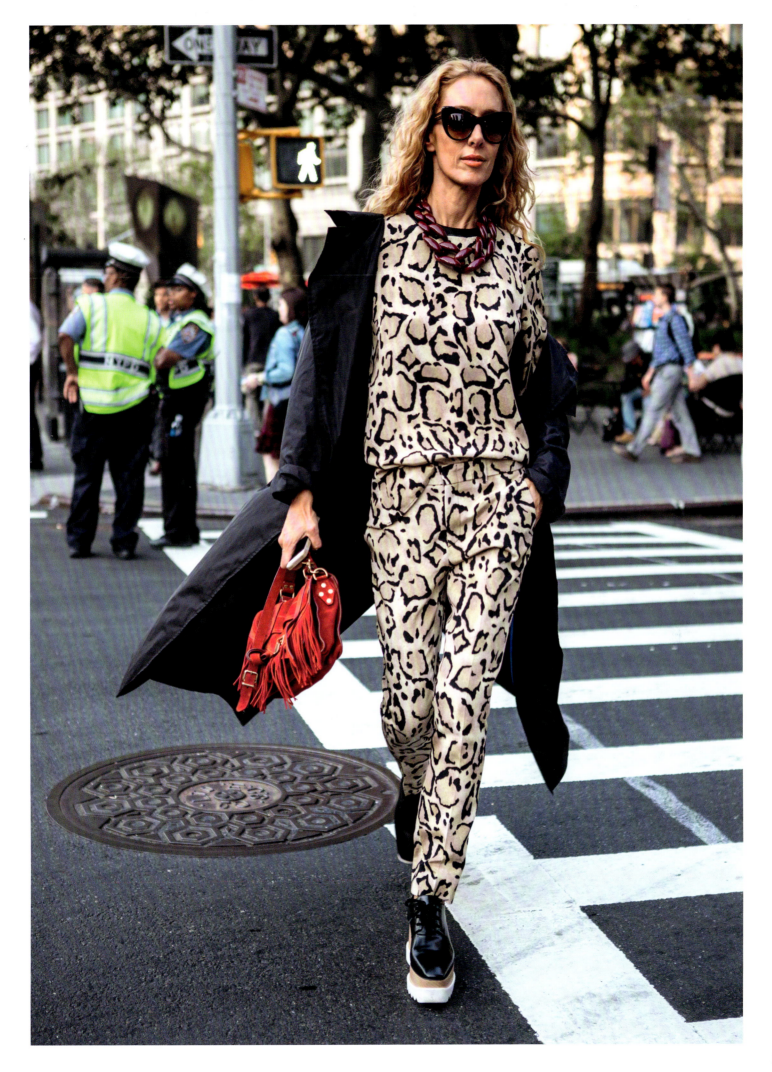

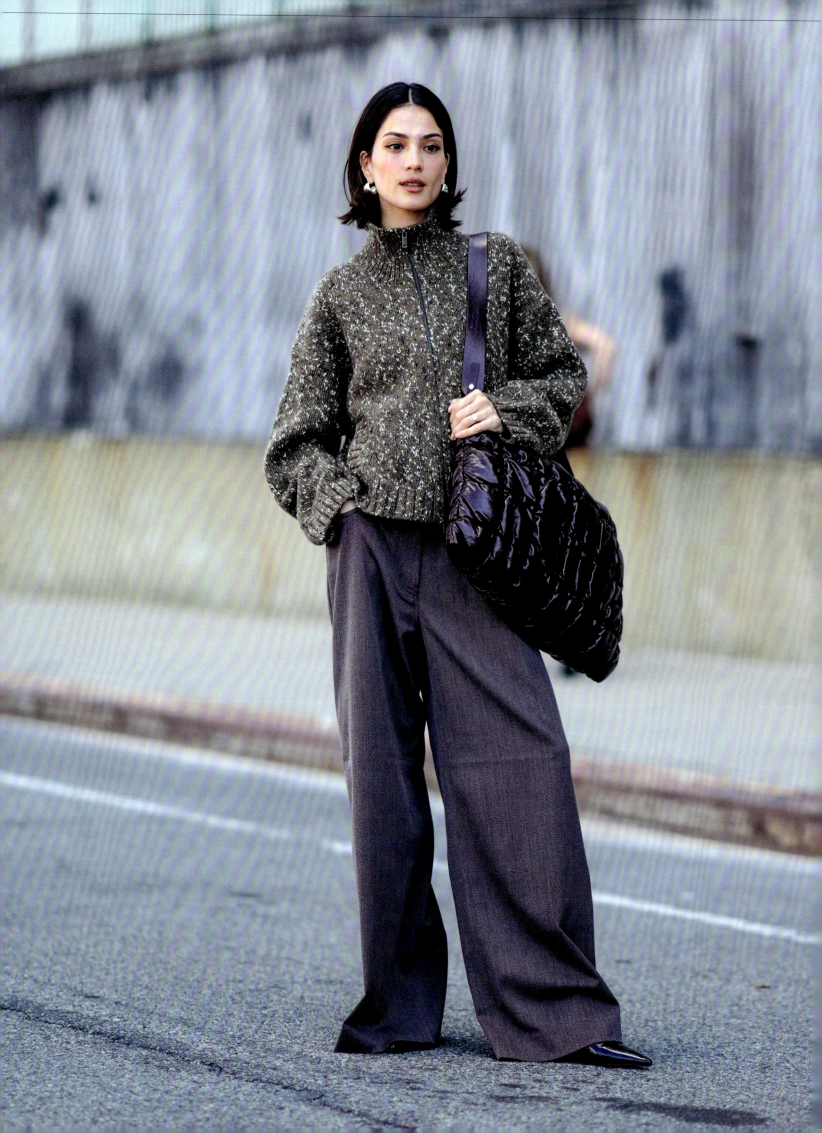

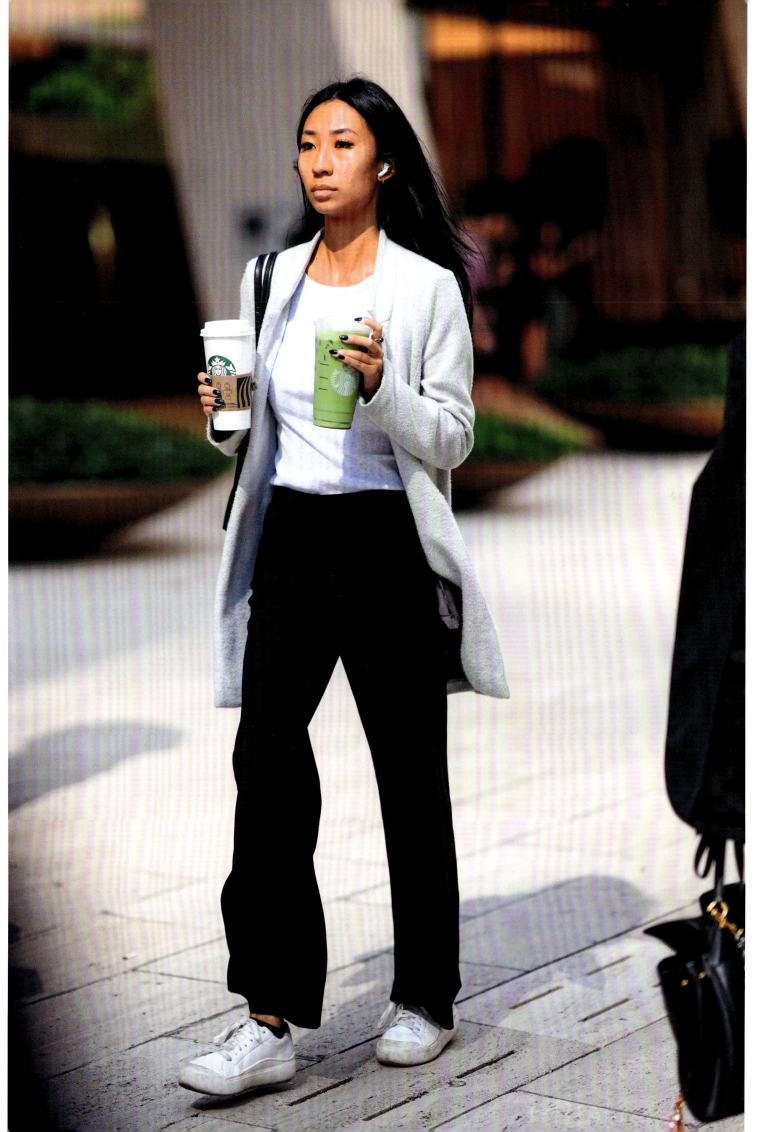

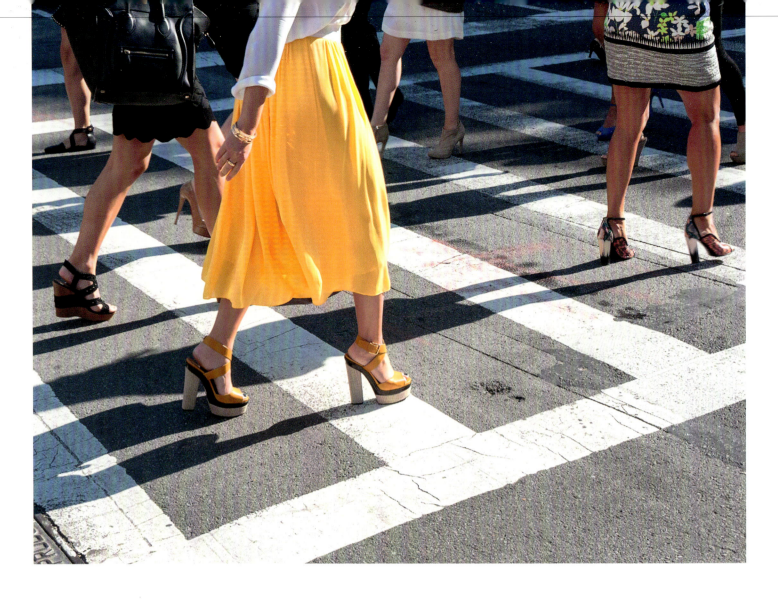

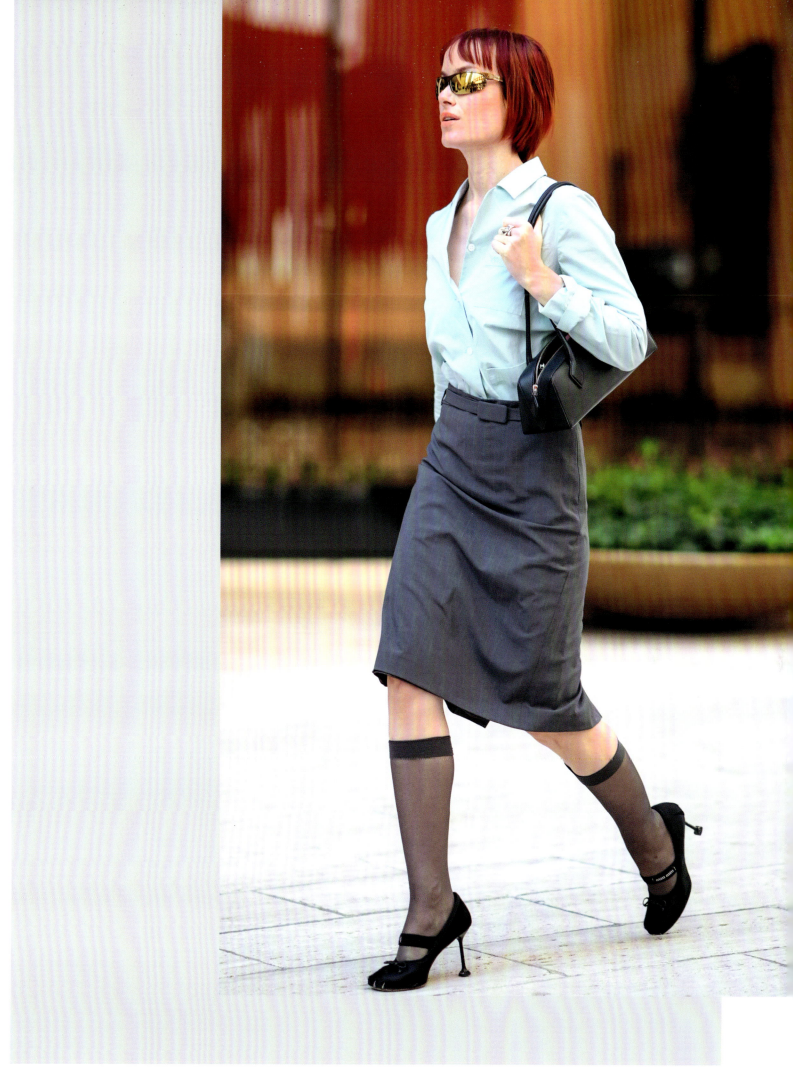

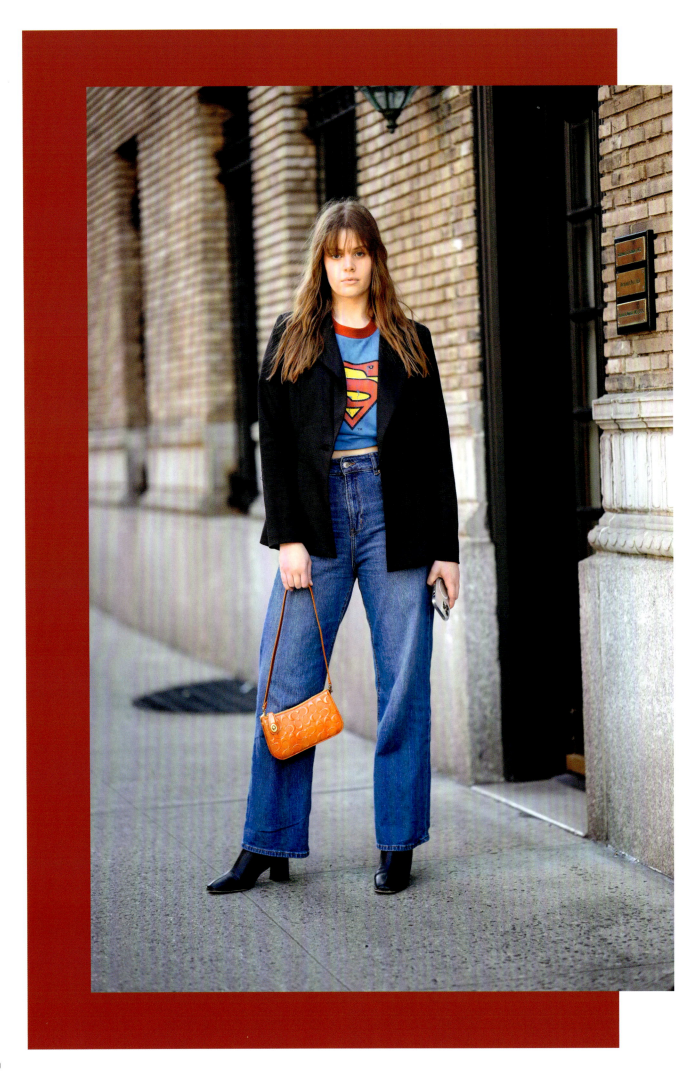

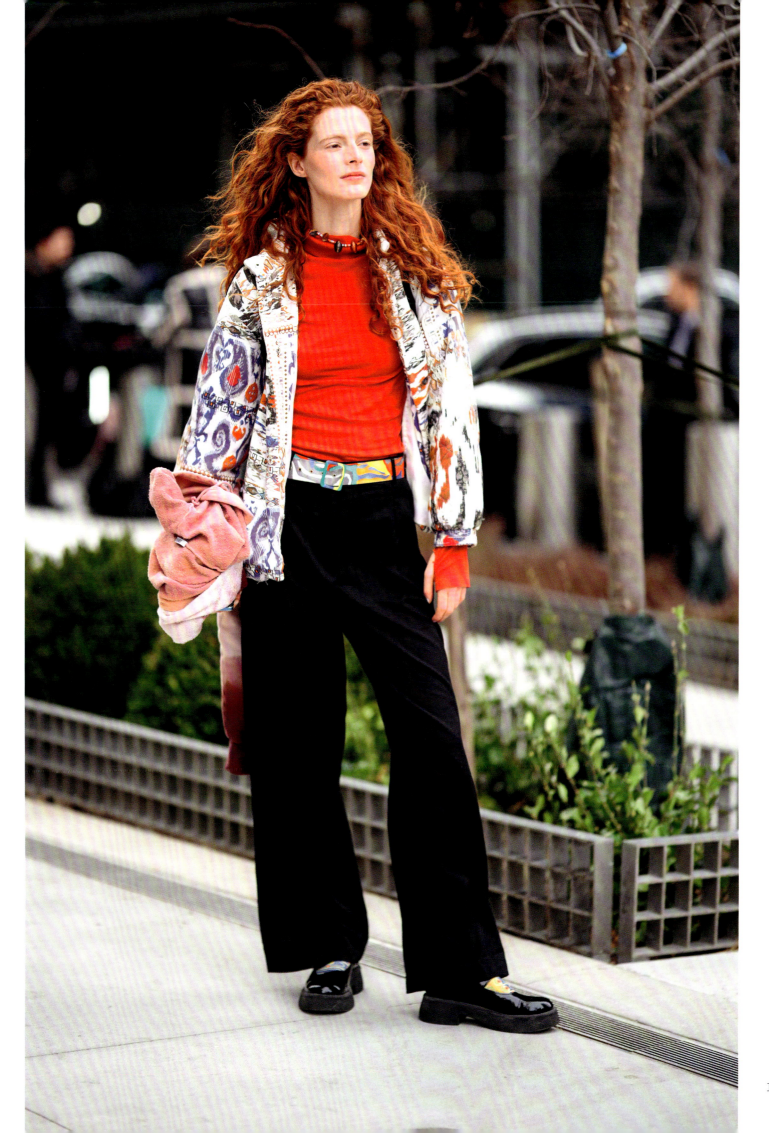

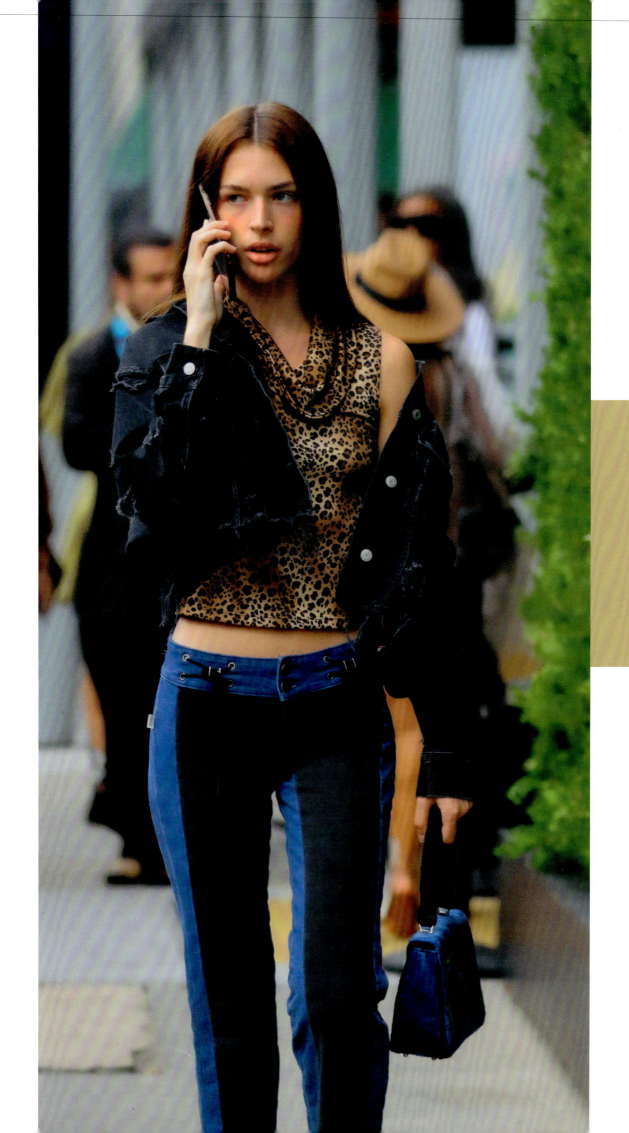

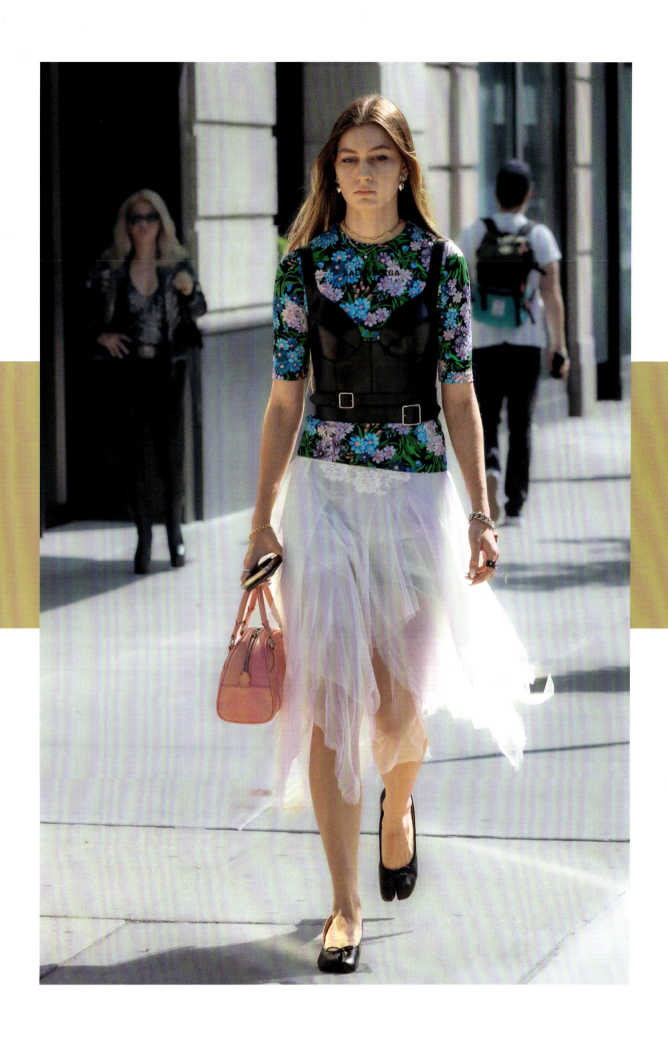

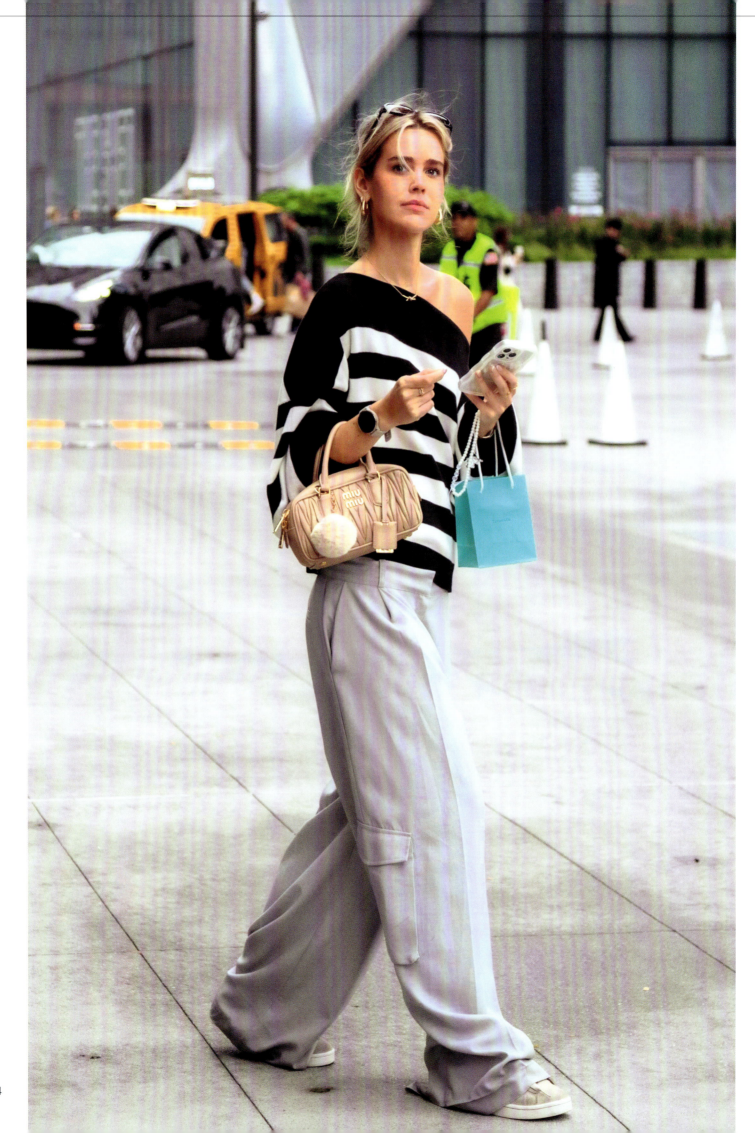

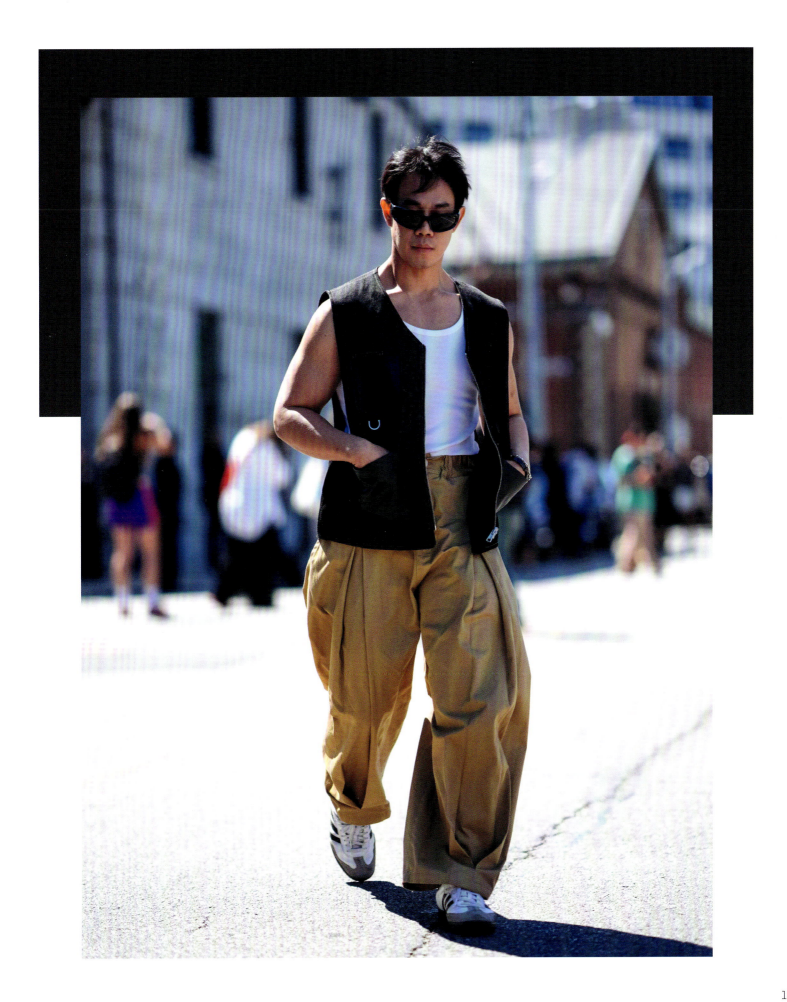

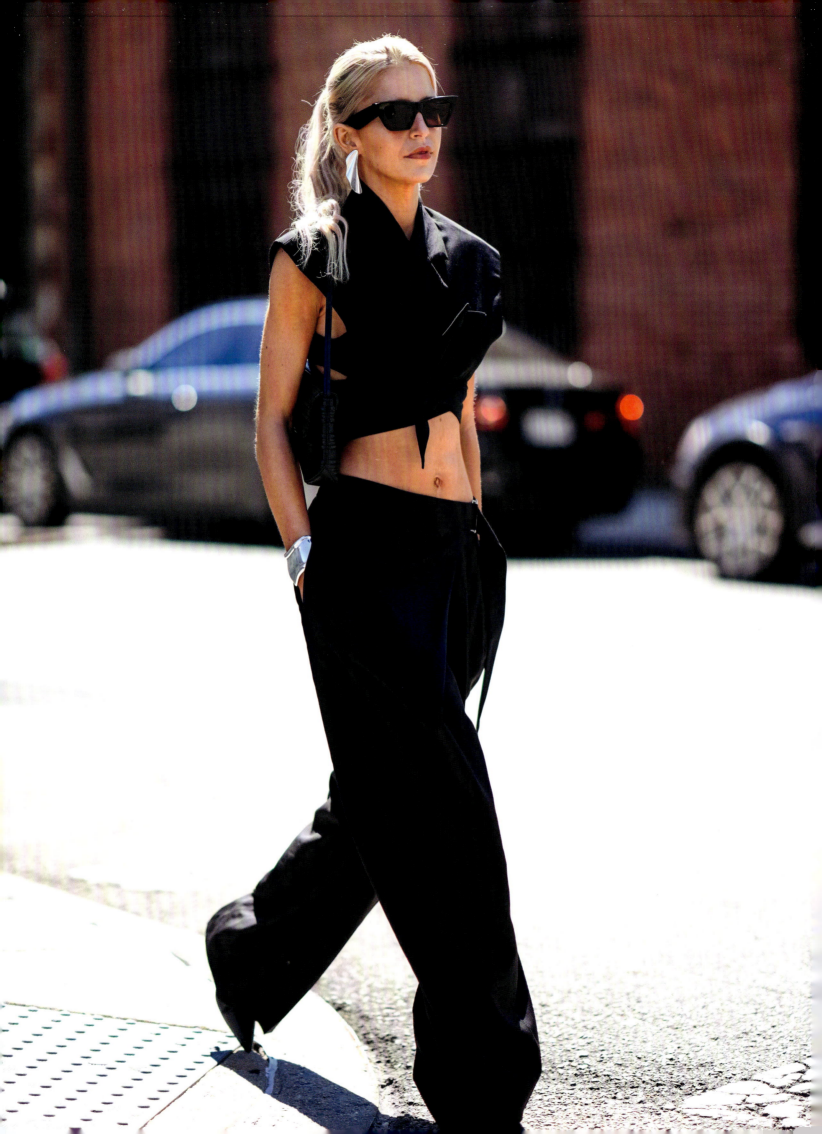

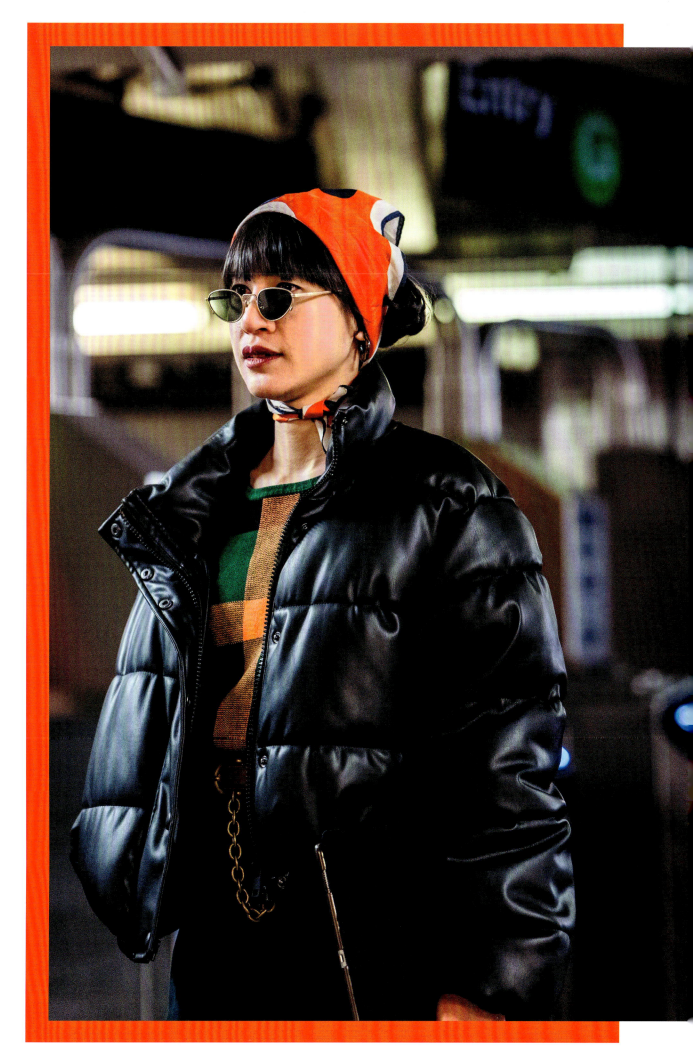

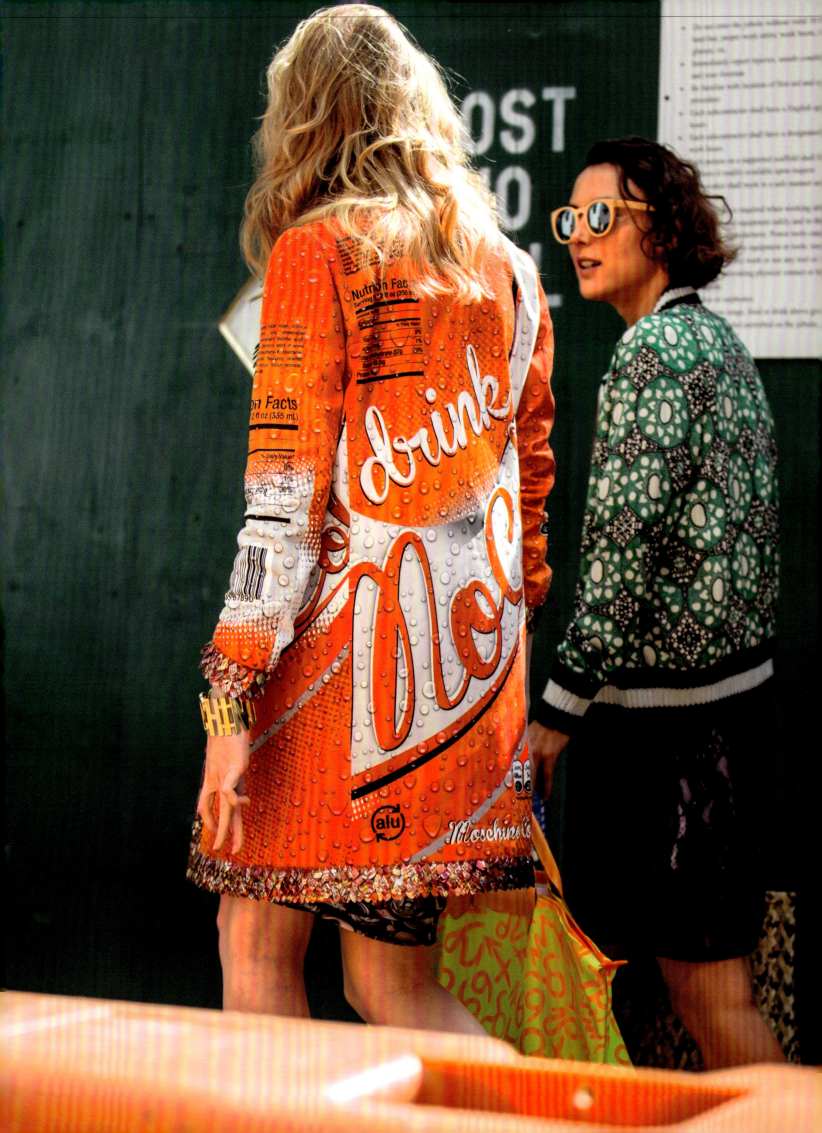

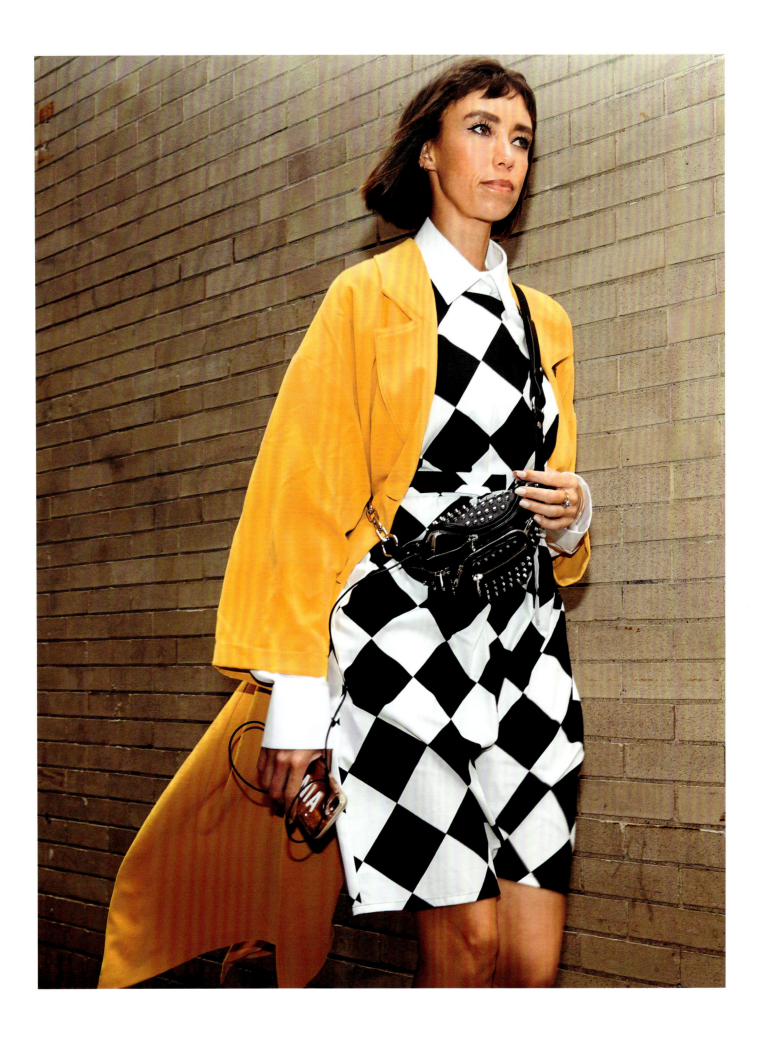

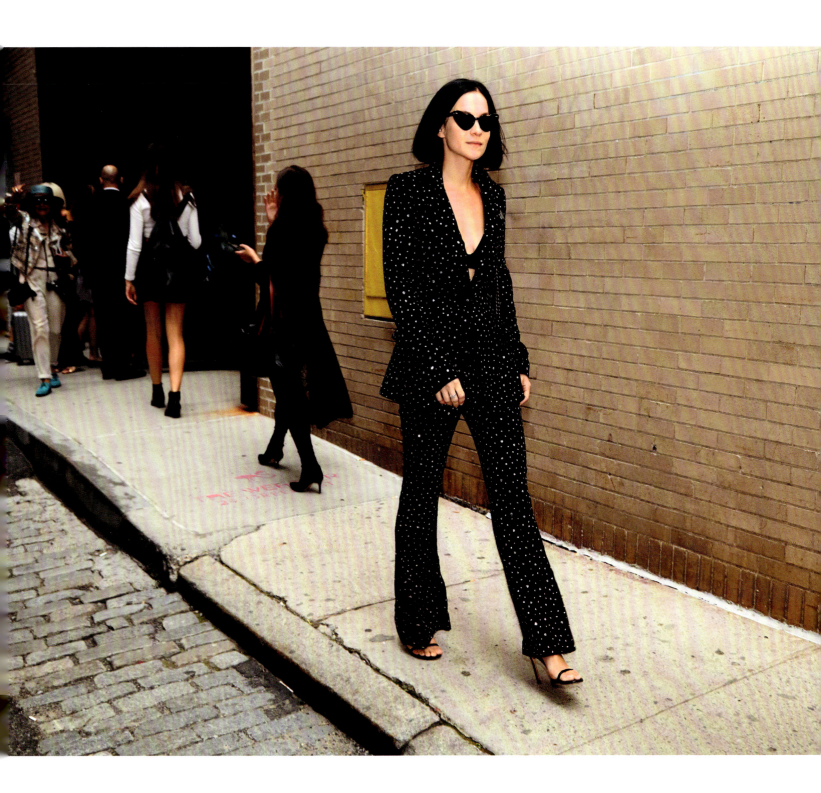

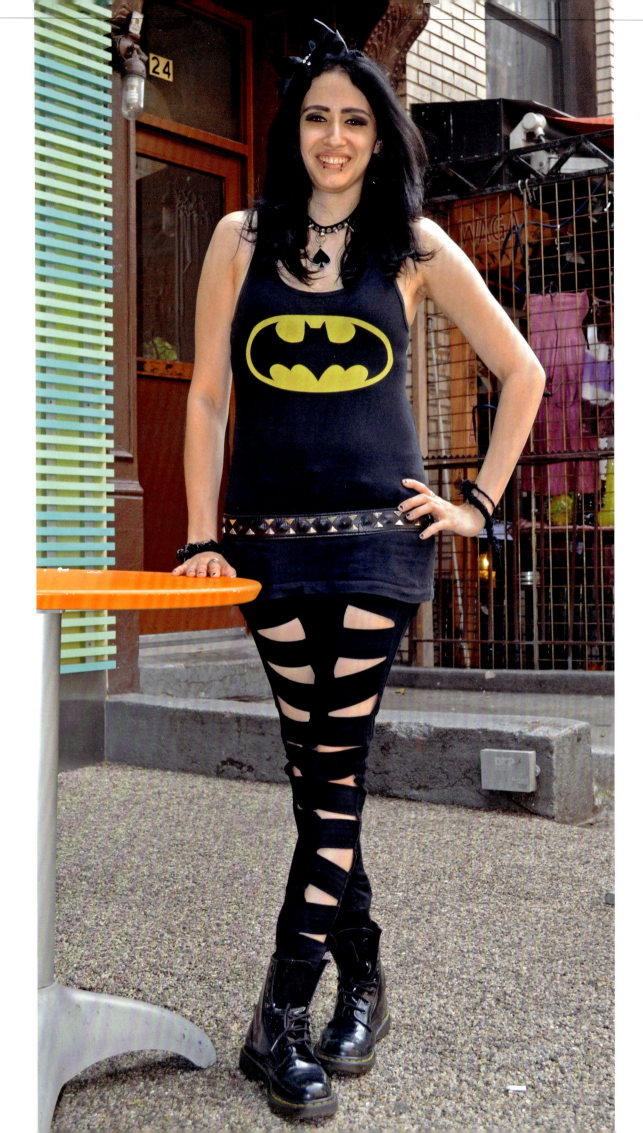

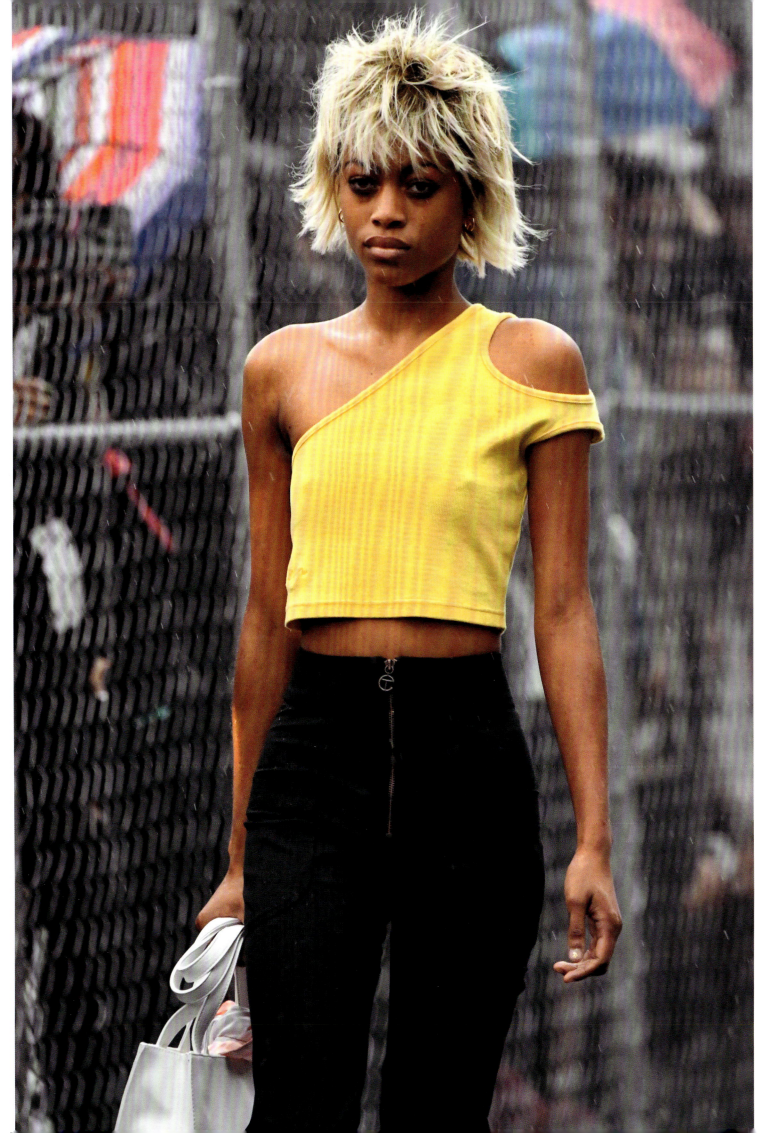

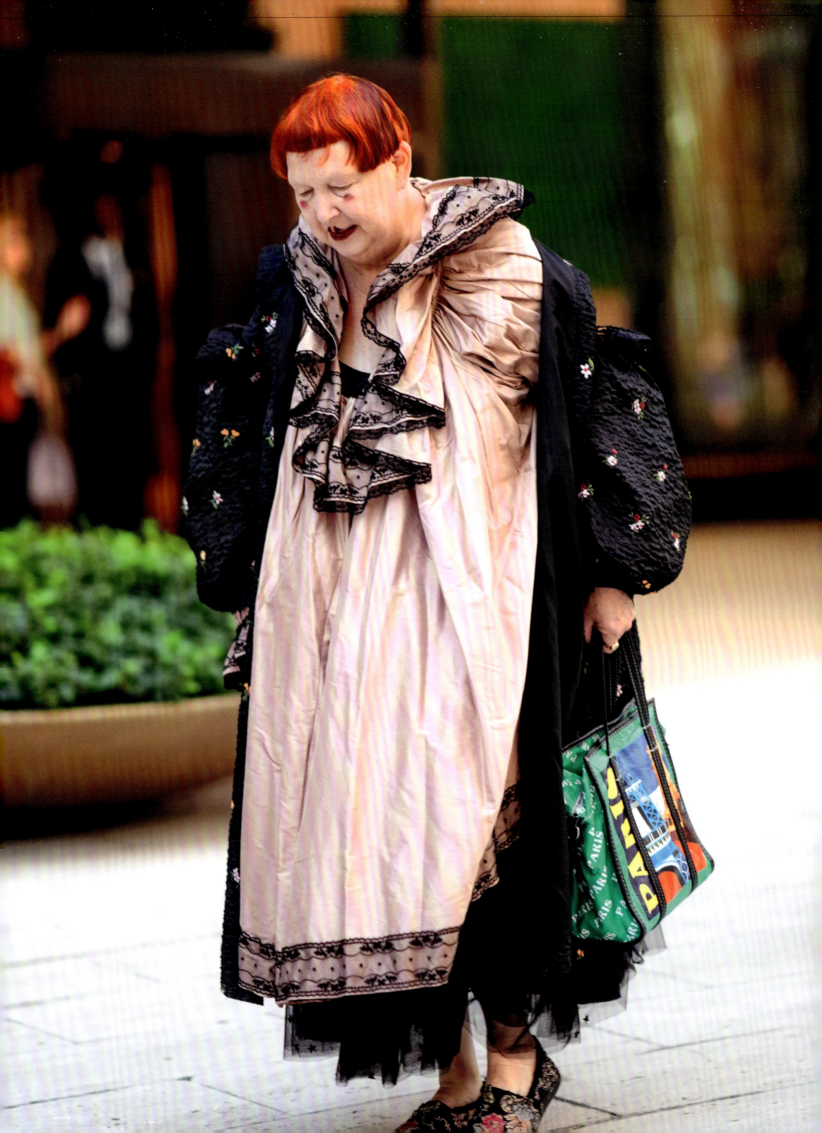

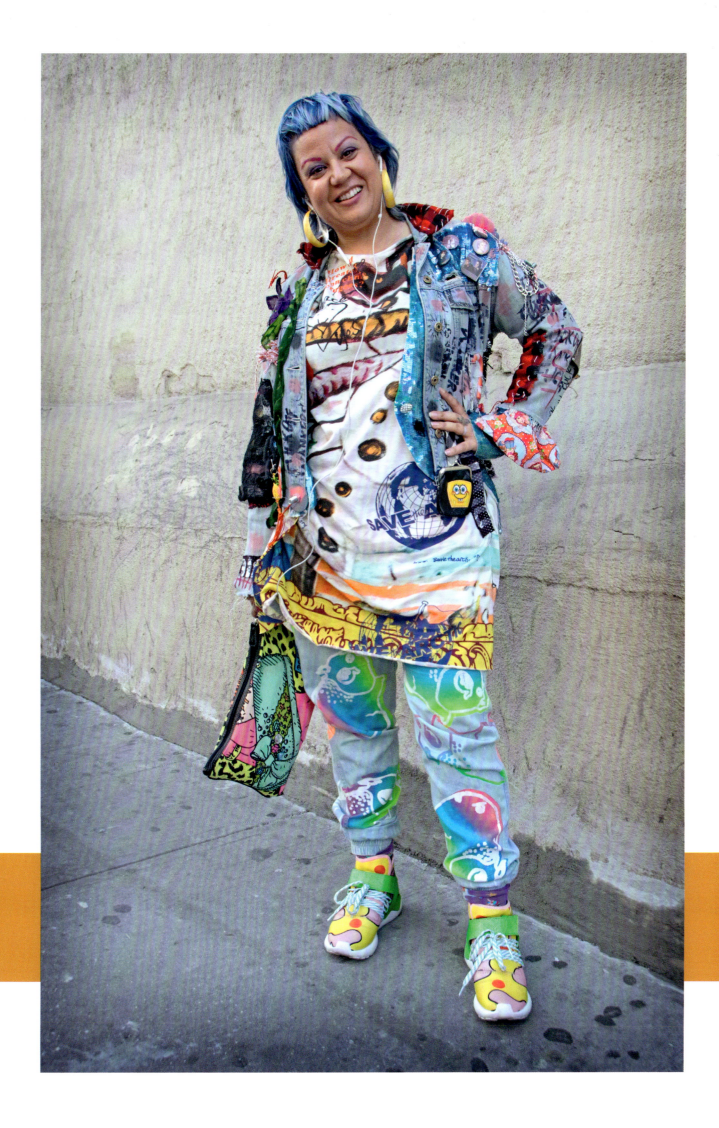

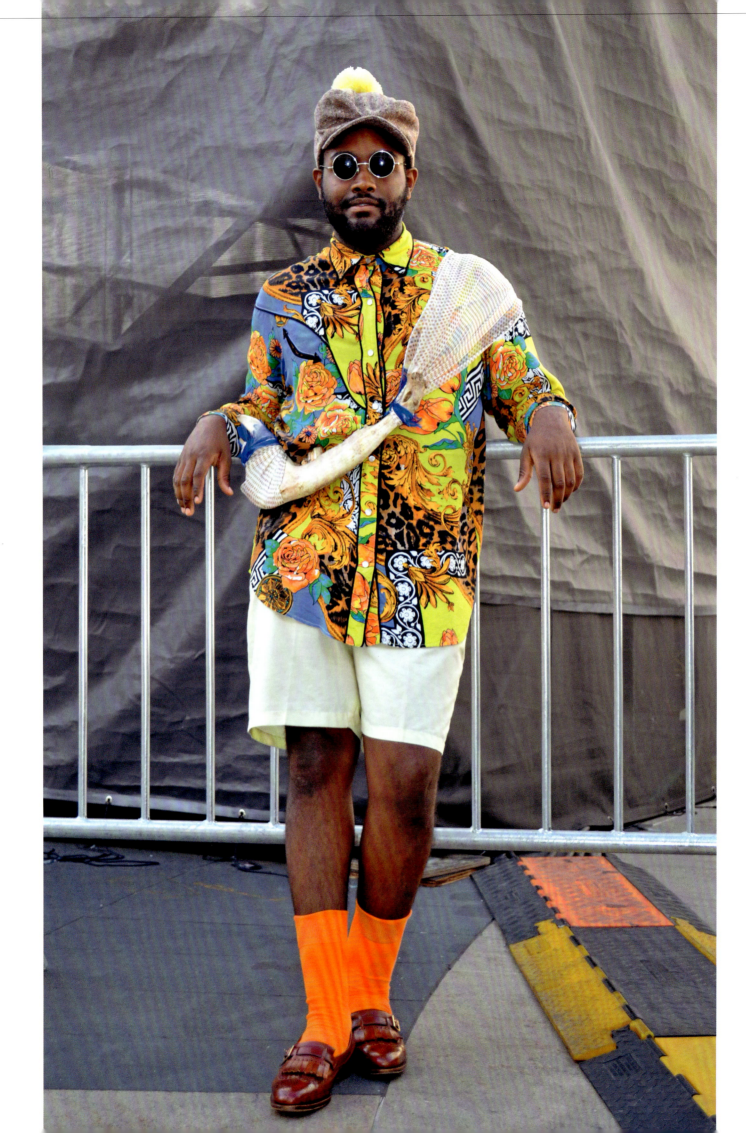

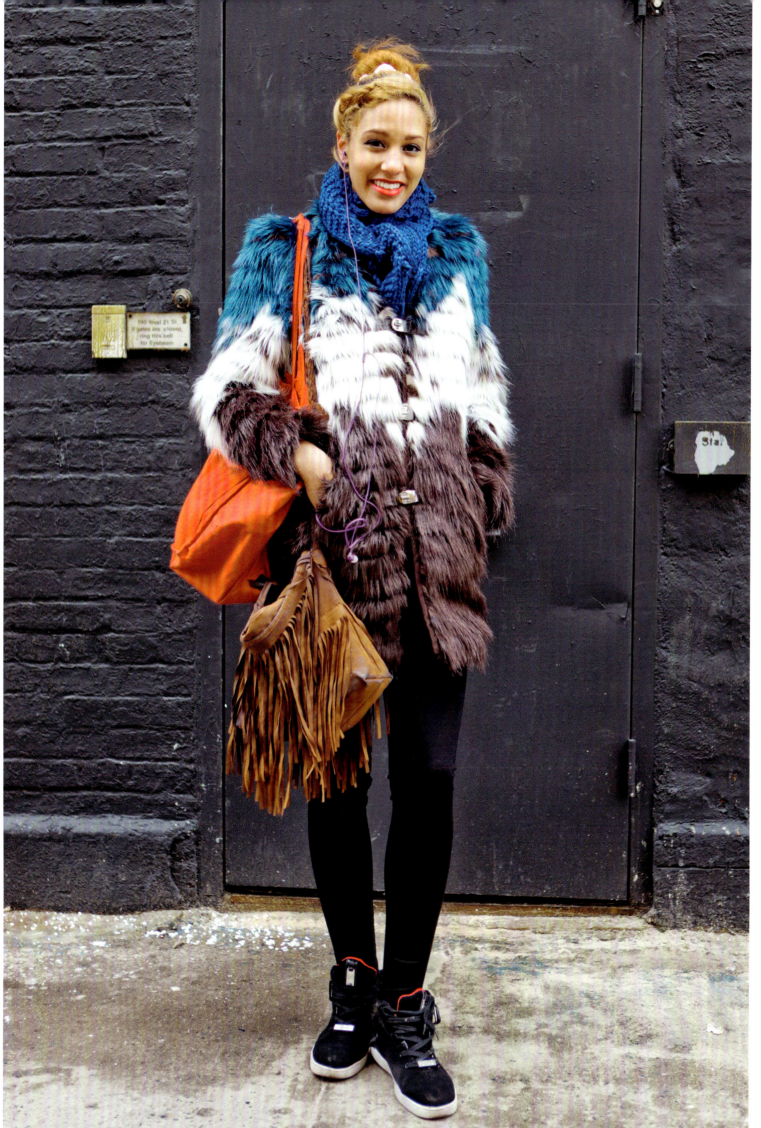

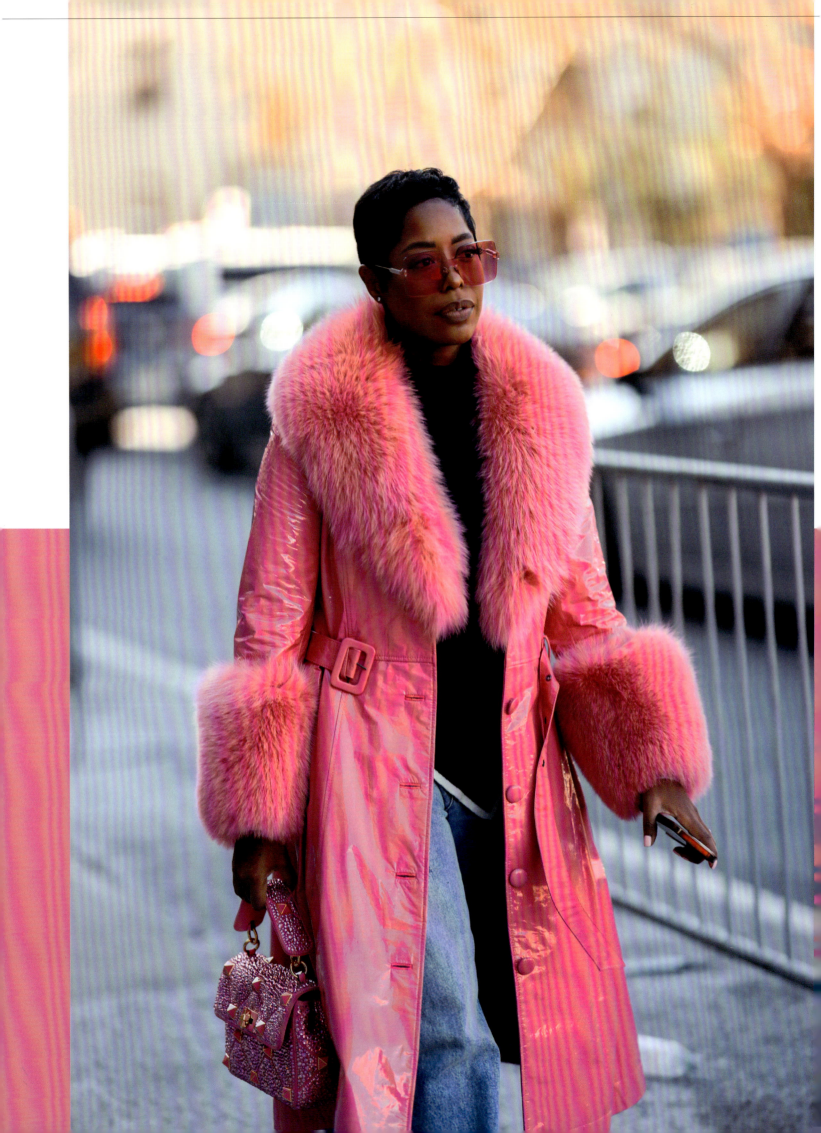

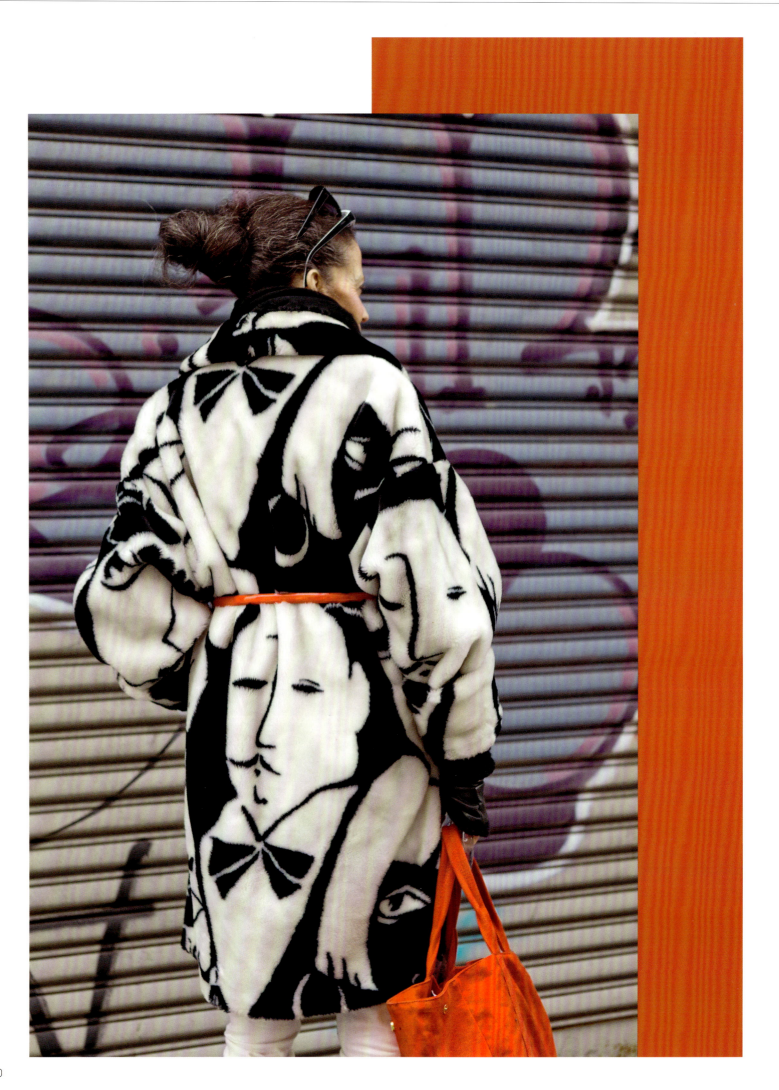

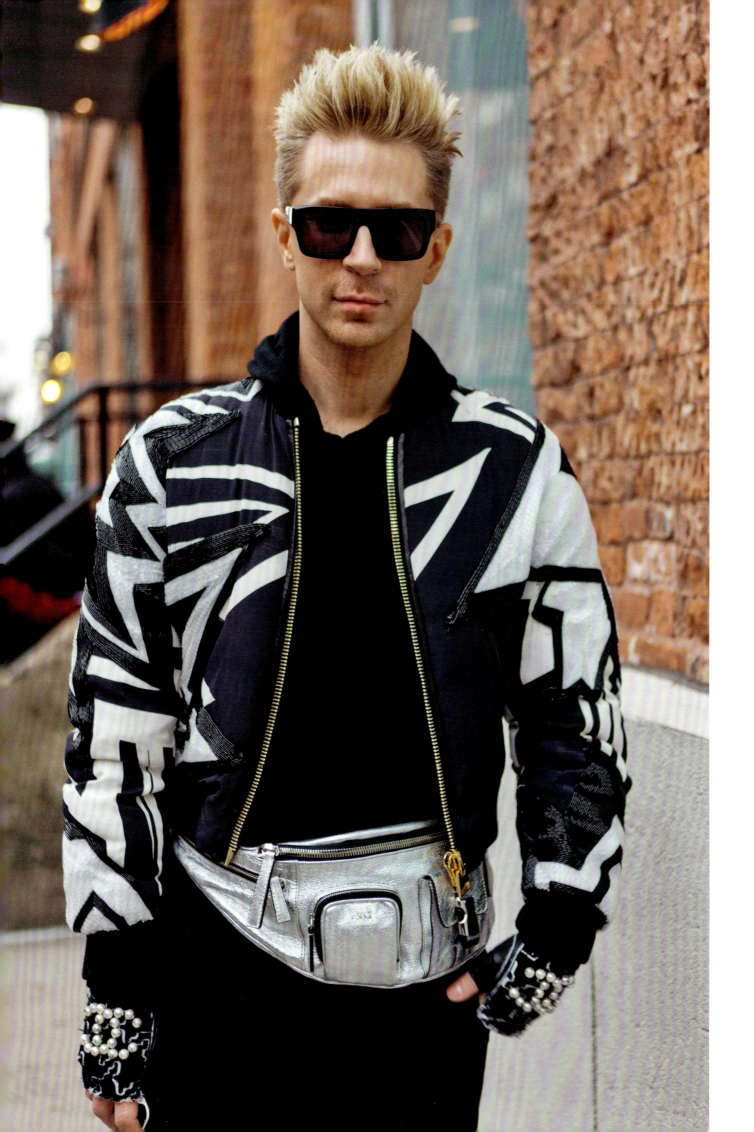

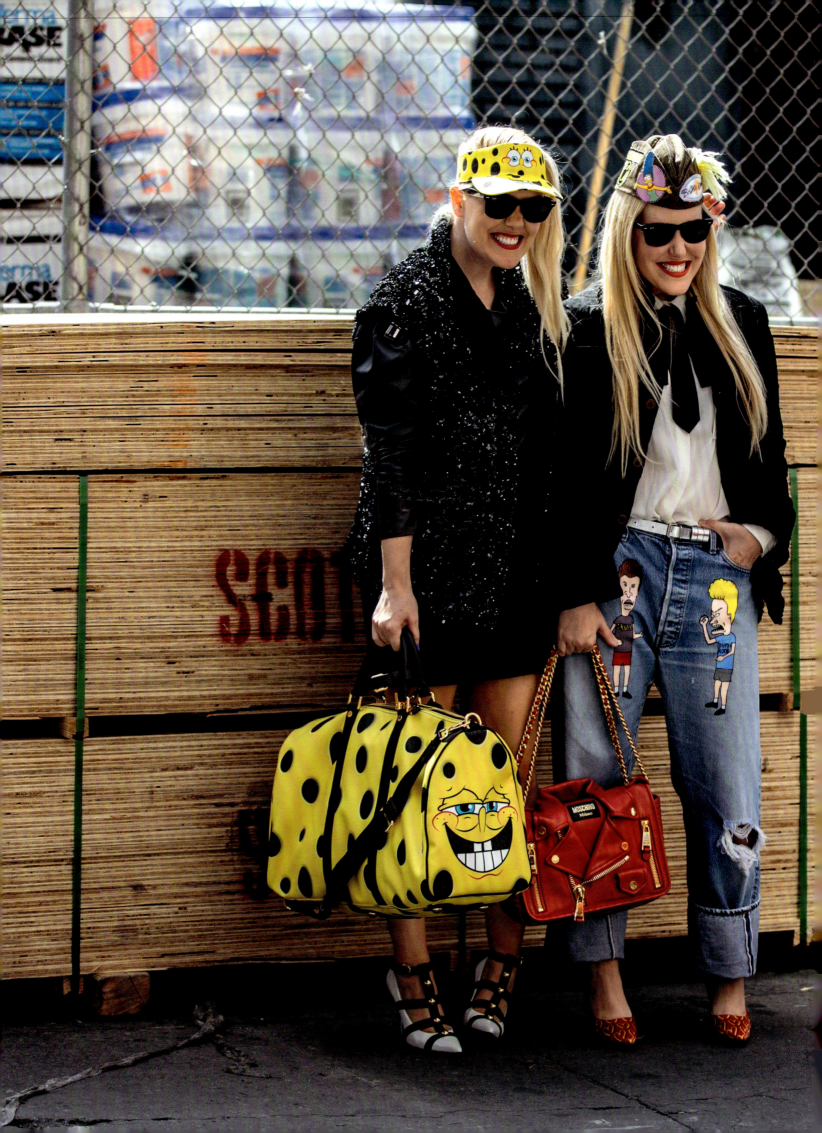

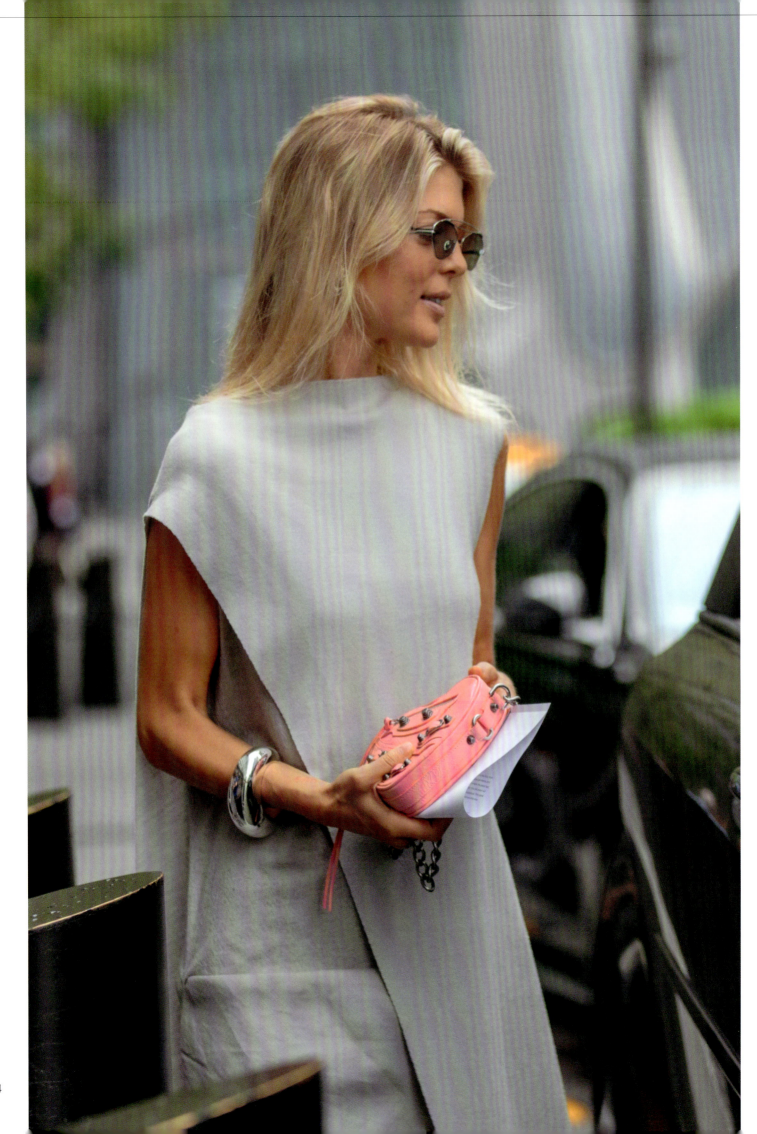

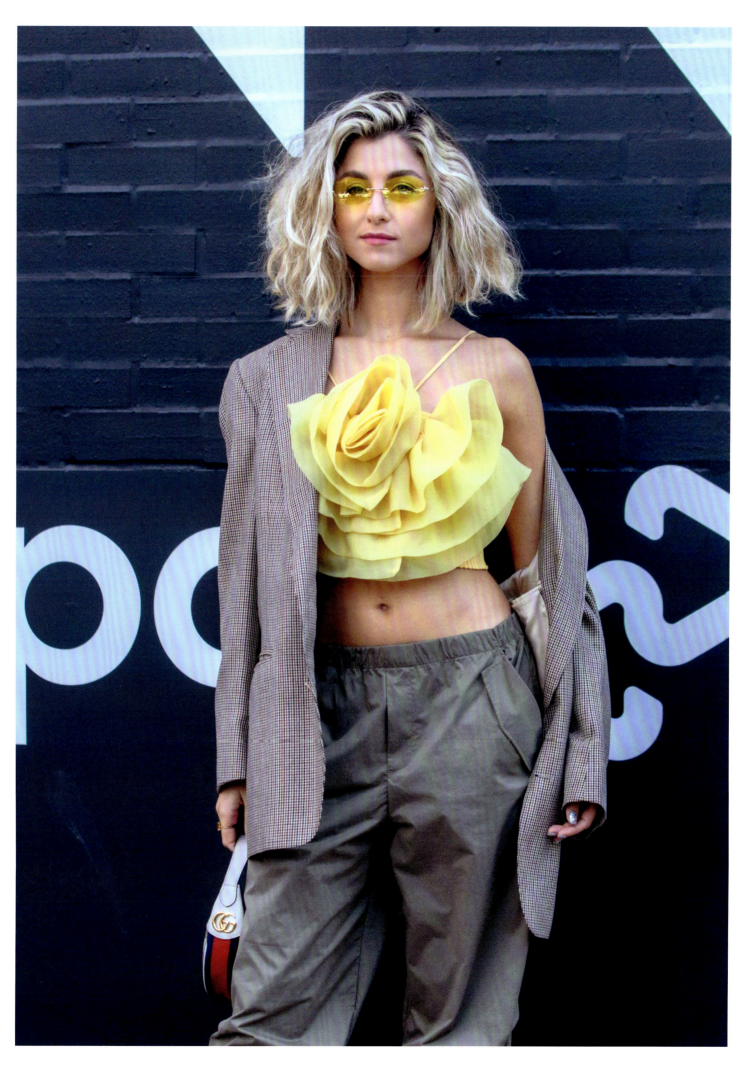

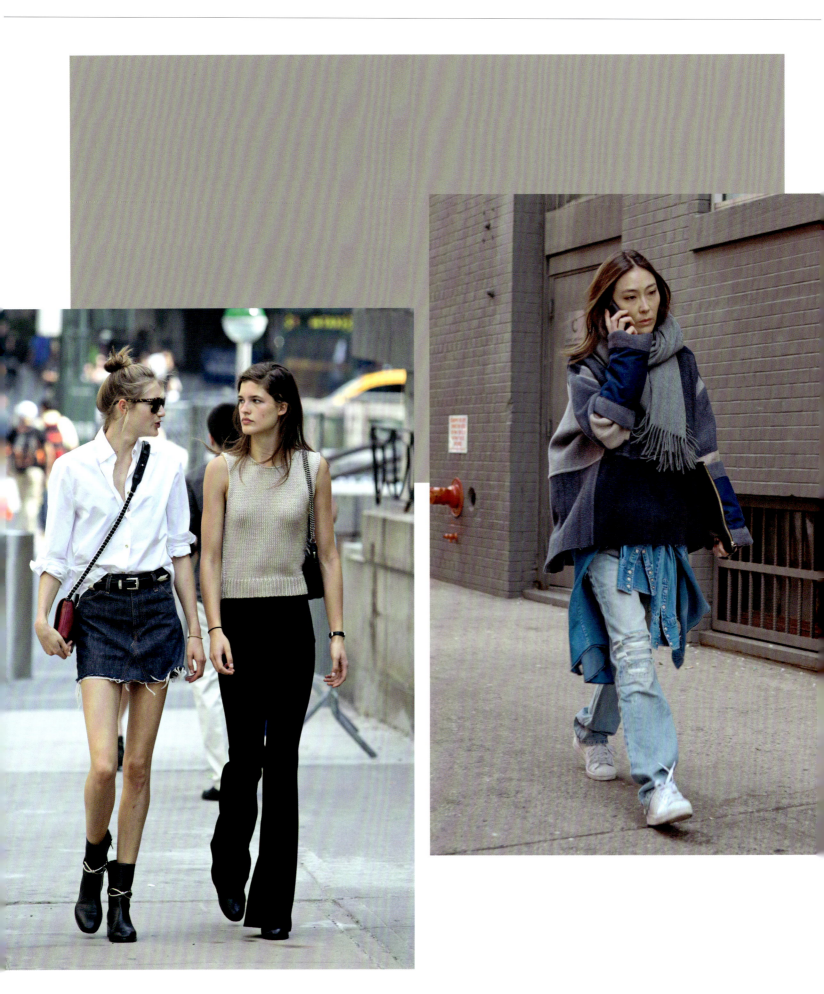

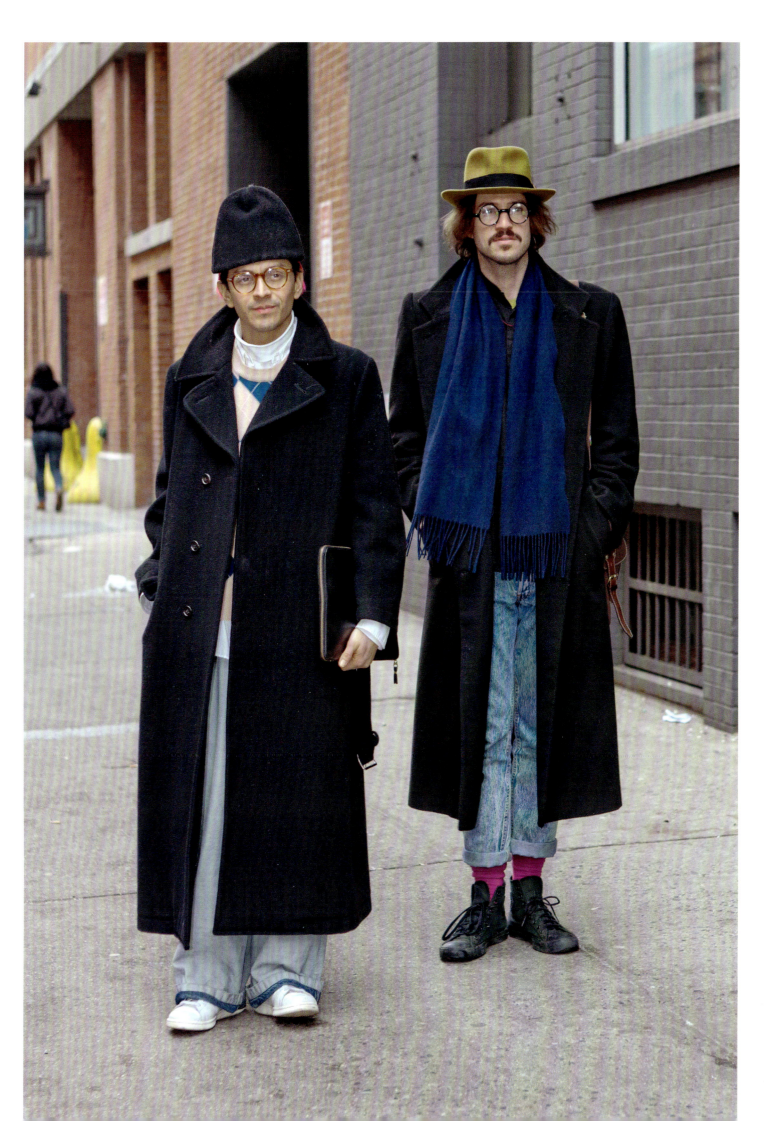

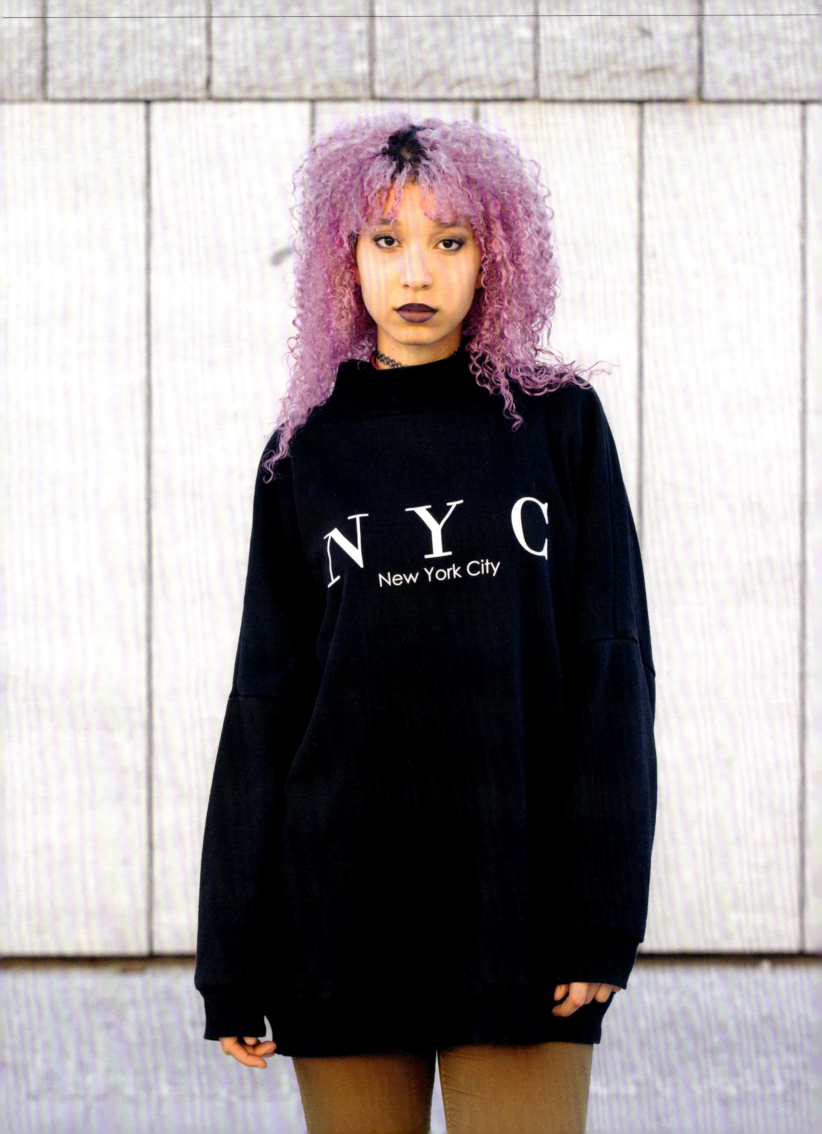

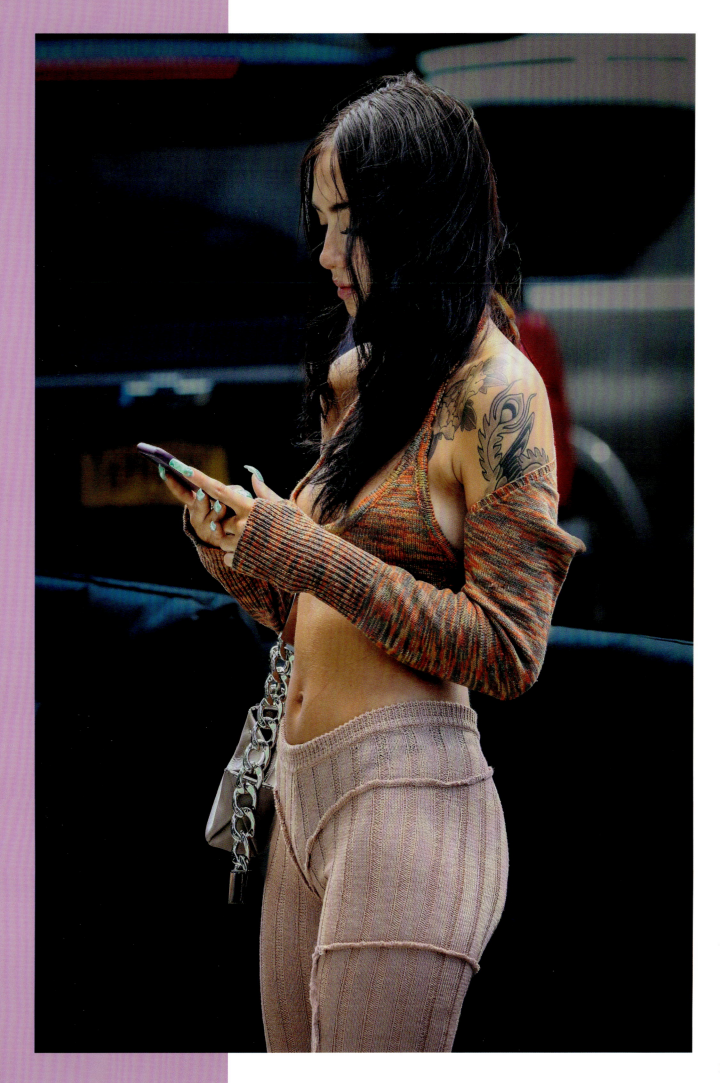

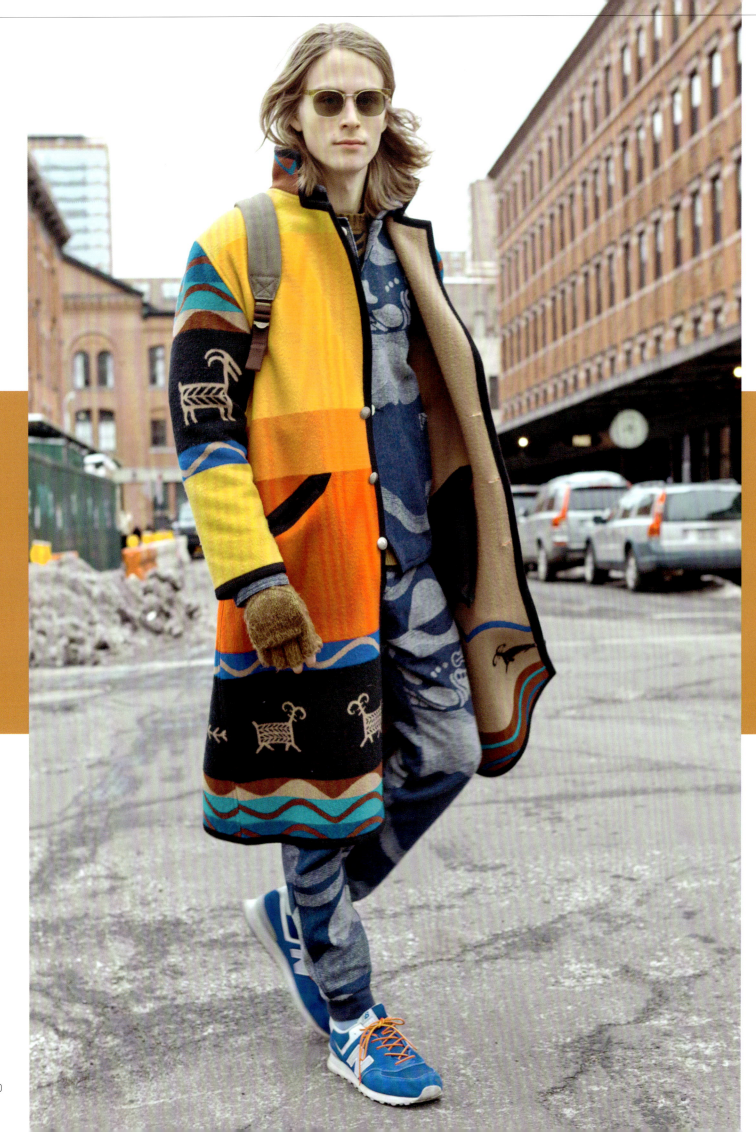

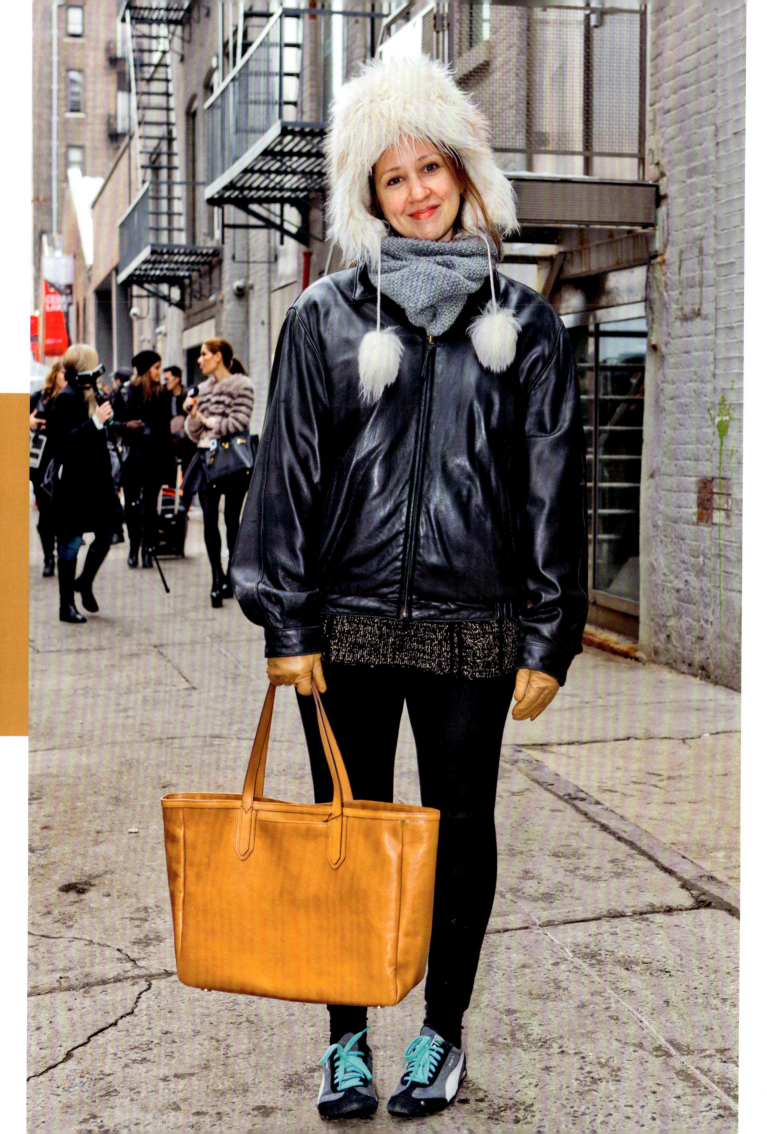

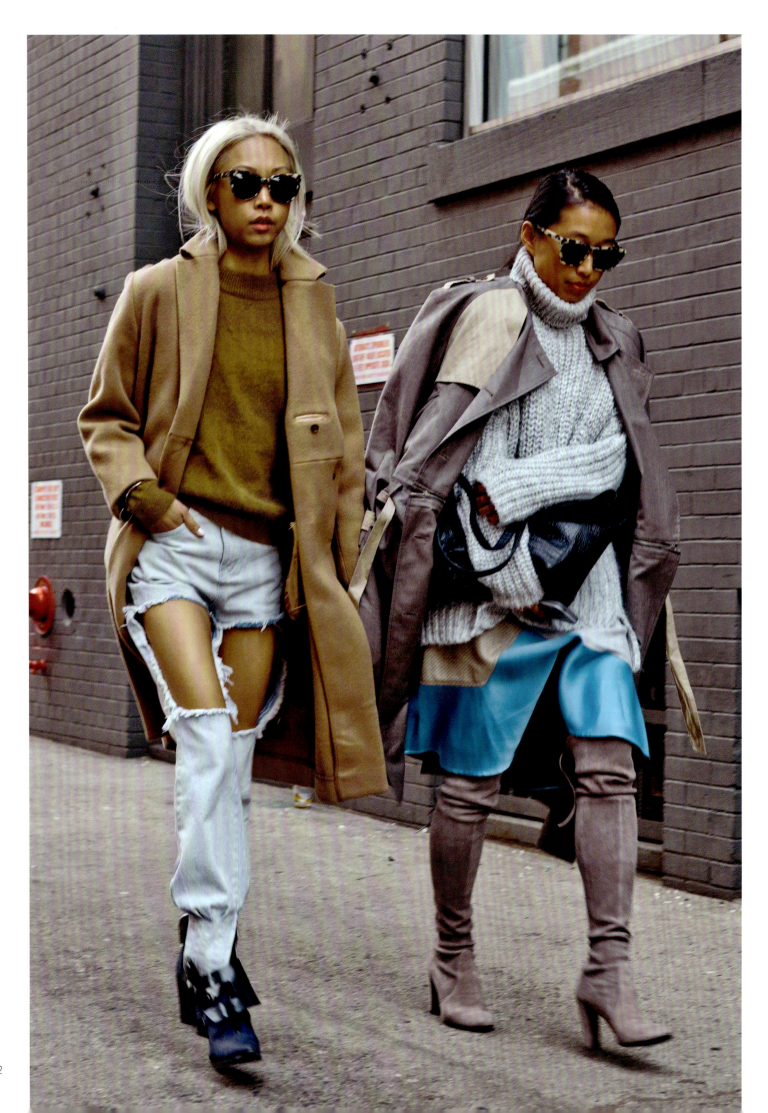

"Being well dressed hasn't much to do with having good clothes. It's a question of good balance and good common sense."

OSCAR DE LA RENTA

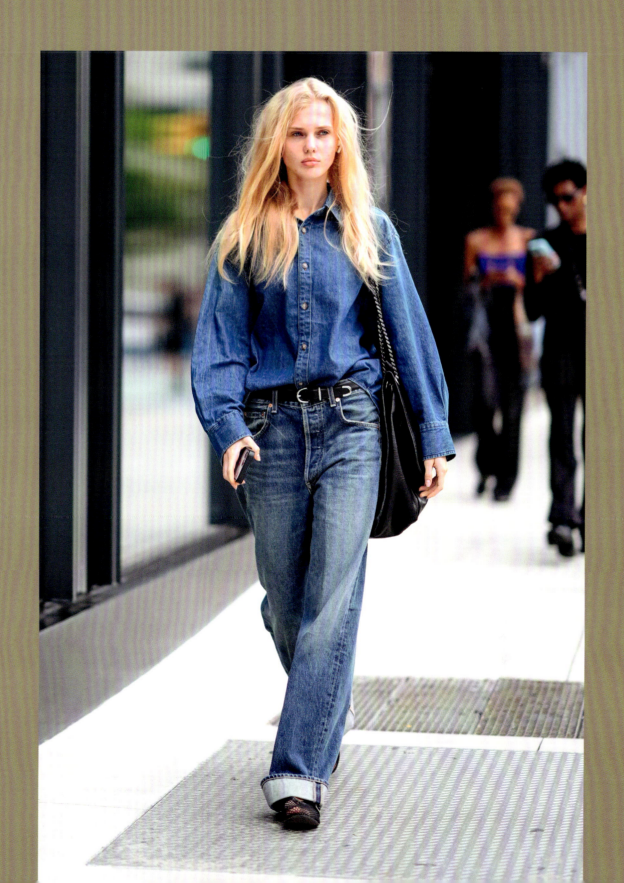

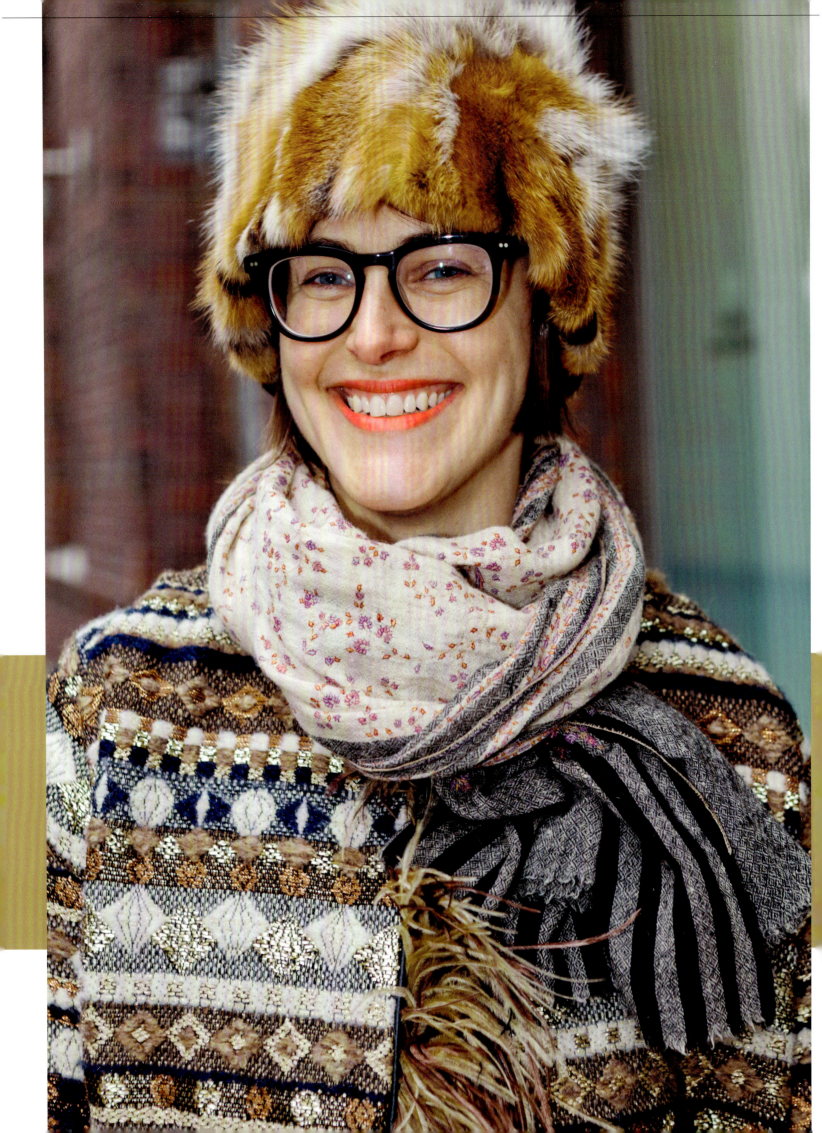

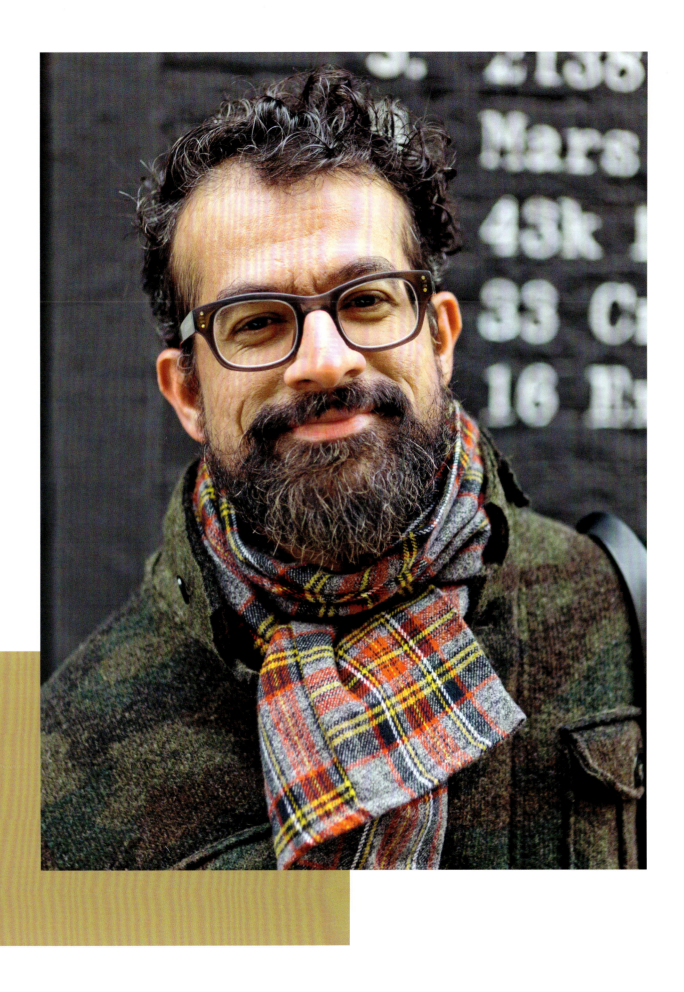

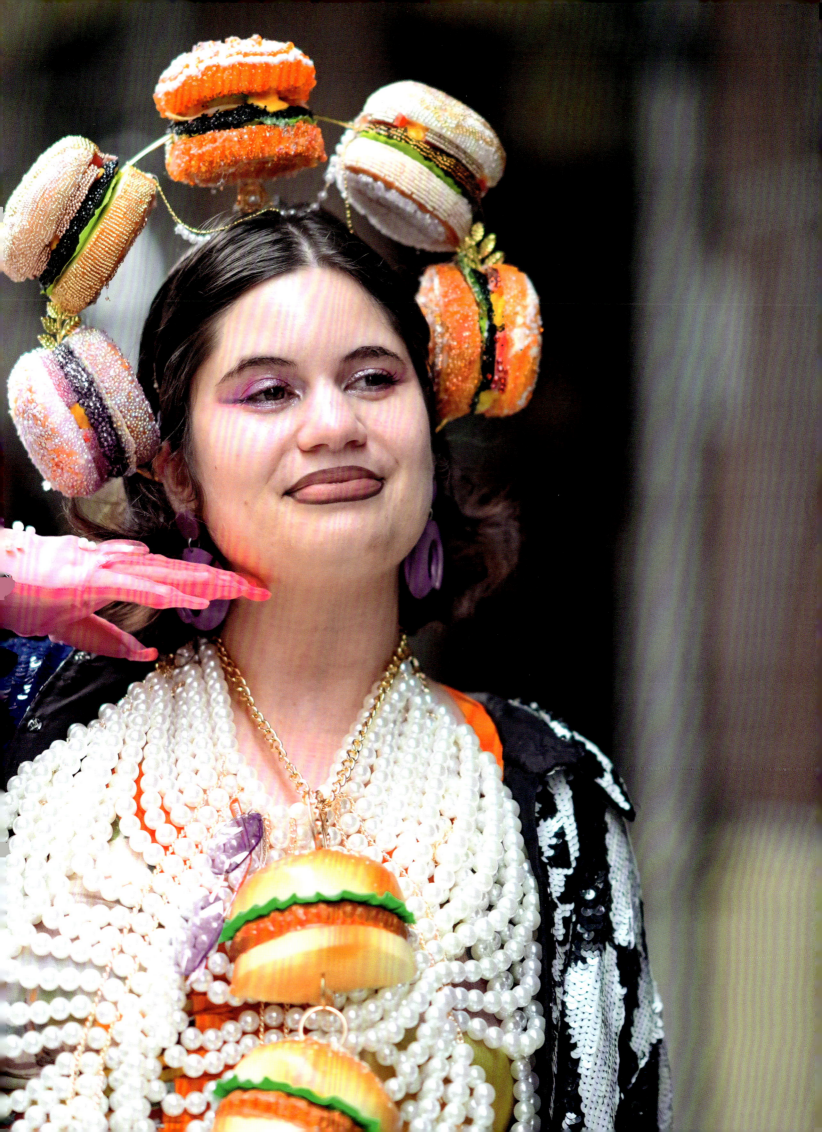

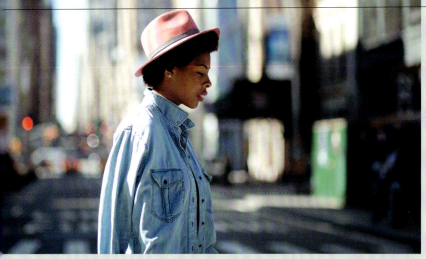

Young woman wearing a fedora hat and a denim jacket, September 2023.

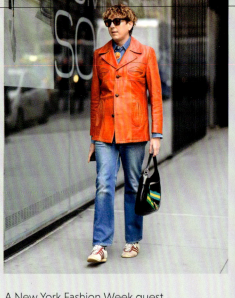

A New York Fashion Week guest, February 2024.

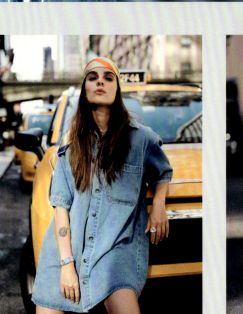

Fashionista posing in front of a taxi, July 2024.

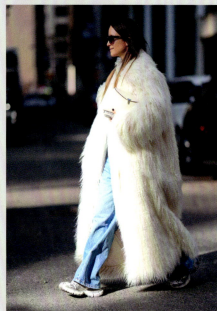

Street style during New York Fashion Week, February 2024.

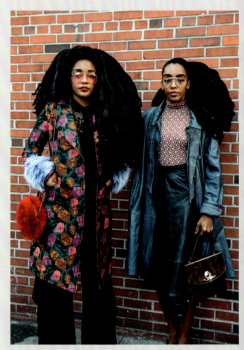

A perfect embodiment of NYC street style, 2017.

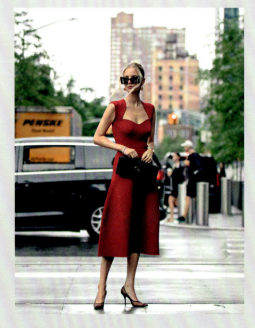

Elegant fashionista on the New York streets, September 2024.

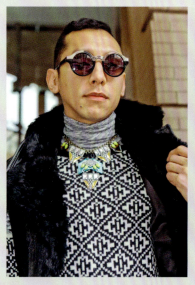

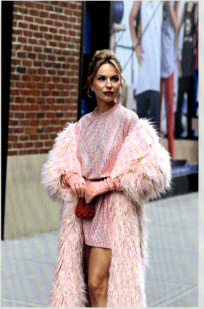

Two chic NY street-style looks, 10 years apart: a grey monochrome top from 2014, above; and a pink monochrome outfit from 2024, right.

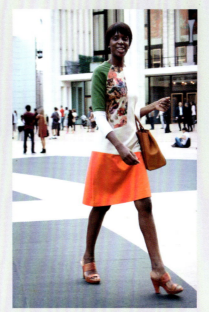
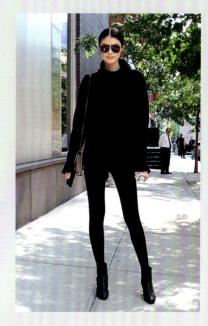

Fashionistas out in NYC, 2012.

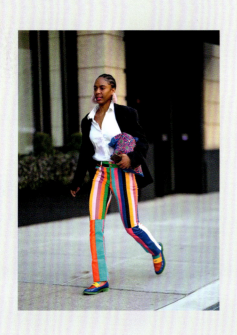
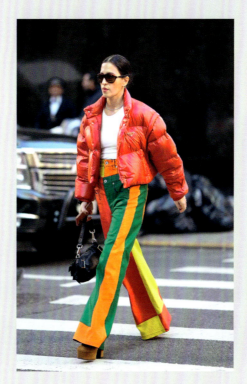

Guests of the New York Fashion Week Autumn/Winter 2023/2024 wearing multicoloured denim trousers, February 2023.

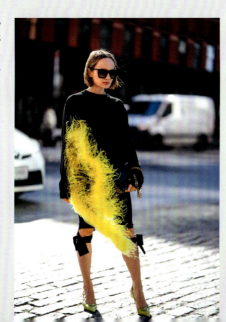

A guest of the Michael Kors fashion show, February 2023.

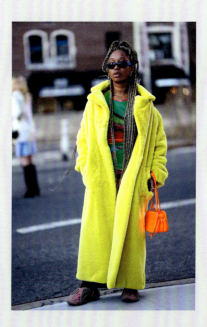

A guest in a yellow fluffy coat attending a fashion show, February 2023.

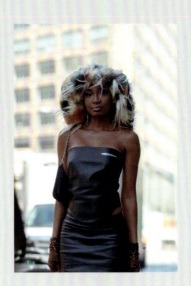

Stylish urban fashion, Spring 2024.

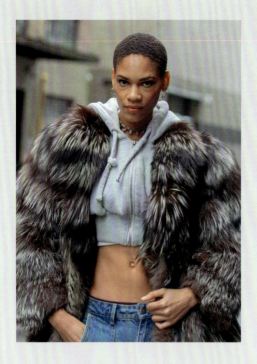

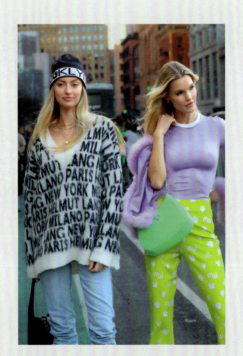

Models at the exit of a fashion show, February 2022.

Fashionistas in fluffy coats.

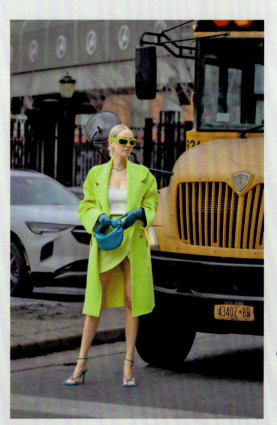

A luminous lady, February 2022.

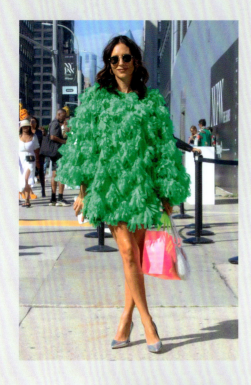

Fashion influencer and blogger Delia Atenea, September 2022.

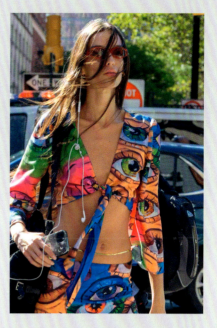

Summer fashion, New York, September 2022.

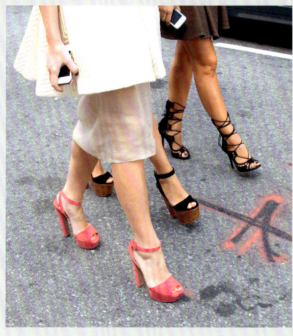

Street-style shoes, September 2012.

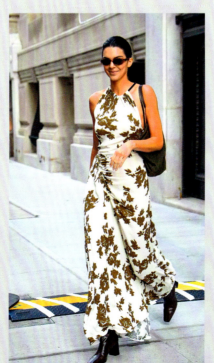

Kendall Jenner leaving a social event during New York Fashion Week, September 2022.

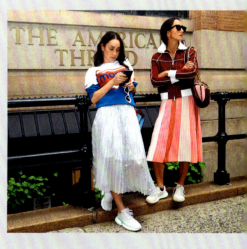

New York Fashion Week guests, September 2017.

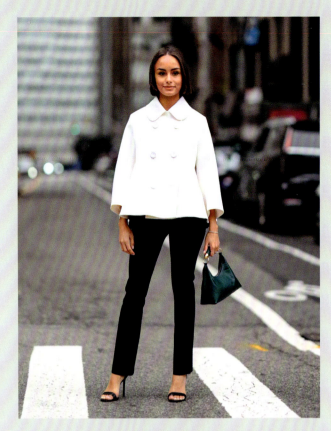

A guest leaving the Altuzarra Spring/Summer 2024 collection show, February 2024.

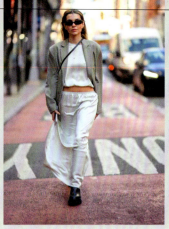

A guest arriving at the Brandon Maxwell Spring/Summer 2023 collection show, February 2023.

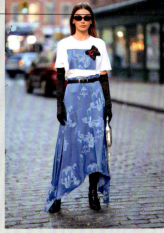

A guest arriving at the Hellessy Spring/Summer 2023 collection show, February 2023.

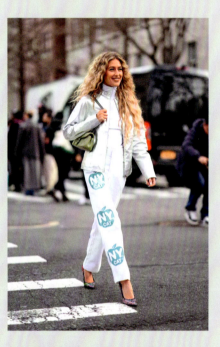

Stylist and fashion influencer Emili Sindlev during New York Fashion Week, February 2024.

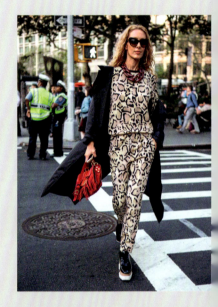

Fashion editor and stylist Elina Halimi attending the Max Mara Spring/Summer 2017 collection show, New York, September 2016.

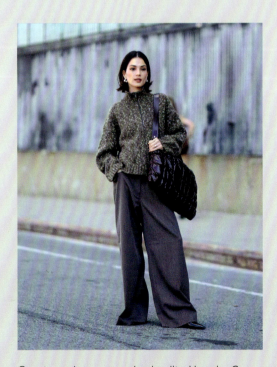

Guest carrying an oversized quilted bag by Cos, posing outside a Cos show during New York Fashion Week, 2024.

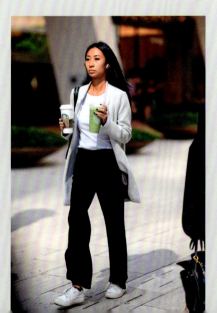

Cool outfit and coffee on the go. What could be more New York?

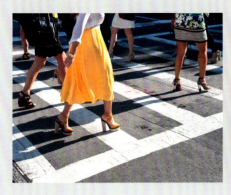
New Yorkers and their fantastic footwear, 2012.

Manhattan signpost.

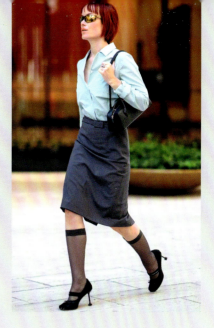
A guest outside Toteme, New York Fashion Week, September 2024.

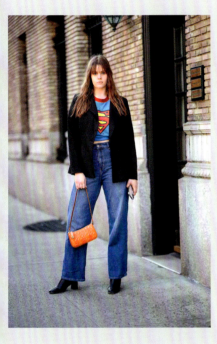
A guest of the Coach Autumn/Winter 2023/2024 collection show, February 2023.

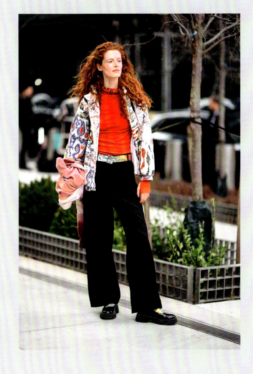
A model at the end of the Ulla Johnson Autumn/Winter 2023/2024 collection show, February 2023.

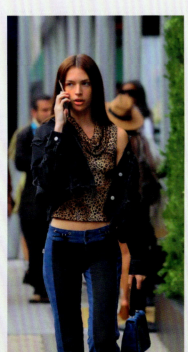
New York fashionista walking while on a phone call, Spring 2022.

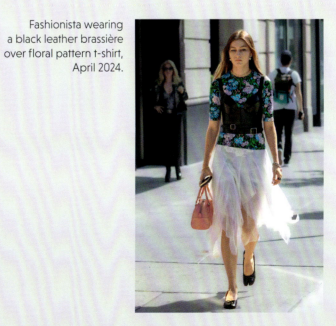
Fashionista wearing a black leather brassière over floral pattern t-shirt, April 2024.

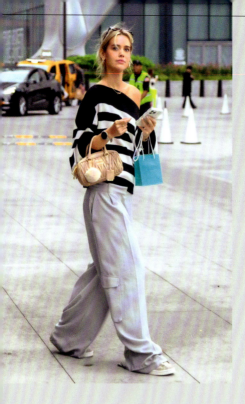

Fashionista with a Miu Miu handbag, New York, September 2024.

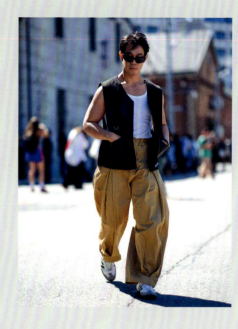

Cos guest during New York Fashion Week, September 2024.

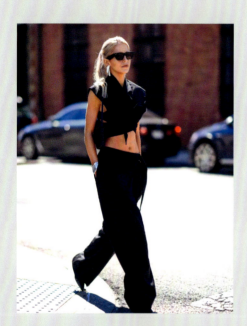

German fashion influencer Caroline Daur outside a Cos Fashion Week show in September 2024.

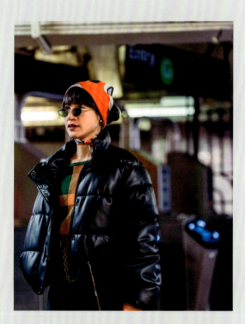

Elegant woman in the subway, March 2021.

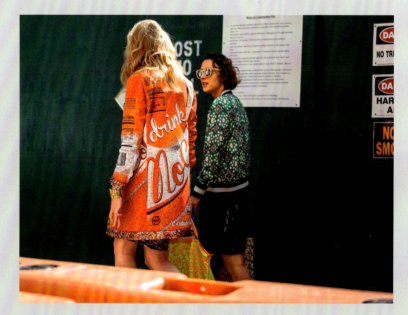

Guests leaving the Moschino Spring/Summer 2015 collection show by Jeremy Scott, September 2014.

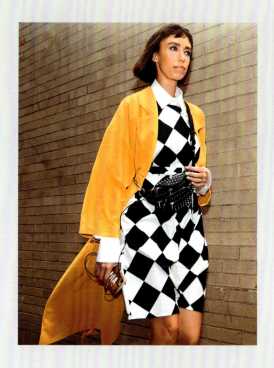

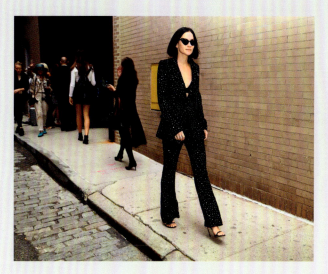

Guests at the end of a fashion show, New York Fashion Week, September 2018.

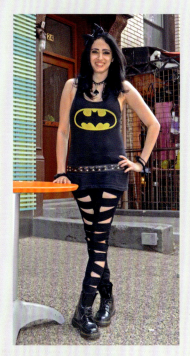

Young woman rocking a Batman top in Greenwich Village, 2012 – New York is the original Gotham, after all.

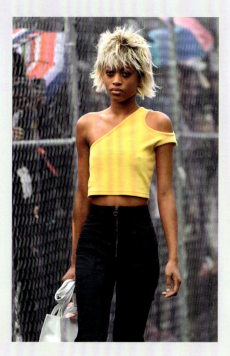

A model leaving the Telfar Clemens Spring/Summer 2019 collection show, September 2018.

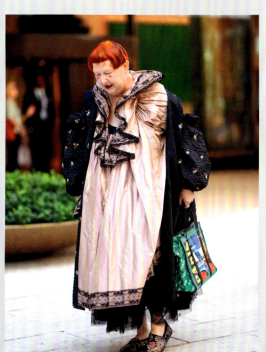

Columnist and contributing *Vogue* fashion editor Lynn Yaeger in a fabulous ruffled dress with lace tulle, 2024.

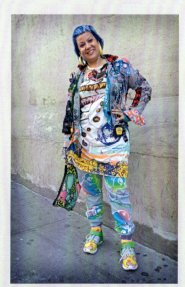

Exceptional colour co-ordination on the streets of SoHo, 2016.

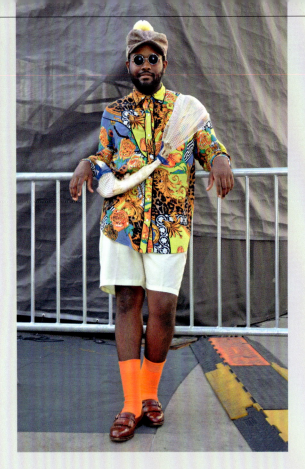

Bold colours, typical of New York fashion, September 2012.

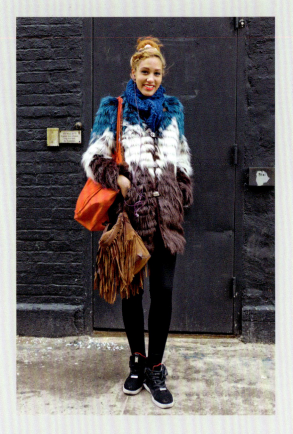

Another snazzy New York ensemble, during Fashion Week, 2014.

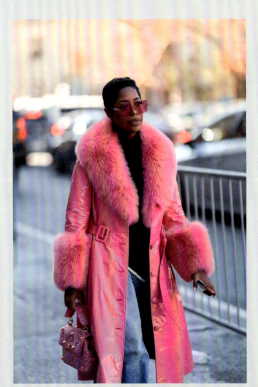

A Fashion Week guest outside a Bibhu Mohapatra show, 2022.

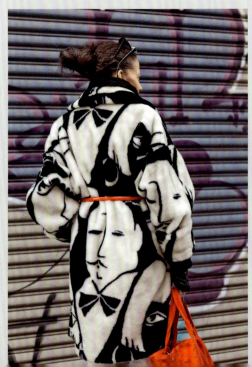

Another chic dresser in NYC, 2014.

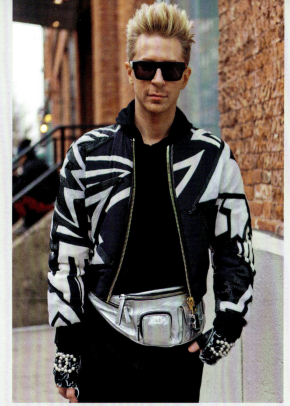

A hip New Yorker during Fashion Week, February 2014.

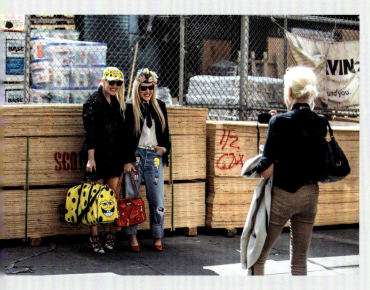

Guests of the Moschino Spring/Summer 2015 collection show by Jeremy Scott, September 2014.

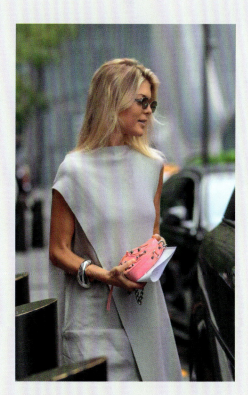

Stylish Manhattan woman, October 2024.

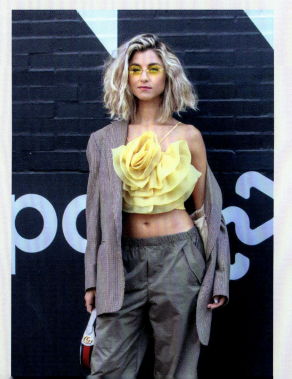

Fashionista with a rose-shaped yellow crop top, October 2024.

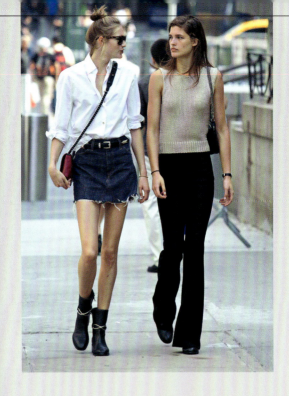

Fashionistas walk in front of the Skylight at Moynihan Station during New York Fashion Week, September 2016.

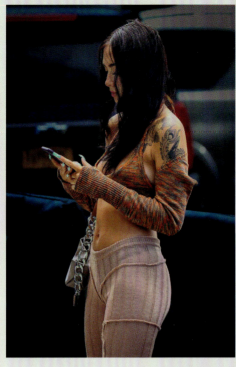

From casual to transgressive: New York street style in the 2020s.

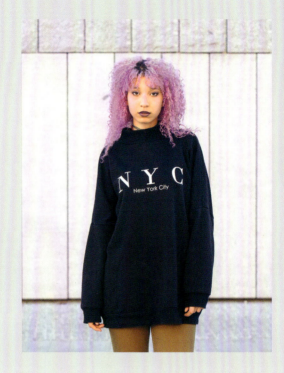

New York cool, Fashion Week 2014.

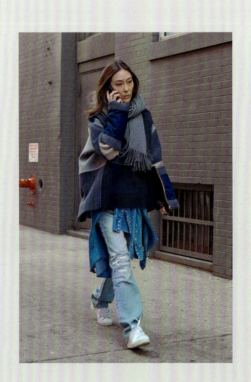
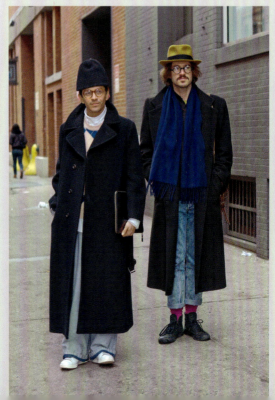
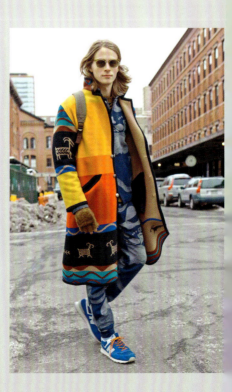

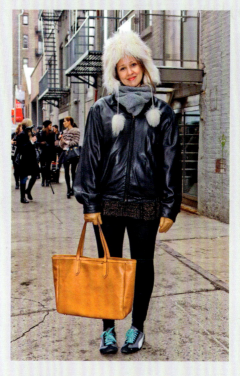
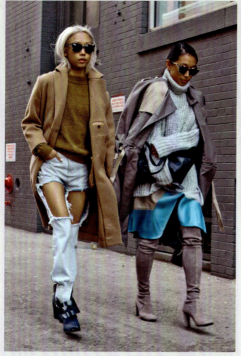
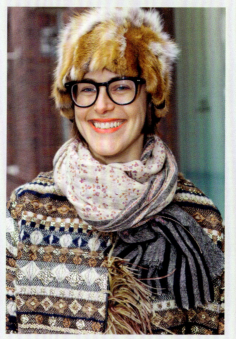
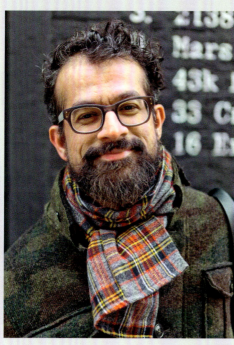

Classic all-denim street outfit in September 2024.

More great looks from the February 2014 New York Fashion Week.

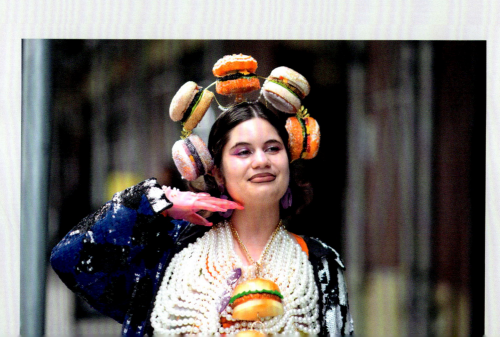

A guest of New York Fashion Week wears a headband decorated with colourful hamburgers and a matching necklace, February 2024.

SHOPPING

A true shopping paradise, New York offers an unrivalled variety of fashion boutiques and shops. Just like Paris, London, and Tokyo, it's a great place for designers and brands to make it big. You can therefore find everything you may dream of there, from budding local talent to internationally renowned brands. Shopping in New York is not only a great way to discover the city's multiple fashionable districts, it is also an immersion into different worlds, from the indie shops in SoHo, where you can look for the latest trends, to the can't-miss department stores, which are the ultimate temples of urban grandeur and chic elegance.

Fifth Avenue, especially between Bryant Park and Central Park, is one of the world's most fascinating streets for luxury shopping. Not only is Fifth Avenue home to iconic department stores such as Saks Fifth Avenue and Bergdorf Goodman, but it also hosts the boutiques of major international brands such as Armani, Dior, Dolce & Gabbana, Gucci, Hugo Boss, Jimmy Choo, Louis Vuitton, Moncler, Prada, Saint Laurent, Ted Baker, Tommy Hilfiger, Valentino, and Versace, to name but a few. Iconic jewellery stores such as Cartier and Tiffany & Co. are ideal locations to indulge in luxury. For the more reasonable shoppers who don't want to break the bank, most of the famous mid-end brands have their NYC flagship stores in the neighbourhood: Abercrombie & Fitch, Massimo Dutti, Muji, Uniqlo, and the like. There's also something for every sneaker fan with Adidas, Nike, and Puma located around 47th Street.

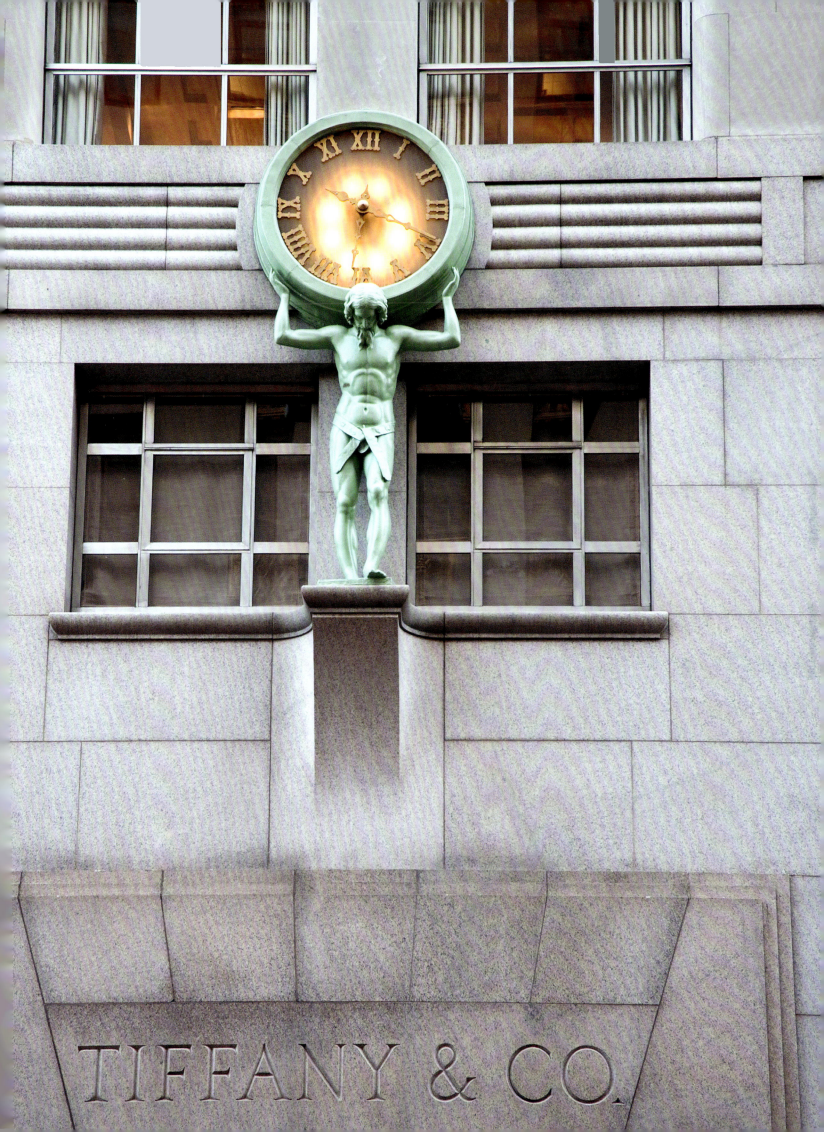

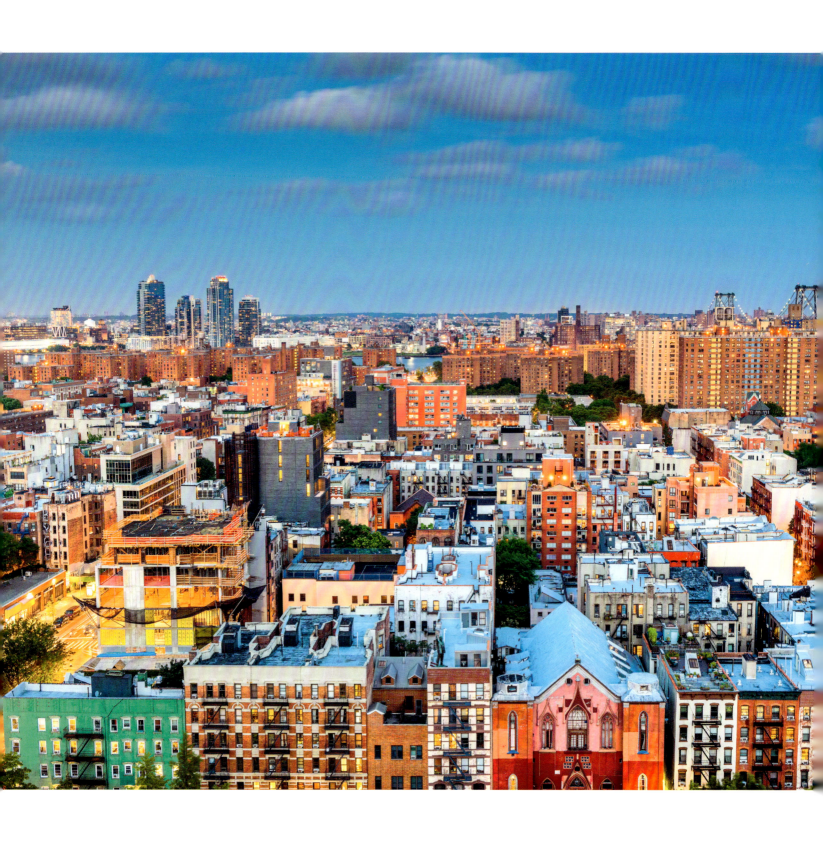

The atmosphere is completely different on the **Lower East Side**, an area bordered by Chinatown, the Bowery, and the East Village. This trendy neighbourhood, bursting with diversity, youthful energy, and creativity, is packed with unique boutiques and stores, from high-end vintage shops to independent designers' showrooms. One of the district's most iconic shops is Assembly New York at 170 Ludlow Street, with its great selection of independent designers and a focus on multiculturalism.

Located on the west side of Lower Manhattan, **SoHo** and its historical buildings with iron façades, make for a charming place to enjoy a long shopping session. It mixes high-end boutiques, such as Chanel, Chloé, Lanvin, and Prada, with more moderately priced fashion stores such as Banana Republic, COS, and Urban Outfitters.

As its name suggests, the **Garment District** is one of New York's fashion hotspots and the birthplace of the American clothing industry. It is home to Macy's, one of the world's biggest department stores (second only to Moscow's GUM), where you can truly "experience the excitement of shopping". If you are keen on exploring the city's amazing street style, the Garment District or **Brooklyn** is the place to see it.

A fashion shopping tour in NYC would be incomplete without a visit to **Bloomingdale's**, one of the prettiest department stores, located at the corner of 59th Street, Third Avenue, and Lexington Avenue. Ralph Lauren has its main stores in the immediate vicinity, on Third Avenue.

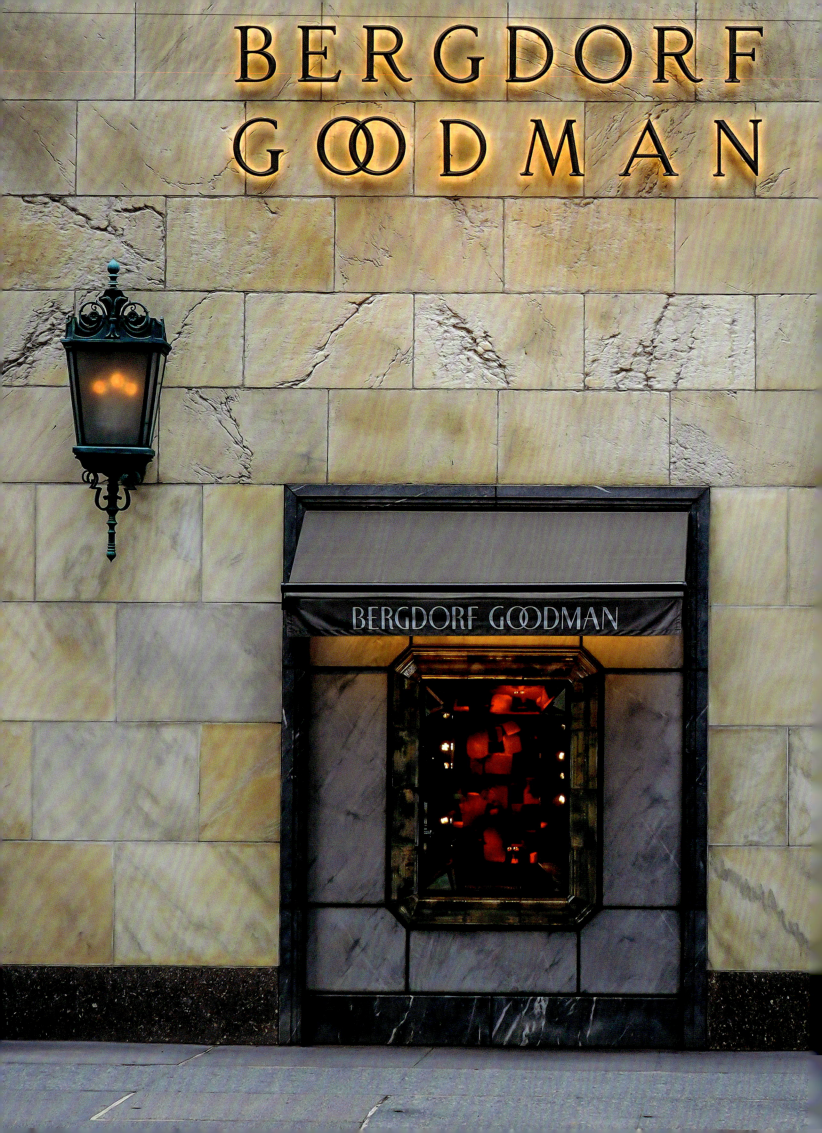

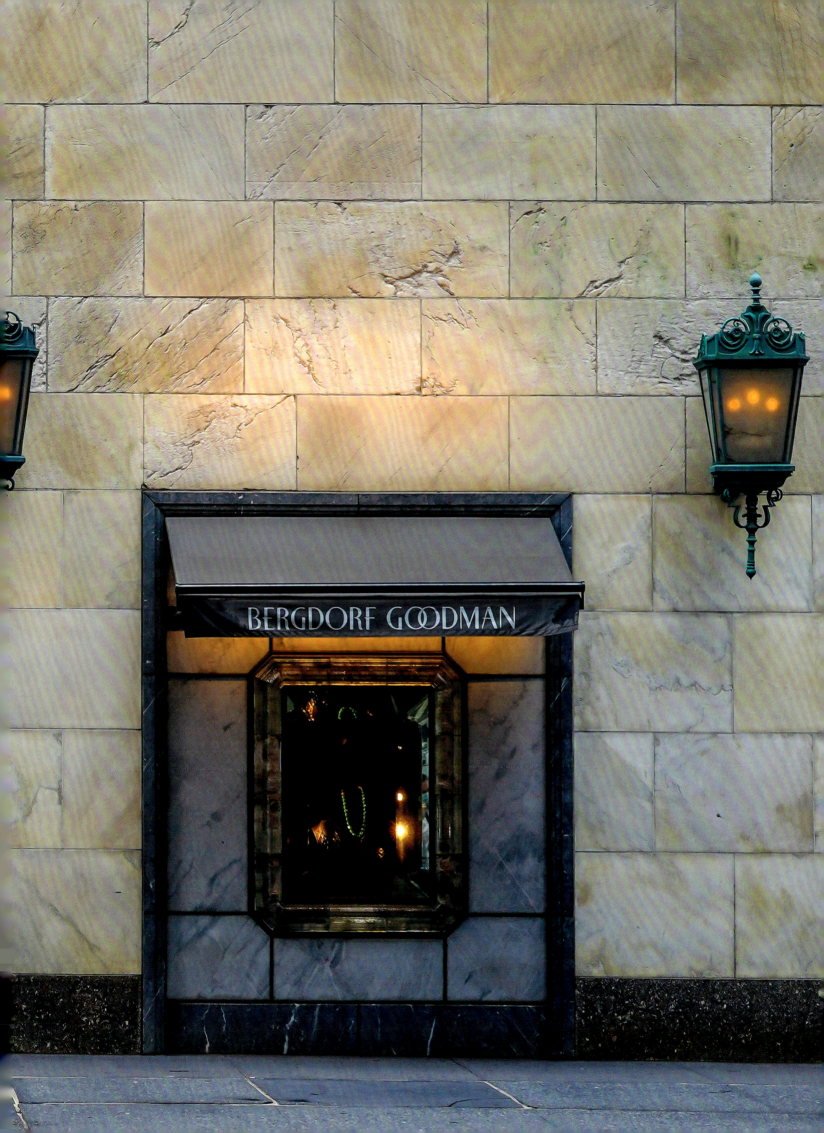

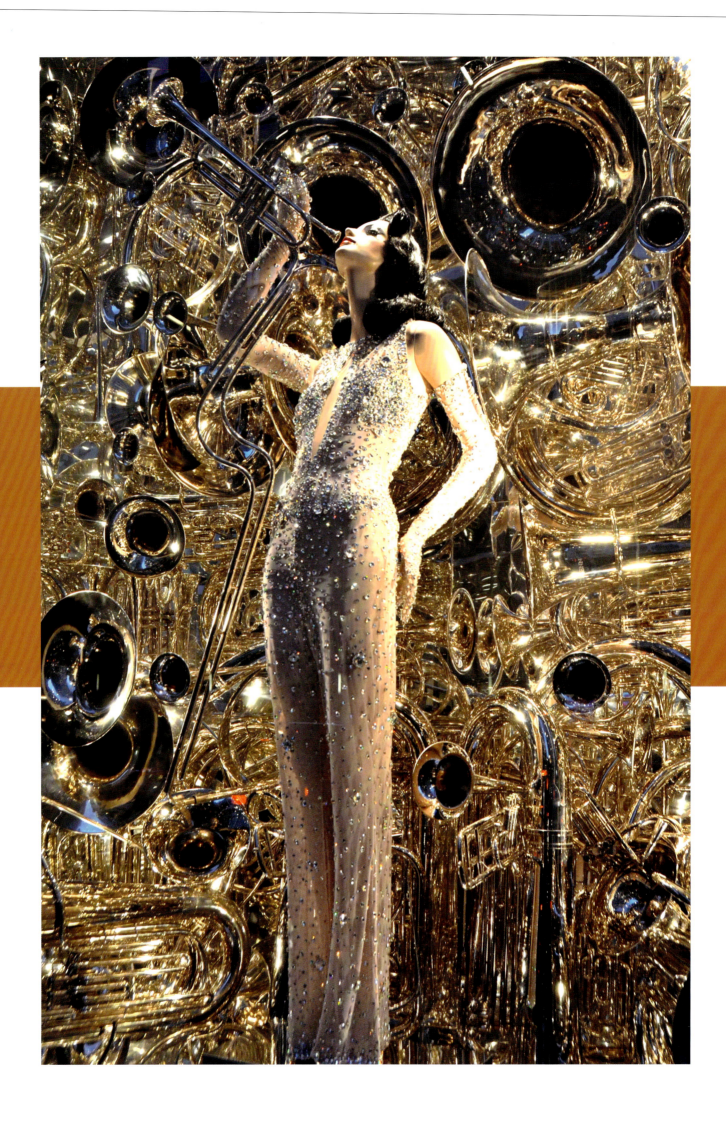

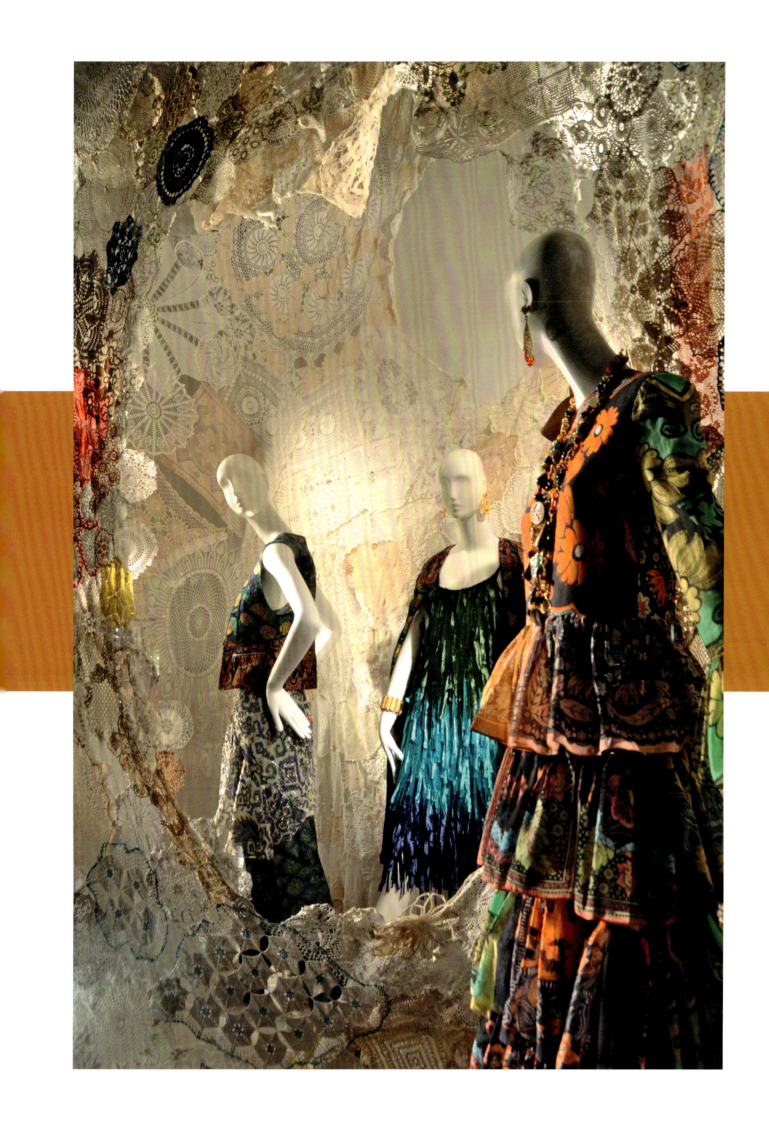

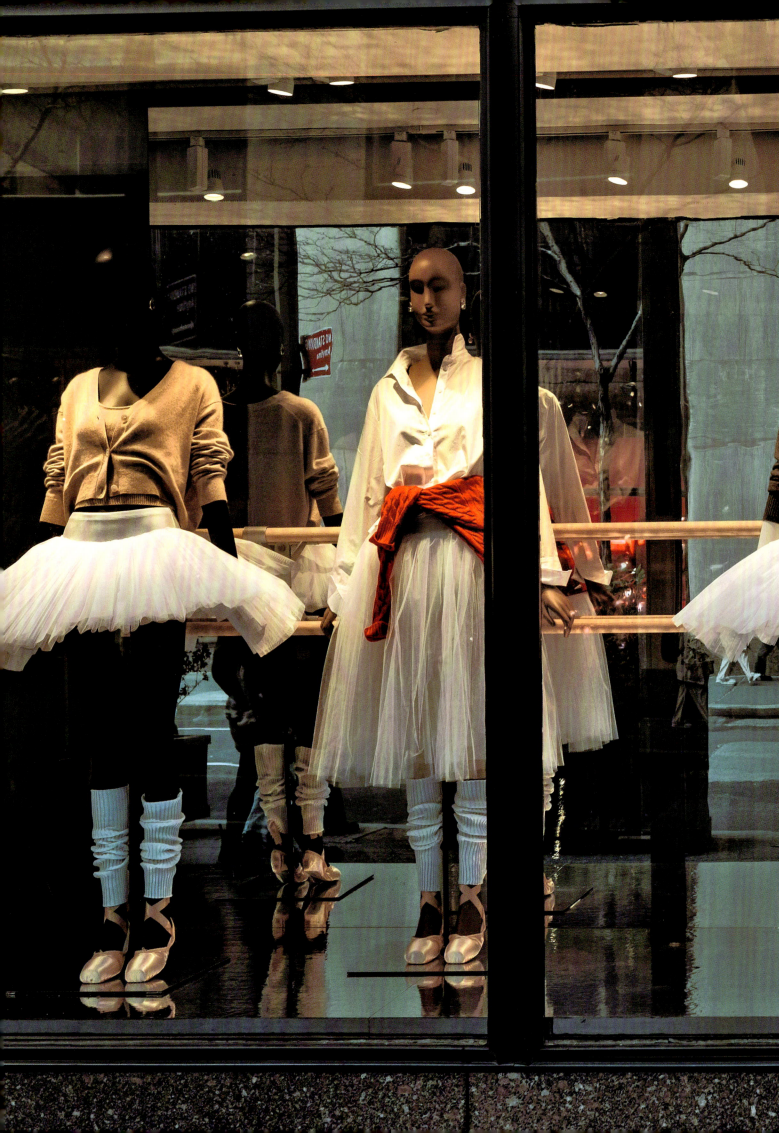

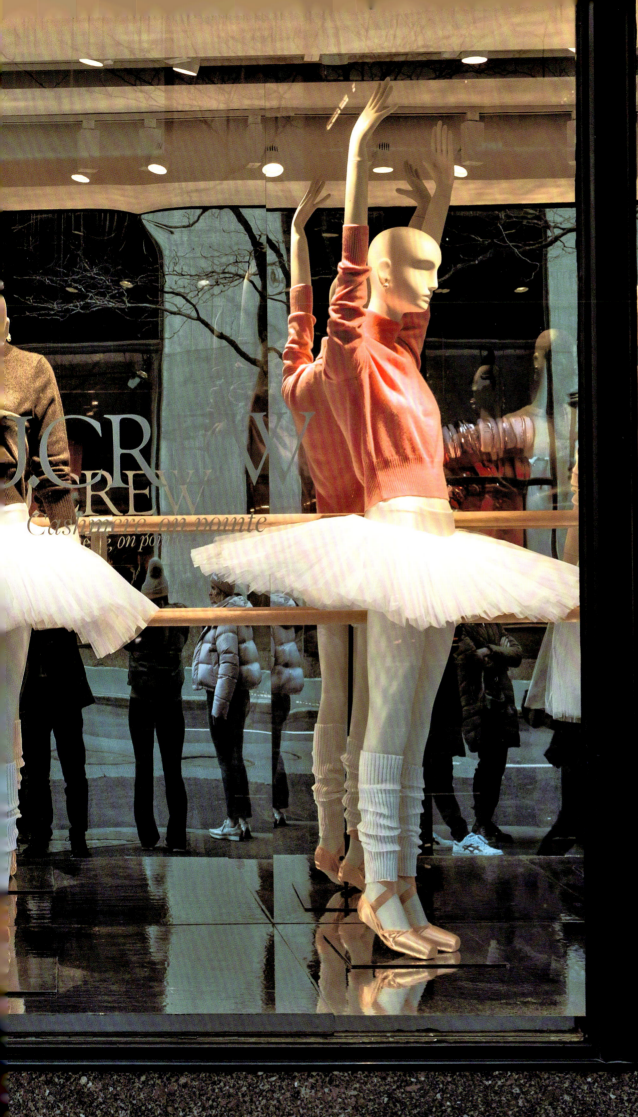

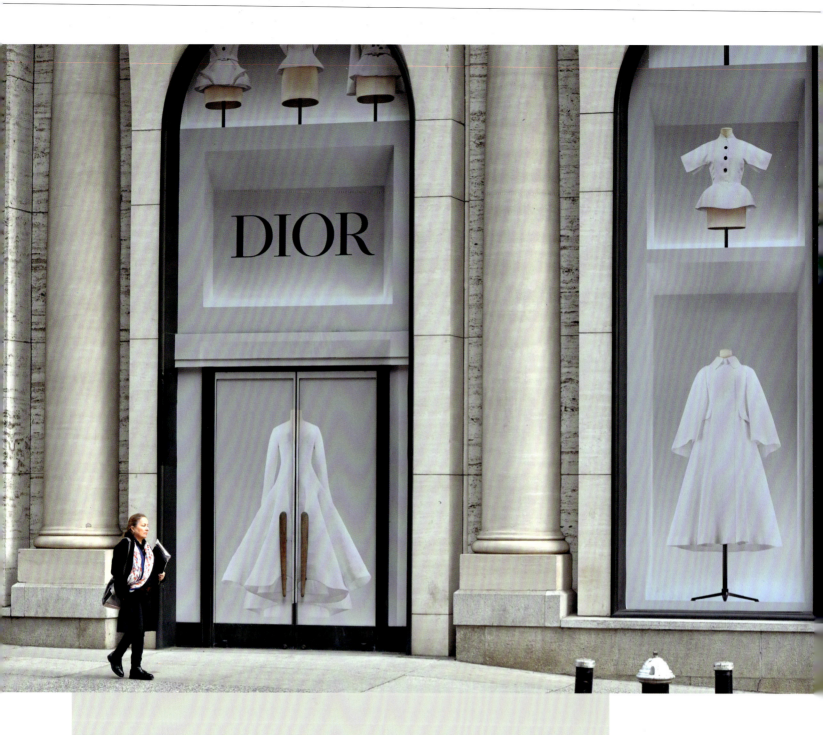

"The need for display, which is dormant in all of us, can express itself nowadays in fashion and nowhere else."

CHRISTIAN DIOR

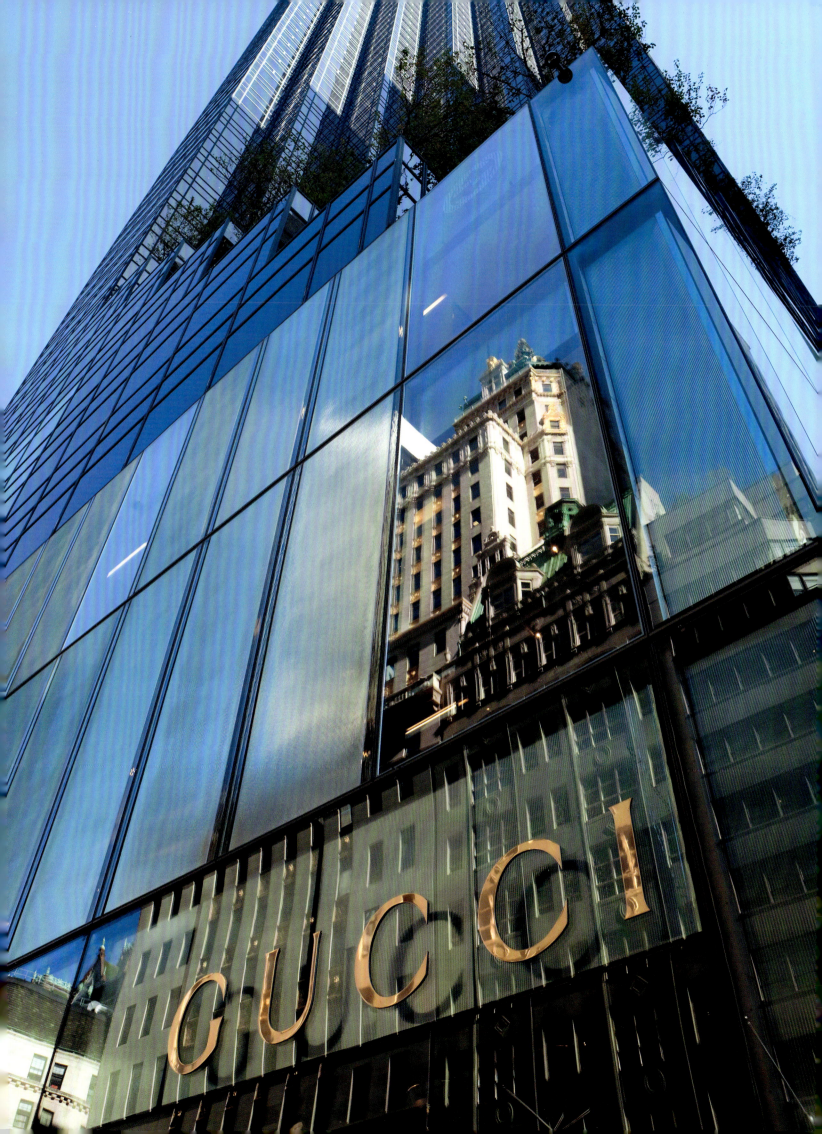

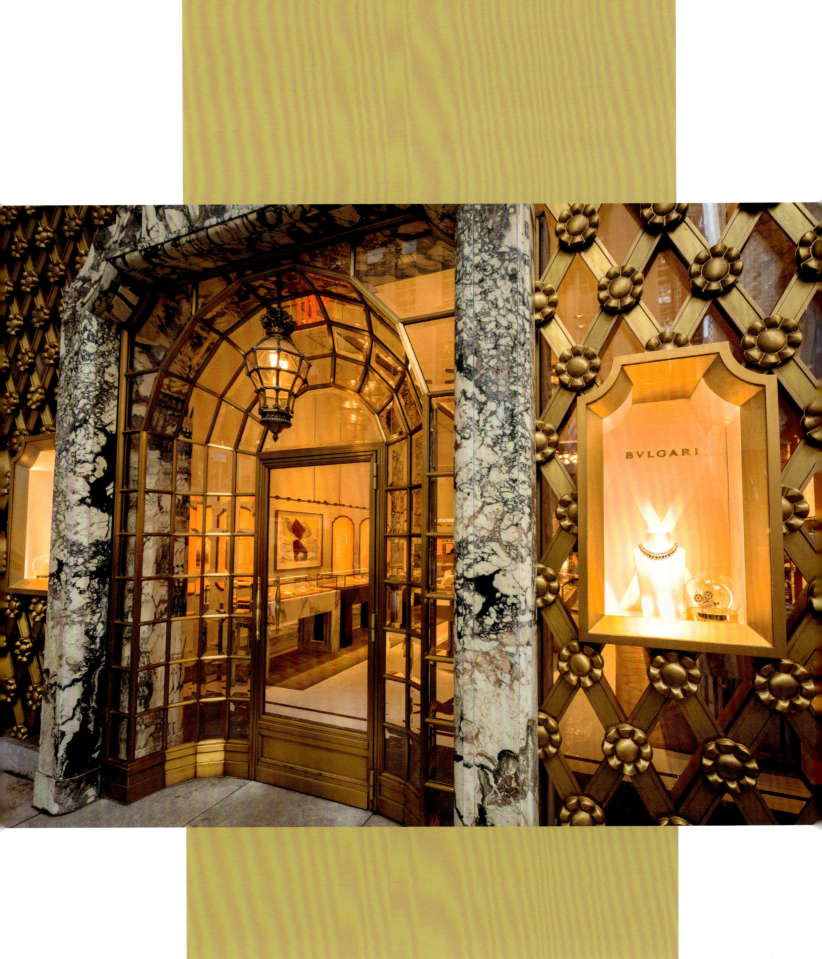

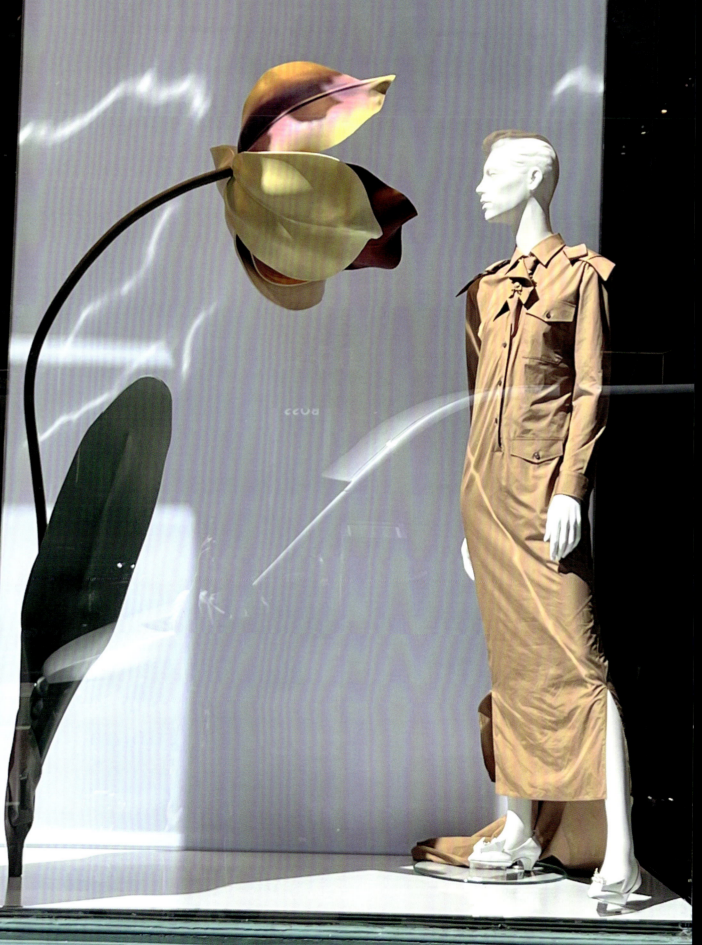

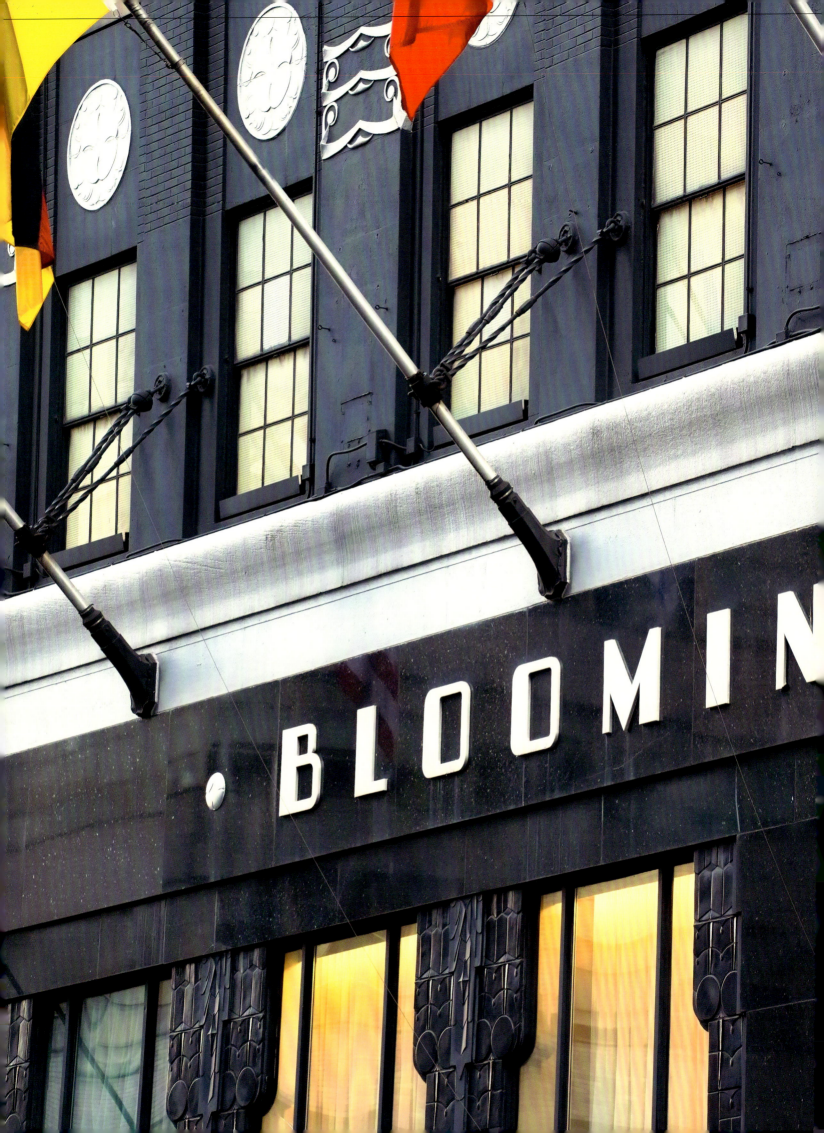

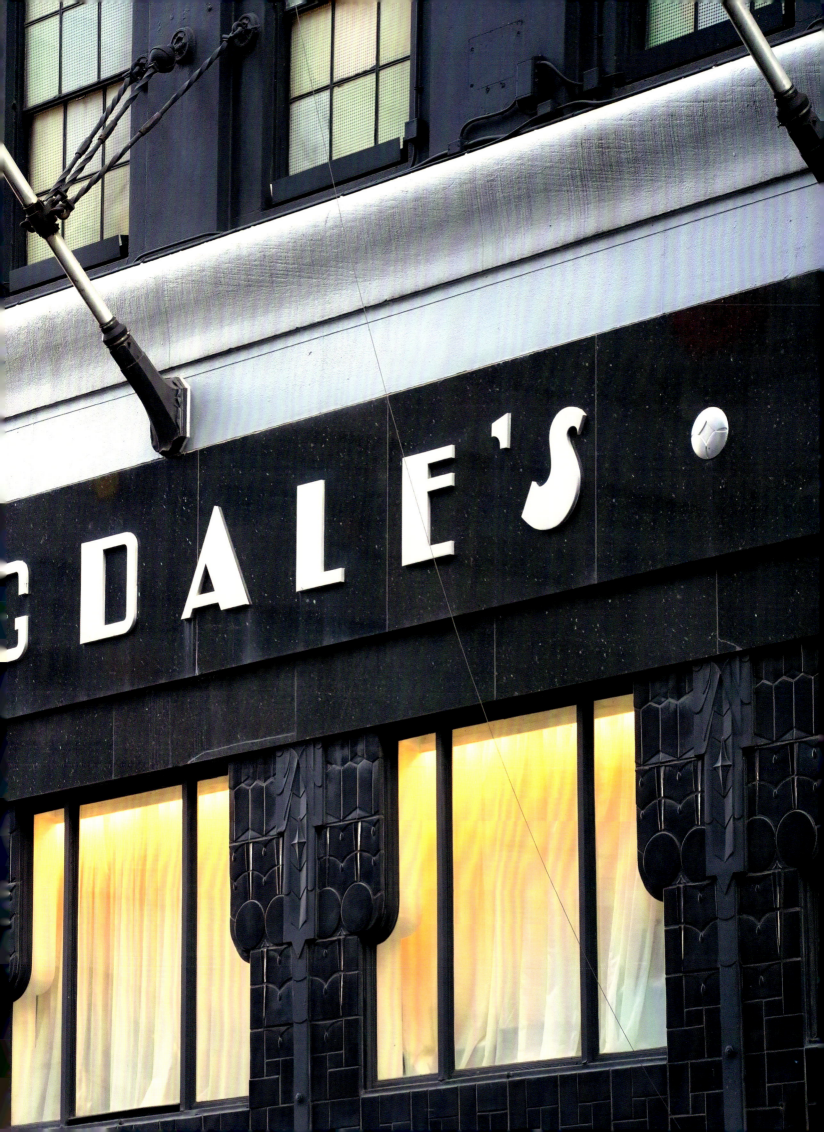

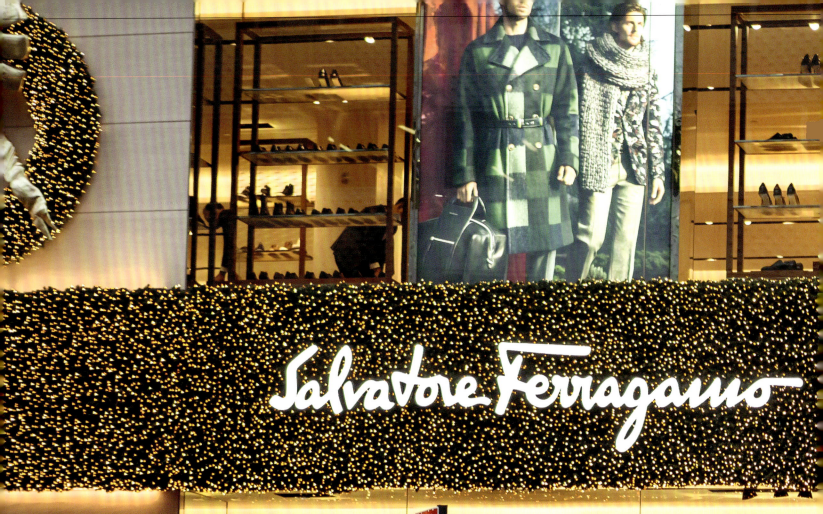

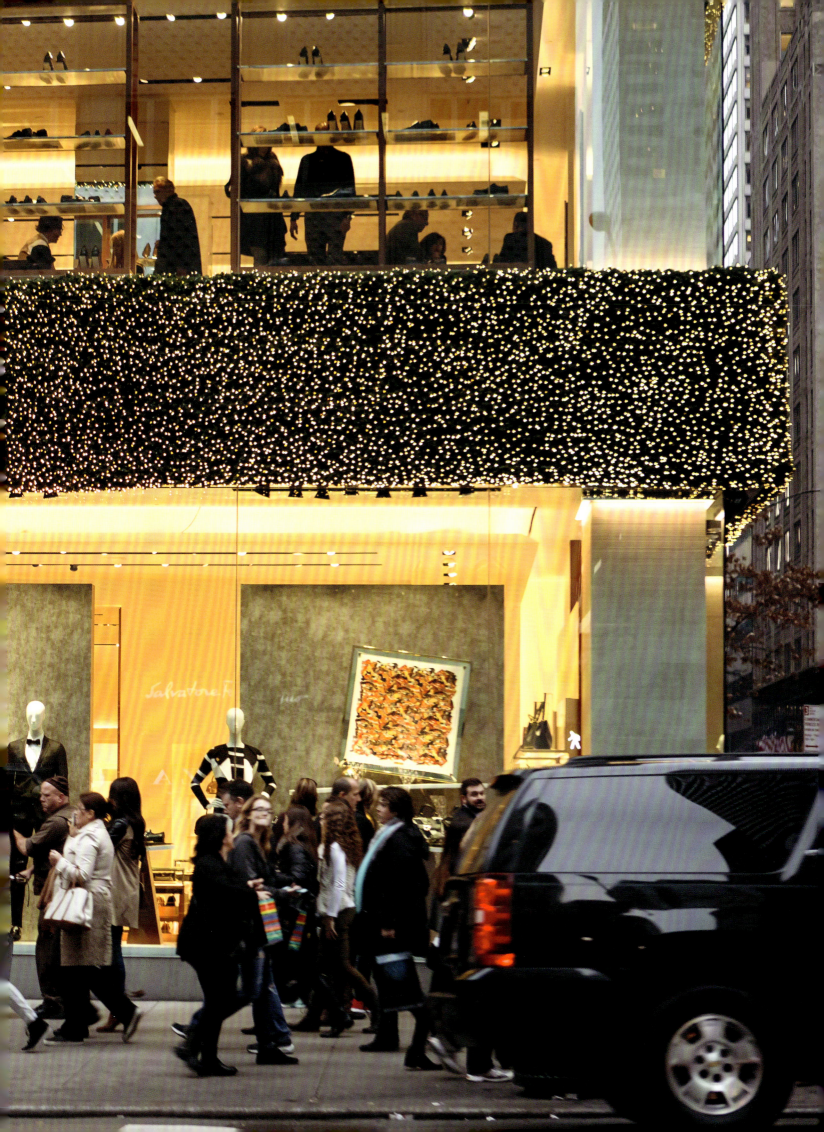

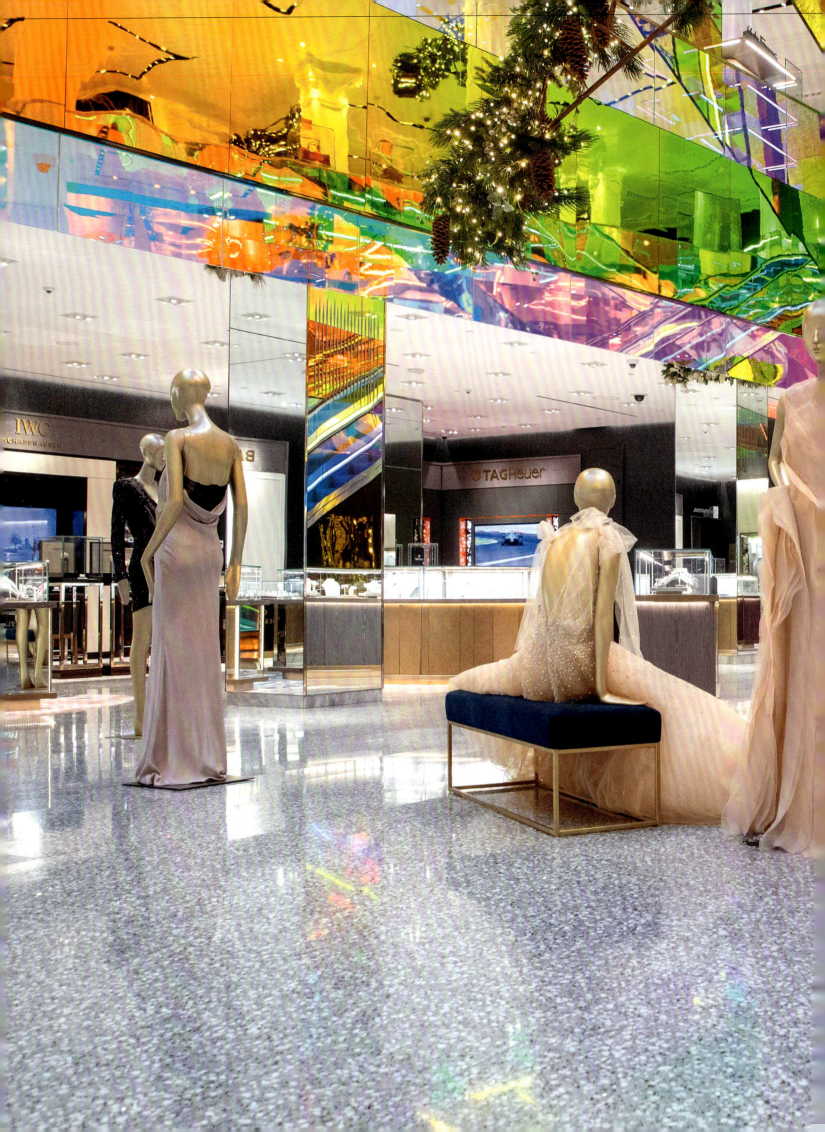

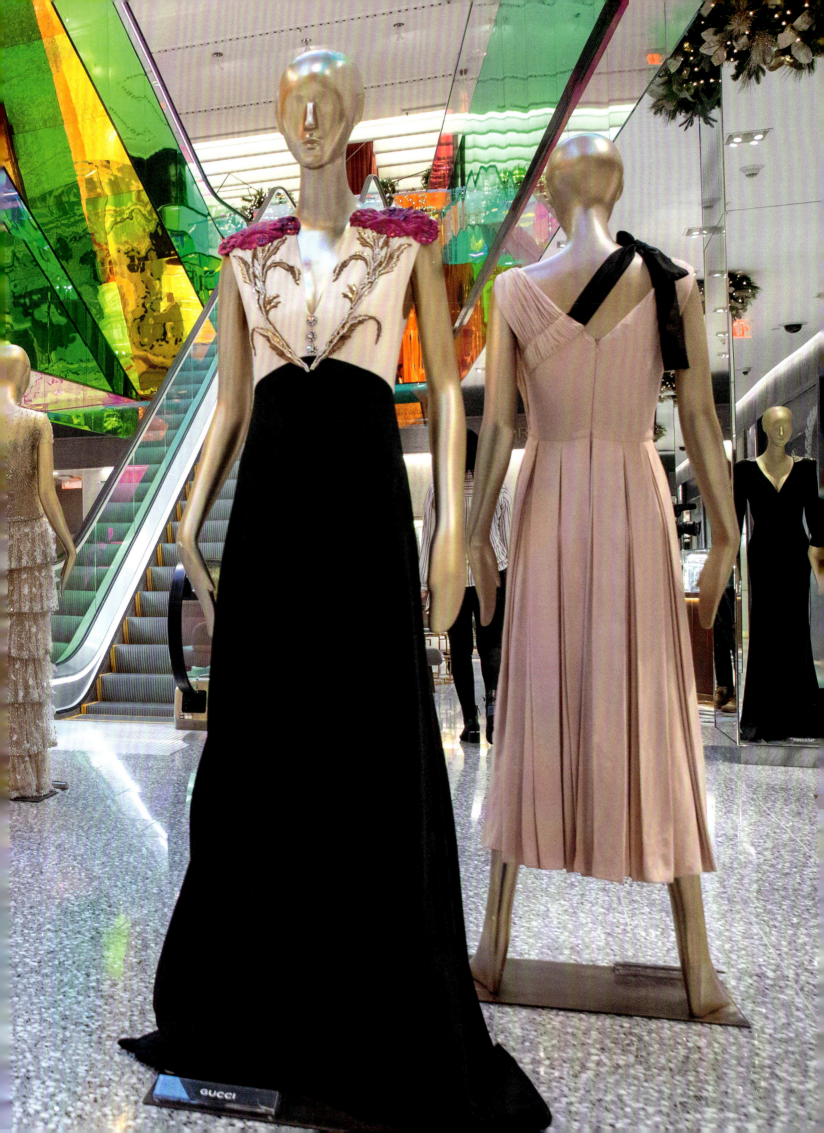

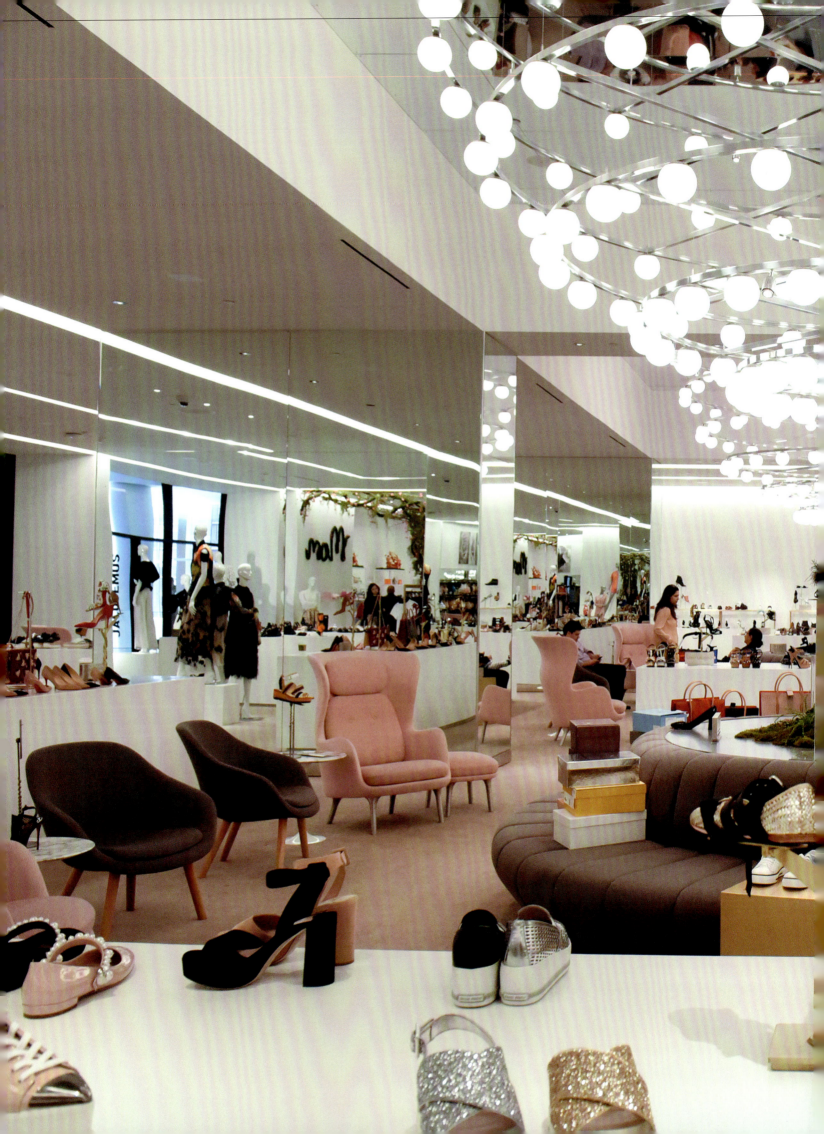

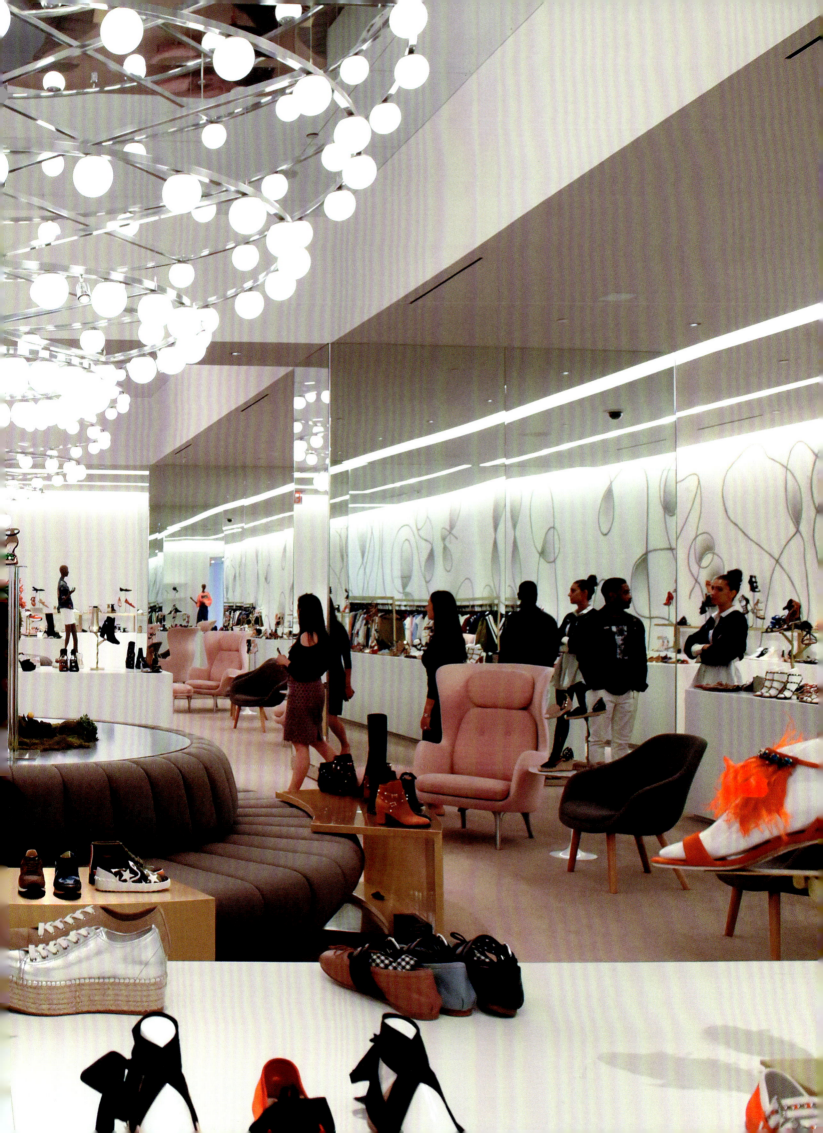

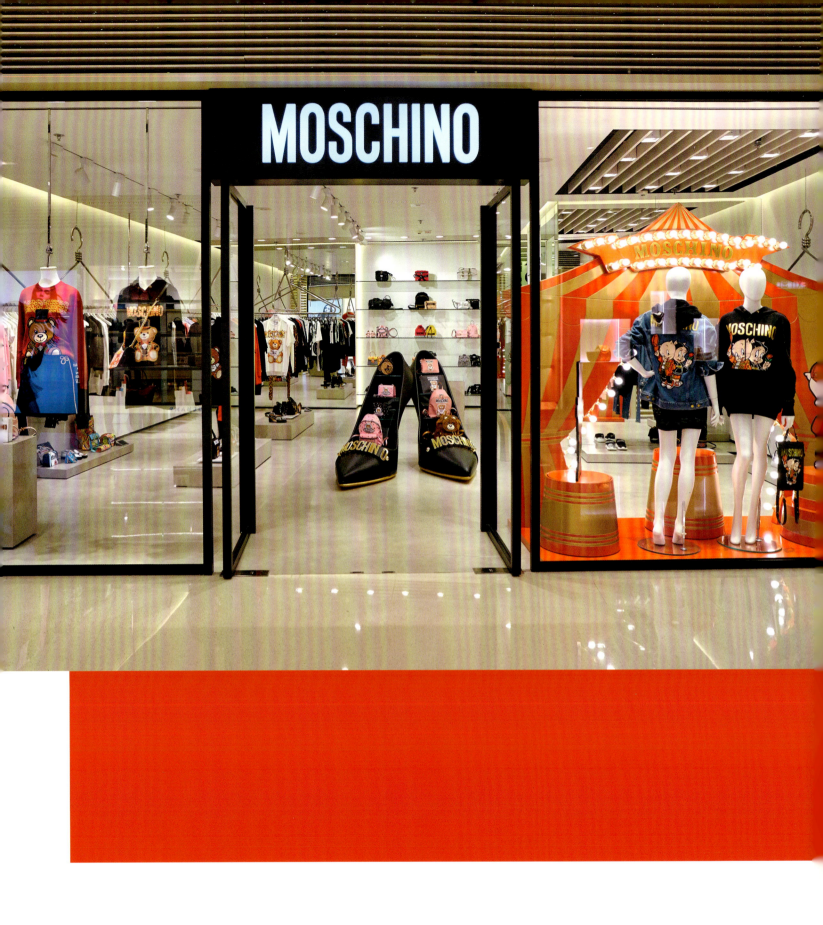

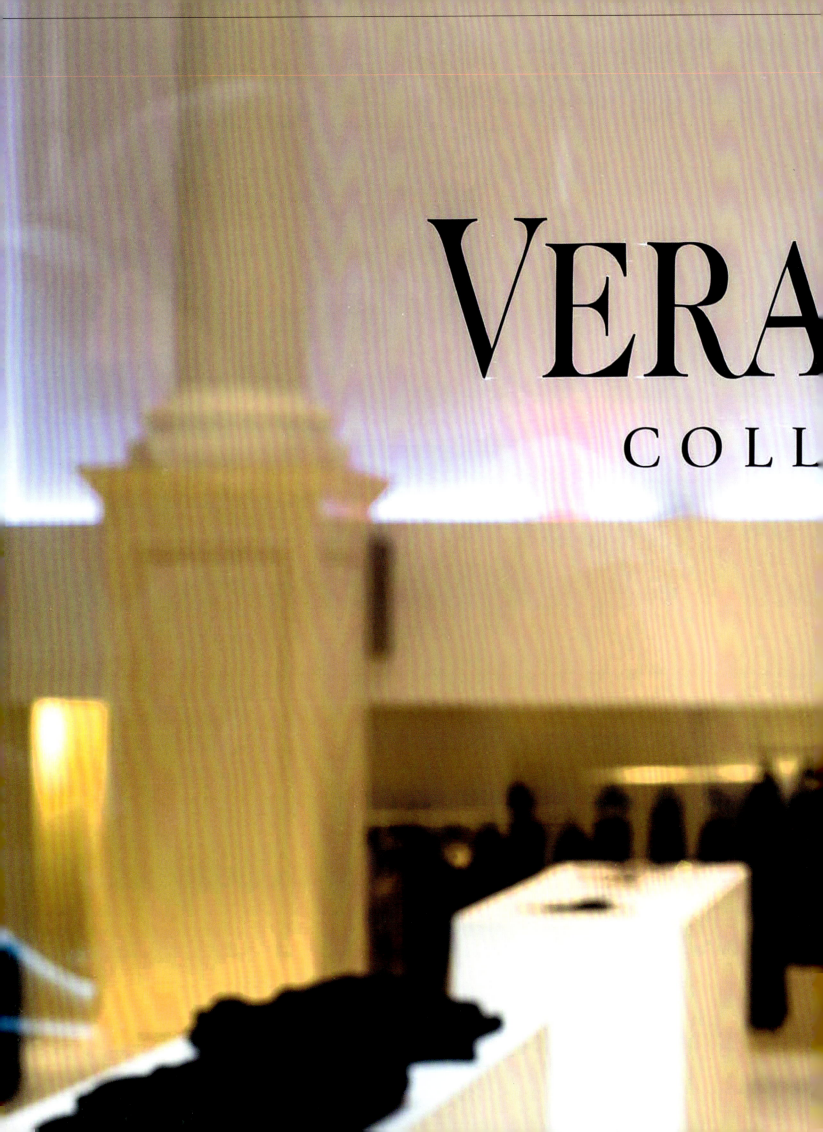

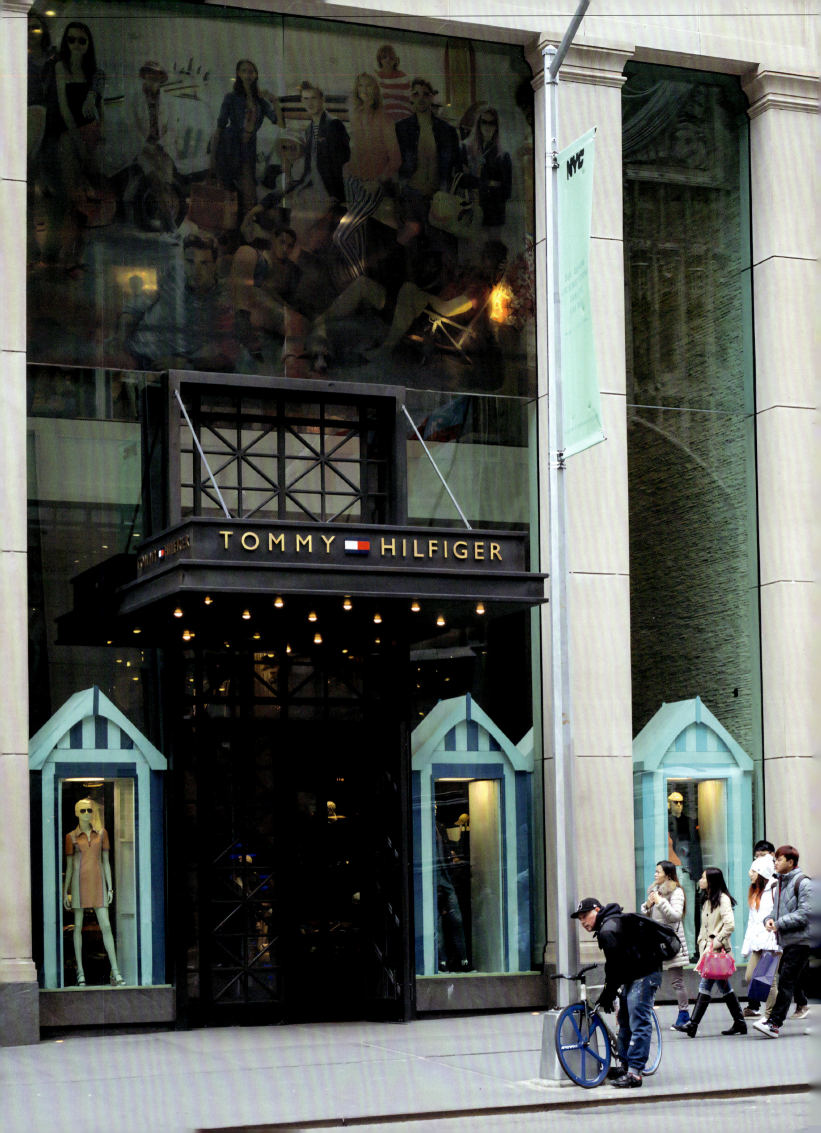

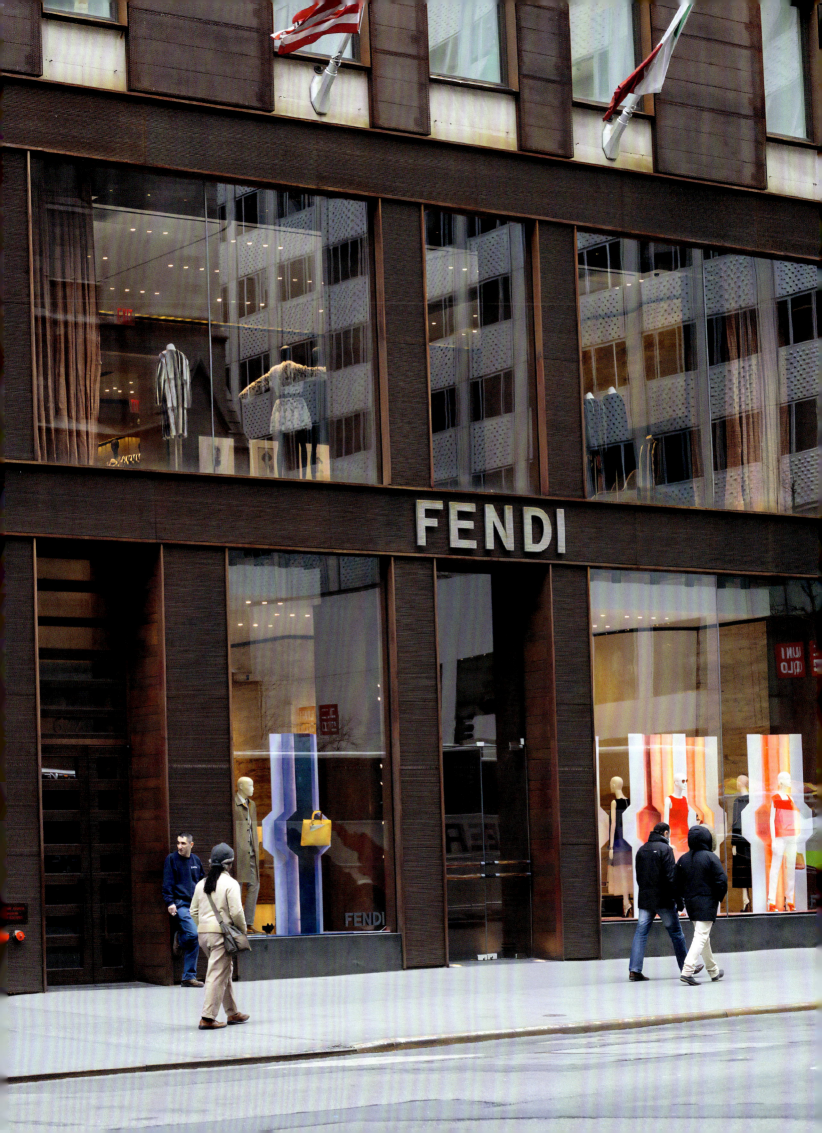

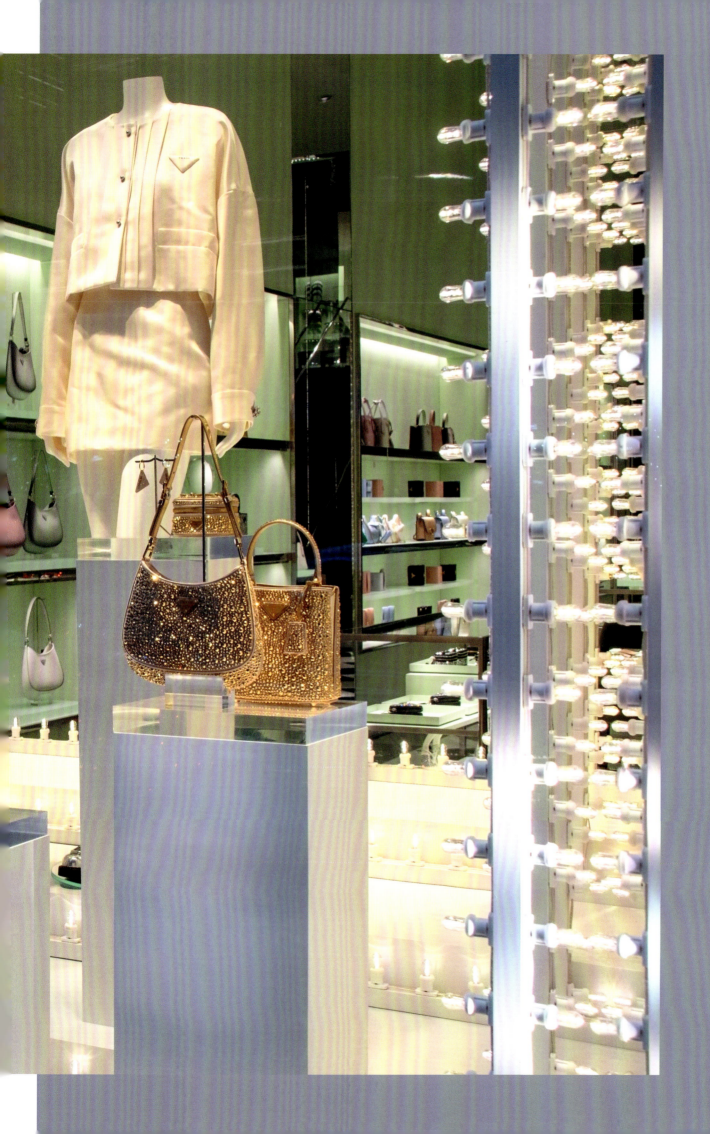

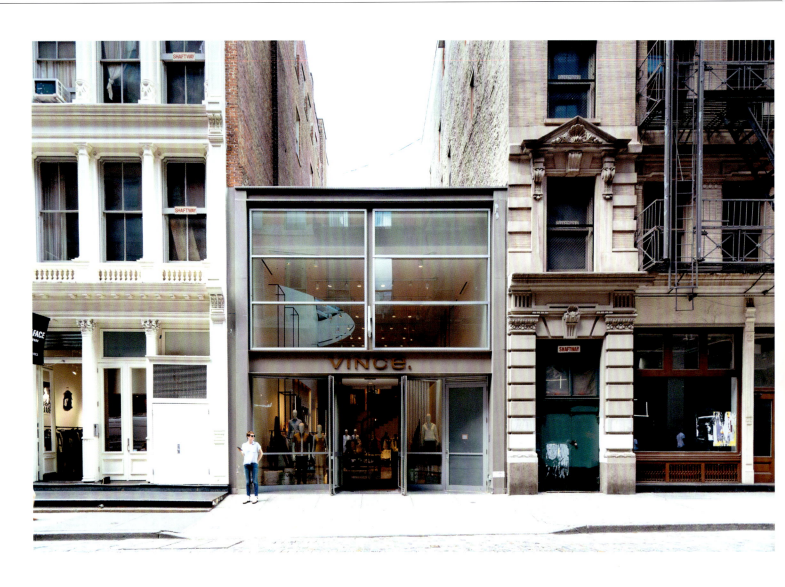

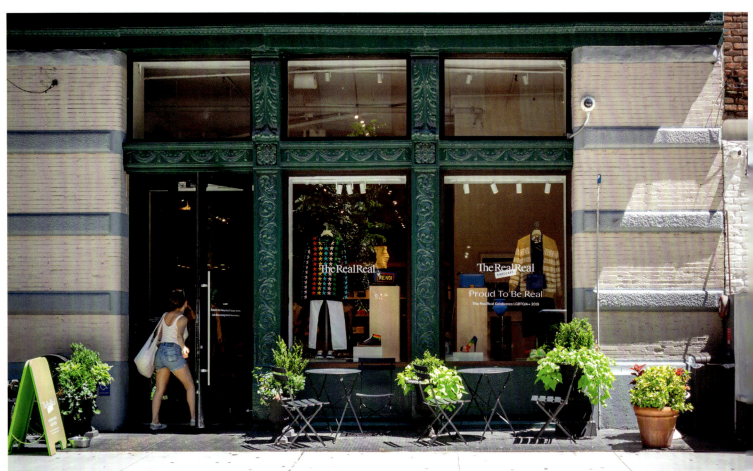

"I love coming to SoHo exploring the neighborhood for two or three days, and seeing what's new. It is definitely a busy and happening spot."

NANA JACQUELINE

"For years, Village rebels have favored biker jackets and ballet flats, rugged dungarees and louche trench coats. Today, vibrant fashion companies like Coach continue to rock this insouciant style."

LYNN YAEGER, *VOGUE*

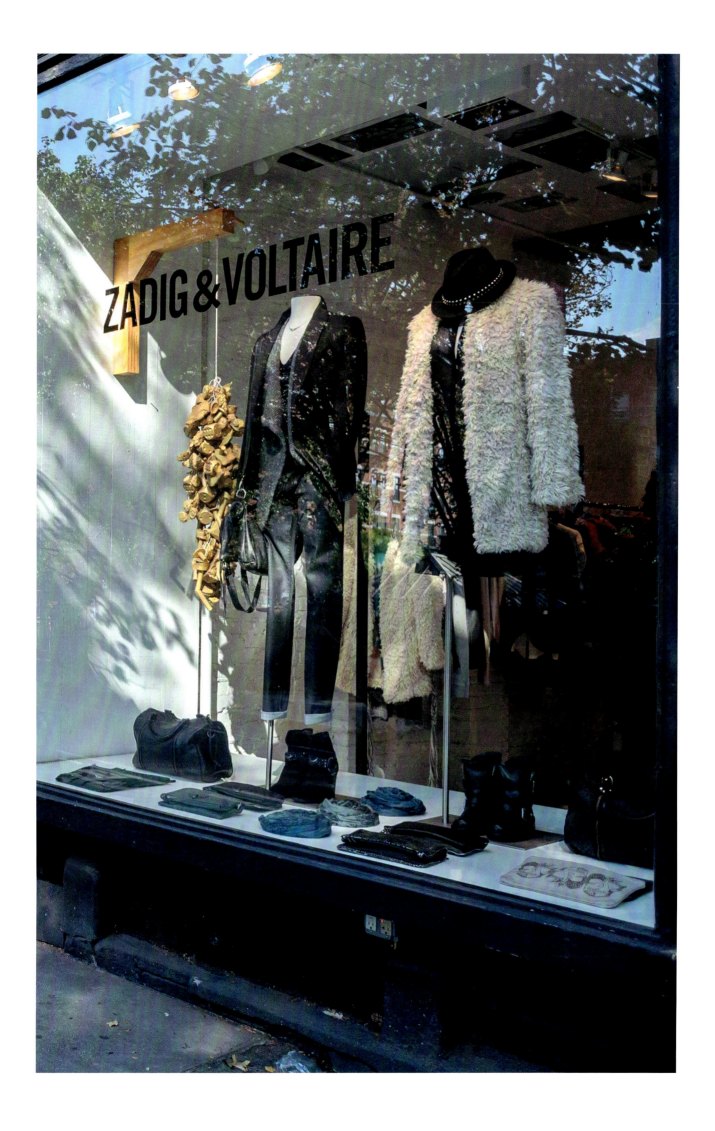

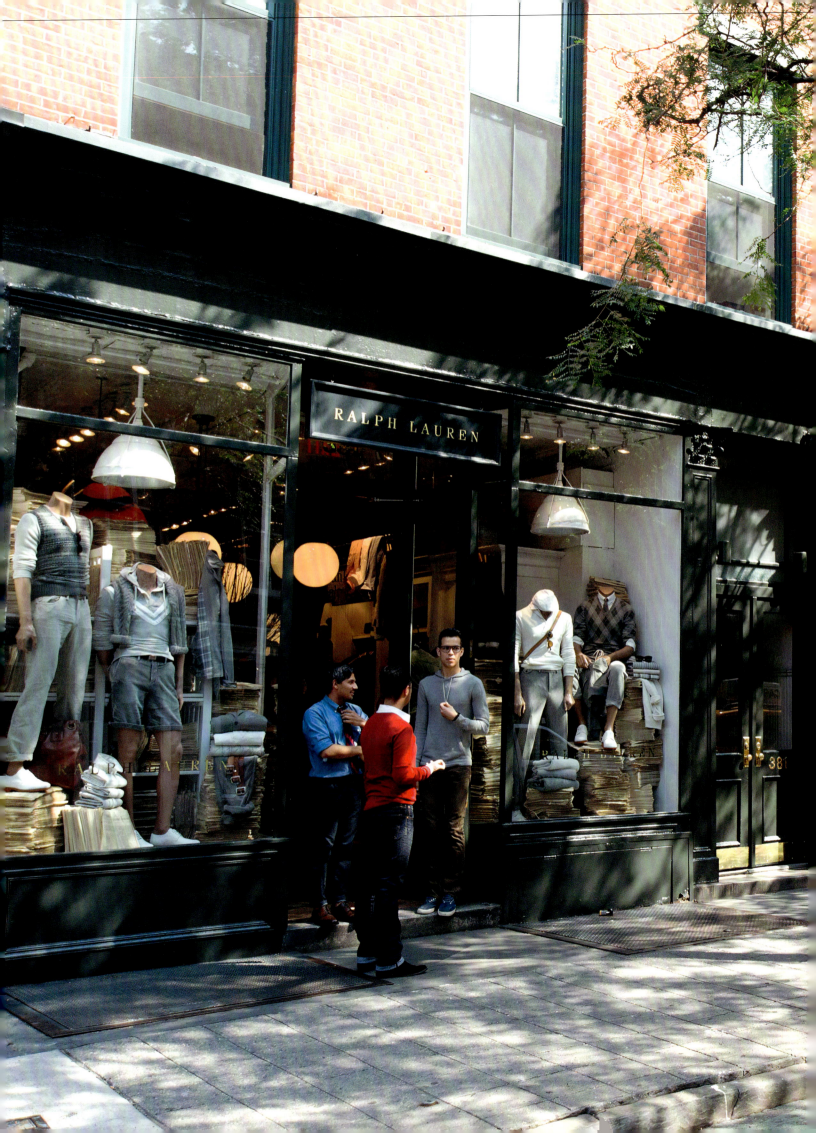

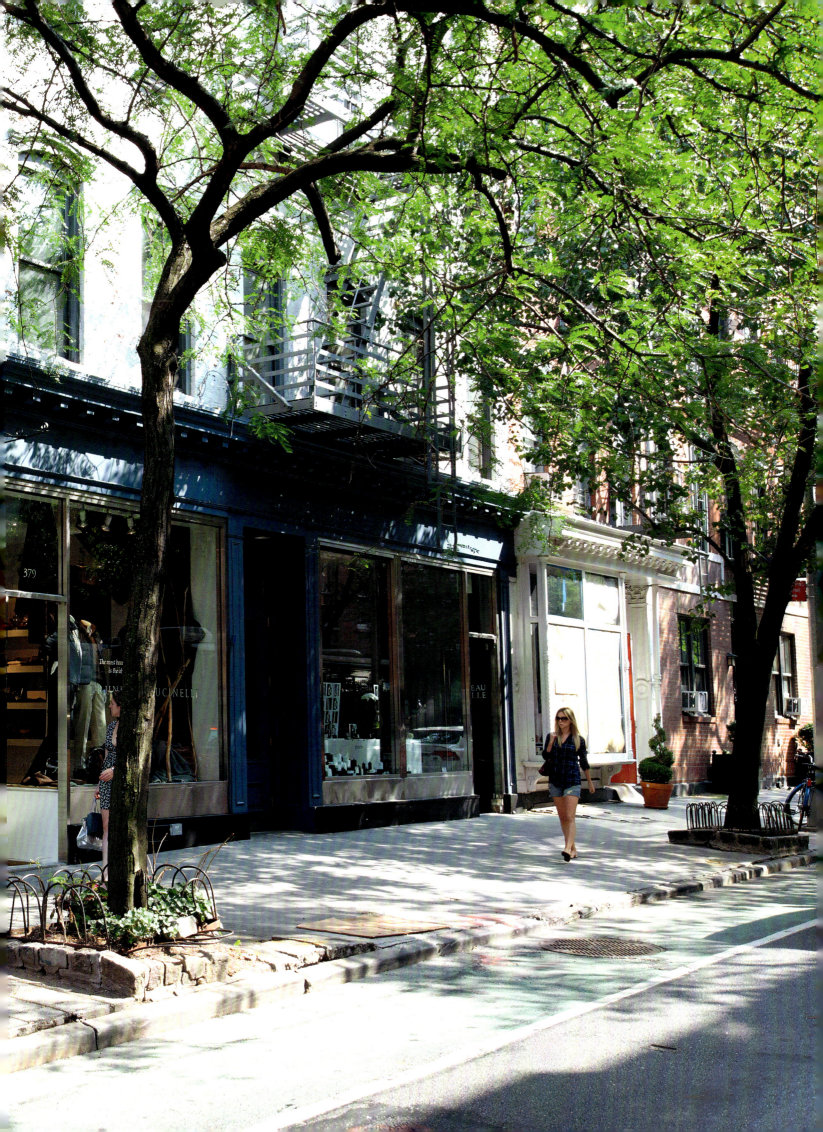

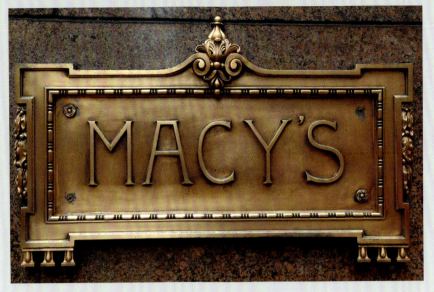
Sign at Macy's Herald Square on Broadway.

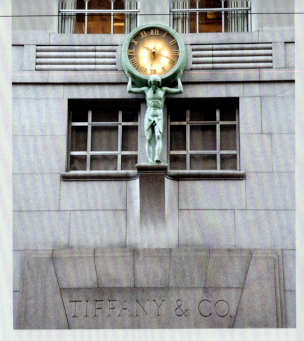
Tiffany & Co. façade on 5th Avenue.

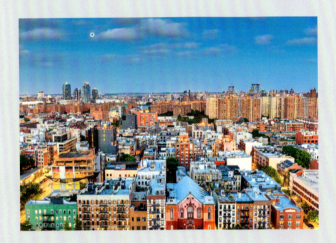
An aerial view of Lower East Side as twilight nears, 2018.

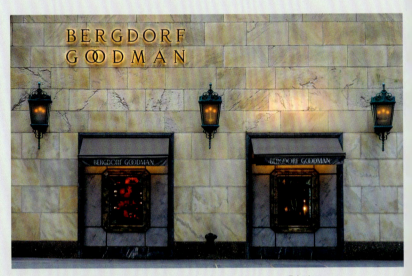
Façade of the Bergdorf Goodman department store on 5th Avenue.

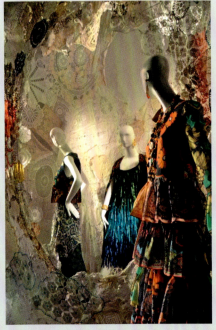
Holiday window displays at Bergdorf Goodman, December 2014.

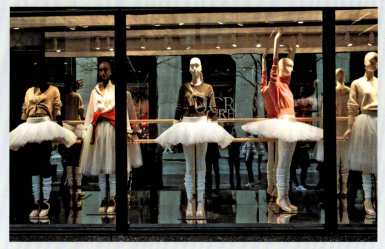

A festive window featuring ballerina mannequins at the J.Crew store, Rockefeller Center, December 2023.

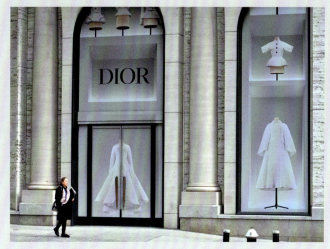

Façade of the Christian Dior store on 5th Avenue.

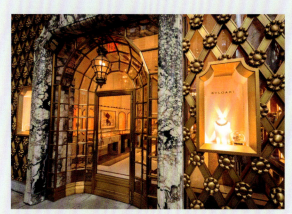

Façade of the Bvlgari store on 5th Avenue.

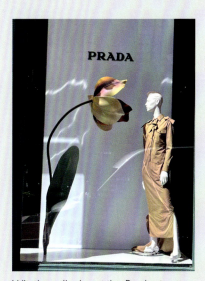

Window display at the Prada store on 5th Avenue.

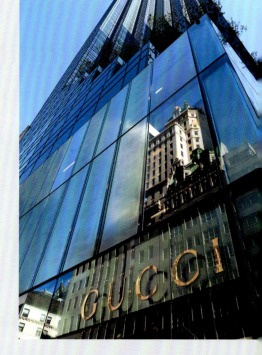

Façade of the Gucci store on 5th Avenue.

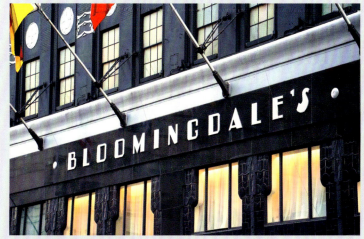

The Art Deco façade of Bloomingdale's department store on 3rd Avenue.

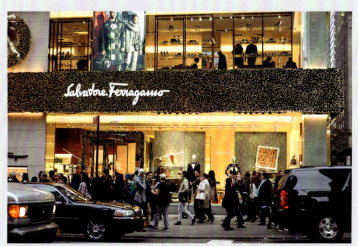

The Salvatore Ferragamo store on 5th Avenue during the holiday season.

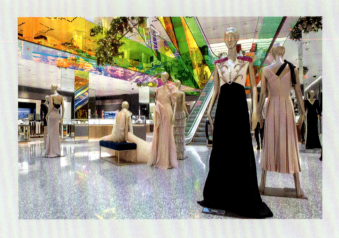
Saks interior on 5th Avenue.

View of the Vera Wang store in SoHo, New York.

The façade and interior of the Moschino store in SoHo.

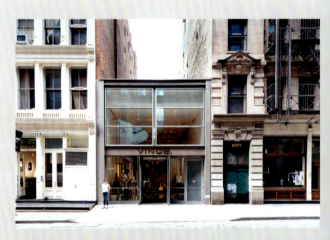
A shoe display in Saks.

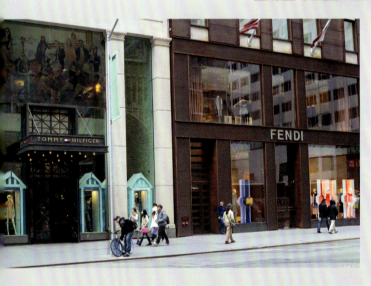
Flagship stores of Tommy Hilfiger and Fendi on 5th Avenue.

Fashion shop on Mercer Street, SoHo.

Window display at the Prada flagship on 5th Avenue.

The RealReal fashion store, SoHo.

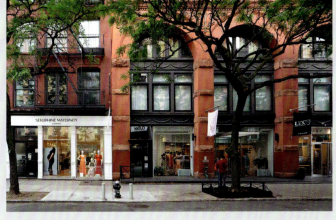

A signpost on the corner of Greene Street and Prince Street.

Trendy fashion shops in SoHo.

Exclusive boutiques on West Broadway, SoHo, 2019.

A Greenwich Village signpost.

Fashion shops in Greenwich Village.

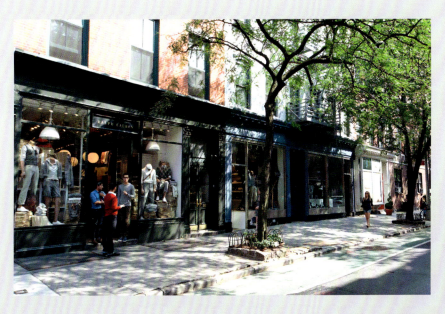

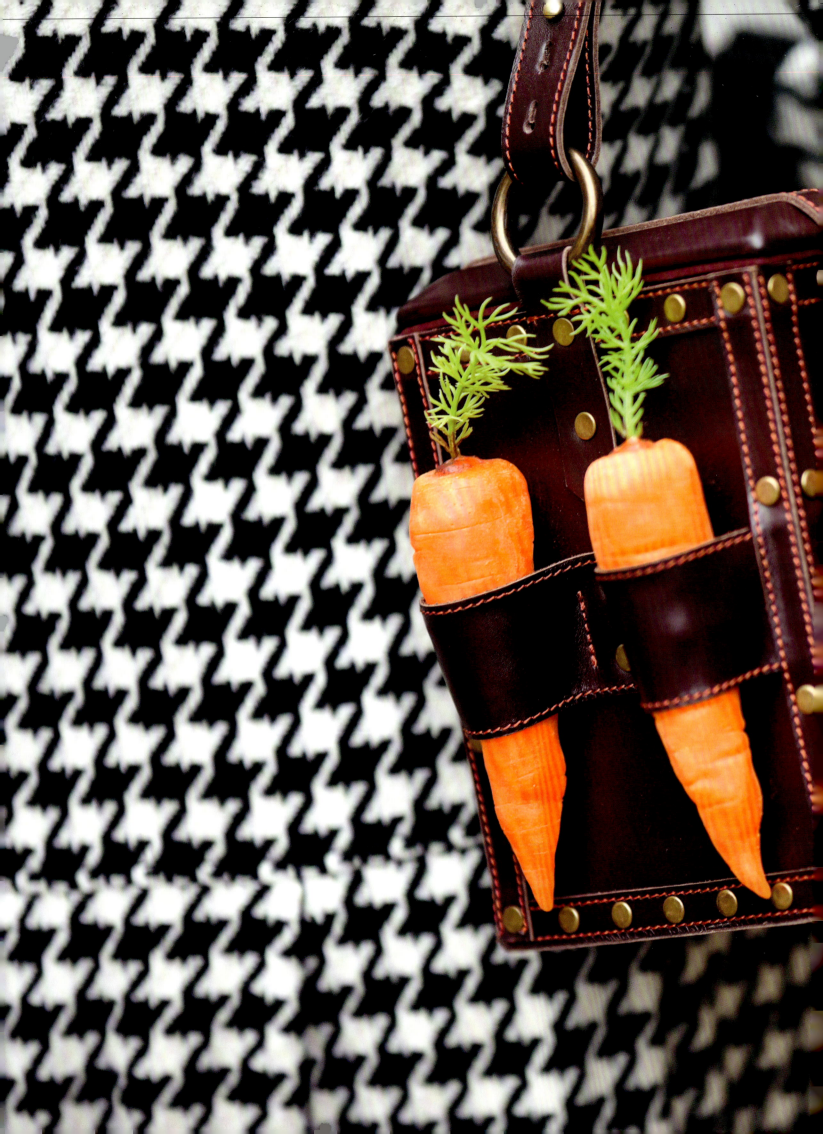

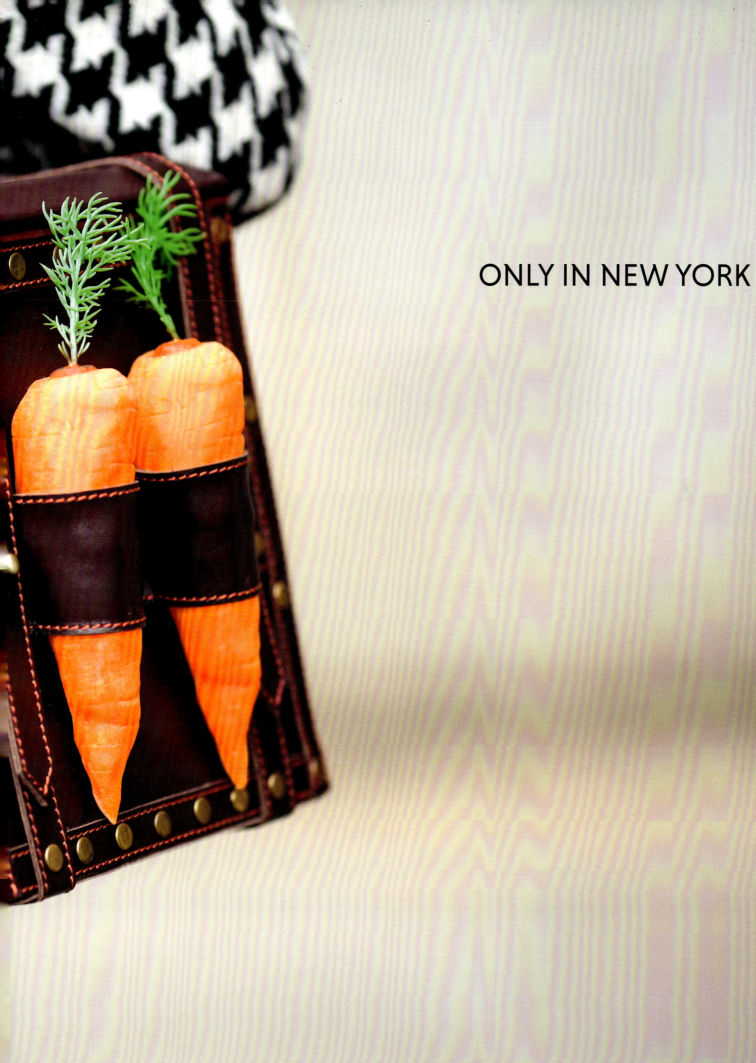

ONLY IN NEW YORK

"For me, America is New York."

MARC JACOBS

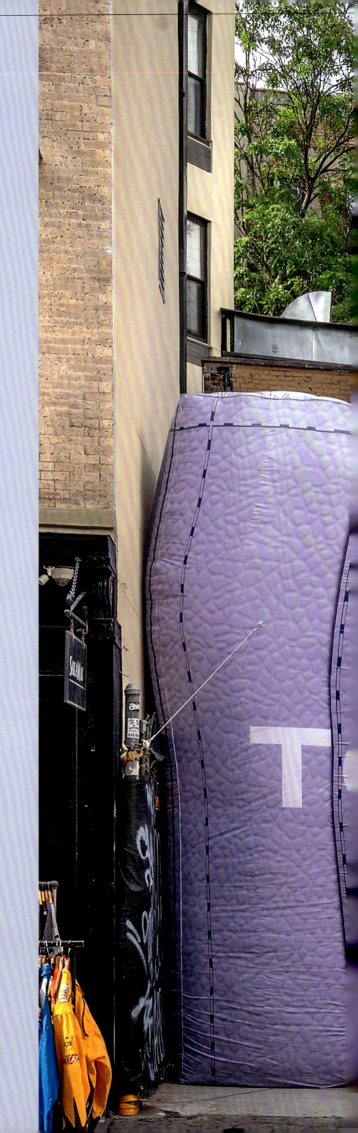

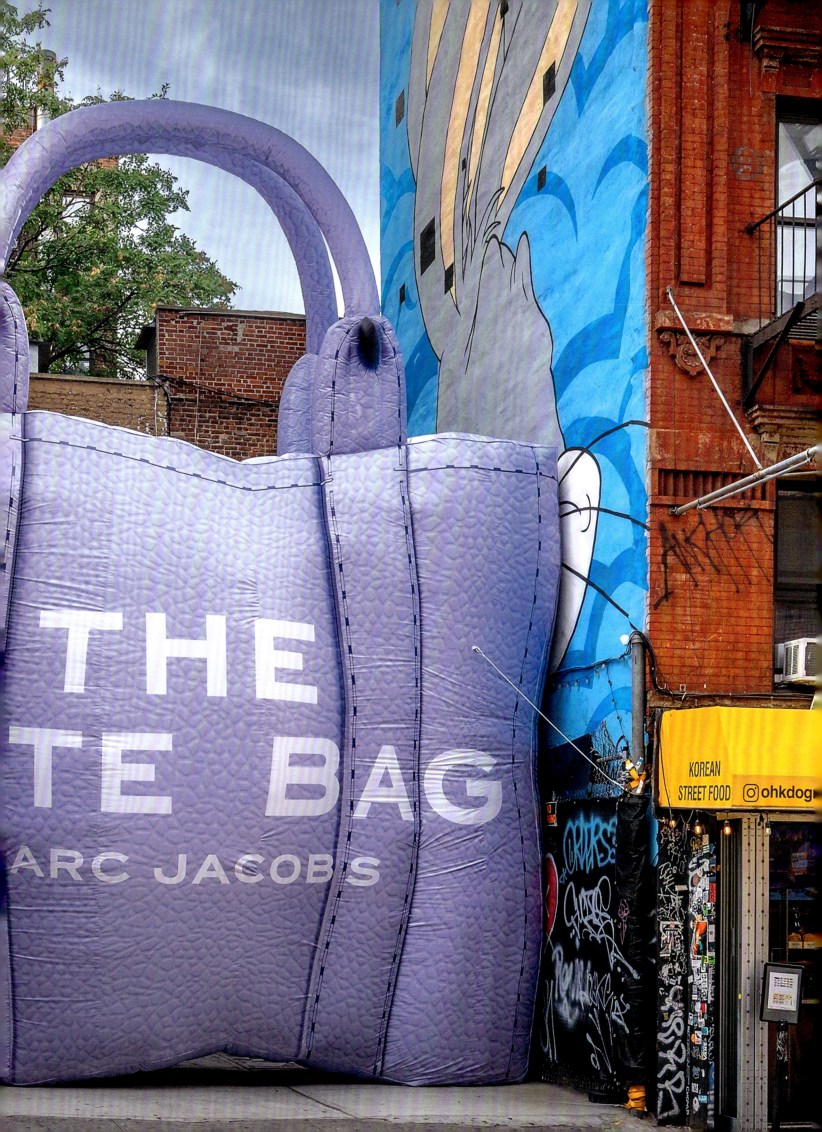

A city of superlatives, pulsating energy, and striking contrasts, New York is unique in many ways. The Big Apple is not only the world's financial capital, but also a leading tech cluster, an unrivalled crossroads of cultures and traditions (40% of New York's residents were born abroad), a global village attracting businesspeople, entrepreneurs, shoppers, and tourists, and a fantastic incubator of creative talents. A relatively unheralded personality in the New York fashion scene perfectly illustrates the kaleidoscope of assets that have made the city so famous. An outstanding talent scout, a brilliant publicist, and a fashion promoter, Eleanor Lambert (1903–2003) was one in a million. As Erin Skarda of *Time* magazine put it, in an homage to Lambert's long career:

> "After growing up in Indiana as a student of art and design, Lambert began her career as a publicist at a New York City ad agency. She quickly established herself as an authority in the art world, representing such famed artists as Walt Kuhn, Jackson Pollock, and Isamu Noguchi, before becoming the first ever press director of the Whitney Museum of American Art and helping to found the Museum of Modern Art. Always searching for ways to integrate art with fashion, Lambert used her diverse talents to establish the famed Costume Institute at the Metropolitan Museum of Art, which is still known for its glittering, high-society balls. But of all her accomplishments, none is more significant than the creation of what she termed 'Fashion Press Week' (1943), a semiannual exhibition of American fashion designers hosted in New York City, which eventually became the present-day New York Fashion Week."

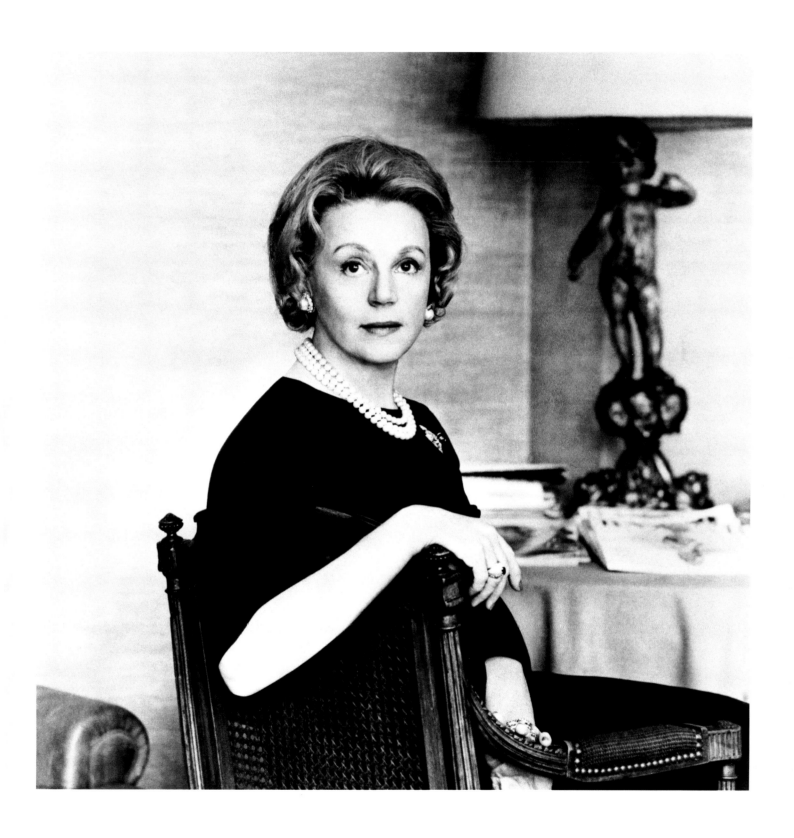

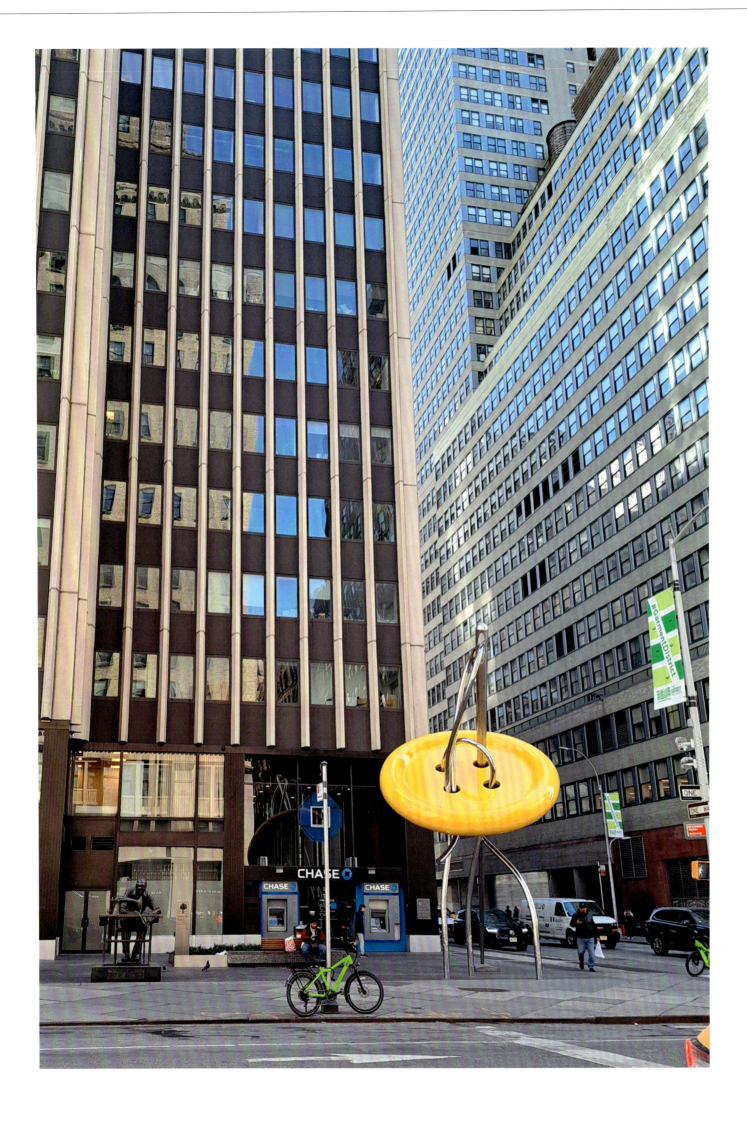

It was also Eleanor Lambert who, in 1948, launched the Costume Institute Benefit, a haute couture gala aimed at funding the newly opened Metropolitan Museum's Costume Institute (now known as the Anna Wintour Costume Center). Since then, the Met Gala has transformed into an internationally renowned fashion and glamour event, where celebrities flaunt their sartorial elegance, as if to remind us that the gala's initiator was also the author of *Vanity Fair*'s annual International Best-Dressed Hall of Fame. Lambert was instrumental in setting up the Council of Fashion Designers of America (CFDA) in 1962 and in organising the legendary "Battle of Versailles", on 28 November 1973, which saw New York couturiers gain the upper hand over their French counterparts, thus confirming the consecration of New York as a fashion capital.

Eleanor Lambert would have deserved a plaque in the New York Fashion Walk of Fame, a project initiated by the Fashion Center in 1999. Similar to Hollywood's Walk of Fame, it celebrated some of the most famous fashion designers who contributed to making New York a fashion hotspot. Anne Klein, Oscar de la Renta, Donna Karan, Ralph Lauren, Calvin Klein, Diane von Furstenberg, and Marc Jacobs were among the 28 names honoured with a plaque. Unfortunately, the plaques were removed by the municipal authorities after complaints that they were slippery on rainy days...

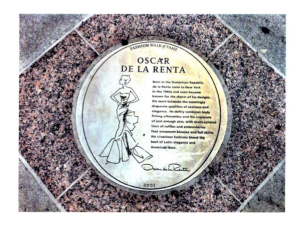
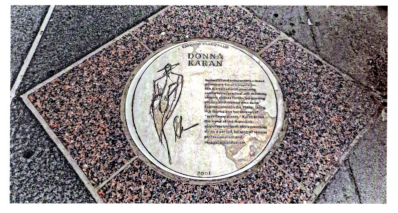

From a more pragmatic point of view, New York offers a unique advantage for all fashion-conscious people: a canvas for personal style. In this city of absolute eclecticism, every individual can find their own sartorial expression and blend into the symphony of garments that brings together everything from the ultimate sophistication of uptown Manhattan to the edgy, artistic vibes of Brooklyn. Nothing will ever look too avant-garde, eccentric or transgressive for New York standards. This total open-mindedness gives the New York fashion scene its extraordinary dynamism, a feeling of perpetual motion and evolution.

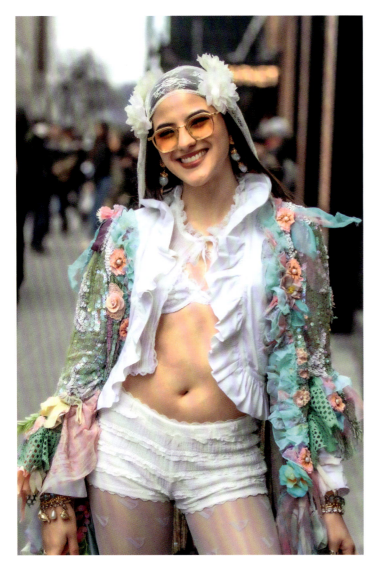
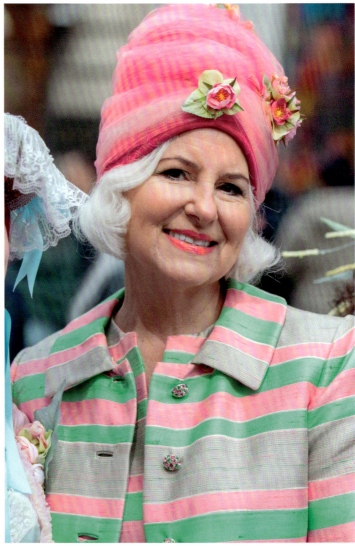

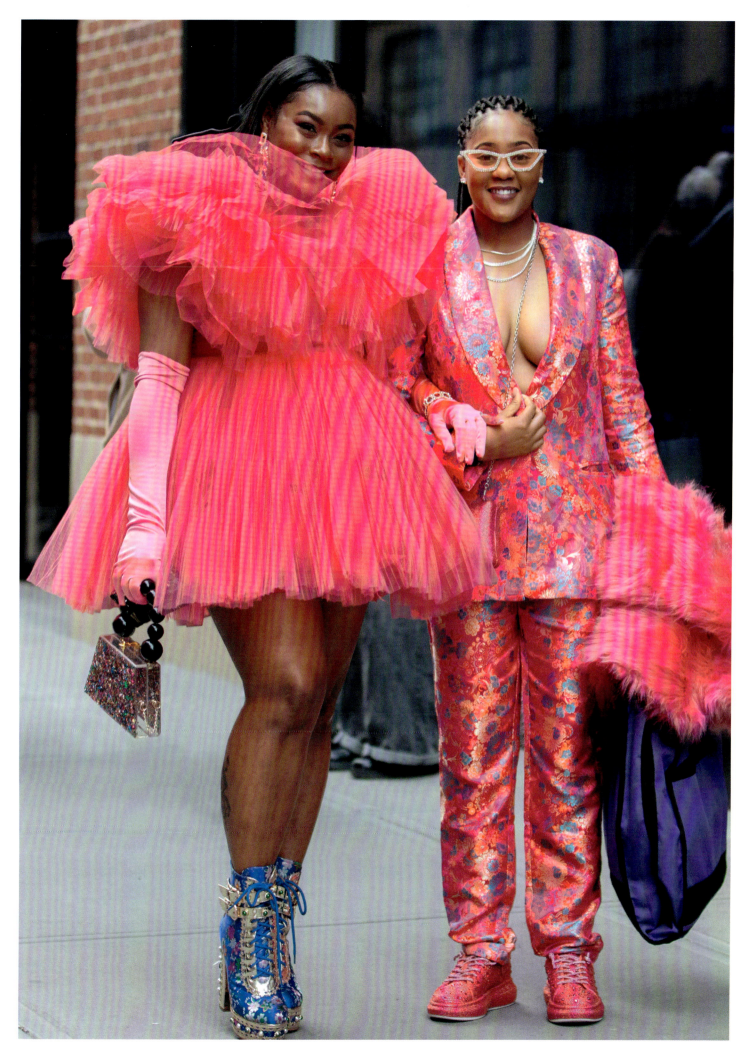

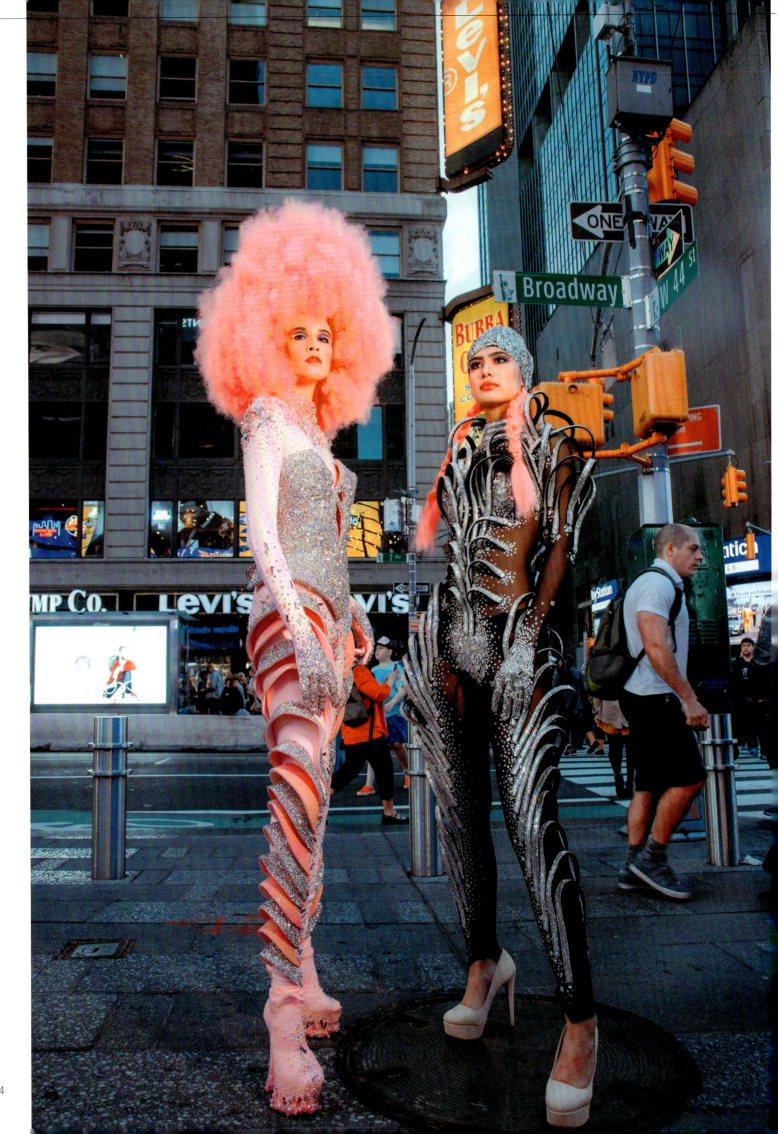

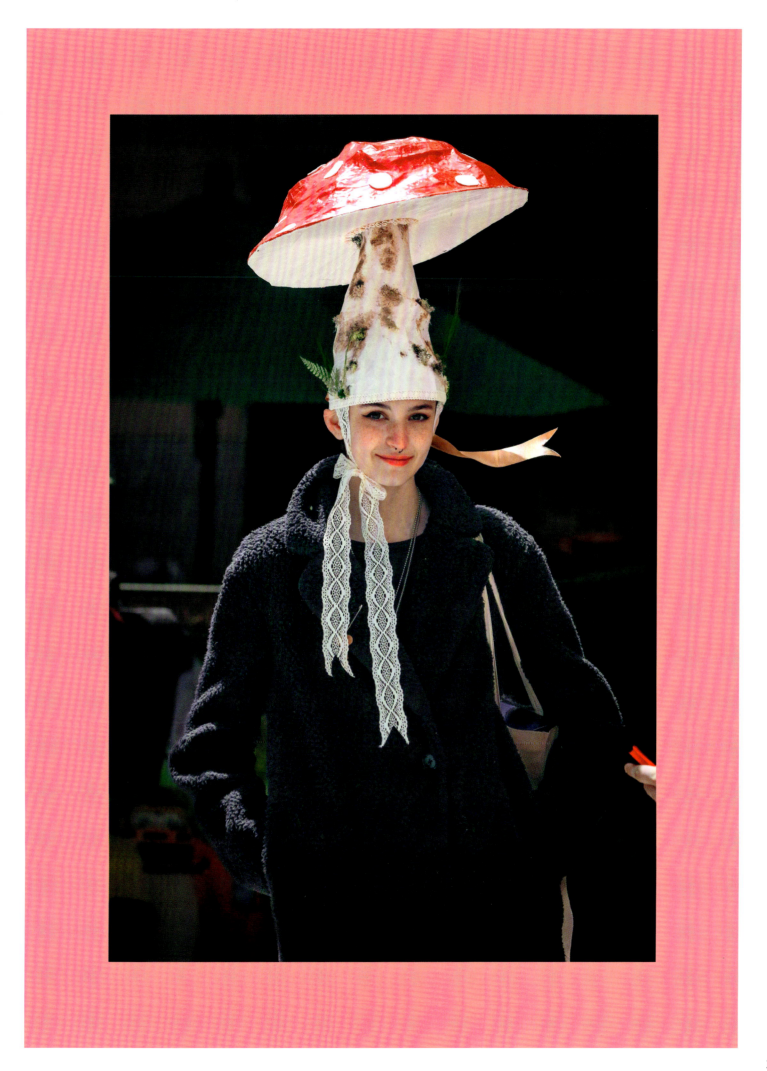

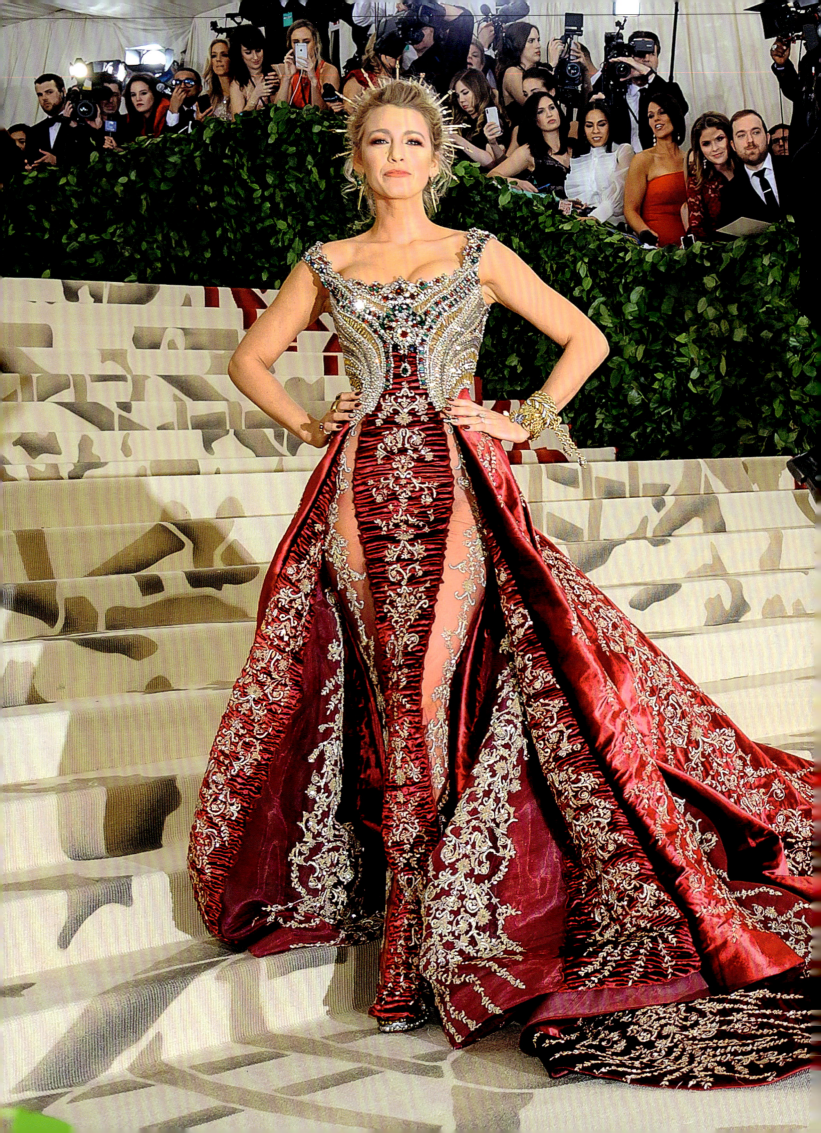

"The Met stairs, the famous red carpet, has grown in spectacle over the years; it's a kind of theater."

ANNA WINTOUR

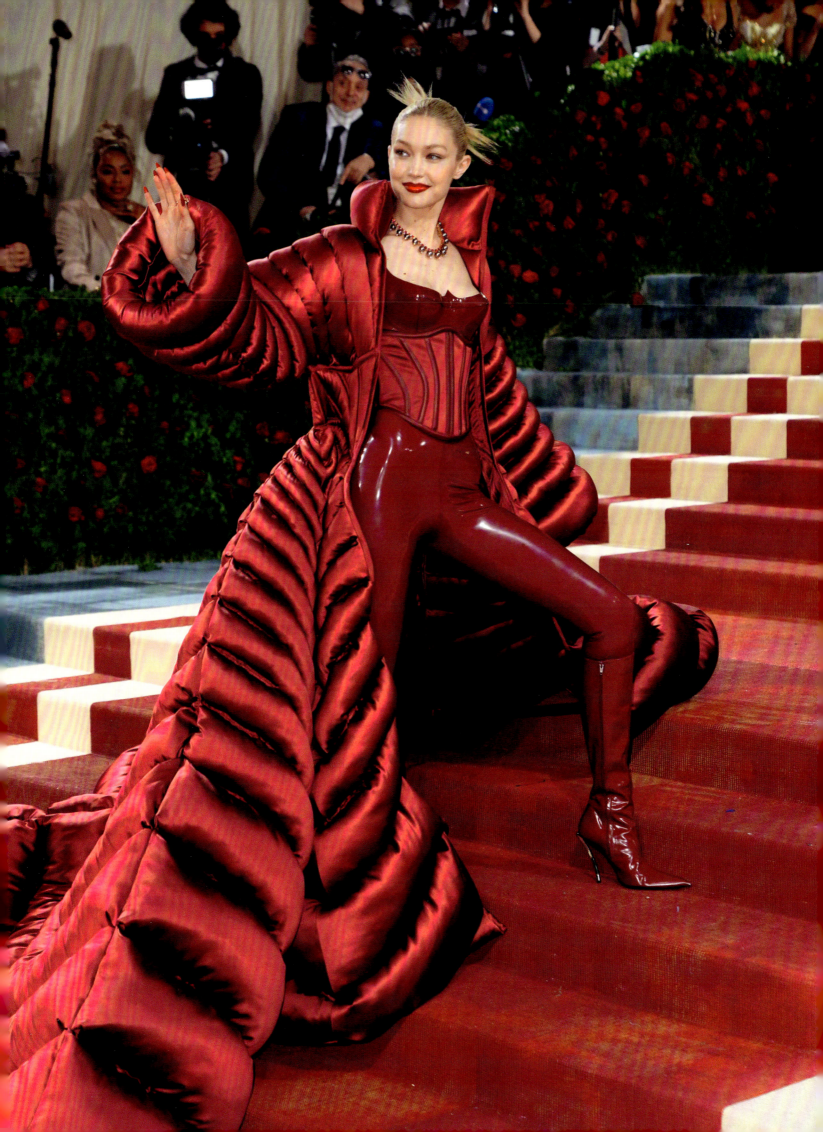

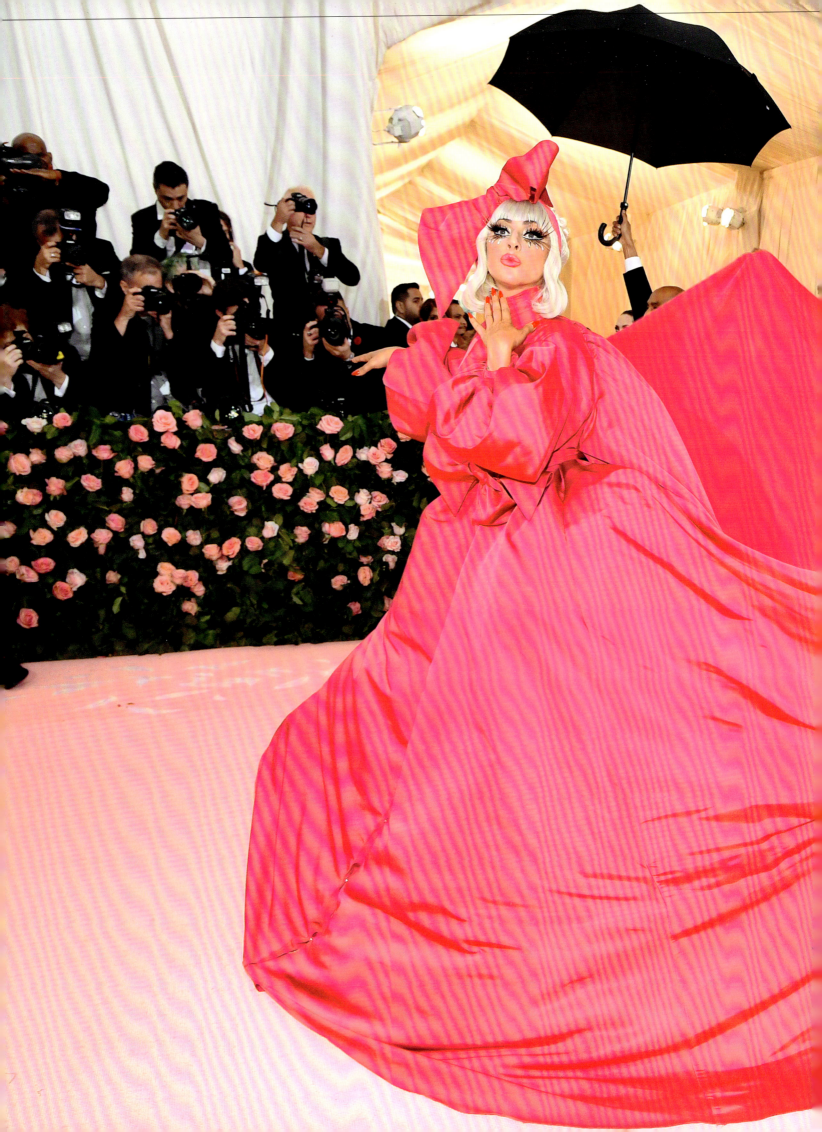

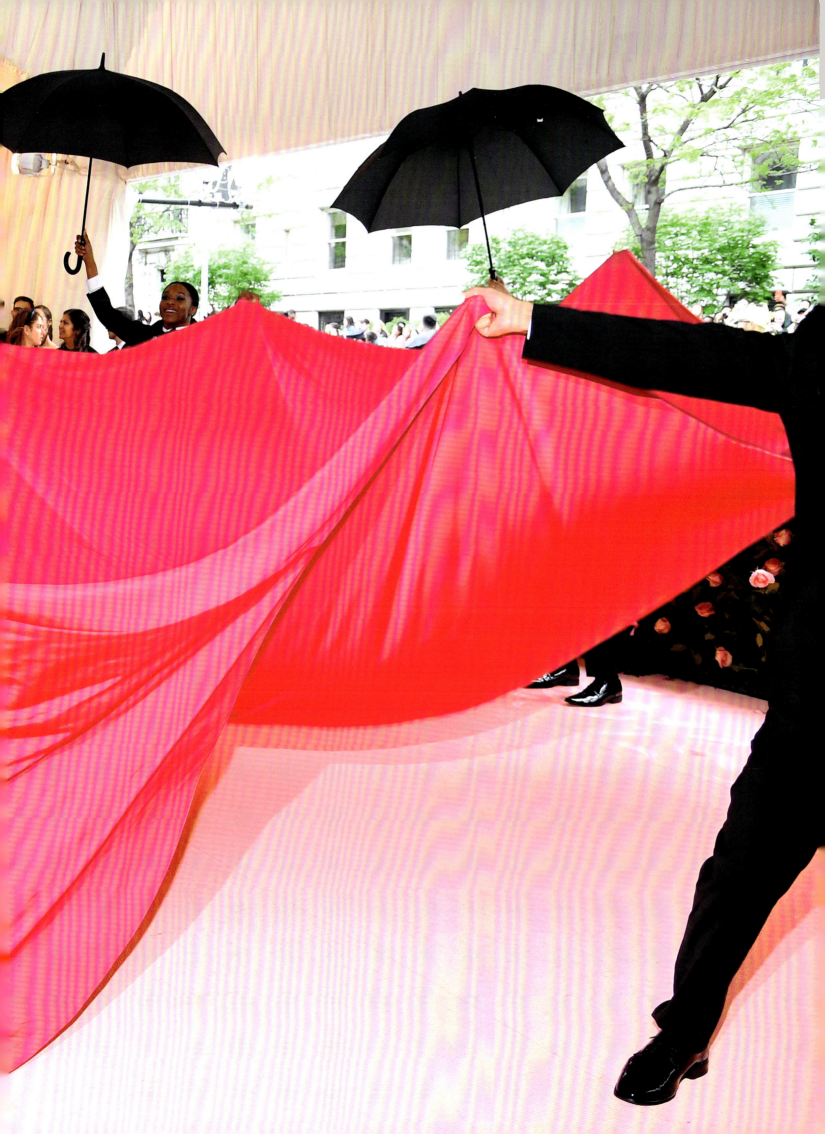

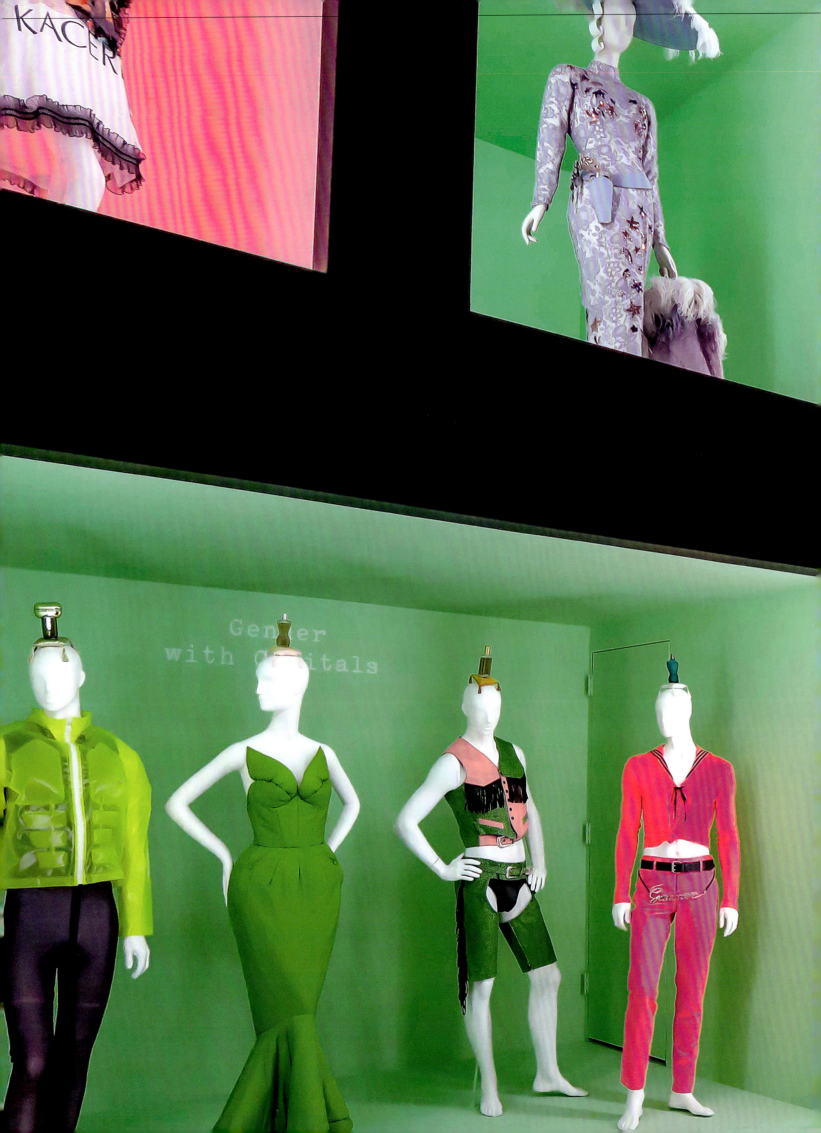

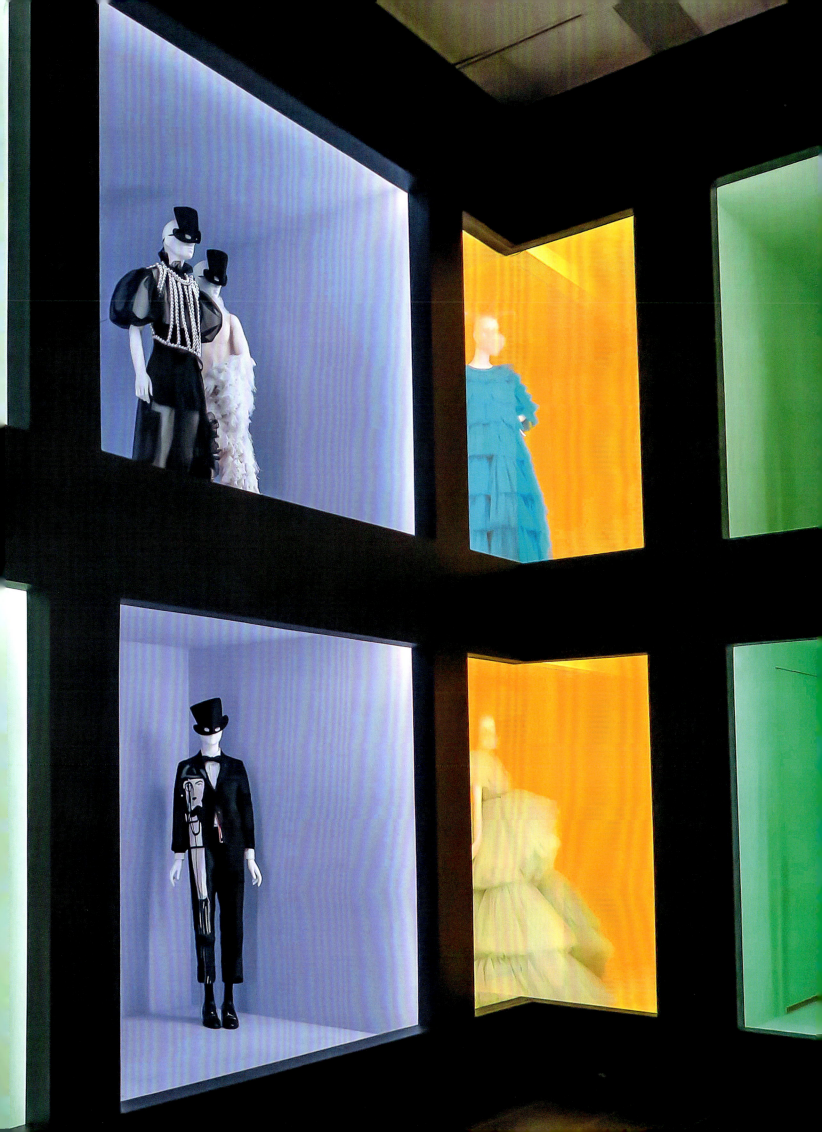

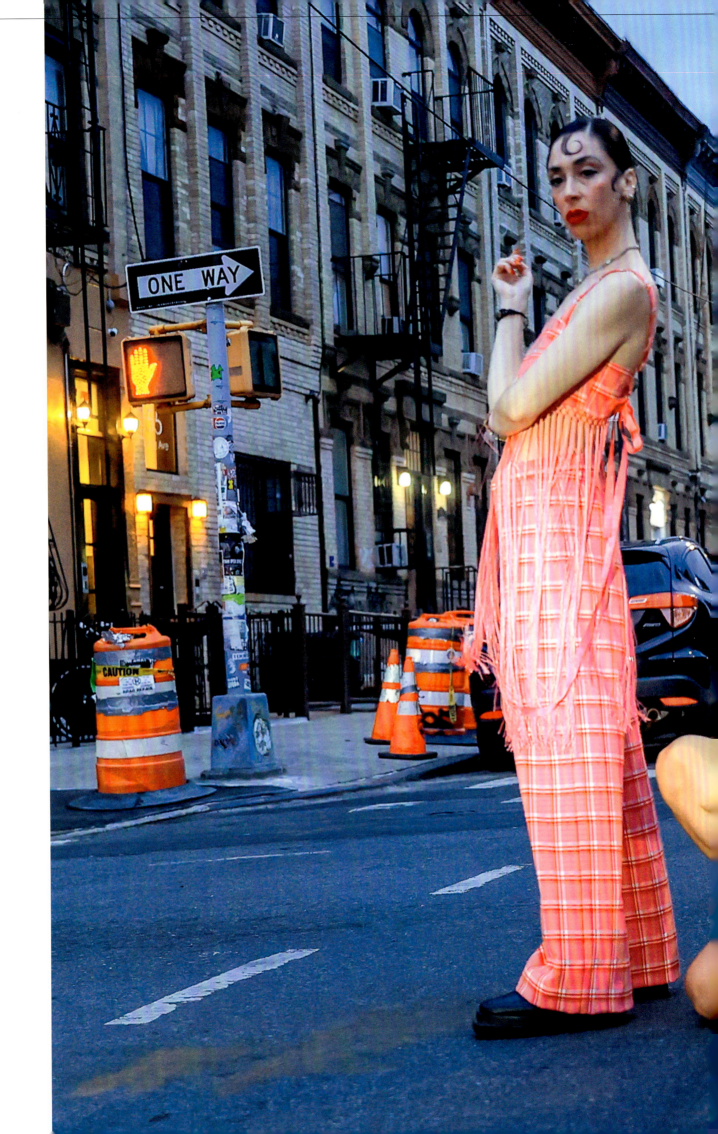

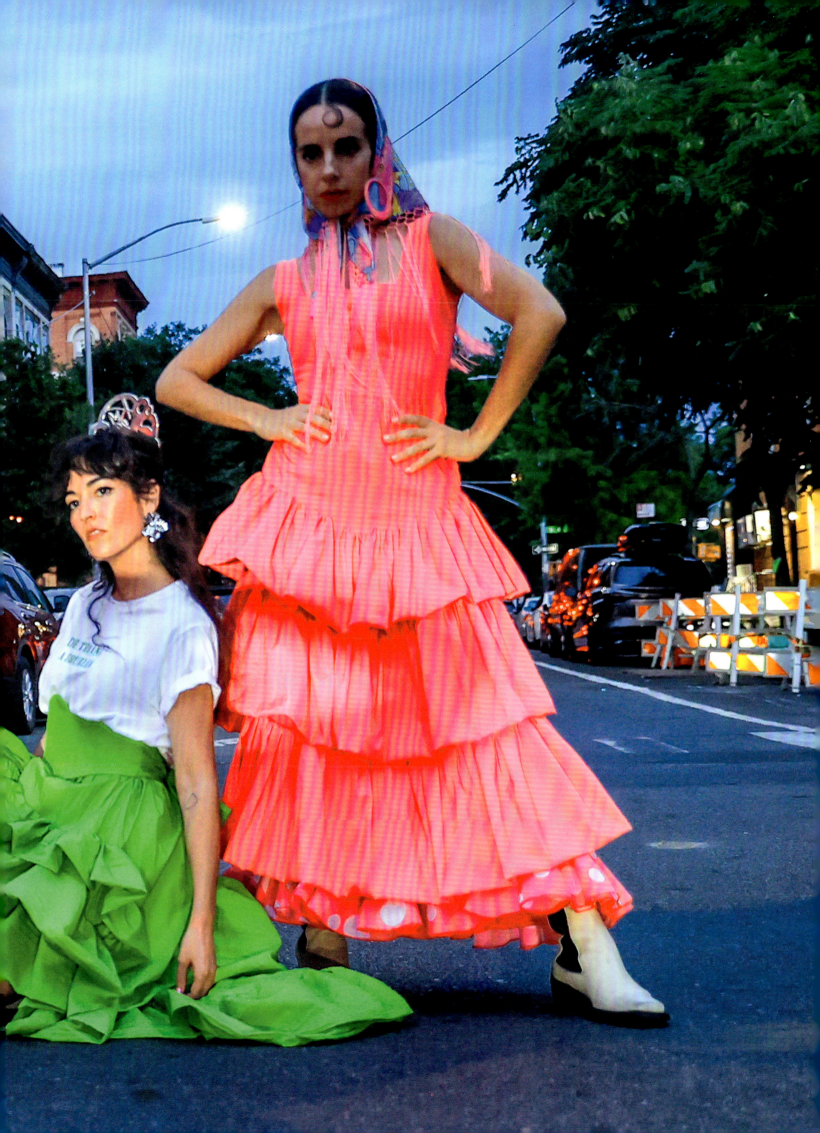

"I never buy what someone says is 'in' or a 'must-have.' I buy what makes me happy."

IRIS APFEL

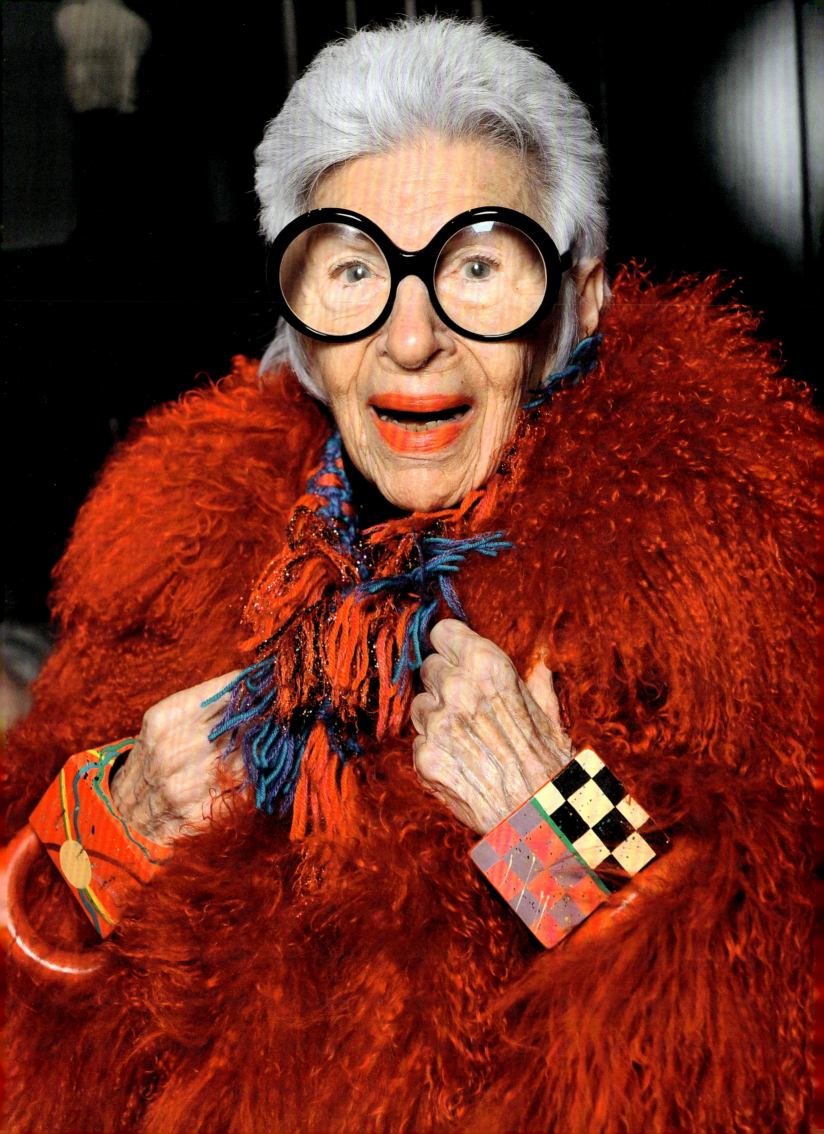

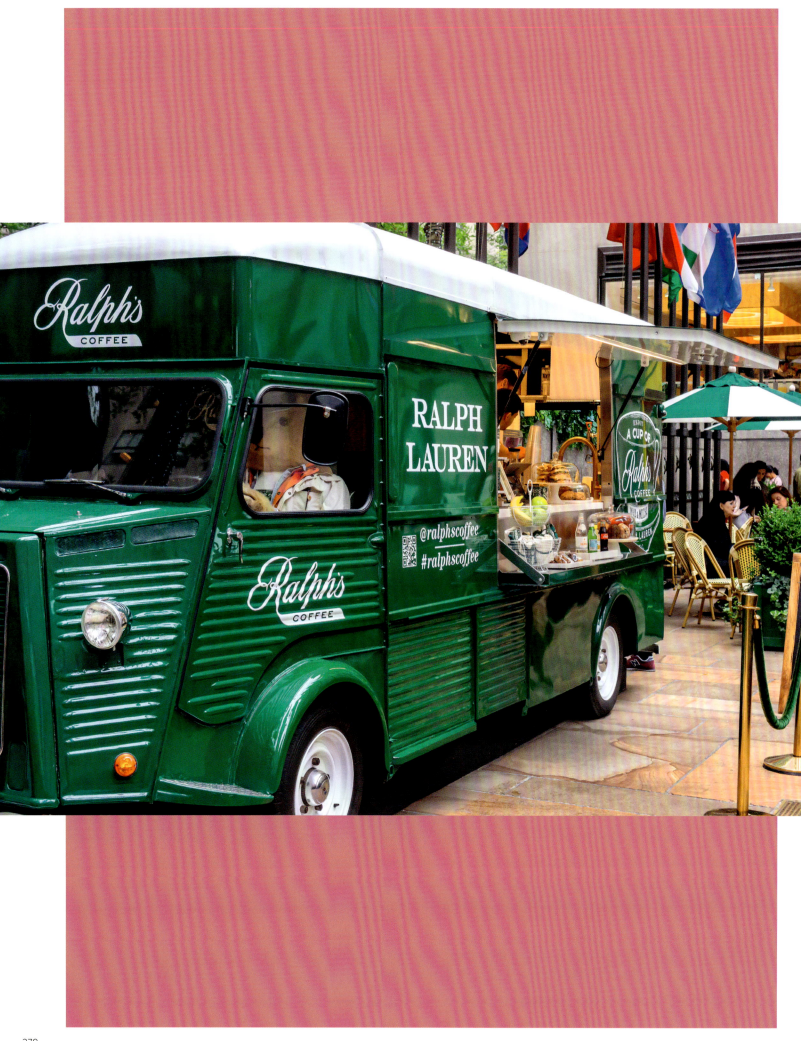

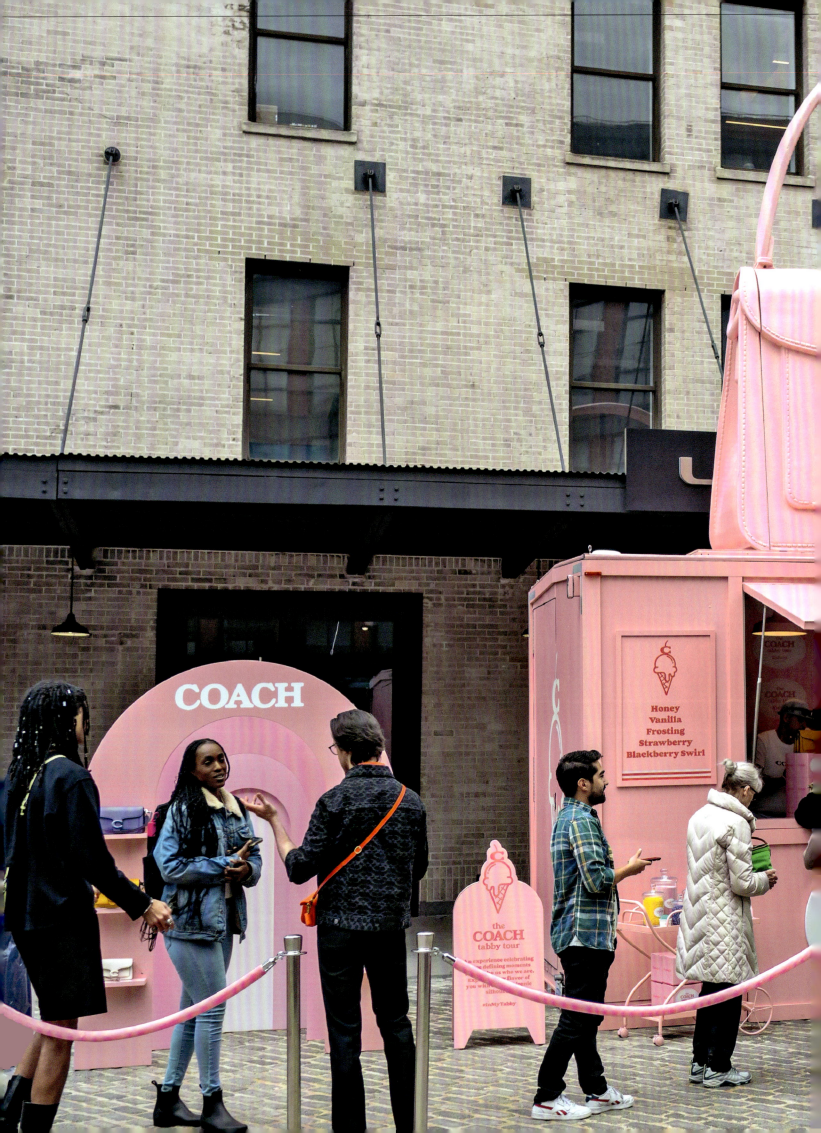

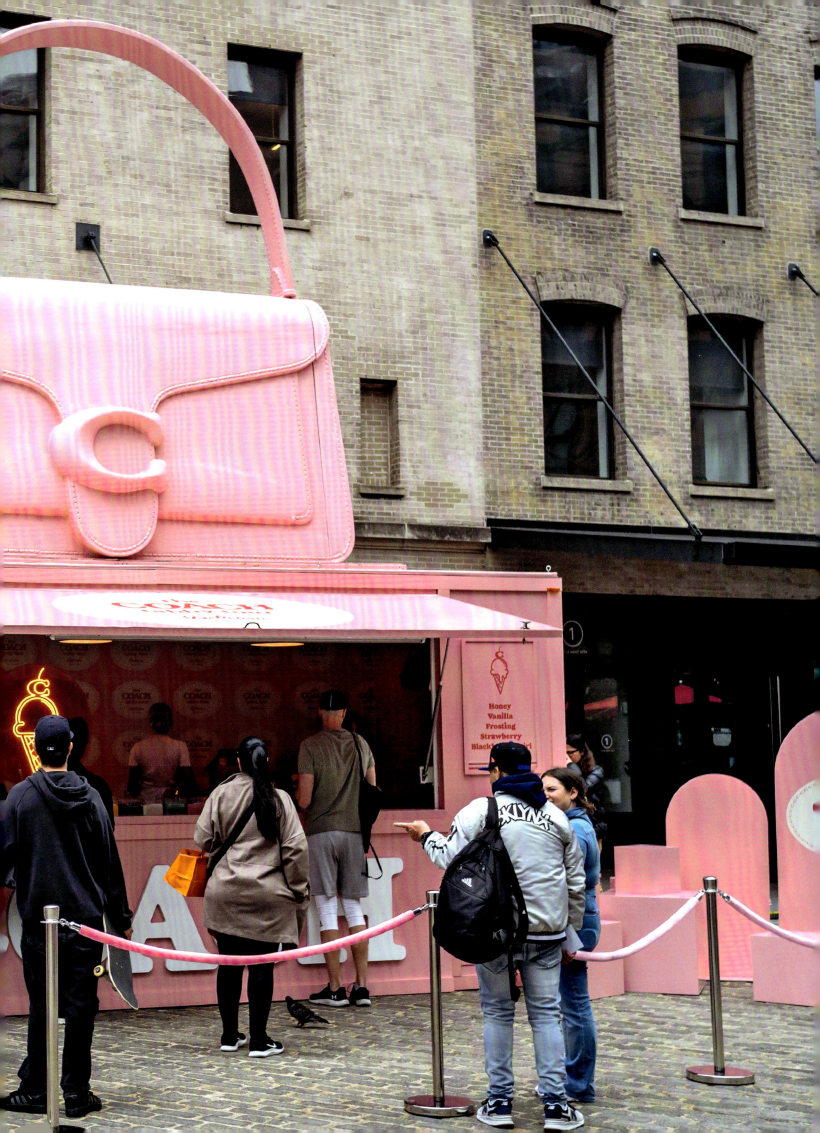

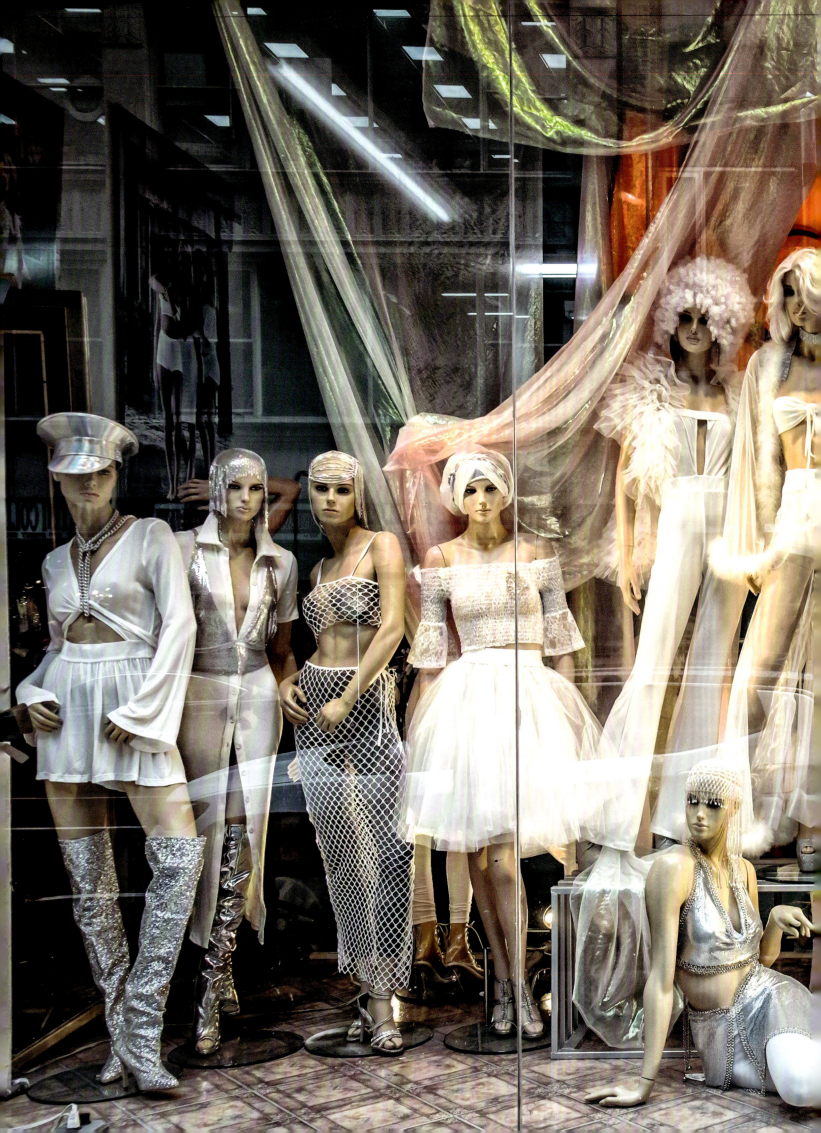

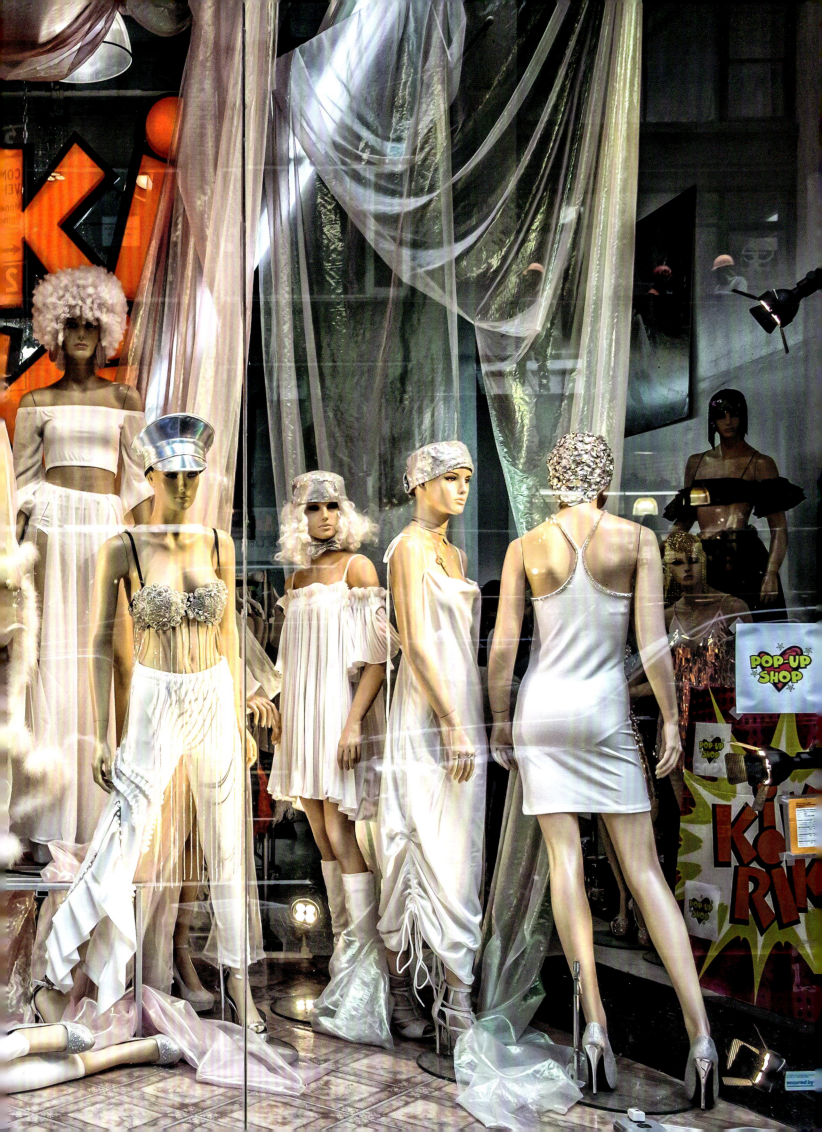

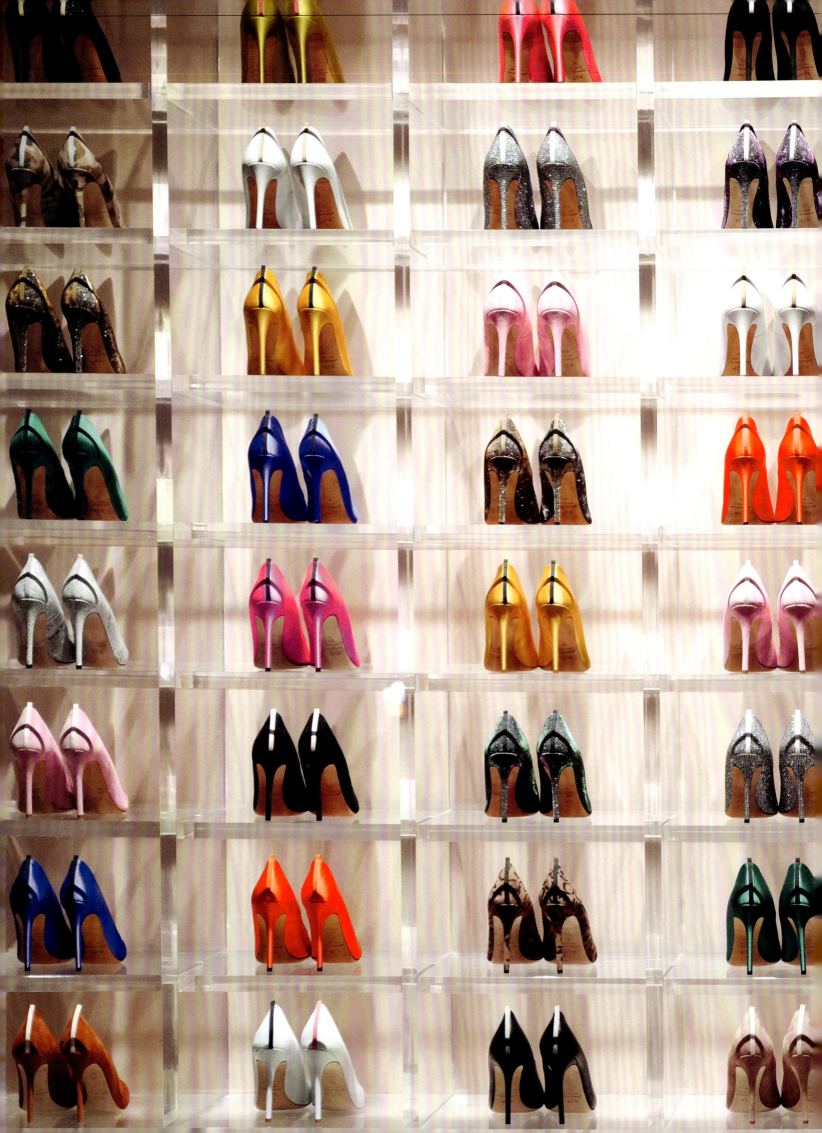

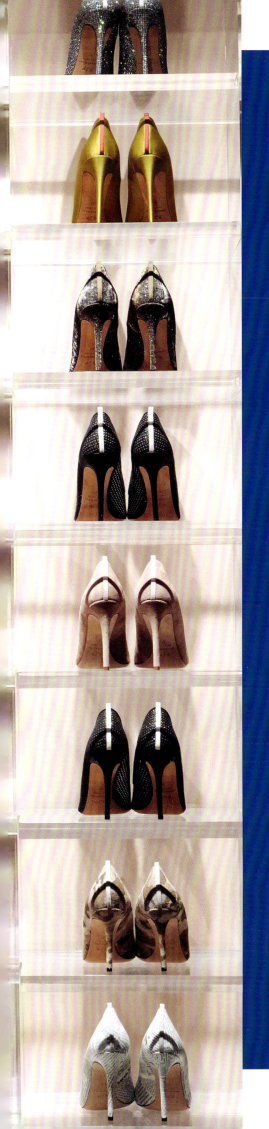

"I'm a New Yorker, and I live the moment."

SARAH JESSICA PARKER

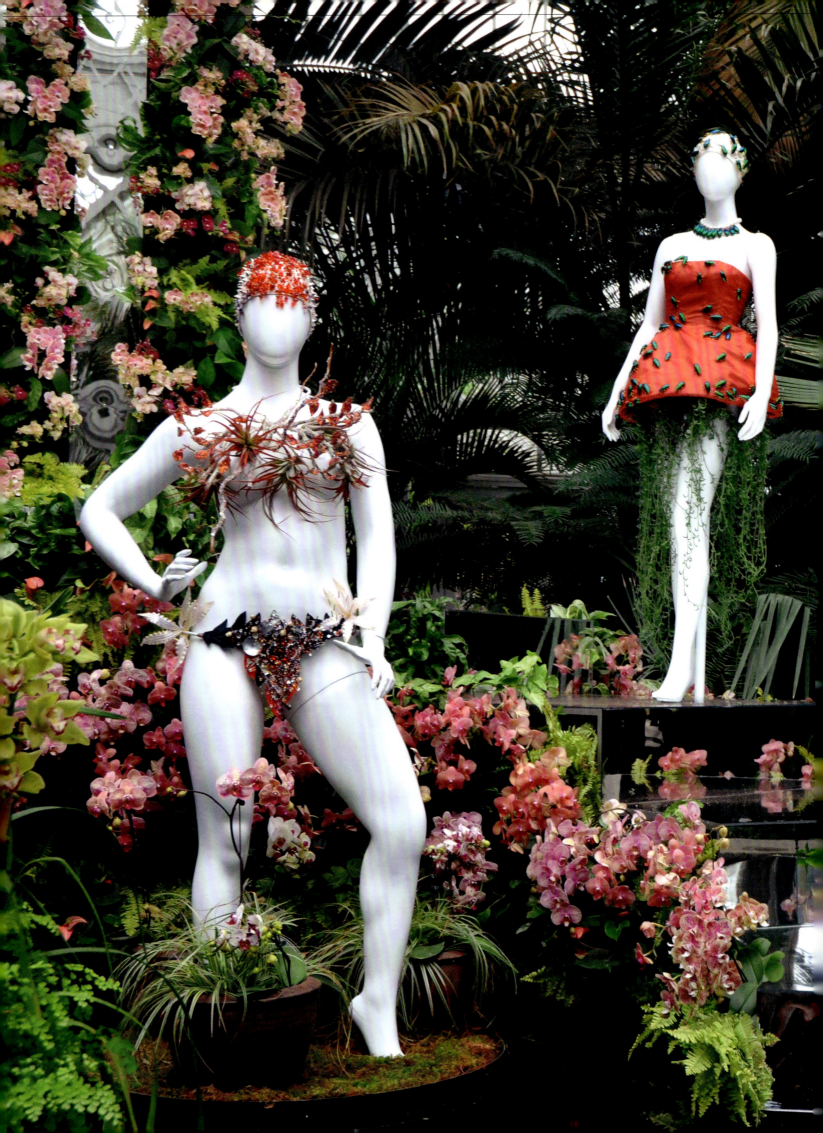

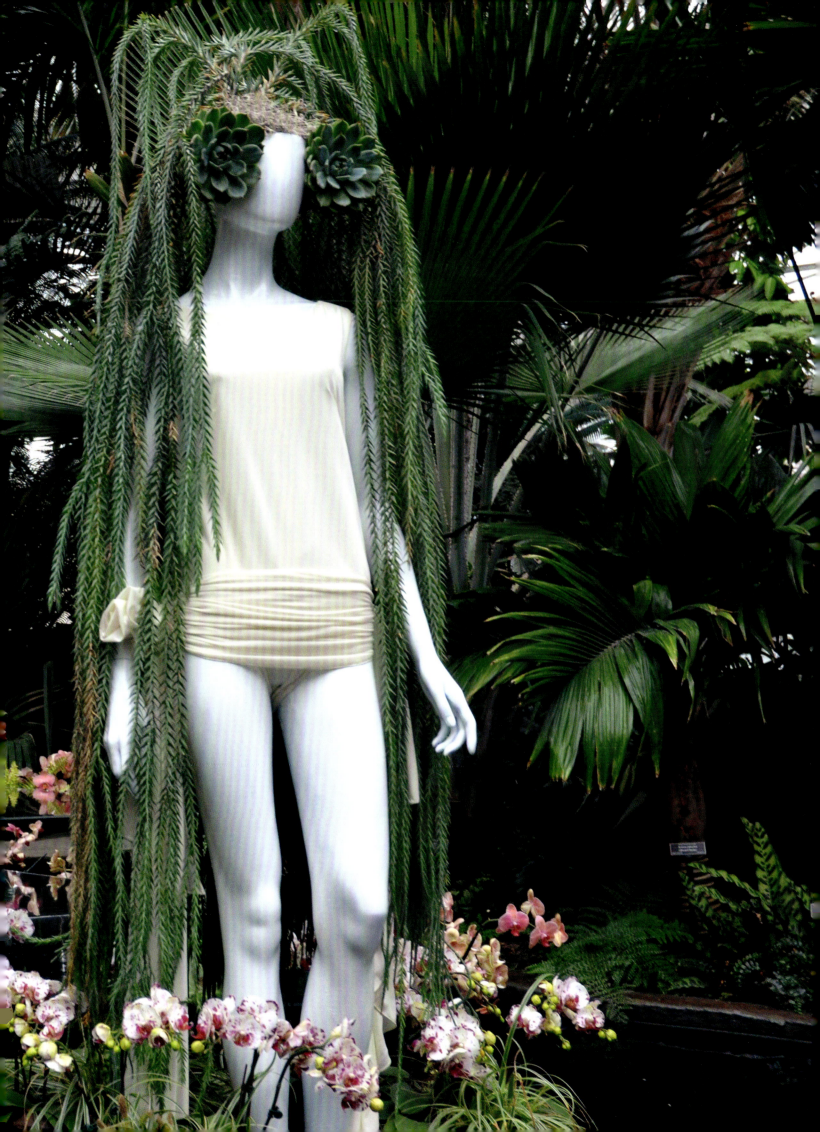

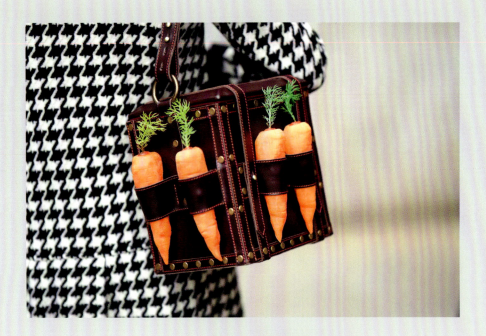

A guest of the Puppets and Puppets Autumn/Winter 2023 collection show wears a leather handbag with carrots, February 2023.

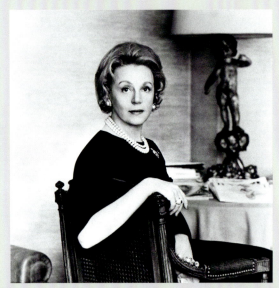

Fashion publicist Eleanor Lambert (1903–2003) in 1966.

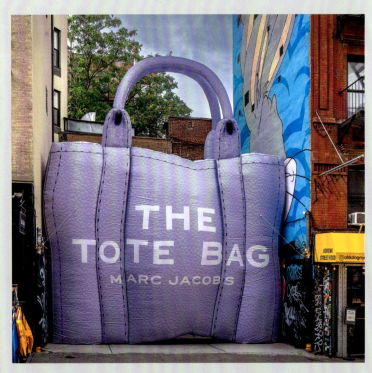

A giant mock-up of a Marc Jacobs tote bag on display on Ludlow Street, Lower East Side, September 2023.

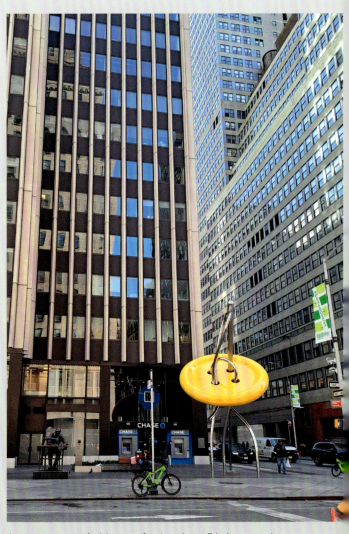

A monument to fashion professionals on 7th Avenue, the very heart of the former Garment District.

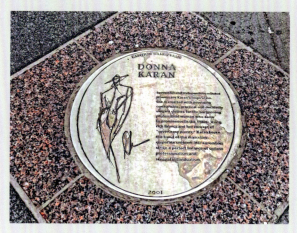 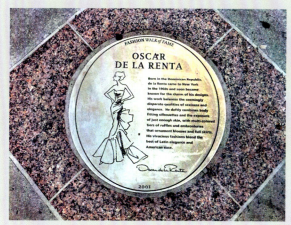

Two of the plaques formerly installed in the New York Fashion Walk of Fame.

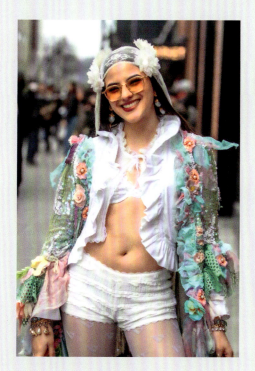 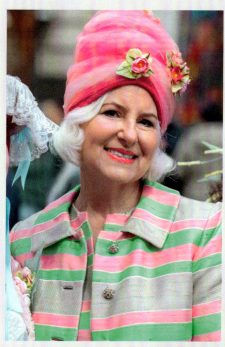

Eccentricity is at the core of New York's DNA.

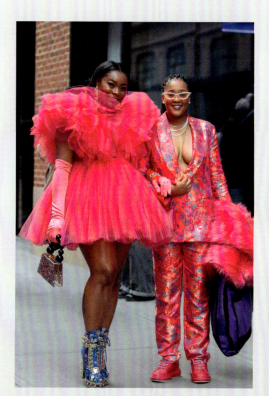 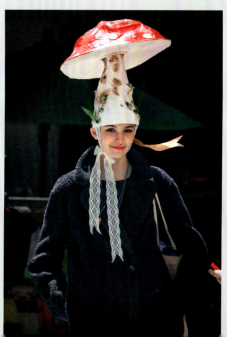 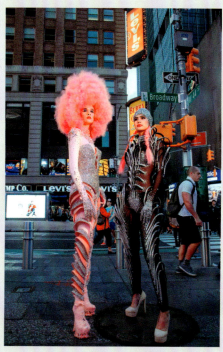

289

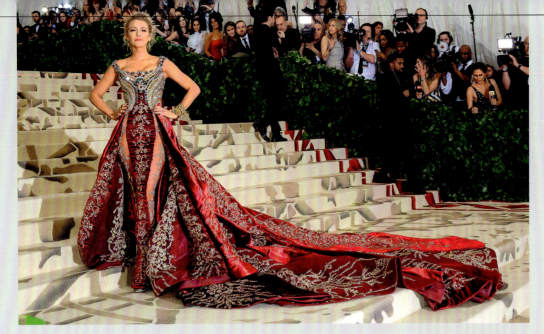

Blake Lively dressed in a Versace evening gown at the Met Gala, May 2018.

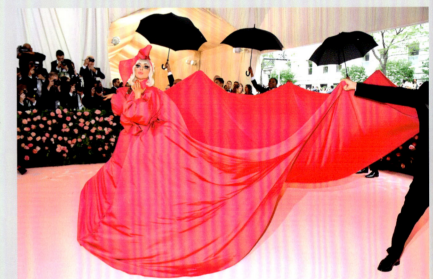

Lady Gaga, dressed in a pink gown designed by Brandon Maxwell, at the Met Gala, May 2019.

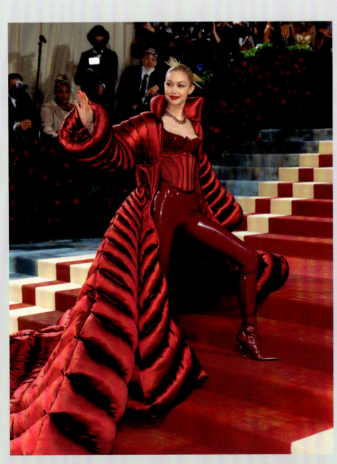

Gigi Hadid in a Versace creation at the Met Gala, May 2022.

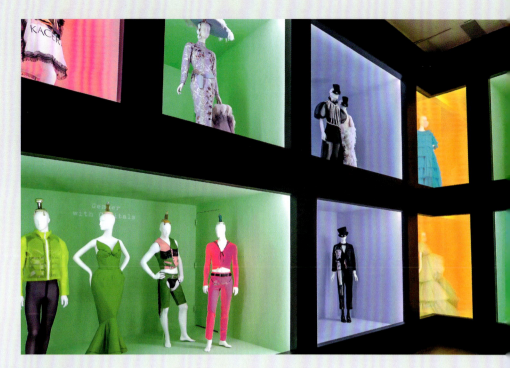

Camp: Notes on Fashion exhibition at the Metropolitan Museum of Art, Summer 2019.

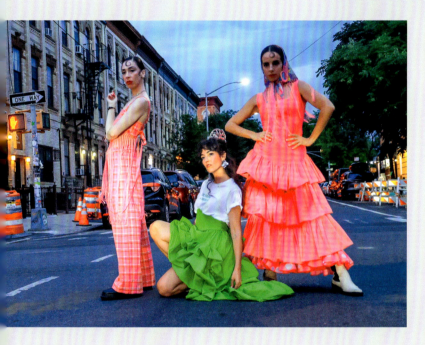

Spanish designer Sara Gomez Arenas (centre) presents a collection on the streets of Brooklyn, June 2024.

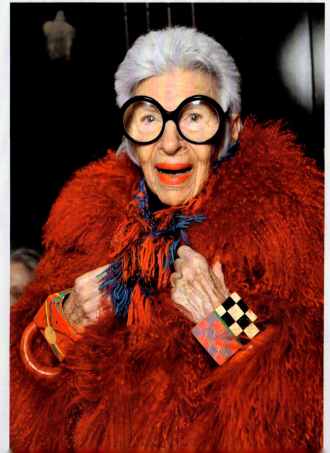

Iris Apfel at the Ralph Rucci Autumn/Winter 2014/2015 collection show.

Ralph Lauren's café and coffee truck on 5th Avenue.

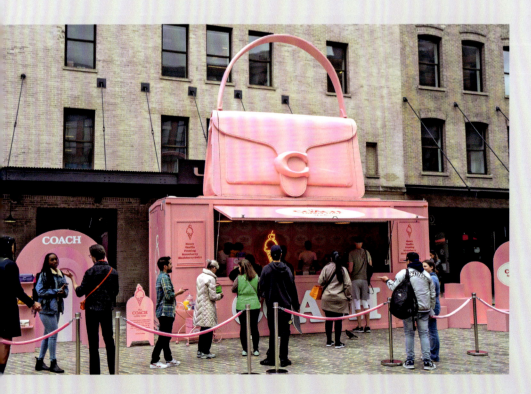

A Coach pop-up café promoting the Coach Tabby handbag on Gansevoort Plaza, Meatpacking District, May 2023.

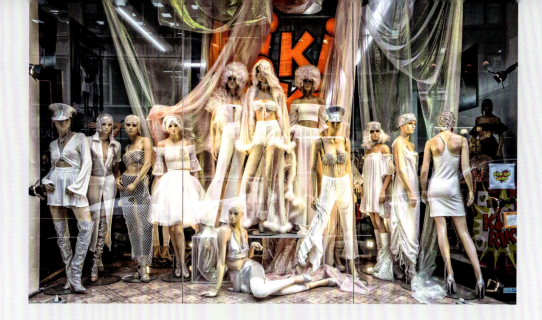

A pop-up fashion shop in the Hell's Kitchen area of Manhattan, 2019.

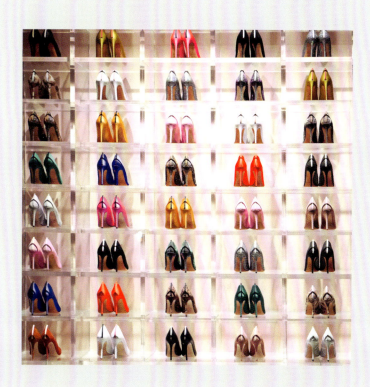

Sarah Jessica Parker's collection of shoes displayed in rows at the actress's erstwhile flagship, SJP by Sarah Jessica Parker, on the corner of Bleecker and Perry Street, October 2020.

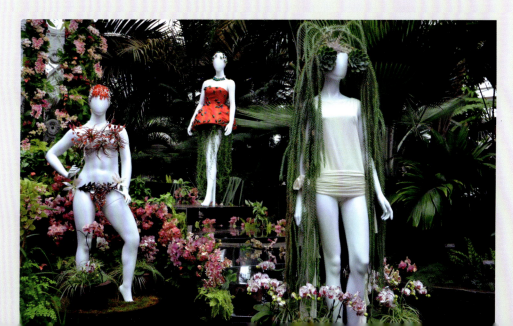

Detail of the *Orchid Show: Florals in Fashion* exhibition of the New York Botanical Garden, February 2024. Three contemporary designers created installations inspired by diverse, colourful and fashionable flowering plants and orchids.

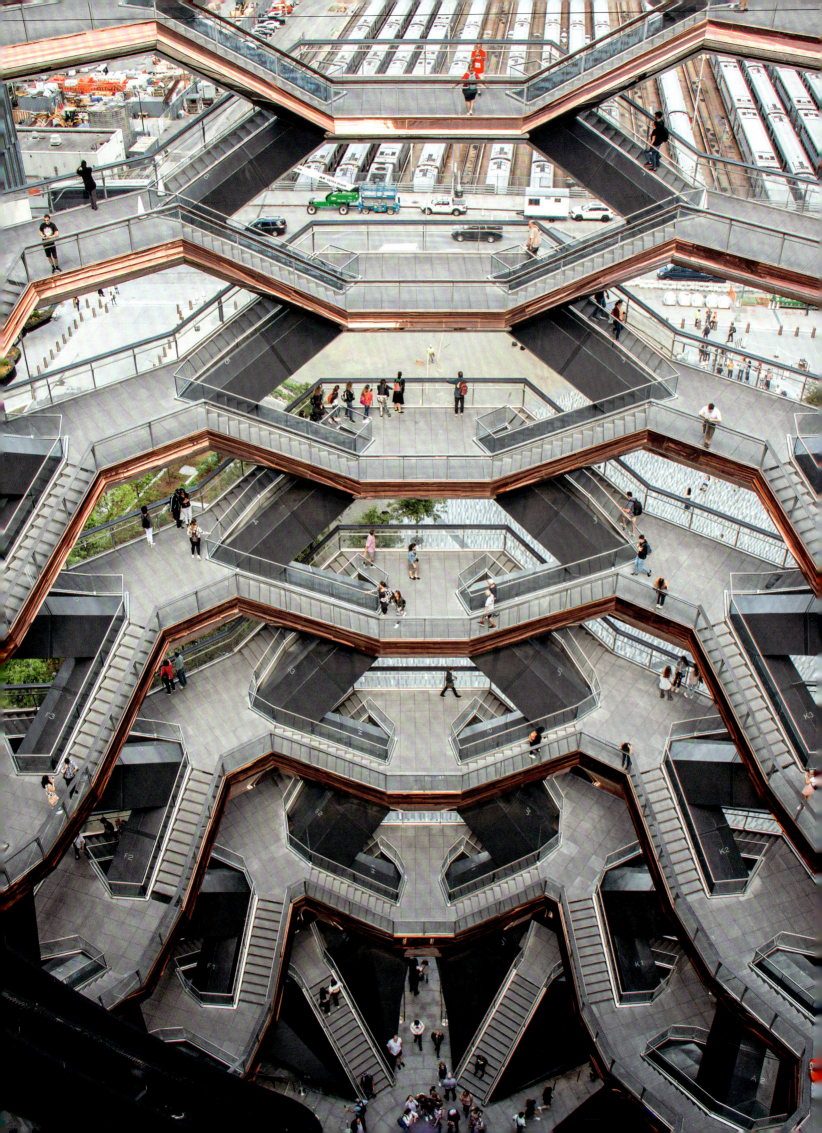

PHOTO CREDITS

Front cover © Photo by Sophie Sahara/WWD via Getty Images
p. 2 © Benjamin Rondel/Alamy Stock Photo
pp. 4–5 © Joshua Haviv/Shutterstock
pp. 6–7 © Rudy Balasko/Shutterstock
pp. 8–9 © Patrick Batchelder/Alamy Stock Photo
p. 10 © Lazyllama/Alamy Stock Photo
pp. 12–13 © Ira Berger/Alamy Stock Photo
p. 14 © Triston Dunn/Unsplash
pp. 18, 36 © MFA Boston
pp. 21, 36 © Bettmann/Bettmann via Getty Images
pp. 22, 36 © John Springer Collection/Corbis via Getty Images
pp. 23 top, 36 © Rijksmuseum, Amsterdam
pp. 23 bottom, 36 © Rijksmuseum, Amsterdam
pp. 25, 36 © Horst P. Horst/Conde Nast via Getty Images
pp. 27, 37 © Picryl
pp. 28, 37 © Picryl
pp. 31, 37 © Earl Leaf/Michael Ochs Archives/Moviepix via Getty Images
pp. 33, 37 © Robert R. McElroy/Getty Images
pp. 35, 37 © Noam Galai/Getty Images for Central Park Tower
pp. 38–39, 114 © Lexie Moreland/WWD via Getty Images
pp. 40, 114 © Bettmann/Bettmann via Getty Images
pp. 42–43, 114 © Bettmann/Bettmann via Getty Images
pp. 45, 114 © Associated Press/Alamy Stock Photo
pp. 46, 114 © Paul Hurschmann/Alamy Stock Photo
pp. 48–49, 114 © davecsmith/Shutterstock
pp. 50–51, 114 © Sam Aronov/Shutterstock
pp. 53, 115 © FashionStock.com/Shutterstock
pp. 54, 115 © Ovidiu Hrubaru/Shutterstock
pp. 55, 115 © FashionStock.com/Shutterstock
pp. 56–57, 115 © Ovidiu Hrubaru/Shutterstock
pp. 58, 115 © FashionStock.com/Shutterstock
pp. 59 all images, 115 © Arturo Holmes/Getty Images Entertainment
pp. 60 left, 116 © Ron Adar/Shutterstock
pp. 60 right, 116 © FashionStock.com/Shutterstock
pp. 61, 116 © Ovidiu Hrubaru/Shutterstock
pp. 62–63, 116 © Ovidiu Hrubaru/Shutterstock
pp. 64, 116 © Antonio de Moraes Barros Filho/FilmMagic via Getty Images
pp. 65, 116 © Antonio de Moraes Barros Filho/FilmMagic via Getty Images
pp. 66–67, 116 © Antonio de Moraes Barros Filho/FilmMagic via Getty Images
pp. 68, 117 © K2 images/Shutterstock
pp. 69, 117 © K2 images/Shutterstock
pp. 70–71, 117 © Arturo Holmes/Getty Images Entertainment
pp. 72, 117 © FashionStock.com/Shutterstock
pp. 73, 117 © FashionStock.com/Shutterstock
pp. 74, 118 © Ovidiu Hrubaru/Shutterstock
pp. 75, 118 © FashionStock.com/Shutterstock
pp. 76, 118 © Ovidiu Hrubaru/Shutterstock
pp. 77, 118 © Debby Wong/Shutterstock
pp. 78–79, 118 © lev radin/Shutterstock
pp. 80–81, 118 © FashionStock.com/Shutterstock
pp. 82–83, 118 © Sam Aronov/Shutterstock
pp. 84, 118 © Ovidiu Hrubaru/Shutterstock
pp. 85, 118 © Ovidiu Hrubaru/Shutterstock
pp. 86, 119 © FashionStock.com/Shutterstock
pp. 87, 119 © FashionStock.com/Shutterstock
pp. 88, 119 © Dia Dipasupil/Getty Images Entertainment
pp. 89 left, 119 © lev radin/Shutterstock
pp. 89 right, 119 © lev radin/Shutterstock
pp. 90, 119 © Frazer Harrison/Getty Images Entertainment
pp. 91, 119 © K2 images/Shutterstock
pp. 92 left, 119 © Peter White/WireImage via Getty Images
pp. 92 right, 119 © WWD/Penske Media via Getty Images
pp. 93, 119 © Peter White/WireImage via Getty Images
pp. 94–95, 120 © Ovidiu Hrubaru/Shutterstock
pp. 96, 120 © Fernanda Calfat/Getty Images Entertainment
pp. 97, 120 © Fernanda Calfat/Getty Images Entertainment
pp. 98–99, 120 © Brian Ach/Getty Images Entertainment
pp. 100, 120 © FashionStock.com/Shutterstock
pp. 101, 120 © FashionStock.com/Shutterstock
pp. 102, 120 © FashionStock.com/Shutterstock
pp. 103, 120 © FashionStock.com/Shutterstock
pp. 104, 121 © Andrew Walker/WWD/Penske Media via Getty Images
pp. 105, 121 © FashionStock.com/Shutterstock
pp. 106 left, 121 © FashionStock.com/Shutterstock
pp. 106 right, 121 © FashionStock.com/Shutterstock
pp. 107, 121 © FashionStock.com/Shutterstock
pp. 108, 121 © Ovidiu Hrubaru/Shutterstock
pp. 109, 121 © Ovidiu Hrubaru/Shutterstock
pp. 110, 121 © Ovidiu Hrubaru/Shutterstock
pp. 111, 121 © Robert Mitra/WWD/Penske Media via Getty Images
pp. 112–13, 121 © Sam Aronov/Shutterstock
pp. 122–23, 198 © goofyfoottaka/Shutterstock
pp. 124, 198 © Edward Berthelot/Getty Images Entertainment
pp. 127, 198 © Valery Rizzo/Alamy Stock Photo
pp. 128, 198 © Kateryna Tsurik/Pexels
pp. 129, 198 © Edward Berthelot/Getty Images Entertainment
pp. 130, 198 © Following NYC/Pexels
pp. 132, 198 © dpa/Alamy Stock Photo
pp. 133, 198 © Following NYC/Pexels
pp. 134, 199 © Luis Molina/Alamy Stock Photo
pp. 135, 199 © Luis Molina/Alamy Stock Photo
pp. 136, 199 © Edward Berthelot/Getty Images Entertainment
pp. 137, 199 © Edward Berthelot/Getty Images Entertainment
pp. 138, 199 © Edward Berthelot/Getty Images Entertainment
pp. 139, 199 © Edward Berthelot/Getty Images Entertainment
pp. 140, 200 © Following NYC/Pexels
pp. 141, 200 © Following NYC/Pexels
pp. 142, 200 © dpa/Alamy Stock Photo
pp. 143, 200 © Following NYC/Pexels
pp. 144, 200 © Following NYC/Pexels
pp. 145, 200 © Following NYC/Pexels
pp. 146, 201 © Following NYC/Pexels
pp. 147, 201 © Following NYC/Pexels
pp. 148, 201 © Luis Molina/Alamy Stock Photo
pp. 150, 201 © Marcy Swingle/Shutterstock
pp. 151, 201 © Phonesvanh Siharat/Shutterstock
pp. 152, 202 © Edward Berthelot/Getty Images Entertainment
pp. 153 left, 202 © Edward Berthelot/Getty Images Entertainment
pp. 153 right, 202 © Edward Berthelot/Getty Images Entertainment
pp. 154, 202 © Edward Berthelot/Getty Images Entertainment
pp. 155, 202 © Alya 108k/Shutterstock
pp. 156, 202 © Edward Berthelot/Getty Images Entertainment
pp. 157, 202 © Edward Berthelot/Getty Images Entertainment
pp. 158 top, 203 © Beth Dixson/Alamy Stock Photo
pp. 158 bottom, 203 © Edd Westmacott/Alamy Stock Photo
pp. 159, 203 © Edward Berthelot/Getty Images Entertainment
pp. 160, 203 © Edward Berthelot/Getty Images Entertainment
pp. 161, 203 © Edward Berthelot/Getty Images Entertainment
pp. 162, 203 © Following NYC/Pexels
pp. 163, 203 © Following NYC/Pexels
pp. 164, 204 © Following NYC/Pexels
pp. 165, 204 © Edward Berthelot/Getty Images Entertainment
pp. 166, 204 © Edward Berthelot/Getty Images Entertainment
pp. 167, 204 © Michael Burrows/Pexels
pp. 168–69, 204 © Alya 108k/Shutterstock
pp. 170, 205 © Phonesvanh Siharat/Shutterstock
pp. 171, 205 © Phonesvanh Siharat/Shutterstock
pp. 172, 205 © Ira Berger/Alamy Stock Photo
pp. 173, 205 © FashionStock.com/Shutterstock
pp. 174, 205 © Edward Berthelot/Getty Images Entertainment
pp. 175, 205 © Ira Berger/Alamy Stock Photo
pp. 176, 206 © Ira Berger/Alamy Stock Photo
pp. 177, 206 © dpa/Alamy Stock Photo
pp. 178, 206 © Jeremy Moeller/Getty Images Entertainment
pp. 179, 206 © Jeremy Moeller/Getty Images Entertainment
pp. 180, 206 © dpa/Alamy Stock Photo
pp. 181, 207 © dpa/Alamy Stock Photo
pp. 182–83, 207 © Alya 108k/Shutterstock
pp. 184, 207 © Following NYC/Pexels
pp. 185, 207 © Following NYC/Pexels
pp. 186 left, 208 © Lars Anders/Shutterstock
pp. 186 right, 208 © dpa/Alamy Stock Photo
pp. 187, 208 © dpa/Alamy Stock Photo
pp. 188, 208 © Beatriz Vera/Shutterstock
pp. 189, 208 © Following NYC/Pexels
pp. 190, 208 © dpa/Alamy Stock Photo
pp. 191, 209 © dpa/Alamy Stock Photo
pp. 192, 209 © dpa/Alamy Stock Photo
pp. 193, 209 © Edward Berthelot/Getty Images Entertainment
pp. 194, 209 © dpa/Alamy Stock Photo
pp. 195, 209 © dpa/Alamy Stock Photo
pp. 196–97, 209 © Edward Berthelot/Getty Images Entertainment
pp. 210–11, 250 © Leonard Zhukovsky/Shutterstock
pp. 212–13, 250 © Christopher Vernon-Parry/Alamy Stock Photo
pp. 214–15, 250 © Sean Pavone/Alamy Stock Photo
pp. 216–17, 250 © Leonard Zhukovsky/Shutterstock
pp. 218, 250 © Victoria Lipov/Shutterstock
pp. 219, 250 © Victoria Lipov/Shutterstock
pp. 220–21, 251 © Lance Mohesky/Unsplash
pp. 222, 251 © astudio/Shutterstock
pp. 223, 251 © Gavin Hellier/Alamy Stock Photo
pp. 224, 251 © christianthiel.net/Shutterstock
pp. 225, 251 © Victoria Lipov/Shutterstock
pp. 226–27, 251 © John Hanson Pye/Shutterstock
pp. 228–29, 251 © DW labs Incorporated/Shutterstock
pp. 230–31, 252 © Mary Altaffer/Alamy Stock Photo
pp. 232–33, 252 © Stephanie Keith/Bloomberg via Getty Images
pp. 234, 252 © Sorbis/Shutterstock
pp. 235, 252 © Solarisys/Shutterstock
pp. 236–37, 252 © Little Vignettes Photo/Shutterstock
pp. 238–39, 252 © Little Vignettes Photo/Shutterstock
pp. 240–41, 252 © Lena Chert/Shutterstock
pp. 242 top, 252 © JJFarq/Shutterstock
pp. 242 bottom, 252 © rblfmr/Shutterstock
pp. 243, 253 © Spiroview Inc/Shutterstock
pp. 244, 253 © Jorge Royan/Alamy Stock Photo
pp. 245 top, 253 © Patti McConville/Alamy Stock Photo
pp. 245 bottom, 253 © Patti McConville/Alamy Stock Photo
pp. 246, 253 © Chris Mellor/Alamy Stock Photo
pp. 247, 253 © Directphoto Collection/Alamy Stock Photo
pp. 248–49, 253 © Alex Segre/Alamy Stock Photo
pp. 254–55, 288 © Edward Berthelot/Getty Images Entertainment
pp. 256–57, 288 © Brian Logan Photography/Shutterstock
pp. 259, 288 © Bettmann/Getty Images
pp. 260, 288 © WikiCommons
pp. 261 left, 289 © OPIS/Shutterstock
pp. 261 right, 289 © OPIS/Shutterstock
pp. 262 left, 289 © Following NYC/Pexels
pp. 262 right, 289 © Following NYC/Pexels
pp. 263, 289 © Following NYC/Pexels
pp. 264, 289 © Juan Antonio Ordonez/Pexels
pp. 265, 289 © Following NYC/Pexels
pp. 266–67, 290 © Sky Cinema/Shutterstock
pp. 269, 290 © Gotham/Getty Images Entertainment
pp. 270–71, 290 © Dimitrios Kambouris/Getty Images for The Met Museum/Vogue via Getty Images Entertainment
pp. 272–73, 291 © Patti McConville/Alamy Stock Photo
pp. 274–75, 291 © Selcuk Acar/Anadolu via Getty Images
pp. 277, 291 © Wendell Teodoro/WireImage via Getty Images
pp. 278, 292 © Richard Levine/Alamy Stock Photo
pp. 279, 292 © Alexandra Folster/Pexels
pp. 280–81, 292 © rblfmr/Shutterstock
pp. 282–83, 293 © eric laudonien/Alamy Stock Photo
pp. 284–85, 293 © Ido Simantov/Shutterstock
pp. 286–87, 293 © Pamela Hassell/Alamy Stock Photo
pp. 294–95 © Lukas Kloeppel/Pexels
p. 296 © Elisa Gaccaglia/Pexels
p. 297 © Following NYC/Pexels
pp. 298–99 © Miles Astray/Shutterstock
pp. 300–301 © Andre Benz/Unsplash
p. 303 © Gary Hershorn/Corbis News via Getty Images
Back cover © Gorodenkoff/Shutterstock

ACKNOWLEDGEMENTS

I am truly indebted to the Big Apple as a great source of inspiration and never-fading amazement. And, of course, to the New Yorkers, who embody coolness, energy and originality.

I would also like to thank the entire team at ACC Art Books for their patient and understanding support, and for all their suggestions that contributed to enhancing the contents of this book.

A big thank you to my beloved wife Agata, whose passion for New York is reflecting on the pages she gorgeously designed, and to my daughters Emilie and Mathilde, who particularly enjoyed some of the eccentric garments.

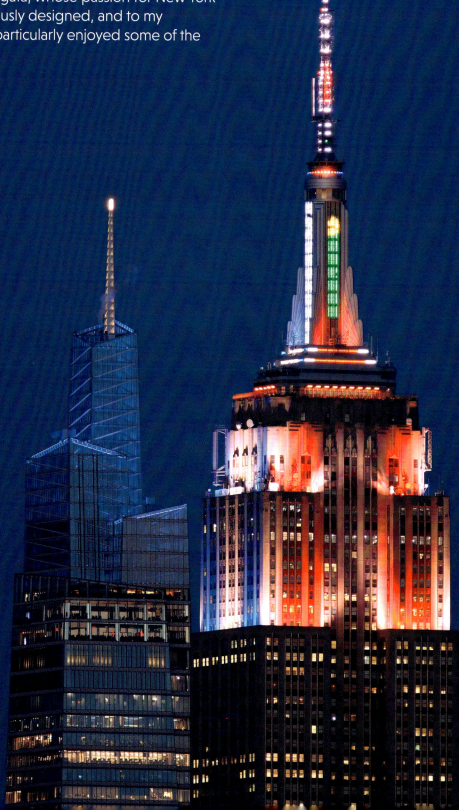

© 2025 ACC Art Books, 2025
Texts and layout © Fancy Books Packaging UG (haftungsbeschrankt)
World copyright reserved

ISBN: 978-1-78884-312-6

The right of Pierre Toromanoff to be identified as author of this work has been asserted by him in accordance with the Copyright, Designs and Patents Act 1988

All rights reserved. No part of this publication may be reproduced, stored in a retrieval system, or transmitted in any form or by any means electronic, mechanical, photocopying, recording or otherwise, without the prior permission of the publisher

A CIP catalogue record for this book is available from the British Library

The author and publisher gratefully acknowledge the permission granted to reproduce the copyright material in this book. Every effort has been made to trace copyright holders and to obtain their permission for the use of copyright material. The publisher apologises for any errors or omissions in the text and would be grateful if notified of any corrections that should be incorporated in future reprints or editions of this book.

Senior Editor: Alice Bowden
Creative Direction: Mariona Vilarós Capella
Design: Steve Farrow
Colour Separation: Corban Wilkin

EU GPSR Authorised Representative:
Easy Access System Europe Oü, 16879218
Address: Mustamäe tee 50, 10621 Tallinn, Estonia
Email: gpsr@easproject.com Tel: +358 40 500 3575

Printed by C&C Offset Printing Co. Ltd in China
for ACC Art Books Ltd, Woodbridge, Suffolk, UK

www.accartbooks.com